Art and Protest in Putin's R

CW01023442

The Pussy Riot protest and the subsequent heavy-handed treatment of the protestors grabbed headlines, but this was not an isolated instance of art being noticeably critical of the regime. As this book, based on extensive original research, shows, there has been gradually emerging over recent decades a significant counter-culture in the art world which satirises and ridicules the regime and the values it represents, at the same time putting forward, through art, alternative values. The book traces the development of art and protest in recent decades, discusses how art of this kind engages in political and social protest, and provides many illustrations as examples of art as protest. The book concludes by discussing how important art has been in facilitating new social values and in prompting political protests.

Lena Jonson is Senior Research Fellow and Head of the Russia Research Program at the Swedish Institute of International Affairs, Stockholm.

Routledge Contemporary Russia and Eastern Europe Series

Art and Protest in Putin's Russia

Lena Jonson

Routledge
Taylor & Francis Group

LONDON AND NEW YORK

First published 2015
by Routledge
2 Park Square, Milton Park, Abingdon, Oxfordshire OX14 4RN

and by Routledge
711 Third Avenue, New York, NY 10017

First issued in paperback 2016

*Routledge is an imprint of the Taylor & Francis Group,
an informa business*

British Library Cataloguing in Publication Data
A catalogue record for this book is available from the British Library

Library of Congress Cataloging-in-Publication Data
Jonson, Lena
 Art and protest in Putin's Russia / Lena Jonson.
 pages cm. — (Routledge contemporary Russia and Eastern Europe
series ; 61)
 Includes bibliographical references and index.
 1. Art—Political aspects—Russia (Federation)—History—21st century.
2. Art and society—Russia (Federation)—History—21st century.
3. Protest movements—Russia (Federation)—History—21st century.
I. Title.
 N72.P6J66 2015
 701'.0309470905—dc23
 2014031080

ISBN 13: 978-1-138-68718-9 (pbk)
ISBN 13: 978-1-138-84495-7 (hbk)

Typeset in Times New Roman
by ApexCovantage, LLC

Contents

Figures

Boxes

Preface

Any work of art is open to various interpretations. In this sense art has a life of its own. The way it is perceived and received lies in the eyes of the beholder. 'The Crack' (Treshchina), a painting by the Russian artist Stas Shuripa, which appears on the cover of this book, serves as a good example. In what sense is there a crack? What kind of crack? Is it a metaphor? A metaphor for what? There are several ways to interpret this painting. Shuripa is an artist interested in the philosophical–ideological connotations of form and visuality. The eye of the artist as well as the eye of the beholder exist in their specific contexts and experiences. It is this openness that creates the fascination of art. It is a language of communication but on different frequencies. The frequency on which you tune in determines what you see.

I have tuned in on the critical eye in art, *dissensus*, to use Jacques Rancière's concept. My attention has been directed towards the way in which this art was perceived and received in Russia.

This is a book about the role of art in Russian society during a period when protest was in the making and was followed by a period of conservative back-lash. Focusing on cultural life and, first of all, the art scene, this book describes and explains tendencies that developed in parallel over a number of years. What resulted in the protest movement of 2011 and 2012 reflected a hope for change in society. When finishing the book in spring 2014, it was obvious that not only had this epoch of hope come to an end, but the new one, replacing it, was in full swing. What remained was to wait for the next turn in Russian history.

The book benefitted greatly from the fact that I lived and worked in Russia for over four years in the period under study. Working in Moscow during 2005–2009 as the Cultural Counsellor at the Embassy of Sweden, I had the unique opportunity to follow the art scene on the spot. Since then I have been closely following events and returned to the city several times each year to visit exhibitions and collect more material. I was a first-hand witness to developments and events as they took place and I could continuously record them.

Although writing a book is a lonely endeavour, many people contributed in various ways. Aside from the artists who kindly provided me with photographs of their works and the people whom I have interviewed, I want to thank Irina Yurna and all my friends in Moscow who created the inspirational environment for my

work and made me long to return to the city. I am also grateful to the late Russian curator Olga Lopukhova, who helped me make my first contacts with some of the younger artists portrayed in this study. My trips and visits to Moscow were made possible thanks to Tamara Torstendahl Salytjeva of the Russian State University for the Humanities (RGGU) and Mårten Frankby of the Swedish Embassy.

I received particularly valuable comments from Kristian Gerner, Per-Arne Bodin, Barbara Lönnqvist, Leslie Johnson and the anonymous reviewer at Routledge, and I am grateful to all of them. I am pleased to have had the help of Andrew Mash, Aleksei Semenenko and Connie Wall on the English text.

I want to thank the Axel and Margaret Ax:son Johnson Foundation and especially the Ragnar Söderberg Foundation for their support. The generous grant by the latter made it possible for me to complete the book. I also want to thank the Swedish Institute of International Affairs for allowing me to extend the research area of the institute into the fields of art and culture.

Last but not least, I want to thank Björn Hagelin, who supported my project and maintained his confidence in me and the book throughout.

In spite of the contributions of all these people, I am solely responsible for the analysis and the conclusions.

Lena Jonson
Stockholm, June 2014

1 Introduction

It was freezing cold in Moscow on 24 December 2011 – the day of the largest mass protest in Russia since 1993. A crowd of about 100 000 people had gathered to protest against electoral fraud in the Russian parliamentary elections, which had taken place nearly three weeks before. As more and more people joined the demonstration, their euphoria grew to fever pitch. Although the 24 December demonstration changed Russia, the period of euphoria was tolerated only until Vladimir Putin was once again installed as president in May 2012. Repression then targeted the leaders of the new protest movement. This period of open protest, however, had raised expectations of further dramatic change.

How could a population that had been characterized as apolitical, passive and living under authoritarian conditions suddenly take to the streets? Why did demonstrations that usually gather only a few hundred people grow to become mass protests? Far from behaving like obedient subjects, people in a number of large cities throughout Russia began to raise their voices and claim their rights. Not all social strata were represented in the demonstrations. Most were well educated and came mainly from the so-called creative class and the middle class. Compared to the mass protests taking place in other countries at that time, the number of participants might seem insignificant – but it was a remarkably large number in the Russian context and it soon became evident that their discontent was over broader issues than just the elections. Theirs was a desperate cry against the way the country was being run – a cry of, 'No more! We have had enough!' A shift in values had obviously taken place. How had this come about?

This volume explores whether – and, if so, how – cultural factors helped to bring about the shift in values that preceded the outburst of discontent in Russia in 2011–2012. It takes as its basic assumption that culture – in particular, the visual arts – played a crucial role. Focusing on the visual arts, the study asks whether there were signs that predicted or laid the groundwork for the sudden outburst of mass protest. What role did the arts community and art itself play in facilitating the formation of the new values and attitudes that led to these developments?

Working in Moscow in the period 2005–2009, and with a background of a life-long interest in Russian society, politics and cultural affairs, I perceived that what was happening on the art scene at that time had relevance far beyond art itself. And then, after fewer than two years, social protest exploded.

Putin's return as president in May 2012 drastically hardened the political climate in the country. This study examines how the arts community reacted under conditions of renewed restrictions on freedom and what role remained for art in the new political circumstances.

The visual arts are interpreted here in a broad sense that includes painting, installations, video, performance, street art and other media. The study covers the period from Putin's rise to power in 2000, with a special focus on 2005–2013, which includes his second term as president (2004–2008), his four years as prime minister when Dimitrii Medvedev was president (2008–2012) and the almost two years after Putin's return as president following the March 2012 election. The present analysis deals almost exclusively with the Moscow art scene. There is a reason for this. Moscow is the Russian art centre, and most Russian artists tend to exhibit in Moscow even if they live elsewhere.

This book is about the role of art in society and in paving the way for protest. Thus, it is not an art historian's analysis of Russian contemporary art, but an empirical study with no pretensions to contribute to a theory of art history or political science. Nonetheless, it uses the theoretical literature to structure the analysis and to define key concepts.

Art and protest

Developments in other places and at other times have shown that value shifts usually precede great upheavals and that these shifts are often visible in the cultural sphere before they are articulated in political terms in wider society. Robin Wright writes about how the demonstrations in North Africa in early 2011 were preceded by changing values and beliefs among young people. They not only used the technology of Facebook and Twitter to promote their causes, but were 'also experimenting with culture – from comedy to theatre, poetry to song – as an idiom to communicate who they are and to end isolation caused by extremists within their ranks' (Wright, 2011: 5). A new atmosphere, a sort of counterculture, began to permeate the thinking. Roland Bleiker came to a similar conclusion in his study of the young East German poets of the 1970s and 1980s and their role in the process that led to the fall of the Berlin Wall (Bleiker, 2000).[1] He writes that the collapse of the Berlin Wall can be seen as the result of a slow and transversal transformation of values that preceded the overt acts of rebellion. Re-reading the events that led to this historic event, he emphasizes the role of the poets, the Bohemian artists and the literary scene in Prenzlauer Berg, the rundown workers' quarter of East Berlin. A counterculture emerged from these circles, as an ersatz public sphere that opened up opportunities for poetry readings, art exhibitions, film shows and the publication of various unofficial magazines (Bleiker, 2000: 245). These were inspired by the new discourses from the West, which spread through 'rock, beat and punk music, Franz Kafka and Marcel Proust novels, or, even "worse", literary traditions of an existentialist, avant-gardist or post-structuralist nature', which had political effects far beyond the infiltration of explicitly political messages. The events that deserve our analytical attention, he concludes, are not the moments

when revolutionaries hurl statues into the mud: 'Key historical events are more elusive, more inaudible in their appearance. They evolve around the slow transformation of societal values' (Bleiker, 2000: 181).

It is well known that both the visual arts and rock music had a similar liberating function in Eastern Europe and the Soviet Union in the 1970s and 1980s.[2] Ales Ervajec, the editor of a book on politicized art under so-called late socialism, highlights the contribution of the visual arts and culture in articulating and intensifying changing moods and values in the period leading up to the social-political upheavals of 1989–91 in the Eastern Bloc (Ervajec, 2003). Art and culture, he writes, 'expressed and mirrored historical processes at the same time as they were contributing to them'. Art, he says, 'was not only visibly expressing the ongoing events that led to . . . "the *first* transition" [away from communism], but also finding a unique way to articulate a historical, social, and political situation while the political sciences and social theory were still in that "unstable state and instant of language wherein something which must be able to be put into words cannot yet be"' (Erjavec, 2003: 7, italics in original).[3] His point is that the development of art was not only confluent with evolving demands in the political sphere, but also visualized what was going on in people's minds before it had been formulated in political terms.

Soviet underground non-conformist visual art challenged official truths and perceptions with some of these artists using mimicry in an ironic and often anarchistic way. Like the Russian rock musicians, the artists regarded themselves as apolitical rather than political. They did not actively participate in the dissident movement or consider their art to have political content. Nevertheless, as Boris Groys writes, the discourses of the Moscow Conceptualists on themes of void, emptiness and marginality as well as the Sots-Artists' mockery of official Soviet ideology changed people's perceptions of the world and how it is made visible (Groys, 2010: 2–3). In this way, art contributed to the change in values in wider society.

These examples highlight what may be called the *mind-liberating function* of art, which follows from the artistic effort to break away from established conceptions. This volume studies this function. The early Russian avant-garde of the 1910s provides an excellent example. In their creativity, the early avant-gardists confronted the accepted and established culture in a search for new modes of expression through questioning, confronting and provoking (Gurianova, 2012). The early Russian avant-gardists had no direct or immediate political ambitions. Instead, they were searching for a new ontology. Their views could be summarized as 'the politics of the unpolitical' (Gurianova, 2012: 10).

The French philosopher Jacques Rancière is in line with this ontological anarchist tradition. He sees the core of both art and politics as the questioning of established ways of understanding the world – questioning what he calls the *distribution of the sensible* (Rancière, 2004: 12), by which he means configurations of the sensory landscape, of what is seen and unseen, audible and inaudible, how certain objects and phenomena are related and also who can appear as a subject at certain times and places (Tanke, 2011: 2). The distribution of the sensible

is shared by society, defines how we understand the world around us and thus determines what is considered possible and what can be expected. He calls the established distribution of the sensible *consensus*. *Dissensus* is the questioning of the established view. Dissensus, according to Rancière, is 'a dispute over what is given and about the frame within which we see something as given' (Rancière, 2010: 69). In this regard the functions of dissensus in art and politics are the same, although the forms may vary. In politics, dissensus takes place when people who do not count and are not listened to raise their voices and act beyond their place in society. He calls this process *subjectivation* – that is, the appearance of a political subject[4] – which is precisely what was seen in the streets of Moscow in December 2011. Consequently, the 'political' is for Rancière the relationships that evolve when the proper order is questioned. This is the approach taken in this book, and thus the subject of the analysis is art that questions the established structure of values and conceptions.

Subcultures and countercultures

On Open Museum Night in May 2008, Moscow vibrated with energy. Thousands of young people filled the streets on their way to view exhibitions of contemporary art. Traffic was congested in the narrow alleyways close to the former industrial area where Vinzavod had recently been converted from a wine store into a gallery complex. Cars were stuck in the middle of the street while the crowds surged past. Contemporary art had become trendy and popular among the young creative class. The art scene already attracted the rich and glamorous as well as intellectuals. Art was not regarded as political. No one seemed interested in politics anyway. Instead, contemporary art offered a new arena for creative and innovative thinking, something that was in great demand.

In June 2010 the Russian art group Voina (War) painted a 64-metre phallus on the Liteinyi bascule bridge in St Petersburg. When the bridge was opened for night traffic on the river, the huge phallus rose like a mighty sign of 'Fuck you!' to the building in the neighbourhood that houses the head-quarter of the St Petersburg Federal Security Service (FSB, formerly the KGB). The performance, 'Prick: a Prisoner of the FSB' (Khui v plenu u FSB), was perceived as a political act that resonated throughout Russia. In April 2011 the Voina group was awarded the prestigious Russian prize in contemporary art, the Innovatsiya Prize, for this performance. How could a state-financed art institution reward such an action? Clearly, something extraordinary had happened.

Protest by organized movements is rare in authoritarian societies. Scholars have concluded that it therefore takes other forms of expression and finds its way into cultural practice (Alinsky, 2009: 255). Other scholars have claimed that 'under repressive regimes, artistic and intellectual production are often sites of oppositional meaning, first, because creativity and artistic freedoms are so much at odds with authoritarian control; second, because the state goes to such lengths to repress them; and, third, because the ambiguity of the message and the popularity

of the artist often make it a costly strategy compared to repressing political activism' (Johnston, 2009: 18). Under conditions of heavy repression, art constitutes a significant proportion of oppositional culture. As repression eases, the textual form becomes more important (Johnston, 2009). Thus, the visual arts, theatre, music and literature are all crucial for the creation and development of sub- and countercultures as well as for their development into social movements.[5] The visual arts in particular might be expected to play such a role, especially at an early stage when protest has not yet been verbalized in society. This would become abundantly clear in Russia.

Various spheres of culture can offer a location or an arena for free space for experimentation. While the definitions may vary, one characteristic of such a place is a space where it is possible to interact beyond the reach of the oppressors. 'Space' should be understood both in a mental sense as free from hegemonic interventions and as the physical place where these activities are carried out (Leach and Haunss, 2009: 258).[6] In such a space, networks of people may develop subcultures and countercultures.

Alberto Melucci uses the concept of 'submerged networks' for groups that are dispersed, fragmented and submerged in everyday life but 'act as cultural laboratories for the experimentation and practice of new cultural models, forms of relationships and alternative perceptions and meanings in the world' (Melucci, 1980).[7] Such networks constitute the basis for countercultures, and from them social movements emerge (Johnston, 2009: 9).

These networks become visible when they engage in overt political conflict, but conflicts in society are often neither directly political nor overt. Instead it is a daily tussle over interpretation. Melucci emphasizes the importance of countercultural movements in opposition to what he calls the dominant codes in society. On the basis of the experience of protest in Western societies, he writes that emerging social conflicts have not expressed themselves through political action in the past 30 years, but rather by posing cultural challenges to the dominant language, to codes that organize information and shape social practices. 'It is the individual and collective reappropriation of meaning of action that is at stake in the forms of collective involvement which makes the experience of change in the present a condition for creating a different future' (Melucci, 1996: 8–9). Both subcultural and countercultural movements function as the antithesis to the established and proper order. It is sometimes difficult to distinguish between them. While subculture refers to networks of people who come to share the meaning of specific ideas, material objects and practices through interaction (Williams, 2011: 3, 39), this study defines counterculture as a socially constructed identity based on values and conceptions that challenge those of the authorities and established society (Roberts, 1978).[8]

In his study of underground Soviet rock music of the 1970s and 1980s, Thomas Cushman defines counterculture as consisting of 'a stock of knowledge which, quite literally, runs counter to the dominant stock of knowledge in a society. . . . If culture is the practical knowledge gained in the course of communicating with

others in the process of living, then counterculture is simply practical knowledge which is the result of engagement in alternative forms of communication among actors engaged in the collective pursuit of alternative ways of living'.[9] Rock music lovers shared a socially constructed identity that he describes as 'an active code of resistance and a template which was used for the formation of new forms of individual and collective identity in the Soviet environment' (Cushman, 1995: 91). It was built on a distinction between a 'we' in opposition to the authorities and the established society. The underground rock music scene was a countercultural movement in its own right but also part of the broader countercultural movement developing in the Soviet society of that time. In this regard the late Soviet underground culture was a parallel to the contemporaneous Western protest culture.

Subcultures and countercultures often give rise to social protest movements: 'agents of resistance are created by virtue of alienation from aspects of the dominant culture and through their own self-affirmation' (Johnston, 2009: 10). What starts as apolitical resistance related to lifestyle may develop into social movements. Studies of subcultural movements in West Germany, the United States and the United Kingdom in the 1960s and early 1970s confirm this: they began by offering an alternative lifestyle as a challenge to what was then considered the stable and homogeneous 'way of life' of these societies (Brown and Lorena, 2011; Buechler, 2000; Cross et al., 2010; Dirke, 1997).

In his *Prison Notebooks*, Antonio Gramsci characterizes society and the cultural sphere as a competition for values, ideas and hegemonic leadership. Gramsci defines hegemony as the organizing principle of a ruling class that connects culture and ideology and permeates a given society (Hoare and Nowell Smith, 1971: 57–58, 80, 195). By securing society's consent, bourgeois hegemonic ideas and beliefs are constantly reproduced in society, but challenged by alternative, counterhegemonic ideas and beliefs. Today, social scientists agree that all regimes do their best to uphold their hegemony of values, but semi-authoritarian and authoritarian societies in particular do so through force and the manipulation of opinion. In such societies, any questioning of the current hegemonic discourse immediately takes on political overtones.

In the late 1980s, the Soviet policy of Perestroika liberated art from the ideological directives that had controlled its form and content.[10] In the Russia of the 1990s, therefore, the cultural sphere was entirely free from any state or party intervention. The other side of the coin was that state financing of the cultural sector was cut drastically. When Russia's public political life was circumscribed after Putin came to power, cultural life and activities continued to be relatively free from state influence, particularly in the field of the visual arts. When the art market boomed in the first decade of the twenty-first century, private galleries and museums opened and former industrial areas were converted into art venues. Thus, the physical territory of art was expanding and the mental space for a subculture of contemporary art was soon in full bloom. Against this background, the major question arises of whether and how a countercultural identity developed within the Russian art community based on a sense of resistance to the evolving hegemonic consensus.

Protest and dissensus in art

The conventional concept of protest, which refers mainly to street demonstrations and actions, has been criticized for being too restrictive, so the definition has been extended to include more subtle forms of opposition (Brown and Anton, 2011). In this study the term 'protest' is used in a broad sense to include all kinds of 'materialization' of expressions of dissensus.

Rancière defines consensus as the dominant 'mode of symbolic structuralization that legitimizes the hierarchical order', according to which everything and everyone are given their places in a kind of 'normal state of things'.[11] Thus, consensus presents the community as an entity that is naturally unified by ethical values (Rancière, 2010; Rancière, 2004). In such a view of society, the specificities of the different parts of the community are ignored and dissenting views abolished (Rancière, 2010: 100, 189).

Dissensus, on the other hand, does not imply the existence of open conflict. Instead, it takes place as a hidden or indirect dispute over the framework within which something is regarded as given. Both aesthetic practices and political action seek to disrupt and alter perceptions and understanding, that is, to break away from 'the proper' and from 'our assigned places in a given state of things' (Rancière, 2010: 143). Yet, dissensus in art is expressed differently from dissensus in politics. While in politics it finds its form in *subjectivation*, in art it is *aesthetic rupture*. Rancière explains rupture as a 'process of dissociation'. The methods for this may vary. It may be the result of a strategy of ambiguity, intervention or over-identification. By splitting the assumptions of the consensus, a component of dissociation is introduced, thereby indicating a different angle, perspective or framing from the established one.[12] Such art does not prioritize the creation of an 'awareness of the state of the world' but rather openness in interpretation. Rancière is sceptical about an art that intends to raise the consciousness of the onlooker by establishing a straightforward relationship between political aims and artistic means out of a didactic purpose. Instead, art is to him an intermediary object, a 'third term', to which both the artist and the viewer relate (Rancière, 2009). Claire Bishop writes that what is significant in Rancière's reworking of the term 'aesthetics' is that it concerns *aesthesis*, a mode of sensible perception proper to artistic production. 'Rather than considering the work of art to be autonomous, he draws attention to the autonomy of our experience in relation to art . . . this freedom suggests the possibility of politics (understood here as dissensus), because the undecidability of aesthetic experience implies a questioning of how the world is organized, and therefore the possibility of changing or redistributing that same world . . .' (Bishop, 2009: 27).[13]

In order to detect 'protest' in its broad definition, this study uses the three basic categories of cultural factors defined by Hank Johnston: artefacts, ideations and performances. Artefacts are 'cultural objects produced either individually or collectively, such as music, art, and literature'; ideations are 'values, beliefs, mentalities, social representations, habitus, ideologies, or more specific norms of behaviour . . .'; and performances are described as 'actions that are symbolic

because they are interpreted by those also present at the action, the audience' (Johnston, 2009: 7). All three categories are social constructions.[14]

The present analysis is inspired by Rancière's concept of dissensus and Johnston's categories of protest, but an additional concept is central to this study – identity. The issue of identity consensus (the search for a collective 'we') is very high on the Russian agenda. It has caused problems over the centuries – and it continues to do so today – because it is loaded with political and ideological connotations. The creation of a collective consensus under Putin is therefore the starting point for the analysis of dissensus in this study.

Who are 'we'?

The Putin regime has felt the need, more than the Eltsin regime did, to create a sense of common national belonging, a 'new Russian idea'.[15] The Putin regime's search for a concept of identity and a feeling of belonging in accordance with its own political priorities and values became more urgent towards the middle of the first decade of the new century, against the background of the colour revolutions on former Soviet territory – most notably Ukraine's Orange Revolution of 2004.[16]

When the Soviet Union disintegrated, the loss of previous official definitions of what constituted the Soviet 'we' created a vacuum, and various definitions began to circulate. Soviet ideology had replaced a nation-state identity with a state identity that had a stance on ideological issues, religion, nation, ethnicity, and so on. The Communist Party regularly provided the authorized and updated interpretation of this identity.[17] In post-Soviet Russia, various identities developed that together provided a scattered picture of Russian identity. As old Russian and Soviet identities resurged, the populations of large cities developed new and fluid subjective identities typical of a post-modern society.

The break-up of the Soviet Union swept away all previous ideological and political directives on how the economy, society and art were to perform. A window of opportunity was opened for carrying out reforms. Soon, however, post-Soviet structures were restored from the 'wreckage and pieces of what was left' (Gudkov, 2012). The 1990s became a decade of lost opportunities with regard to transforming society and the system. When the decade came to an end, most reform ambitions were stuck or lost in new power constellations, a crashed economy, a weak state apparatus and growing corruption.

Vladimir Putin, appointed heir to Boris Eltsin in the autumn of 1999 and elected president in March 2000, immediately took measures to centralize and strengthen state power. Boosted by international energy prices, he managed to give the impression of a strong and efficient leader who would bring stability and a better standard of living to Russia's citizens. As soon as he came to power he initiated a policy reversal in an authoritarian direction, restricted the freedom of the media, started to manipulate the political scene and changed the rules of the election process in order to establish 'stability'. When the colour revolutions took place, he shared the fear of other leaders of post-Soviet states that something similar might happen in their countries. In March 2004 Putin was elected for a second term. This

was the beginning of a period of relative wealth. An economic boom followed from the inflow of petrodollars, and there were expectations that this situation would last forever. Russia seemed politically stable on the surface, albeit at the price of development in an authoritarian direction (Shevtsova, 2010).

The creation of a new Russian identity became a central task for the regime's ideologists. Putin chose a strategy of traditional, basic collective values. The aim was to promote state cohesion and to legitimize the demand for the unconditional subordination of Russian citizens. According to Zygmunt Bauman, identity is a construction, a 'fiction', and to transform this fiction into reality requires much coercion and convincing to harden and coagulate it 'into the sole reality thinkable' (Bauman, 2004: 20). Putin was trying to formulate such a fiction – a collective 'we'.

One major aspect of this collective identity defines the relationship between rulers and ruled. On the part of the regime, this entails finding a unifying concept. The definition of a 'we' by the regime and by groups close to the regime here constitutes the official, 'proper' way – consensus – of how things should be viewed, interpreted and evaluated. These efforts stumbled, however, because not everyone accepted them. Modern societies naturally include a growing number of individuals with multiple identities, and many of them do not recognize the predetermined identities defined by a dominant discourse of consensus. Moreover, Russians have often regarded those in power as 'them'– different from 'we'– but their alienation could not usually be expressed openly or directly.[18] The relationship between rulers and ruled has been and is reflected in different understandings of aspects of identity in national, political and religious matters, such as, for example, a national–ethnic Russian entity vis-à-vis a national–civic community, an Orthodox Christian unity vis-à-vis a non-confessional one, and a regime–loyal political community vis-à-vis a community of independent, free-thinking citizens.

Since the regime's new efforts were an attempt to create a common identity of rulers and the ruled based on political support for the regime, expressions of disagreement were often seen as signs of disloyalty. The sense of a growing gap in definitions of 'we' and 'them' constitutes the driving force behind the development of a 'counterculture'.

Protest on the art scene

In order to identify dissensus/protest in the art sphere, three specific questions are addressed. First, were there works of art that represented aesthetic rupture? Second, were there discussions and public stances by the arts community that reflected a counterculture? Third, did people from the visual arts in any way actively participate in the new protest movement?

Three categories of art are defined that differ according to how close to or far away they are from the prevailing consensus. Although the distinctions between the categories – an 'other gaze', 'dissent art' and 'art of engagement'– may not always seem razor sharp, they are nonetheless helpful and sufficient for this analysis.[19]

The first category of art, identified as an *other gaze*, is a subtle form of dissensus.[20] This art is ambiguous but implies a questioning, sometimes hardly visible, of established conceptions. It may function 'subversively' through its mere 'otherness'. It is important to point out that these artists most often deny any political motifs or motives. Nonetheless, their works may be interpreted as dissensus. The viewer's reaction determines whether that is the case.

The second category, *dissent art*, is defined by open disagreement with the official consensus. The term 'dissent' implies the existence of a contrary belief or opinion, or at least a different position.[21] The disagreement is, however, often indirect rather than direct. It may include an art activist element. The third category, *art of engagement*, is art intended to openly and directly intervene in the public sphere with a political message. However, it should not be confused with what in the West is called 'engaged' art or 'participatory' art.

The second and partly the third categories are in the tradition of provocation and rupture, dating back in part to the early Russian avant-garde of the 1910s. The techniques used by these artists – irony, parody, satire, laughter, mockery and burlesque exaggeration – follow the traditions of the carnival culture of the Middle Ages. Although the medieval carnival was a circumscribed and regulated activity, it contributed to liberate the mind from dogmatism and pedantry, and from fear and intimidation (Bakhtin, 2007; Platter, 2001: 54–57). The Soviet underground artists of Sots-Art in the 1970s and 1980s followed this tradition. The term *styob* was coined for exaggerated support for the target of criticism by mimicking its style and form. It was the 'exposure to mockery that leads to an irreversible and permanent profanation'.[22]

As the field of art in Russia expanded dramatically in the 2000s, explored new territories and extended into everyday life, Russian artists started to experiment, pushing the frontier between art and politics beyond its traditional border, in a similar way to processes that took off much earlier in the West. The Situationists of the 1950s and 1960s provided art with tools and techniques for political communication (Lievrouw, 2011). As the Internet and new social media spread in the West, new techniques were spawned for using art for political purposes (Lievrouw, 2011). The spread of Internet users in Russia at the end of the first decade of the twenty-first century opened the door for such media activism there. This study classifies such media activism as 'political action' and discusses it in a separate chapter.

While protest through art raises the general question of the relationship between art and power, dissent art and art of engagement also raise specific questions with regard to the artist's role in politics. The late Russian avant-garde of the 1920s wanted to use art to create political awareness in the service of the utopian goals of the Bolshevik regime. Within a few years, these artists, who initially worked enthusiastically in the service of the new regime, were compelled to subordinate their grand plans to party directives. This experience led the Soviet non-conformist artists of the 1960s to reject any politicization of art and paved the way for a tradition of the non-involvement of art in politics among independent artists (Groys, 1992). This may partly explain why art in the service of a political agenda has encountered difficulties ever since in finding a foothold in Russia. The question

of whether there has been a change in this regard is examined elsewhere in this volume.

Johnston's categories of artefacts, ideations and performances are used here to highlight various forms of expression within protest in art (Johnston, 2009). The 'artefacts' analysed in this study are objects that have been nominated for the two prestigious annual Russian art awards, the Kandinsky Prize and the Innovatsiya Prize, shown at major exhibitions in Moscow, discussed in Russian art debates, or caused a strong reaction in society. 'Performances' are analysed as words and deeds by the arts community articulating protest by organizing exhibitions, seminars, discussions or publishing statements. The 'arts community' is not a homogeneous entity. The term is used here to indicate words and actions made public by people from the arts community. Discussions and statements are traced with regard to public stances in defence of common professional interests. This includes reactions in cases where its members are put on trial or threatened with legal action. Material about such activities can be found on websites, in art journals and other journals, in daily newspapers and on personal blogs. Ideational content is identified from exhibition catalogues, art reviews, articles and interviews with artists and art critics. The criteria for selection follow from what can be considered relevant to the identity discourses and art dissensus. Major art exhibitions held in Moscow during the years under study are included. Information on art outside the galleries – such as street art, performances and actions – was collected from the Internet, where these activities were usually well documented at that time. The selection of works of art in this study is determined by its research questions and is therefore not representative of Russian contemporary art as a whole.

The present study also discusses whether there was more direct participation by the arts community in building a protest movement. The direct contribution of people from the cultural sphere to political mobilization in the autumn of 2011 and the winter of 2012, before the December parliamentary elections and March presidential elections, respectively, is analysed as political activity. The sources of material on political actions and demonstrations are newspaper articles, websites and documents directly from or about these groups and activities.

Art and the protest movement

How does protest communicated through art relate to political protest? We assume that a counterculture in art appears in parallel with a broader social counterculture. These are phenomena of confluence, but art – being strongly receptive to what is happening in the social environment – may articulate/visualize sentiments, beliefs and values before they are articulated in political terms. However, art needs to reach out to a wider audience if it is to have any effect on the spread of new values (Bleiker, 2000: 211).

Contemporary art has long been considered a small, isolated, marginal world in Russian society. Small circles of artists and intellectuals lived in Moscow in splendid isolation for years without any ambition to reach out to wider groups. Nonetheless, it can be assumed that art of dissensus reached members of the

creative class and groups within the middle class during the years under study.[23] These groups would turn out to be the key groups in the protest movement. The question is therefore *how* ideas of contemporary art spread among these groups. The emergence of an art market and the opening of new galleries in the first decade of the twenty-first century certainly helped. More and new categories of people showed an interest in the visual arts, and contemporary art attracted young urban students and professionals. It became trendy and fashionable to visit exhibitions in the galleries in central Moscow, such as Vinzavod, Art Strelka, Krasnyi Oktyabr and Garazh. This new interest in the visual arts may be assumed to have helped to make contemporary art a means for communicating new ideas and values to the Moscow middle class. These were also spread through the Internet to other cities, some of which were creating their own local art scenes. Thus, the ideas and values expressed through art were disseminated to the young, educated strata of wider Russian society.

As several commentators have pointed out, the protest movement that arose in December 2011 was values based, not based on material interests.[24] It was primarily a movement of the creative class and parts of the middle class mobilized through communication over the Internet and social media. Social science theory, based on the experience of various protest movements in the West since the 1960s, emphasizes the specific character of such movements. They relate to identities, and their concerns are directed towards cultural rather than productive and distributive relations (Buechler, 2000; Diani and Eyerman, 1992; Whittier and Robnett, 2002). They are not organizations in the traditional sense but loosely affiliated, informal, anti-hierarchical networks. As the availability of the Internet spread in Russia as well as across the world as a whole at the end of the first decade of the twenty-first century, it became a tool of such networks (Firat and Kuryel, 2011; Lievrouw, 2011). An interesting question for this study is whether and how people from the cultural sector – with their knowledge of communications and new media methods and techniques – contributed directly to the mobilization of protest from 2011.

When in March 2012 Vladimir Putin was elected president for a new term, the political climate hardened. The protest movement had not yet been able to develop sustainable organizations. Whether and how such will appear is a question for the future. Whether art and the arts community will play any substantial part in this process in the future is also an open question. In the meantime, a more urgent question is whether art can continue as a space for counterculture in a situation where the political 'spring' has rapidly transformed back to 'winter', or if it will fall in line with new official injunctions of the day. Was the end of the spring of 2012 a sign that there never will be a summer, or was it a first sign that something – that still needs time – is in the making? These questions are returned to in Chapters 8 and 9.

An expanding art scene

During my more than four years in Moscow in 2005–2009, I closely observed the art scene by visiting exhibitions and by meeting and talking to people from the cultural sphere. Since then, I have regularly travelled to Moscow to keep abreast

of major art exhibitions and the latest events. The art scene is a 'moving target' as you try to keep up with the latest news. Thus, over the years I searched the Internet, paper media, bookstores and exhibition kiosks for material. The major principle was to continuously keep an alert eye on the flow of information. Apart from exhibition catalogues, only a few monographs and anthologies have been published on contemporary Russian art, and then primarily covering art up to the 2000s.[25] I also conducted interviews with artists, curators and art critics who told me about their work. The interviews were important in providing the specific *Fingerspitzengefühl* for understanding developments.

During the years under study, the art scene was characterized by a dynamic expansion and institutional build-up. In the period of economic boom, the interest in a potential Russian art market also boomed. With minimum state financing, private capital covered a large part of the costs of the institutionalization of art.

However, the first institutions of contemporary art had been created much earlier. In 1992 the National Centre for Contemporary Art (NCCA) was created under the Russian Federal Ministry of Culture. It was the result of the work of Leonid Bazhanov, who, as soon as Gorbachev's Perestroika allowed independent associations, created the Hermitage art association in 1986. He soon found a location on Yakimanka Street, which for some years became the hub of Moscow art life with exhibitions, seminars and concerts (Borusyak, 2009).With the Pompidou Centre in Paris as a model, he created the Centre for Contemporary Art. After he was offered a position in the Ministry of Culture, he was able to transform it into the NCCA in 1992, the first Russian federal state institution of its kind.[26] Later, branches were created in other Russian cities.[27] Private galleries were also set up after 1989: the First Gallery in 1989 (Pervaya galereya, later to become the Aidan Gallery), and the Marat Gelman Gallery and Gallery Regina in 1990. In 1999 the Moscow Museum of Modern Art opened at the initiative of Zurab Tsereteli, an artist and close friend of Moscow's Mayor Luzhkov, with financial support from the city government.[28]

Although the private market for Russian contemporary art was limited, private galleries and actors now came to dominate the contemporary art scene. Two large annual art fairs (Art Moskva and Art Manezh) had started in Moscow in 1996 and were well established by the early 2000s. They incorporated both national and international art, mostly commercial.

The economy improved, but the federal government only reluctantly allocated a minimal sum to culture in the state budget. It had limited interest in contemporary art and did not understand its value. Even so, it was persuaded that an international biennale of contemporary art could improve Russia's image abroad. The first Moscow Biennale of Contemporary Art was held in the spring of 2005, with the major exhibition at the former Lenin Museum next to the Historical Museum on Red Square.[29] Several years later Mikhail Shvydkoi, who at the time had financed the Moscow Biennale as head of the Agency of Culture and Media, said: 'I did not like what I saw of contemporary art but I understood that it was necessary to support it'.[30] Two years later the deputy head of the presidential administration, chief ideologist Vladislav Surkov, even wrote the introduction to the catalogue

of the 2007 biennale. In 2005, the Innovatsiya Prize for Contemporary Art was instituted and the NCCA organized the contest. However, apart from providing the basic financing of the NCCA and a major part of the costs of the Moscow Biennale, the federal state did little to support contemporary art. Art had to depend on the private market and private financing.

Over the period 2005–2008 several new private galleries opened in Moscow. As Marat Gelman said in June 2008, 'People who previously thought of opening boutiques or fashion franchises now think of opening art foundations' (Chernysheva, 2008: 13). Former industrial areas in the centre of Moscow were converted into modern gallery districts. Rough but beautiful old brick buildings of factory architecture provided an excellent environment for the new *tusovka* (trendy gatherings) of art lovers.[31] Art Strelka (part of the former Krasnyi Oktyabr chocolate factory) opened in 2004,[32] and Art Play opened in a former silk factory at about the same time. In 2006 Proekt Fabrika was created on the grounds of the still functioning Oktyabr paper factory, and in 2007 Vinzavod (a former store for cognac and wine)[33] became an important art centre when several of the most important galleries moved there. The same year two private galleries/museums opened to exhibit the private collections of two businessmen – Art4Russia[34] and Fond Ekaterina.[35] In 2008, the Garazh Center of Contemporary Culture, funded by the oligarch Roman Abramovich, opened in a newly renovated former bus garage built by the constructivist architect Konstantin Melnikov in the late 1920s.[36] In 2008, Marat Gelman expanded his activities to the city of Perm in Western Siberia, when he was invited by the governor to open a museum of contemporary art in a grand Stalin-era former riverboat station.

In 2007 the Kandinsky Prize was created with private money as the second most prestigious art award in the country, complementing the state-awarded Innovatsiya Prize.[37] Both contests were organized in such a way that an expert council makes the initial selection of art works and an international jury of art specialists takes the final decisions on the awards. The Innovatsiya Prize and the Kandinsky Prize became *the* events of the year in the community of contemporary art, and intensive debate soon took place around them. Moscow had become a major centre of contemporary art for a quite logical reason – most of the private capital was concentrated in the city.

Critics complained that there were no counterweights to the influence of the market as there was no state-sponsored system of professional education in contemporary art, no education for art critics and no system of state grants to artists. The small Institute of Problems of Contemporary Art, set up in 1991 by Iosif Bakshtein together with a group of artists, came to play an important role as the first and only educational centre of contemporary art. With Bakshtein, a long-term member of the circles of Moscow Conceptualism, the tradition of the Soviet underground was transferred to and integrated into the worldview of the young artists who graduated from this programme each year.[38] More than 10 years later, the Moscow Museum of Modern Art also started courses in contemporary art.[39] Nonetheless, in 2013 state-organized or -financed education in contemporary art still did not exist, although a system of grants for artists was in development.

A restructuring of the system of art institutions would take place in 2012–2013 (see Chapter 8).

Structure of the study

This is a book about the role of art in society. It asks whether and, if so, how art contributed to the evolving protest movement of 2011–2012. The 'political' element of art is defined as participating in reconfiguring what is seen, heard and understood about the contemporary world. This takes form through aesthetic rupture. The narrative of the book follows a trajectory that comes closer and closer to the core of politics from the subtle art of an other gaze to dissent art and art of engagement, and from discussions within the art community to political action. The analysis runs from the development of a subculture to the buildup of a counterculture and discusses the direct contribution of people from the cultural sphere to the art-related activities of the protest movement.

The reader is taken closer and closer to politics in art. Chapter 2 provides the background to dissensus in Russian art during the twentieth century and sets out the political context of today's art – that is, the major parameters of the Putin consensus as it developed during his first two terms as president (2000–2008). Chapter 3 analyses art of an other gaze as the most subtle form of dissensus in art. Chapter 4 describes the conflict between art and the church, most notably the trial of the exhibition 'Forbidden Art 2006'. This trial is regarded as a crucial event in the development of a counterculture within the Russian community of contemporary art. Chapter 5 presents dissent art as art that disagrees with the official consensus. Chapter 6 focuses on the possible transformation of a subculture of art into a counterculture by analysing seminars, acts and statements by the arts community plus the category of art of engagement – that is, art that makes direct political statements. Chapter 7 concentrates on the political activities of the so-called new media activists during campaigns that preceded parliamentary and presidential elections, as well as the textual messages of slogans and banners at protests in December 2011 to June 2012. Chapter 8 describes the Bolotnaya Square demonstration in May 2012 as a political turning point and analyses art and politics after Bolotnaya. The concluding chapter summarizes the results of the study and relates them to the concept of subjectivation – that is, when people who normally are not listened to raise their voices in public.

Notes

1 In Bleiker, see especially the chapter on 'Political boundaries, poetic transgression'. On the example of Iran, see Kurzman (2009).
2 On rock music, see Troitskii (2007) and Cushman (1995).
3 Erjavec quoting Jean-Francois Lyotard (1988).
4 'A political subject is a capacity for staging scenes of dissensus' (Rancière, 2004: 69).
5 See, for example, the case studies of Brown (2011) and Lison (2011).
6 See their discussion of the concepts of 'space' and 'scene'. The way 'space' is used here is close to their concept of 'scene'. See also Polletta (1999: 1–38).

7 Quoted by Leach and Hauss (2009: 260).
8 Keith A. Roberts (1978) refers to the fundamental difference between a counterculture and a subculture. Counterculture rejects the norms and values that unite the dominant culture while the latter finds ways of affirming the national culture and the fundamental value orientation of the dominant society.
9 Cushman (1995: 7–8) makes a distinction between 'counterculture' and 'alternative culture', where the latter, although different from the dominant culture or norm, presents no challenge. This distinction can, however, sometimes be difficult to make. What may seem nonpolitical and fairly harmless can still have a political effect in the longer run. It may also be perceived by the authorities as a genuine challenge.
10 For studies of ideological directives in the cultural field in Soviet times, see, for example, Sokolov (2007), Groys (1992) and Clark and Dobrenko (2007).
11 Chantal Mouffe (2008: 9) explains it in the following way: 'What is at a given moment considered to be the "natural order" – together with the "common sense" that accompanies it – is the result of sedimented hegemonic practices; it is never the manifestation of a deeper objective outside the practices that bring it into being. Every order is therefore political and based on some form of exclusion. There are always other possibilities that have been repressed and that can be reactivated'.
12 According to Rancière (2004: 63), 'Suitable political art would ensure, at one and the same time, the production of a double effect: the readability of a political signification and a sensible or perceptual shock caused, conversely, by the uncanny, by that which resists signification. In fact, this ideal effect is always the object of a negotiation between opposites, between the readability of the message that threatens to destroy the sensible form of art and the radical uncanniness that threatens to destroy all political meaning'.
13 Compare with Susan C. Haedicke's (2013: 45) notion that Rancière emphasizes the meeting between the artist and the spectator, claiming that a spectator achieves emancipation or critical awareness by translating what he sees into his own experience, linking it to what he already knows and, through that association, creating new awareness.
14 'Artefacts are not only materially constructed but also socially constructed. Even though they may be individually produced, their creation too is, in a sense, a social performance, because the audience is always in the artist's mind. Because of their performance, cultural artefacts can serve as the focus of numerous other performances after their creation. Both social performances and artefact-based performances, however, are closely linked to the ideations' (Johnston, 2009: 7).
15 Graeme Gill (2013) writes about the efforts by the Russian post-Soviet presidents to create a meta-narrative to fill the ideological vacuum that replaced the Soviet narrative. See also Billington (2004).
16 Compare the introduction of the official concept of 'sovereign democracy'. See Hayoz (2012).
17 Alexei Yurchak (2006: 10–14) writes about the Soviet Communist Party as the source of the official updated interpretation of the 'truth', thereby solving the 'Lefort's Paradox' between ideological enunciation and ideological rule in the Soviet Union.
18 For the gap between the intelligentsia and the authorities, see Shalin (1996). On peasants and the authorities, see Hosking (1997).
19 Brown and Anton (2011: 2) use the term 'subversive art', which could be a joint term for the last two categories above. They explain it thus: 'The concept of the subversive . . . functions in two senses: first, it refers to the activities of individuals and groups . . . operating with the explicit aim of disrupting politics and challenging dominant narratives; second, it refers to the effects of social actors and trends that, although not explicitly political, have been interpreted by dominant elites in political terms'.
20 Compare the term the 'other gaze' used by Groys in the sense of Russian unofficial art in the Soviet Union. Groys (2003: 55) had in mind Moscow Conceptualists and Sots-Art, first and foremost.

21 Compare Tökes (1975: 16).
22 On *styob*, see Beumers (2005: 245, 261).
23 The term 'creative class' as used by Richard Florida (2002) includes people in the knowledge-based and creative sectors such as scientists and engineers, university professors, poets and architects, plus people in design, education, the arts, music and entertainment, whose economic function is to create new ideas, new technology and/or creative content.
24 These demonstrations were described by Yurii Grigorii (2012), a sociologist from the Higher School of Economics, as a protest 'against the very idea that loyalty can always be bought' and as a 'moral protest, a protest against corruption and greed, against the lack of moral order'.
25 An overview of Western and Russian art is provided by Andreeva (2007). A collection of articles about Russian artists previously published in the Russian media can be found in Kovalev (2005). Interviews with people from contemporary culture, among them artists, can be found in Bazhanov and Iro (2012). There are exhibition catalogues covering individuals or groups of artists, and of the collections of private collectors.
26 Author's interview with Leonid Bazhanov, Moscow, September 2007.
27 Nizhnii Novgorod, www.museum.ru/m3065; St Petersburg, ncca-spb.ru; www.ncca-kaliningrad.ru; Ekaterinburg, www.uralncca.ru.
28 www.mmoma.ru. For the development of the Moscow art scene in the 1990s, see Rekonstruktsiya/Reconstruction, 1990–2000 (2013).
29 www.moscowbiennale.ru.
30 Mikhail Shvydkoi at a meeting of the Cultural Counsellors of the EU member states, Moscow, October 2009.
31 Beumers explains that *tusovat* describes the activity of just being friends with a group not necessarily of the same composition (2005: 245, 261). Viktor Miziano uses the term to describe the socio-cultural phenomenon of the informal gathering around the art scene in the 1990s. He calls it a kind of personalized self-organization of the artistic environment in a world without institutions and state protection for the arts (Miziano, 2004: 15–42).
32 www.artstrelka.ru.
33 www.winzavod.ru.
34 www.art4.ru.
35 www.ekaterina-fondation.ru.
36 http://garageccc.com/ru/page/about.
37 www.kandinsky-prize.ru.
38 They have remained part of a loose network of former students, and Bakshtein, as an influential operator on the Moscow art scene, was also able to place his students in the art scene and connect them abroad.
39 www.mmoma.ru/about.

References

Alinsky, Saul D. (2009), 'Protest Tactics', in Jeff Goodwin and James M. Jasper (eds.), *The Social Movements Reader: Cases and Concepts* (Oxford: Wiley Blackwell), pp. 255–258.
Andreeva, Ekaterina (2007), *Postmodernizm: Iskusstvo vtoroi poloviny XX–nachala XXI veka* (St Petersburg: Izdatelstvo 'Azbuka-klassika').
Bachtin, Michail (2007), *Rabelais och skrattets historia* (Swedish translation of Tvorchestvo Fransua Rable i narodnaya kultura srednevekovya i Renessansa) (Riga: Anthropos).
Bazhanov, Leonid and Iro, Volf (eds.) (2012), *Besedy s deyatelyami kultury sovremennoi Rossii* (Moscow: NCCA, Goethe Institut and Akademie der Künste).

Bauman, Zygmunt (2004), *Identity* (Cambridge, UK and Malden, Mass.: Polity).

Beumers, Birgit (2005), *Pop Culture Russia! Media, Arts and Lifestyle* (Santa Barbara, Denver, Oxford: ABC-CLIO).

Billington, James H. (2004), *Russia in Search of Itself* (Washington, D.C.: Woodrow Wilson Center).

Bishop, Claire (2009), *Artificial Hells: Participatory Art and the Politics of Spectatorship* (London and New York: Verso).

Bleiker, Roland (2000), *Popular Dissent, Human Agency and Global Politics* (Cambridge and New York: Cambridge University Press).

Borusyak, Lyubov (2009), 'Intervyu s Leonidom Bazhanovym', *Okolo iskusstva*, 26 October, http://rupo.ru/m/1940/interwyyu_s_leonidom_bazhanowym.html.

Brown, Timothy and Lorena, Anton (eds.) (2011), *Between the Avant-Garde and the Everyday: Subversive Politics in Europe from 1957 to the Present* (New York and Oxford: Berghahn Books).

Buechler, Steven M. (2000), *Social Movements in Advanced Capitalism* (New York and Oxford: Oxford University Press).

Chernysheva, Veronika (2008), 'Znatok budushchego, Marat Gelman: "Vinzavod seichas vazhnee, chem Duma"', *Nezavisimaya gazeta NG Antrakt*, 20 June, www.ng.ru/figure/2008-06-20/13_gelman.html.

Clark, Katerina and Evgeny Dobrenko (eds.) (2007), *Soviet Culture and Power: A History in Documents, 1917–1953* (New Haven and London: Yale University Press).

Cross, Peter, Savage, Jon, Wilson, Andrew and Proll, Astrid (2010), *Goodbye to London: Radical Art and Politics in the Seventies* (Ostfildern: Hatje Cantz).

Cushman, Thomas (1995), *Notes from the Underground: Rock Music Counterculture in Russia* (Albany: State University of New York).

Diani, Mario and Eyerman, Ron (1992), *Studying Collective Action* (London: Sage Publications).

Dirke, Sabine von (1997), *All Power to the Imagination! The West German Counterculture from the Student Movement to the Greens* (Lincoln and London: University of Nebraska Press).

Ervajec, Ales (ed.) (2003), *Postmodernism and the Postsocialist Condition: Politicized Art under Late Socialism* (Berkeley, Los Angeles: University of California Press).

Faure, G. O. and Sjöstedt, G. (1993), *Culture and Negotiation: An Introduction* (Newbury Park, Calif.: Sage).

Firat, Begum Özden and Kuryel, Aylin (eds.) (2011), *Cultural Activism: Practices, Dilemmas and Possibilities* (Amsterdam and New York: Rodopi).

Florida, Richard (2002), *The Rise of the Creative Class and How It's Transforming Work, Leisure, Community and Everyday Life* (New York: Basic Books).

Gill, Graeme (2013), *Symbolism and Regime Change in Russia* (New York: Cambridge University Press).

Grigorii, Yurii (2012), 'Putin vnutri', *The New Times*, 13 January, www.newtimes.ru/articles/detail/45560.

Groys, Boris (1992), *The Total Art of Stalinism: Avant-Garde, Aesthetic Dictatorship and Beyond* (Princeton, NJ: Princeton University Press).

Groys, Boris (2003), 'The Other Gaze: Russian Unofficial Art's View of the Soviet World', in Ales Erjavec (ed.), *Postmodernism and the Postsocialist Condition: Politicized Art under Late Socialism* (Berkeley, Los Angeles: University of California Press), pp. 55–89.

Groys, Boris (2010), *History Becomes Form: Moscow Conceptualism* (Cambridge, Mass.: MIT Press).

Gudkov, Lev (2012), 'The Nature and Function of "Putinism"', in Lena Jonson and Stephen White (eds.), *Waiting for Reform under Putin and Medvedev* (London and New York: Palgrave Macmillan), pp. 61–80.

Gurianova, Nina (2012), *The Aesthetics of Anarchy: Art and Ideology of the Early Russian Avant-Garde* (Berkeley, Los Angeles, London: University of California Press).

Haedicke, Susan C. (2013), *Contemporary Street Arts in Europe: Aesthetics and Politics* (Basingstoke and New York: Palgrave Macmillan).

Hayoz, Nicolas (2012), 'Globalization and Discursive Resistance', in Lena Jonson and Stephen White (eds.), *Waiting for Reform under Putin and Medvedev* (Basingstoke and New York: Palgrave Macmillan), pp.19–37.

Hoare, Quintin and Nowell Smith, Geoffrey (1971), *Selection from Prison Notebooks, Antonio Gramsci* (New York: International Publishers).

Hosking, G. (1997), *Russia: People and Empire, 1552–1917* (London: Harper Collins Publishers).

Inglehart, Ronald and Welzel, Christian (2005), *Modernization, Cultural Change and Democracy* (Cambridge: Cambridge University Press).

Johnston, Hank (ed.) (2009), 'Protest Cultures: Performance, Artifacts and Ideations', in Hank Johnston (ed.), *Culture, Social Movements and Protest* (Surrey, UK and Burlington, USA: Ashgate), pp. 3–29.

Kovalev, Andrei (2005), *Imennoi ukazatel* (Moscow: Novoe literaturnoe obozrenie).

Kurzman, Charles (2009), 'The Iranian Revolution', in Jeff Goodwin and James M. Jasper (eds.), *The Social Movements Reader: Cases and Concepts* (Oxford: Wiley-Blackwell), pp. 42–52.

Leach, Darcy K. and Haunss, Sebastian (2009), 'Scenes and Social Movements', in Hank Johnston (ed.), *Culture, Social Movements and Protest* (Burlington, Vt.: Ashgate), pp. 255–275.

Lievrouw, Leah A. (2011), *Alternative and Activist New Media* (Cambridge, UK and Malden, Mass.: Polity).

Lison, Andrew (2011), 'Postmodern Protest? Minimal Techno and Multitude', in Timothy Brown and Lorena Anton (eds.), *Between the Avant-Garde and the Everyday: Subversive Politics in Europe from 1957 to the Present* (New York and Oxford: Berghahn Books), pp. 201–218.

Melucci, Alberto (1980), *Nomads of the Present* (Philadelphia, Penn.: Temple University Press).

Melucci, Alberto (1996), *Challenging Codes: Collective Action in the Information Age* (Cambridge: Cambridge University Press).

Meyer, David S., Whittier, Nancy and Robnett, Belinda (eds.) (2002), *Social Movements, Identity, Culture and the State* (Oxford and New York: Oxford University Press).

Miziano, Viktor (2004), *"Drugoi" i raznye* (Moskva: Novoe literaturnoe obozrenie).

Mouffe, Chantal (2008), 'Art and Democracy: Art as an Agonistic Intervention in Public Space', in *Open (No 14): Art as a Public Issue, How Art and Its Institutions Reinvent the Public Dimension* (Rotterdam: NAi Publishers SKOR), pp. 6–13.

Platter, Charles (2001), 'Novelistic Discourse in Aristophanes', in Peter I. Barta and Paul Allen Miller (eds.), *Carnivalizing Difference: Bakhtin and the Other* (London and New York: Routledge), pp. 51–78.

Polletta, Franscesca (1999), 'Free Spaces in Collective Action', *Theory and Society* 28: 1–38.

Rancière, Jacques (2004), *The Politics of Aesthetics: The Distribution of the Sensible* (London and New York: Continuum).

Rancière, Jacques (2009), *The Emancipated Spectator* (London and New York: Verso).

Rancière, Jacques (2010), *Dissensus: On Politics and Aesthetics* (London and New York: Continuum).

Rekonstruktsiya/Reconstruction 1990–2000 (2013), exhibition catalogue (Moscow: Ekaterina Cultural Foundation, Garage Center for Contemporary Culture, XL Projects).

Roberts, Keith A. (1978), 'Toward a Generic Concept of Counter-Culture', *Sociological Focus* 11(2): 111–126.

Shalin, Dmitri N. (1996), 'Intellectual Culture', in Dmitri N. Shalin (ed.), *Russian Culture at the Crossroads: Paradoxes of Postcommunist Consciousness* (Boulder, Colo.: Westview Press), 41–97.

Shevtsova, Lilia (2010), *Putin's Russia* (Washington, D.C.: Carnegie Endowment for International Peace).

Sokolov, K. B. (2007), *Khudozhestvennaya kultura i vlast v poststalinskoi Rossii: Soyuz i borba (1953–1985gg)* (St Petersburg: Izdatelstvo 'Nestor-Istoriya').

Tanke, Joseph J. (2011), *Jacques Rancière: An Introduction. Philosophy, Politics, Aesthetics* (London and New York: Continuum).

Tökes, Rudolf L. (ed.) (1975), *Dissent in the USSR: Politics, Ideology and People* (Baltimore and London: Johns Hopkins University Press).

Troitskii, Artemii (2007), *Back in the USSR* (Moscow: Amfora).

Williams, J. Patrick (2011), *Subcultural Theory: Traditions and Concepts* (Cambridge: Polity Press).

Whittier, Nancy and Robnett, Belinda (eds.) (2002), *Social Movements, Identity, Culture, and the State*. Oxford and New York: Oxford University Press.

Wright, Robin (2011), *Rock the Casbah: Rage and Rebellion across the Islamic World* (New York, London, Toronto, Sydney: Simon & Schuster).

Yurchak, Alexei (2006), *Everything Was Forever, Until It Was No More: The Last Soviet Generation* (Princeton and Oxford: Princeton University Press).

2 A history of dissensus, consensus and illusions of a new era

To set the stage for the analysis, the first section of this chapter presents a brief overview of dissensus in Russian art during the twentieth century. The next section describes the political context of Russian art today and the major parameters of the Putin consensus as it developed during his first two presidential terms (2000–2008). The illusions of the new glamorous era, reflected in critical comments in the Russian media, are captured in the final section.

A history of dissensus in art

The view that art is capable of changing the way the world is understood runs like a red thread through Russian art during large parts of the twentieth century. At different periods, however, it found different forms of expression. As the saying goes, in Russia the poet is always more than a poet and thus an artist is more than just an artist.[1]

The Russian intelligentsia has historically played a key role in demanding the liberalization of society. Ever since the word 'intelligentsia' entered the Russian vocabulary in the 1860s (Pipes, 1990: 249–256), it has represented the resistance by intellectuals against the authoritarian Russian regime, concern about the conditions of society and dedication to the idea of repairing the torn ethnic and social fabric of the country (Hosking, 1997; Shalin, 1996). The intelligentsia defined in this way is not the same as the official definition in Soviet times – people with a high level of education. Instead, it is a moral and normative category of people who speak out against the rulers not in their own material interests, but for the whole of society. It has always constituted the core of the counterculture of its time. The intelligentsia developed the skill of hiding messages in innuendo or allusion, which would evade the eyes of the censor but be understood by those who could read them. Hidden criticism masked by ambiguity – in a book, a play or a painting – is an age-old tradition of the Russian intelligentsia.[2]

Stalinism almost deleted the intelligentsia – in both a physical and a mental sense. Many intellectuals were attracted to and identified with the Soviet modernization project and with the goals of social and cultural transformation espoused by generations of the Russian leftist intelligentsia. Stalinism manipulated their original values of self-improvement, social activism and commitment to being

an agent of historical progress (Zubok, 2009: 6). Soon after the death of Stalin, restrictions were eased and the intelligentsia was visible on the scene again.

The avant-garde in the 1910s

The roots of Russian art dissensus can be traced back to the avant-garde of the early twentieth century. The avant-garde played a crucial role as an alternative model of artistic practice and approach in Russian and European art history. Nonetheless, some authors believe that its ideas had an inherent trajectory that explains why it became the instrument of totalitarian regimes.[3] The US Russian scholar Nina Gurianova (2012), however, makes a distinction between the early and late Russian avant-garde. She dates the early period to 1910–1918, claiming that it had an aesthetic ideology of its own, which she calls 'the aesthetics of anarchy'. Only the late avant-garde movement, which dated from the Bolshevik takeover in 1917 and peaked in 1923 with Constructivism and the creation of the Left Front of Art (LEF), had an aesthetic ideology in line with the new Bolshevik regime. Even so, it was suppressed in the second half of the 1920s.

The Russian avant-garde of the 1910s was influenced by Bakunin's concept of 'creative destruction' and Dostoevskii's anti-utopian and anti-rational comments on the individual's fight against the utilitarianism and determinism of the time. The art group 'Jack the Diamond' (Bubnovyi Valet), created in 1910 around the artists Mikhail Larionov and Natalya Goncharova, played a crucial role in the development of the avant-garde. For almost ten years the avant-garde exploded in a creative diversity of styles while sharing an aesthetic and philosophical foundation that Gurianova calls 'ontological anarchism'. This can be described as an attack on all closed concepts and systems of thinking. In their search for a new language of art, the avant-gardists challenged established concepts in art and in society at large (Ashton Sharp, 2006). Their vision was to integrate art and life. Art was to be open to life, and life was understood as a flow without goal or purpose and without an answer to the question 'why'. Provocation was regarded as an instrument for shock effect. Unexpected breaks in the flow of words, images or tones should force the viewer out of habitual perceptions and into new associations. Art enticed the viewer to think independently.

The early avant-garde shared with many in Europe a strong premonition that an epoch was coming to an end. As the outbreak of the First World War came closer, this feeling grew stronger. In Russia, thoughts of apocalypse and catharsis intensified as the tsarist system became increasingly authoritarian after the brief reform period after the 1905 mass disturbances (Selunskaya and Toshtendal, 2005). The artists of the early avant-garde were socially concerned but not politically engaged. In contrast to their contemporaries, the political revolutionaries, the avant-gardists were anti-utopian – politically and aesthetically. They did not allow their art to be subordinated to social or political interests and rejected art schools and styles. Their activities still had a political effect as they helped to liberate the minds of people in a society that was stuck in old ways and with old ideas.

The First World War radicalized the Russian avant-garde. After Goncharova and Larionov left for Paris in 1914, younger and more radical artists defined the Russian art agenda. For a short time Malevich was one of the most influential. He wanted to create a general aesthetic ideology valid for all fields of art (Nakov, 2010). Such an approach was far from the previous thinking of the avant-gardists and signalled that a new era was on its way.

Most avant-gardists supported the Bolshevik takeover of power, but they soon reacted to the restrictions on freedom of speech and the new regime's efforts to control cultural life. Several artists (among them Malevich and Rozanova) began to cooperate with political anarchism, contributing articles to the cultural section of the *Anarkhiya* newspaper, an organ of the Moscow Federation of Anarchist Groups that was in open opposition to the Bolshevik regime (Gurianova, 2012). Its first issue was published in September 1917, but by July 1918 the Bolsheviks had shut the paper down.

Tension grew among the avant-gardists between utopians and anti-utopians. The former wanted a cultural revolution in support of the political and social revolution. The Bolshevik takeover strengthened utopian ideas as well as a utilitarian view of art. Soon, artists abandoned painting in favour of industrial design, construction projects and photography in the service of the revolution. It was not long before they had to submit to party directives and were integrated into the Bolshevik propaganda machine. The avant-garde's dream of a cultural revolution was dashed when in the early 1930s the Party dissolved all independent organizations in the various fields of culture in favour of a single centralized organization in each field. In 1934, Socialist Realism was made the official doctrine of Soviet literature at the First Congress of the Writers Union. All fields of art and culture soon followed (Clark and Dobrenko, 2007). The aims of Socialist Realism were to guarantee that art was easily understood by the masses and that it transmitted the communist vision of a future paradise. According to the standard official formulation, art was now to be 'realistic in form and socialist in content' (Groys, 2008). According to Boris Groys (2010: 2), Socialist Realism was like Soviet society in general during these years: 'a society completely oriented toward the future, completely immersed in the vision of the future – a society living in a unifying communist project'.[4] Avant-garde art was taken away from public view and removed from museums for many decades. Yet, the memory of this art lived on among a small group of artists who would hand it over to a younger generation.

Art did not immediately conform (see, for example, Degot, 2006) and in literature anarchistic absurdism continued underground. In the autumn of 1927, the writer Daniil Kharms together with the poets Nikolai Zabolotskii, Aleksander Vvedenskii and Igor Bakhterov created Obedinenie Realnogo Iskusstva (OBERIU, the Association for Real Art), which was only allowed to exist for a few years (Kharms, 1991: 8–11). Their absurd texts continued in the Soviet underground and, more than 80 years later, a member of Pussy Riot would refer to them as a source of inspiration in her defence in court.

The post-Stalin Soviet underground

The years that followed Stalin's death in 1953 created a relative freedom that made it possible for dissensus to find its way in art once again. The late 1950s and early 1960s were years full of hope and expectation. In their enthusiasm for the new freedom in life and art, young people gathered to read poetry at the statue of Mayakovskii in central Moscow. Poems by Yevtushenko, Voznezenskii and Akhmadulina and songs by Okudzhava framed the mental world of the young generation (Manevich, 1991; Sokolov, 2007; Volkov, 2008).

Khrushchev's 'thaw' reopened the door to the international art world. There was a Picasso exhibition in 1956, international art exhibitions during the 1957 Moscow International Youth Festival and a huge exhibition in 1959 of US abstract expressionists such as Jackson Pollock, Willem de Kooning, Arshile Gorky and Mark Rothko. These exhibitions were eye-openers for young Russian artists (Zubok, 2009: 110–111).[5] A first exhibition of Russian abstract art took place in Gorky Park in 1958. It was organized by Eli Belyutin and his group of artists called the New Reality. Belyutin's group was one of the first autonomous artist communities, and by 1960 it consisted of about 250 painters (Zubok, 2009: 178).

Abstract art was perceived as a language of individual expression and contravened everything prescribed in the doctrine of Socialist Realism (*Drugoe iskusstvo*, 1991a). The free form of abstract art was perceived as a reaction to the Party's collectivist plan and reflected the individual's search for an inner private truth. Thus, the 'rebellion in forms' by the Belyutin group on the canvases of abstract art carried a much larger cultural and social meaning: 'The formalist trend [abstract art] became a universal yearning for change and liberalization, a social symbol of progressivism' (Zubok, 2009: 178). This inward-looking individual-oriented art would soon become highly controversial.

The Belyutin group was invited to represent young artists at an exhibition to commemorate 30 years of the Moscow Union of Artists in December 1962. When Khrushchev arrived with his entourage, he looked at the artworks in shock and disgust. In an emotional outburst he called them 'shit' (govno) and the artists 'faggots' (pidarasy). The scandal was complete when politburo members joined in with such phrases as 'send them abroad', 'arrest them' and 'liquidate them' (Gerchuk, 2008: 101–117). *Pravda*, the Communist Party newspaper, followed up the incident with a campaign against what it called formalism and nihilism in art. As a result, a sharp divide was drawn for years to come between official art and non-official, non-conformist art.

Non-conformist artists went underground, continuing their work within circles of friends who met, discussed, read poetry and exhibited works in private apartments. Most of them were educated at art schools, but because this kind of art was not officially recognized, they were not allowed to exhibit it in public. Instead, they lived double lives, earning income as illustrators, designers or manual workers while dedicating their free time to non-conformist art.[6]

The non-conformists made a conscious decision to stay out of politics. They reacted to the political dictates under which artists had to subordinate themselves

and defended the idea of art as an autonomous space and their own right not to engage politically. In this way they contributed to a process of intellectual emancipation in society. In 1974 the artist Oskar Rabin and his friends decided to test the limits of freedom by organizing an open-air exhibition in a suburb of Moscow (*Drugoe iskusstvo*, 1991a: 16–17). The time seemed ripe. Soviet leaders had announced a policy of detente with the West and people expected improved East–West relations to create more relaxed conditions domestically. Instead, the exhibition was immediately bulldozed by the local authorities and several paintings were destroyed. This brutal intervention resonated internationally as foreign journalists and diplomats had witnessed the event. The local authorities were reprimanded by higher officials, and two weeks later a four-hour open-air exhibition of non-conformist art was permitted in Izmailovo Park (*Drugoe iskusstvo*, 1991a: 211–217). The Izmailovo exhibition began a gradual and partial legalization of non-conformist art. The underground existence continued and slowly began to penetrate the public space as it found its way into non-traditional exhibition venues such as research institutions.[7]

By the early 1970s, some underground artists had begun to critically deconstruct Soviet cultural codes and political-ideological clichés in an effort to deconstruct the myth of Soviet utopia. They wanted to get behind the facade of official Soviet life. Some would later form Moscow Conceptualism,[8] while others formed Sots-Art. While the former drew mainly on the narrative, the latter drew primarily on the image, although such a strict definition is difficult to maintain when examining individual artists and their work.[9]

Sots-Art artists used irony and satire to twist the original meaning of Soviet symbols and signs. In so doing they deconstructed the myths of Soviet utopia and its leader, Stalin.[10] Sots-Art derived its name from the word 'Socialist' and American Pop Art, but where Pop Art aimed its irony at a society of mass consumption, Sots-Art addressed a Soviet society of mass ideology. Also religious symbols and signs were used to criticize Soviet ideology. Mikhail Roshal-Fedorov's 'Let us over-fulfil the plan for coal' (1972) is one example (see Chapter 4). Had this piece of art been shown in public at that time, it would probably have caused marginal reaction for its use of religious symbolism. When exhibited 30 years later, its use of religious symbols in secular art was seen as scandalous.

If Sots-Art dealt thematically and quite bluntly with the symbols of power, myths and ideology of the Soviet system, Ilya Kabakov, the best known of the Moscow Conceptualists, concentrated on the aesthetics of everyday life. His focus on Soviet Man, 'Homo Sovieticus', formed by the stagnation and degradation of society, captured the life and dreams of the individual in the void of the failed collective dream.[11] The *kommunalka*, a large apartment with one room per family and a shared kitchen, became for Kabakov a metaphor for Soviet life. His works became like a diagnosis of the surrounding Soviet society.

A younger generation of Moscow Conceptualists gathered in 1976 in the group Collective Actions (Kollektivnye deistviya).[12] Their regular performances, 'Walks beyond the City', were part of a highly intellectual and conceptual project that they claimed was not about politics or society. Nonetheless, these performances

had an important social-political dimension (Bobrinskaya, 2010; Groys, 2011). Andrei Monastyrskii, a key figure in the group, invited friends to join the walks, or rather long excursions to the outskirts of Moscow by train, bus and on foot, to watch for something unexpected and inexplicable to happen during a few minutes in an empty field. The actions were carefully documented. Monastyrskii called these walks 'empty actions'. The intention was to create a zone for contemplation beyond all officially regulated political, social and ideological conceptions: 'In the Stalin or Brezhnev era, contemplation of an artwork involved a certain compulsion, a kind of tunnel vision. There was nothing peripheral. But when one comes to a field – when one comes there, moreover, with no sense of obligation but for private reasons of one's own – a vast, flexible space is created, in which one can look at whatever one likes. One is under no obligation to look at what is being presented – that freedom, in fact, is the whole idea'.[13] Boris Groys, who took part in several actions, later characterized them as: 'a void, an emptiness, a . . . rift in the texture of the world' that tears this world apart and opens a clearing in the middle of it. 'Only through and in this clearing, inside this rift, the moment of "un-concealment" . . . becomes possible – [of] the concealment of the world being produced by the routine of everyday life' (Groys, 2011: 7). Against the background of Soviet ideology, which at the time still aimed to penetrate society and the life of the individual, these performances of Collective Actions became acts of dissensus.

It is true that Soviet underground artists avoided becoming involved in opposing the regime, but they belonged to the same larger subculture that included human rights campaigners and political dissidents. The arrests in September 1965 of the writers Yurii Daniel and Andrei Sinyavskii for publishing anti-Soviet works in the West under pseudonyms had had an enormous impact on a whole generation. When they were found guilty in the first post-Stalin political trial, a new movement emerged among the young generation of intellectuals and artists – the movement for human rights (Jonson, 1980). As a result, the independent Moscow Helsinki Committee was created in 1975 to monitor the Soviet Union's implementation of the so-called third basket of the Helsinki Final Act.[14] Nevertheless, artistic dissensus and political dissent developed along parallel but separate lines (Groys in Kozlova, 2008). Visual art artists – part of the same generation and the same subculture – avoided being branded dissidents.

The Glasnost and Perestroika of the late 1980s brought an end to the distinction between official and non-official art. When the Soviet Union broke up in 1991, art was liberated from party directives. By then another event of great importance and a symbol of the new era to come had already taken place – the Sotheby's art auction in Moscow in 1988. Works of art by about 30 Russian artists, who not long before had been considered 'beyond the law of their own country',[15] were sold for high prices on the international market. By the start of the post-Soviet era, many non-conformist artists of the older generation, including Kabakov and most Sots-Art artists, had already emigrated to the West. The remaining artists were now to react and work under completely new conditions.[16]

Post-Soviet art of the 1990s

The situation for both art and society was radically altered by the new social, political and economic conditions of the early 1990s. Soviet state structures broke down, market reforms were initiated and democratic reforms were announced. At the same time, the economic reforms hit the population like a slap in the face. These were years when the great narrative was dissolved and the struggle for survival consumed the lion's share of people's time and energy. In this situation, Anatolii Osmolovskii, Aleksander Brenner, Avdei Ter-Oganyan, Oleg Mavromati and Oleg Kulik became highly influential through their immodest, aggressive and naked art performances. In Moscow, Actionism became a dominant art trend of the 1990s.

Actionism was formulated as a reaction to Conceptualism, which the Action-ists perceived as too intellectual and too focused on texts. The Actionists wanted direct action rather than contemplation. According to Osmolovskii, they wanted the force of reality to break down the textuality that had completely taken over in Soviet times.[17] Many years later, Avdei Ter-Oganyan characterized Moscow Actionism as a successor to the provocations of the avant-garde in the 1910s.[18] Both, he said, wanted to use confrontation and shock to make a spontaneous impact on the audience.

In spite of their critique of Conceptualism, the Actionists were children of conceptualist ideas. Like Sots-Art and Moscow Conceptualism, they dealt with different aspects of power, tried to desacralize them and emphasized the perspec-tive of the vulnerable individual.[19] The Actionists lived the rapid flow of events in the 1990s, when it was difficult to grasp what was happening, although the absurdities of social life were fully exposed. One of the first actions to attract attention took place in Red Square in April 1991. Osmolovskii and his group of young artists, Expropriators of the Territory of Art (ETI), lay down in front of the Lenin Mausoleum, the most sacred place in the Soviet Union. Their bodies formed the word 'khui' (prick) as a shout of "Fuck you!" to the absurdities that surrounded them. The action built on the contradiction between the sacredness of the loca-tion and the use of a vulgar and taboo word,[20] in the turbulent months before the break-up of the country.[21]

Throughout the 1990s, similar actions were reported in the media, which at the time was free enough to report such events. When President Eltsin ordered the attack on parliament in October 1993, Osmolovskii, Brenner, Ter-Oganyan and Mavromati demonstrated in front of the burned-out parliament building, naked from the waist down with their backs to the building. In 1995 Brenner, dressed only in shorts and boxing gloves in the middle of winter, challenged Eltsin at Lobnoe mesto in Red Square, shouting that he wanted the president to come out and fight (Kovalev, 2007b: 172–173). Brenner said this was a protest against the Chechnya war, which Russian troops had just embarked on.[22]

The Actionists remained artistically rather than politically motivated (Kovalev, 2007c). They promoted the gesture and the action, and they used their bodies for this purpose. Exploring limits their performances were physical in all senses,

including the exposure of naked bodies, aggression, blood – and vulnerability. Oleg Kulik, naked and vulnerable in his role as a chained dog aggressively trying to bite people at Russian and international exhibitions (Bredikhina et al., 2007), could be interpreted as a metaphor for the new life of millions of former-Soviet citizens after the introduction of neoliberal economic reforms. Some years later, a younger generation of artists spoke of how the Actionists had expressed 'the existential conditions in the range from euphoria to total despair including masochism, renouncing God and so on', and that their leitmotif had been the metaphor for the struggle for survival (Lomasko and Nikolaev, 2011).

The Actionists expressed a duality in relation to the authorities. They focused their actions on the absurd realities of political life, on the one hand, while supporting the democratically elected president, Boris Eltsin, on the other. Their actions played on the remarkable political vacuum in which there were no proper political parties or organizations but only economic, political and criminal cliques that manipulated events from behind the scenes. The absurd cheerfulness of Oleg Kulik's campaign as a candidate for the fictive 'Party of the Animals' reflected the political situation of '[a] dispersing reality and the impossibility of direct political statements, and the fatal lack of real political movements' (Kovalev, 2007c: 9). The Actionists played the role of the jester according to the tradition of carnival culture.[23]

A 1998 street performance on Nikitskii bulvar commemorated the May 1968 student revolt in Paris. It simulated a political demonstration by building false barricades, carrying banners with slogans written in French and shouting slogans in Russian. The participants managed to convince the police that it was a genuine political demonstration. The slogans, however, followed the absurdist tradition of the Russian avant-garde of the 1910s, such as: 'There is no money – and no money is needed' (Deneg net – i ne nado), 'God Exists and there is no God' (Bog est i net Boga) and 'Freedom to the Parrots' (Svoboda popugayam) (Degot and Riff, 2008; Kovalev, 2007b: 308–309).

In late 1999 the art actions took a more political turn. In December, during parliamentary elections and three months before the presidential election in which Putin was standing for the first time, the art groups 'Nongovernmental Control Commission' and RADEK, in which Osmolovskii played a leading role, managed to hang a banner from the roof of the Lenin Mausoleum (Kovalev, 2007b: 360–361) which read 'Against all [candidates]'. It hung there for three minutes before the guards took it down. The phrase 'Against all' was an option on the ballot paper to demonstrate discontent with all candidates and parties. The artists were thus using an existing legal electoral option for their art project. Their manifesto explained that: 'We are brought up and exist in a system which is built on the desire for power. What we ought to really hate is power itself. And we must renounce this desire to take power. . . . Therefore the only thing we can do is to not join the power but to fight it' (Kovalev, 2007b: 362).

The KGB found ways to make Osmolovskii understand that his actions were straying too far into the realm of politics and were therefore unacceptable. After three months of being openly harassed by the secret police, Osmolovskii came to

the conclusion that the group must make a choice between either continuing as an art group or becoming a conspiratorial underground political group. He explained that the authorities were frightened at the prospect that 'Against all' would become the preferred option of voters in the upcoming presidential election. In local elections this option had received a remarkably high percentage of the votes and new elections had had to be held. The authorities felt that 'the intelligentsia having to choose between Putin and Zyuganov' would choose the third option, and therefore took to playing dirty tricks (Osmolovskii, quoted in Kovalev, 2007b: 363). The last performance by the Osmolovskii group took place in August 2000, three months after Vladimir Putin's inauguration as president.[24] In retrospect, this was the end of an era.

This brief overview of twentieth century Russia suggests the existence of art that questioned the official consensus of its time even though artists did not engage directly in politics. The periods of freedom of expression in art mirrored the vacillations of what was allowed in terms of the intellectual and cultural spheres in general. Nonetheless, art visualized a dissensus before it was verbalized in political terms. In this sense, Ales Ervajec seems to have got it right when he emphasizes the important role of art in paving the way for the revolutionary changes in Eastern Europe and the Soviet Union in the late 1980s and early 1990s (Ervajec, 2003).

Looking back, the 1990s was a dynamic period in Russian art (Rekonstruktsiya, 2013). Yet, the political developments made the decade seem like an interlude. Something was being created in its own right but was never consummated. In the first decade of the twenty-first century, a completely new symbolic order would replace the one of the 1990s. At the beginning of the new millennium, however, few foresaw that what was to come in Russia would completely change the political conditions.

The political context, 2000–2008

Putin became prime minister in August 1999. His most urgent task was to deal with the Chechnya conflict, and in September he initiated a second war against the small republic. He became acting president at the end of December 1999, was elected president in March 2000 and then successfully consolidated his power by exploiting various crises in the following years. In so doing, he also gradually built a new understanding of the 'proper', that is, how people should identify with and look at society, its past and its present.[25] This section identifies the major parameters of Putin's evolving consensus, which provide a new political context for art.

The Chechnya war secured Putin support among nationalists. At the same time his Internet article, written as he became acting president, 'Russia at the Turn of the Millennium', read like a liberal manifesto and raised hopes of a policy of reform to come.[26] Instead, as soon as he was inaugurated president, he began attacking the media empires of Vladimir Gusinskii and Boris Berezovskii. In 2003 the oligarch Mikhail Khodorkovskii, a major possible rival for power, was arrested. After being re-elected in 2004, Putin skilfully exploited the tragic Beslan terrorist drama to further centralize decision-making. If the authoritarian shadow

of his policy had not previously been fully visible, it now became clear in all its darkness. Well before the 2007 parliamentary elections, new legislation circumscribed elections and the activities of political parties and non-governmental organizations (see Evans, 2013: 105–108; Remington, 2013: 45–56; Sakwa, 2010: 164–169). His plan to prevent the liberal opposition from entering parliament was successful, and he secured the dominance of the pro-Putin United Russia Party in the federal Duma and regional assemblies throughout the country. The political party system of the Eltsin era evaporated and Putin blocked independent public debate about alternative policy avenues. As a result, the existing political institutions in Russia came to resemble decorative facades.[27]

By closing down the public space for free exchange of political opinions, Putin killed a forum not only for airing grievances but also, and more importantly, for new ideas and public demands. The vacuum that appeared when genuine political life in the country was cut off was filled by a 'virtual reality transmitted to the population by media in close cooperation with the authorities' (Dubin, 2009). The media, especially television, reported what the government wanted it to report. Journalists also accepted the official worldview without direct instructions to do so.

Official political life was wrapped in new grandiose ceremonies and rituals to aggrandize the power of the regime. The presidential inauguration ceremony in the renovated tsarist halls of the Kremlin and the military parades in Red Square emphasized grandeur and greatness (Dubin, 2011: 233–253; Gill, 2013: 85–86, 101–103). At the same time, political participation by the people at the polls had become an empty ritual. The less political weight carried by the vote of a citizen, the more powerful and ornamental high politics became: 'Glamourization of the public sphere, of politics and culture has been the dominant trend in the social and cultural life of the country in recent years' (Dubin, 2009).

Opinion polls demonstrated political passivity. There was a general interest in political issues, but little interest in taking part in political life. This apolitical mood went hand in hand with low levels of confidence in political institutions. At the same time, there was a perception that no alternatives to the current regime existed (Dubin, 2011: 230). This lack of trust in society included a lack of trust in collective action. The feeling of being without means to influence politics gave rise to political alienation and mass apathy. Lev Gudkov (2009: 16), director of the Levada Centre, described this as a logical reaction of people who feel that 'nothing can be changed'. Several scholars described Russia's political system as characterized by fragmentation and atomization, having in mind the absence not only of a civil society but also of a social fabric between people and bonds of solidarity. Against this background, it is easy to understand how large groups of the population became easy targets for political manipulation from above.

Nevertheless, in spite of the strong state control over television broadcasting, small and comparatively outspoken private television channels appeared from time to time and, together with a few small independent newspapers and journals and the Internet, free debate continued – albeit at the margins.

Liquid society

Zygmunt Bauman characterizes life in modern European society as the feeling of living on quicksand – something that is repeatedly changing, shifting form and without a solid core (Bauman, 1999: 5). He calls it liquid society (liquid modernity): 'What all these fluid features amount to, in simple language, is that liquids, unlike solids, cannot easily retain their shape. Fluids, so to speak, neither fix space nor bind time. . . . Fluids travel easily . . . they pass around some obstacles, dissolve others and soak their way through others still. From meetings with solids they emerge unscathed, while the solids they have met, if they stay solid, are changed – they get damp or are drenched' (Bauman, 2000: 2). Bauman uses the term *Unsicherheit* to describe the feeling that follows from this state of society – a term that blends experiences that in English demand three terms: uncertain, insecure and unsafe (Bauman, 1999: 5).

Feeling unsafe creates a dangerous passivity: '[P]eople wary of what the future might have in store and fearing for their safety are not truly free to take the risks which collective action demands. They lack the courage to dare and the time to imagine alternative ways of living together; and they are too preoccupied with tasks they cannot share to think of, let alone to devote their energy to, such tasks as can be undertaken only in common' (Bauman, 1999: 5). In this state of mind people more readily listen to the alluring tones of an authoritarian voice that offers partly illusory stability and security. These characteristics are perhaps even more true of Russian society than of the societies studied by Bauman. In contrast to the relative predictability of life in Soviet society, Russia's wild and perverted forms of capitalism and neoliberalism increased the feeling of uncertainty about the future among the old as well as the young.

The efforts of the Putin regime to create a feeling of belonging and a new collective 'we' should be seen against the background of the *Unsicherheit* of post-Soviet conditions. The authorities tried to win the confidence of the population by presenting a vision of stability, consolidation and continuity. The pro-Putin youth organization Nashi (Compatriots), created in 2005 at the initiative of the presidential administration and its chief ideologist, Vladislav Surkov, reflected the regime's fear that something similar to the 'colour revolutions' in Ukraine and Georgia in 2004–2005 would happen in Russia. The youth organization was created as an active standby force in case public opinion shifted towards a Ukrainian scenario.

The regime soon learned how to exploit and build on sentiment in society. Opinion polls had shown since the mid-1990s a trend for a return to traditionalism, including elements of ethnic nationalism, religiosity and a longing for a 'golden past'. These were general trends seen throughout former Soviet territory (Pain, 2009: 38–49). Putin exploited these trends and channelled them for his own purposes.

Constructing a new identity

A main task of the regime was to strengthen its legitimacy by creating a collective 'we'. Russia has a long history in search of itself, and many of its most brilliant

thinkers of the most diverse political views have tried to formulate what constitutes 'Russia', or what is a Russian.[28] Putin's search for ideas at first seemed to go in various directions – discourses of the Great Power, a Russian national idea, Orthodox belief and an authoritarian Russian Eurasia-oriented Unique Path. Gradually, these different discourses were linked together into an overall discursive formation that developed common traits with the state conservative thought of Official Nationality under Tsar Nicholas I in the nineteenth century (Riasanovsky, 2005: 133–148). Thus, while Western scholars claimed that the Putin regime lacked an ideology, this was becoming less and less the case as the outline of a Putin consensus gradually took on a more distinct form. Western scholars may be forgiven as this policy was initially not formulated on paper but took shape in interactions with major actors, among them the church. The evolving consensus was, however, reflected in words and deeds by high-level state representatives. Four aspects of the identity discourse in the Putin consensus stand out.

State Nationalism: A stronger emphasis on the central role of the state gave a top-down perspective, where the interests of the population became subordinated to those of the state. This also implied identification with Russia as a great power, although the interpretation of what this meant in practice and how such status was to be regained varied.

The state nationalist emphasis underlined continuity in the Russian state-building process and opened the door for the pragmatic selection of historical leaders of whom to be proud, regardless of whether they were from tsarist or Soviet times. Eltsin had also understood the value of references to the great past of the Russian state, reintroduced the tsarist flag and other symbols from tsarist time and recognized the status of the Orthodox Church. His motive, however, was first and foremost to counterbalance the Soviet heritage, while Putin by contrast seemed to be exploiting these symbols as part of a political strategy to create legitimacy for his own power (Pain, 2009).

Against the background of the state nationalist discourse, it is not surprising that Putin considered the break-up of the Soviet Union to be 'the largest geopolitical catastrophe of the twentieth century' (Putin, 2005). Nor is it surprising that the victory in the Second World War received such a prominent place. The ceremonies on 9 May to commemorate the end of the war became a demonstration of the success and greatness of Russia. The enormous celebrations in 2005 to commemorate the 60th anniversary of the end of the war could have been a natural peak to be followed by a reduced focus on the Great Patriotic War as it receded into the past. Instead, the celebrations took on an even larger scale in the years that followed. Memorial concerts were televised in honour of the armed forces, blending elements of national, military and religious discourses with pop and hip-hop music in order to attract younger generations to the homage to Russia and create the image of a great power.

This strong emphasis on the victory in 1945 resulted in a more pronounced role for Stalin as a war leader. Soon, this was extended to Stalin as a statesman capable of modernizing and developing the country. Television series exploited a new interest in Stalin as a person, portraying him as a lonely old man in his final days in a 40-episode broadcast in 2007, *Stalin Live*.

Viewed from a state-building perspective, Ivan the Terrible, Peter the Great and Stalin were great statesmen and 'managers', while the huge humanitarian costs of their regimes were ignored. In 2007 the Russian Ministry of Education approved teaching guidelines for history teachers in schools according to which Stalin's terror should be mentioned, but his decisions and policies should be understood in the larger context of his own time and the problems of external and internal threats (Filippov, 2007; Jonson, 2010: 286–292). It should perhaps therefore have come as no surprise when quotes from the old Stalinist national hymn, which refer directly to him, were restored to the ceiling of the Kursk metro station in Moscow in 2009 and, 130 years after Stalin's birth, several Russian cities expressed a wish to build new Stalin monuments. Local and national authorities and television companies, in particular, took a new, uncritical look at the Soviet past. As a result, the percentage of the population who were positive about Stalin increased substantially during the 2000s.[29]

Individual scholars, journalists and others tried to carry out critical investigations of the past as part of the intellectual debate and academic research, but the official emphasis on historical continuity, state-building and eternal Russian state interests coloured the official understanding of Russia's past, present and future. The positive effects were emphasized. Just as during the harsh reality of Soviet times there had been the promise of a glorious future and a better life, Putin now promised stability, and harmonious and corporate striving towards the goal of a golden economic future. Against this background, highlighting the bleak sides of reality was labelled 'chernukha' and was considered an act of exaggerating the darkness of social life.[30]

Russia the Nation: On 4 November 2005 a new state holiday was introduced and celebrated for the first time – the Day of People's Unity (Den Narodnogo Edinstva). It was invented to replace the holiday of 7 November, the anniversary of the 1917 revolution.[31] The new holiday referred back to 1612, when Russian troops repelled the invading Poles during the Time of Troubles. According to the church calendar, this day was a holiday in praise of the Kazan Icon of the Godmother and in commemoration of the victory over the Poles. Although this victory seems natural to remember, the celebration took on complicated political overtones.

The new holiday had an anti-Western flavour but its nationalist concept also seemed in line with the growing distrust of non-Russians. Xenophobic attitudes were growing, most notably in hostile sentiment towards Central Asian and Caucasian guest workers in Russia, but also in the tense relations between Russia and Georgia after the 2004 Georgian revolution. The ethnic overtones of the holiday became obvious when Russian nationalists tried to co-opt it. Both the Russian authorities and the public were surprised by this multifaceted mobilization of radicalism. In 2006 the nationalist demonstrators on 4 November faced a huge police presence in Moscow. By 2007 the authorities had managed to reduce the number of nationalist participants.[32]

What happened around this holiday reflected the larger problem of defining Russia as a nation. Russia was an empire of many peoples, religions and cultures, and the 1993 Constitution made the Russian Federation a secular state. Muslims

therefore became concerned about the presence of Orthodox representatives, Orthodox symbols and the attendance of the Patriarch at state ceremonies. Putin tried to tread a cautious line between supporting ideas of Russia as a nation state and avoiding ethnic references. Although he tried not to play the 'ethnic card', the appearance of the Orthodox Church in the official discourse was in itself taking an ethnic Russian stance.

Russia the Orthodox Nation: Religion was controlled in the Soviet Union and to become a believer before 1991 was therefore for many a demonstration of a civic independent stance. In the 1990s the church was rehabilitated and the state began to return previous rights and proprieties. During the 2000s, the church strengthened its influence as the Putin regime needed its support and moral authority, and Orthodox belief offered a unifying concept of a new Russian identity. The growing status of the church was reflected in 2006 when, during the Easter ceremony in the Cathedral of Christ the Saviour in Moscow, the then Patriarch, Alexei II, greeted Putin publicly in the name of God for the first time.[33]

The state allowed the church to take on a role in state and public life, but also in spheres that according to the constitution should remain secular, such as prisons, the military and schools.[34] The church wanted to be an educator and formulator of norms. The Orthodox tradition, however, exerts 'a conservative influence on Russian history, culture and the Russian mindset' as traditionalism, the so-called imperial constant, and close church–state relations ('symphony') are fundamental characteristics of Russian Orthodoxy (Bodin, 2009: 25–42). This fitted the Putin regime perfectly. The church emphasizes national unity, patriotism and conservative values, especially on moral issues. The extent to which the state would allow the church to set the agenda now became the crucial question.

The church, claiming Orthodox belief to be the defining factor of the Russian nation, actively participated in discussions on the future of Russia and its policy, arranging seminars and initiating book projects (Krug, 2008).[35] The church also contributed to the production of a film on the Byzantine Empire with clear references to the contemporary political situation in Russia. The film *The Death of an Empire: Lessons from Byzans*, produced by Father Tikhon, head of the Sretenskii Monastery in Moscow, was shown on television several times in 2008.[36] The film addressed the question of how it was possible for the Christian Orthodox Byzantine Empire to collapse after more than 1000 years of existence. It opened with a camera panning Istanbul, showing women in hijab and the sound of muezzins calling to prayer. Tikhon's thesis was that the West was responsible for the fall of the Empire, as Western states exploited its domestic splits and refused to provide assistance when it was attacked by Islamic forces. He used a contemporary Russian political vocabulary and references to contemporary society, and the viewer could easily recognize the narrative about external and internal threats and enemies of the Russian state. According to Tikhon, the domestic weakness of the empire was the result of power struggles at the top, weak central authority, greedy oligarchs, failed reforms, nationalist splits and ethnic ambitions, a reduced role for Orthodox belief and an intelligentsia that admired the West. In Tikhon's view, the only way to prevent such a development happening again was a strong centralized

authority, a common ideology and a platform of Orthodox belief. The film was an excellent fit with much of the rhetoric of the Russian authorities at the time, but it took the arguments further than the state authorities did.

A Unique Russian Path: The idea of a unique Russian path and the belief in a special Russian destiny became fundamental parts of official Russian rhetoric. When Eltsin tried to formulate the concept of a Russian national idea in the mid-1990s, he did not refer to the uniqueness of Russia. This idea was given its distinct form under Putin, with an emphasis on the differences between Western and Russian values and traditions, the virtue of the old patriarchal and hierarchical characteristics of Russian society and Orthodoxy as its moral and religious basis.

The concept of sovereign democracy, coined by Vladislav Surkov in February 2006, was a contemporary effort to draw a line between Russian and Western political ideas and a response to the colour revolutions in Georgia and Ukraine. The concept was in line with Russian debate over the centuries about Russia's relationship with Europe – whether it was a part of Europe or 'unique' and following its own path.[37] Although Surkov claimed that Russia was a part of the European civilization, he stressed that the authoritarian tradition was a central component of Russia's political and cultural heritage: 'Culture [political culture] is our destiny' (Surkov, 2007). He therefore saw the tragic history of oppression and autocracy in Russia as a part of its political tradition and a factor in forming its political institutions.

As dividing lines were drawn up, the concept of the 'enemy within' was also identified. Concerns were raised by independent Russian media as early as September 2004 over what they saw as the beginnings of such a campaign. After the Beslan tragedy, when North Caucasian terrorists took hostages in a school and people were killed in the police operation that followed, Putin declared that Russia was at war with both external and internal enemies. Surkov expanded on the internal enemies, explaining that in Russia, as in a besieged country, a 'fifth column' had appeared, which consisted, he said, of 'leftist and rightist radicals' and targeted explicitly both liberals around the Yabloko leader, Grigorii Yavlinskii, and the national Bolshevik leader, Eduard Limonov. They share the same sponsors and the same hatred of Russia, he said: 'We must be aware that the enemy is at the gate. The frontline now runs through each city, each street, each house. We need vigilance, solidarity, mutual help, and joint efforts by the citizens and the state' (Kaftan, 2004).

This was the regime's attempt to delineate the 'inner' borders of Russia as a political–ideological entity. The key individual behind this campaign, as in all the major ideological moves by the regime at this time, was Surkov. He had an enormous ideological influence on everything related to the domestic sphere in the early 2000s. He determined the thinking of the regime for a number of years. Aleksander Dugin, a radical conservative and an ideologist of the Eurasian school of thought, wrote in a moment of clear-sightedness that Surkov and his concept of sovereign democracy disguised authoritarian management as formal democracy: 'This means dictatorship disguised by democratic procedures where major processes are directed from the centre' (Dugin, 2012).

Although Surkov's influence cannot be underestimated, Putin defined the political–ideological line with regard to the West. His tone became sharper after 2003. His Western audience was taken aback by the blunt language he used at the 43rd Munich Conference on Security Policy in early 2007, when he criticized US world dominance and the Western policies of international organizations (*Washington Post*, 2007).While his critique was principally not new, his tone was.

The West was now depicted as an enemy trying to undermine Russian society and giving support to Putin's liberal opponents. Putin developed this argument in December 2007 at the Luzhniki Stadium in Moscow, in front of 5000 young supporters of the United Russia Party. He said that Russia's enemies 'need a weak and sick state [Russia] in order to do their dirty business' (Melikova, 2007). There are people, he said targeting his liberal opponents, who hover around like jackals (shakalit) outside foreign embassies and are dependent on foreign money. 'Shakalit', KGB jargon from the world of prisons and work camps, meaning pitiful beggars for cigarettes, now entered the mainstream Russian political vocabulary.

Putin's harsh words surprised Russian commentators, but this did not restrain his future rhetoric. That Russia was completely different from the rest of Europe became a fundamental part of the Putin consensus. This view was soon shared by a growing number of people, as evidenced in opinion research by the Levada Centre. 'Russia's unique path' is a mythological archetype with consequences for the way people view themselves and their rulers, according to the Russian sociologist Boris Dubin (2012). By creating a collective 'we' in line with 'Russia's uniqueness', any deviance from the norm can be labelled as 'other' and 'foreign', and references to universal norms can be excluded. The unique path concept is static and implies that people accept existing conditions because they are perceived as 'our way'. The ruler is looked on as the superior authority beyond the reach of ordinary citizens. The notion of a unique Russian path is an effective obstacle to the very idea of reforming Russia (Dubin, 2012).

The 'Putin consensus' and its definition of 'we' took form with the support of actors with similar views – the church, and different patriotic–religious organizations and nationalist movements. Each of them had its own interests and agendas, and sometimes more far-reaching goals than those of the Putin regime. Together, they found a common language around ideas of Russia as a unique civilization, a great power with a glorious past and a similarly glorious future founded on Orthodoxy. Gradually, the Putin consensus moved closer to the core of the Russian conservative tradition of 'Orthodoxy, Autocracy and Nationality' (pravoslavie, samoderzhavie, narodnost), coined in the 1830s during the reign of Tsar Nicholas I (Pipes, 2005). When Dimitrii Medvedev became president in 2008, things had, however, not yet come full circle.

The Kremlin tried to mask the gap between the rulers and the ruled by political manipulation (Pain, 2008). Conscious efforts were made to ideologically and mentally reprogram the population. Regime-initiated campaigns hammered home the values and messages of the official consensus. With state-controlled television channels dominating the media space, independent voices were hardly ever

heard. Putin's form of reprogramming has been described as intellectual–utopian constructivism, based on two fundamental ideas: first, that any social mass movement is the result of the goal-oriented activity of a small group of people; and, second, that any small group of political consultants is able to form trends in social development by working out a strategy for such a scenario and then using means of social manipulation (Kukulin, 2007: 169–201).

With this belief in manipulation it was not surprising that the revolutions in Georgia and Ukraine were regarded by the Russian authorities as nothing more than the work of foreign agencies. The headmaster of the Higher School of Management, where the elite of the pro-Putin youth receive their education, explained that 'no youth movement can spring up from below; it can only be created from above either by the authorities or by the opposition'. The question is, therefore, who is first to organize the youth – because he will have the advantage (Vinogradov and Bolotova, 2005). This approach characterized Surkov's creation of the pro-Putin youth organizations in 2005.

Putin glamour and its aesthetics

Many Russian observers characterized the four successful years after 2005 by the buzzword 'glamour'. An interest in everything marked by glamour was awakened in the late 1990s when the 'nouveaux riches' first appeared. This was followed by the petrodollar boom of the 2000s. Champagne, oysters, fur coats and diamonds became prominent symbols.[38] In the spring of 2005 a centre of exclusive boutiques, restaurants and entertainment opened in the wealthiest part of Moscow. Nothing could have more clearly represented the time than the name given to the shopping mall, the Barvikha Luxury Village. In the autumn of 2005 the first Millionaire Fair was held, offering for sale the most extreme luxury goods. The dominant taste of the day was the glossy, grand and glittering. Glamour became the new utopia.[39]

It was not only the upper social classes that longed for glamour. Many tried their best to live up to the level of luxury or dreamed of a status never to be gained. Just 10–15 per cent of the population could afford a truly glamorous lifestyle, but they became role models and set the cultural expectations and values. Money was a prerequisite to enter this circle, but so too was strict adherence to the informal rules of this specific social group.

Glamour with a patriotic and authoritarian bent also affected aesthetics. In 2007, the editor-in-chief of the journal *Iskusstvo kino*, Daniil Dondurei (2007: 94–95), characterized the official and semi-official culture and art of the Putin regime in the following way:

1. Patriotism as defined by the ideological concepts 'sovereignty' (suverennost) and 'uniqueness' (samobytnost) and resulting in the perception that what comes from Russia is unique, more interesting and special than what emanates from other nations of the Soviet Union or from the West.

2. Glamour and its image of the world as completely free from controversial questions. Glamour does not raise political aspects or dramatic social events; it is indifferent to issues of justice; its heroes are all rich; and consumerism, shopping, beauty and the cult of successful commerce are the traits of this civilization.
3. Banality in the sense of expensive tastelessness. The state welcomes archetypical products such as gold and all that is pompous, voluminous and made from expensive or pseudo-expensive material, since this 'demonstrates greatness, and hence helps the state win the love of the people'.
4. The presence of a middleman – a producer or curator – to guarantee commercial success.
5. Eclecticism with regard to genres and styles.

The author concludes rhetorically: 'How to oppose this?'

Critics thus accused glamour of a distance from all problems, eclectic aesthetics and a tendency to focus only on the surface and make things appear smooth and uniform. The phenomenon was discussed in novels and journals.[40] The novel *Generation P* by Viktor Pelevin described the new commercial conditions under which the first post-Soviet generation entered their adult life (Pelevin, 1999). In his novel *Empire V: The Tale of a Real Super Man*, Pelevin made 'glamour' and 'diskurs' key concepts for understanding Putin's Russia (Pelevin, 2006). The poet Lev Rubinshtein called glamour the official ideology of contemporary Russian society (*Bolshoi gorod*, 2006). Nikolai Uskov, chief editor of the journal *GQ* (*Gentlemen's Quarterly*) and a historian by training, talked about 'Putin glamour' and also used the ironic term 'sovereign glamour', alluding to Surkov's 'sovereign democracy' (Uskov, 2006). Uskov said that the nouveaux riches had set the agenda and the political elite quickly adopted it, as reflected in their suits, watches, hairstyles, and so on. He characterized 'Putin glamour' as a feeling of expectation similar to the eve of some great event, transmitting the feeling that everything can only get better. There was an expectation, he argued, of economic growth that would never end, which would solve all problems. The fact that political freedom was circumscribed was of minor importance (Chernysheva, 2007: 13–14). A few months later Uskov added: ' . . . in front of us you find the grandiose simulacrum of the country. We live in a world of appearance of what seem to be films, stars, television, literature, president, prime minister, constitution, domestic and foreign policy, success, rigour, honesty, morality and strength. All as it seems' (Uskov, 2008a). Rubinshtein, who had come to a similar conclusion, wrote in early 2009 that 'glamour is the current official ideology and the *ersatz* of a national idea' (Rubinsthein, 2009). He emphasized that the term not only described a philosophy of material consumption but also constituted 'the regular Russian dream of the grand utopia, and of the cloudy and alluring horizon', which 'also depicts a universal system of values'.

Nonetheless, Uskov saw that the nouveaux riches were no longer satisfied with just wealth – they also wanted to 'have principles, a footing and belief in ideals'. The new buzzwords were 'autocracy, Orthodoxy and emotions' (samoderzhavie, pravoslavie, emotsii) and the existential question "Why all this?" (Zachem vse?) appeared in the salons of the rich (Uskov, 2008b).

Life and art in the time of glamorous consensus

In the midst of the predominant illusion of glamour some expressed concern about the evolving authoritarianism. Vladimir Sorokin published his novel *One Day in an Oprichnik's Life* in 2006. Oprichniki were members of the security police created by Ivan the Terrible in the 1560s, and Sorokin used them in a metaphorical way to present Russia's authoritarian future trajectory (Sorokin, 2006). The story takes place amid a future revival of Holy Rus, when the country is cut off from the West by a grand Western Wall and, in an act of loyalty to the regime, citizens have burned their passports in Red Square. Sorokin regarded the book as a fantasy inspired by life,[41] but it was read by many as an informed illustration of where Russia was heading.

A few years earlier, Sorokin had personally been the target of the new authoritarian wind. In the summer of 2002, the Putin loyal youth organization Going Together (Idushchie vmeste) had, in a symbolic action in central Moscow, thrown several of Sorokin's books – most notably his novel *Blue Fat* (Goluboe salo) – into a huge mock-up lavatory pan (Shusharin, 2002, 2009). The action was in response to Putin's statement that he wanted to 'whack [terrorists] in the john/shithouse' (mochit v sortire) (Litnevskaya, 2010).[42] Sorokin also received death threats.[43] In March 2005 his libretto for the opera *The Children of Rosental* (Deti Rozentala), with music by the composer Leonid Desyatnikov, was heavily criticized by Duma deputies, and the Bolshoi Theatre, where it was being performed, temporarily removed it from its repertoire (Lyubarskaya, 2005).

However, Sorokin was an outsider. The cultural mainstream fell in line with the evolving Putin consensus.[44] The weekly newspaper *Kultura* described in its chronicle of cultural events during 2006 two trends that bore witness to the rising neo-conservatism in society: a 'religious interpretation of life' and a 'nostalgia for Soviet life'.[45] The film *The Island* (Ostrov), directed by Pavel Lungin, reflected the new interest in religiosity and was enthusiastically applauded in church circles.[46] Nostalgia for Soviet life was expressed in television series about Stalin, Brezhnev and the people around them, photographic exhibitions about Soviet life, and popular songs and films from the Soviet era. Nostalgia for tsarist times was evident in the film *The Admiral*, about Alexander Kolchak, one of the leaders of the Whites in the civil war. The film was produced in 2008 and shown as a television series in 2009.

The religious trend was reflected in various ways. Within the church, radical groups blended Orthodoxy, patriotism and a firm belief in Russia as a great power. One example was the musician Konstantin Kinchev, a member of the group Alisa, which had had a hit in the 1980s with the song 'My Generation' that became a youth anthem at that time (Beumers, 2005: 224–225). In November 2005 he proudly announced: 'I am a derzhavnik (a believer in a strong Russian state) since I am an Orthodox believer. Come to the church – we are all derzhavniki. Everybody stands for the tsar-priest' (*Izvestiya*, 2005).

In general, however, people in the cultural sphere avoided everything that could be considered politically problematic or delicate. The liberals of the 1960s, the

'shestidesyatniki', now in their 70s and 80s, were an exception as they staged plays which contained references to contemporary problems. The media, however, paid no attention to such references. Thus, when the theatre director, Yurii Lyubimov, staged *Antigone*, a tale of the classical conflict between the law of those in power and the morals of the individual, the media saw no parallels with contemporary life and society.

While cultural workers sought to avoid politics, the authorities tried, sometimes successfully, to tie them to the regime. In 2005 Surkov held a meeting with popular rock musicians,[47] and before long the former rebels were holding concerts in the Kremlin.[48] Putin had a first meeting with writers in February 2007, and further meetings would follow.

Symptomatic of the new atmosphere evolving in society was a scandal in September 2009 around a little Moscow kebab café called 'Anti-sovetskaya'.[49] The café was located in a street opposite the hotel Sovetskaya, and its name was an ironic play on the name of the hotel. In Soviet times it had been a café where dissident intellectuals used to meet. Now, 18 years after the break-up of the Soviet Union, the local prosecutor told the café owner to change its name because some citizens were offended by it. The conflict soon lost all proportion. After the name was changed, the liberal journalist Aleksander Podrabinek, who had spent several years in the Gulag, published a letter where he criticized the leaders of the veterans' organization and regretted that the owner had given in to their request (Podrabinek, 2009). As a result, the pro-Putin youth organization Nashi stirred up a campaign against Podrabinek for offending Second World War veterans and even picketed his home. They demanded that he make a public apology to the veterans or leave the country.[50] This whole campaign, which at first seemed inexplicable but then became a textbook case of how to make a mountain out of a molehill, demonstrated how authoritarian patriotic paranoia was tightening its grip.

In this situation of glamour and authoritarianism, independent art critics accused Russian visual arts of being commercialized and conformist. The art critic Andrei Kovalev stated in 2007 that 'independent and critical art has disappeared' (Kovalev, 2007a: 32). The Russian–German art historian Boris Groys expressed a similar view when he said in 2008 that Russian contemporary art was a commercialized culture (Kutlovskaya, 2008: 20): 'Like commercialized art, it registers contemporary life but without a critical or investigative gaze . . . that is, Russian art does not conceive urgent analytical statements about the situation "Here and now". There is no feeling that it clearly reacts to the contemporary socio-psychological or aesthetic situation' (Kutlovskaya, 2008: 20). Artists seemed to have no ambition to evoke reflections or thoughts, he said. Instead, all 'actors' seem 'to agree on how the scene is organized and how to act in it' (*The New Times*, 2008: 46–48). This behaviour, he said, fell into the Stalinist tradition, which he described as forcing different opinions to merge into a single version that was acceptable to the top echelons of society (Groys, 2008: 169).

Iosif Bakshtein painted a different picture of Russian contemporary art in 2007. Appointed by the Ministry of Culture as the Commissar of the Moscow Art Biennale, he was part of the establishment. Nonetheless, his background in Soviet

underground art gave him authority in the art community. He argued that contemporary art was a free territory: 'All that goes on there takes place with the maximum of freedom given at that specific historical period' (*The New Times*, 2007: 46). He continued: 'Free people, basically young people, visit the biennale of contemporary art, and it [visual art] reflects their picture of the world more exactly than any other field of art' (*The New Times*, 2007). Bakshtein took as his reference point the tradition in Russian art of questioning established truths and conceptions.

The above statements by Kovalev, Groys and Bakshtein suggest different interpretations of the contemporary art scene in Russia at that time. Was there room for an art that did not accept the glamour of the Putin consensus?

Notes

1 The art group Sinie nosy (Blue Noses) used these words at an exhibition in 2007. The group went on to say, 'We have been cradled in the very same way and think it to be the purpose of our work'. Blue Noses, 'Naked Truth/The History of Our Times Seen with the Eyes of a Philistine: The "Shame of Russia" is now in Russia!', M and J Guelman Gallery, 12 December 2007.
2 An example of hidden criticism of the authorities presented in an ambiguous way can be found in Pushkin's parody of Aleksander Radishchev's book *Journey from Petersburg to Moscow*, published in 1790. Radishchev's book, which is full of political and social reflections in the tradition of the Enlightenment and against censorship, autocracy and serfdom, earned him a death sentence, although he was reprieved and deported to Siberia. Pushkin's text supports Radishchev's thesis, albeit in a veiled form (Gerner, 2011: 117–21).
3 The avant-garde movements are not the only source of totalitarian doctrine, but their role in its appearance cannot be ignored, say Todorov and Walker (Todorov and Walker, 2010). The idea that there is a straight line of development from the avant-garde to the Socialist Realism of the Stalin era can also be found in Groys (1992). Groys would later make a clear distinction between the early and late avant-garde (see Chapter 8).
4 On Stalinist art, see Golomstock (2011), Groys (1992) and Groys (2007).
5 Research has since shown that it was CIA policy to spread abstract art to the Eastern bloc. Nonetheless, abstract art was an eye-opener for many young Russian artists and played a big role in the development of Russian art at the time.
6 On the life of the non-conformists, see the author's interview with Valerii Orlov, Moscow, September 2013. See also the special issue of the art magazine *Iskusstvo* (2012) and Andreeva (2012).
7 In 1975 non-conformist artists were legally allowed access to an exhibition space at Malaya Gruzinskaya Street (*Vsegda drugoe iskusstvo*, 2010: 124).
8 In 1979 Boris Groys coined the term 'Moscow Romantic Conceptualism' in an article in *A-YA*, a Russian emigrant journal on non-conformist art published in Paris. The term was later shortened to 'Moscow Conceptualism', although it had little in common with the conceptualism in Western art at that time (Groys, 2010: 4).
9 Compare Vadim Zakharov, 'Zolotaya kniga moskovskogo kontseptualizma', in Degot and Zakharov (2005: 7).
10 Vitalyi Komar and Aleksander Melamid are often considered the fathers of Sots-Art.
11 In his 10 albums of drawings, *Ten Characters, 1971–1976* (see Wallach, 1996). For more on Kabakov, see Kabakov and Kabakov (2008), an exhibition catalogue in two volumes.

12 In addition to Monastyrskii, there were Nikita Alekseev, Elena Elagina, Sabine Häns-gen, Georgii Kizevalter, Igor Makarevich, Nikolai Panitkov and Sergei Romasko (see Groys, 2011a).

13 Monastyrski quoted in an unpublished article by Victor Tupitsyn; and Monastyrski quoted in Bishop (2011: 14).

14 The 1975 Helsinki Final Act was signed by the 35 nations of the Conference on Secu-rity and Co-operation in Europe (CSCE). It dealt with many issues, which were divided into three 'baskets'. The third basket emphasized human rights, including freedom of emigration and the reunification of families divided by international borders, cultural exchange and freedom of the press.

15 *Vsegda drugoe iskusstvo* (2010: 199).

16 Oleg Kulik told how the young generation of artists suddenly felt alone in the new situ-ation. Interview by Denis Mustafin with Oleg Kulik, Vimeo, 26 Feb. 2010, available at http://vimeo.com/9905123.

17 Interview by Denis Mustafin with Osmolovskii, Vimeo, 11 March 2010, http://vimeo. com/10171949. Groys (2010: 9) writes: 'In the 1990s the controversy between Moscow conceptualists and Moscow Actionism very much dominated the Russian art scene. But today these polemics seem to be completely obsolete'.

18 Interview by Denis Mustafin with Avdei Ter-Oganyan, Vimeo, 2010, http://vimeo. com/10267185.

19 On Moscow Actionism and art in Moscow in the 1990s, see Kovalev (2007b).

20 The police arrested them and legal action was initiated according to article 206, para. 2, of the Criminal Code: 'Malicious hooliganism characterized by exceptional cynicism or especial audacity'. The case was closed after three months due to lack of proof of criminal intent. See 'Iz istorii protestnogo iskusstva v Rossii', www.lookatme.ru/mag/ art-design/art-and-design/159845-hlystom-i-pryanikom. Interview by Denis Mustafin with Anatolii Osmolovskii, Vimeo, 11 March 2010, http://vimeo.com/10171949.

21 See the interview with Anatolii Osmolovskii in Kovalev (2005: 247–57).

22 *Kommersant Daily*, 14 February 1995, quoted in Kovalev (2007b: 173).

23 Nonetheless, some of these artists were later drawn into the political whirlwind of events. Osmolovoskii, for instance, worked for a while in the mid-1990s with the gal-lery owner Marat Gelman in the political consultancy 'For Effective Politics'.

24 It was called 'Demonstration' and was organized by the RADEK group. Like the 1998 'Barricade', this action simulated a demonstration, with participants carrying banners and flags, and shouting slogans. However, the slogans were absurdist and the demonstrators blended with ordinary pedestrians so that they unintentionally par-ticipated in the demonstration. There were five medium-sized banners: 'Everyone Against Everyone' (*Vse protiv vsekh*), 'Devil Revolution Onanism' (*Dyavol Revoly-utsiya Onanizm*), 'A Microrevolution Is Going On' (*Mikrorevolyutsiya proiskhodit*), 'We Will Take Another Way' (*My poidem drugim putem*) and 'To Everyone 700 USD' (*Kazhdomu 700 USD*), as well as two large banners which read: 'A Microbe Is the Murderer of the President' (*Mikrob ubiitsa prezidenta*) and 'Sex Marx Karl Pistols'. There were also two flags. The eight genuine participants in the action selected road crossings where pedestrians were waiting and then joined them, crossing the street and pretending they were protesting. As one of the participants later wrote, 'It made absolutely no difference what slogans we used. The main thing was that the demon-stration took place. And the people who walked with us were this time not bystanders, but created the event themselves and participated in it' (Bystrov, quoted in Kovalev, 2007b: 403).

25 For an overview and analysis of Putin's policy during these years, see Sakwa (2008) and Shevtsova (2005).

26 The document appeared on 28 December 1999 on the Russian government website, www.gov.ru/ministry/isp-vlast47.html. It was also published in *Nezavisimaya gazeta* on 30 December 1999.

27 Lev Gudkov (2012) wrote in 2010 that there was no single accepted characterization or definition of the Putin political system. Scholars use terms like 'simulated' or 'imitated democracy', or 'hybrid', 'chimerical' or 'centaur regime'. Some compared Russia to authoritarian regimes in transitional processes in Latin America and Asia, others saw Putin's system as a normal dictatorship common to most states on former Soviet territory. Gudkov himself used the term 'Putinism'.

28 There is a rich literature on this. See, for example, Billington (2004). For a contemporary discussion see Emil Pain (2006).

29 In 1994, 27 per cent of those polled were positive towards Stalin, but by 2003 this had risen to 53 per cent (in 2009 49 per cent). In the meantime, those critical of Stalin fell from 47 per cent in 1994 to 33 per cent in 2003 (33 per cent also in 2009) (Gudkov, 2013).

30 Criticism of *chernukha* in literature, film, the visual arts and music is not just a phenomenon of Putin's time. On the situation in the 1990s, see Beumers (1999: 1).

31 The day of the October revolution was renamed the Day of Accord and Reconciliation (den soglasiya i primireniya) in 1996. The date has not been a state holiday since 2005.

32 A dominant organization among the nationalists was the League Against Illegal Immigration, an outspoken xenophobic organization based primarily on ethnic nationalism. It was outlawed by the authorities a few years later.

33 'I zhelayu chtoby Voskreshii Gospod ukrepil vas v podvige, kotoryi vy sovershaete na blago Bozhie'; 'Pomolimsya o gospodine prezidente' ('I pray that Our Resurrected Lord strengthens you in your heroic deed, which you perform for the good of God'). One of the priests asked the attending public to pray for the president (Melikova, 2006).

34 On 1 September 2006 a new topic was introduced as an experiment in four Russian regional schools: 'The Fundaments of Orthodox Culture'. The course was compulsory, and critics pointed out that not even in tsarist schools had such subjects been compulsory (*Izvestiya/Nedelya*, 1 September 2006, p. H4). In later years the experiment was developed further but, in order to minimize criticism, offered options for followers of the major official beliefs as well as a secular syllabus.

35 See, for example, the seminar in 2008 in connection with the book project *Russian Doctrine* by A.B. Kobyakov and V.V. Averyanov, who argued in favour of Orthodoxy as the central pillar of society (Kobyakov and Averyanov, 2008).

36 'The Death of an Empire: Lessons from Byzans' (Gibel imperii. Vizantiiskii urok), 2007 film (Russian), 71 mins.

37 For a discussion of the concept, see Hayoz (2012).

38 See the study of glamour culture under Putin in Goscilo and Strukov (2011).

39 Compare the 'Introduction' in Goscilo and Strukov (2011).

40 See also the discussion in 'Diskurs glamura', *Bolshoi gorod*, 6 December 2006.

41 Author's interview with Vladimir Sorokin, Moscow, November 2009.

42 At a press conference, Putin commented on the events of 23 September 1999 when the Russian air force bombed Groznyi: 'The Russian air force are carrying out and will continue to carry out attacks only on terrorist bases in Chechnya, and this will continue wherever the terrorists are. . . . We will hunt them everywhere. If they are at the airport, then at the airport. This means, if you excuse me, we will find them in the toilet and whack them in the john/shithouse. That's that, the question is finally closed' (Litnevskaya, 2010).

43 See '2002. Dela pornografov Sorokina i Ivanova', Artprotest, 16 May, http://artprotest. org/index.php?option=com_content&view=article&id=308&chtoto=2002-&catid= 4&2011–03–04–14–58–14=&ordering2=4&Itemid=4.

44 This consensus was especially visible in the film industry. One example is the film '1612' about Russians fighting Polish invaders during the Time of Troubles, which had its premiere on 4 November 2007. Its purpose was to entertain, but at the same time to foster patriotism in the audience. It failed not because it had a highly doubtful relationship with historical fact, but because the audience did not turn up as expected.

45 *Kultura* 51 (28 December 2006–10 January 2007).
46 The film 'Ostrov' by Pavel Lungin (2006). See the positive review on the website of the Sretenskyi monastery: 'Retsentsiya na film Pavla Lungina "Ostrov"', Internet zhurnal Sretenskogo monastyrya, www.pravoslavie.ru/jurnal/060905150536.htm.
47 Among them were Boris Grebenshchikov, Zemfira, Sergei Shnurov, the group Bi-2 and the producers of the groups Spleen and Chaif.
48 The first two were Boris Grebenshchikov and Andrei Makarevich. After the election of Medvedev in 2008, Makarevich's group, Mashina vremeni, played at the huge rock concert in Red Square (Kozyrev, 2008).
49 'Sila slova. Smena nazvaniya odnogo iz stolichnykh kafe sprovotsirovala politicheskii skandal', Sobesednik.ru, 1 October 2009, http://sobesednik.ru/node/20442.
50 Ella Panfilova, the President's Representative on Human Rights Issues, defended Podrabinek against this political onslaught. In a further ratcheting up of the conflict, Duma deputies demanded that Panfilova leave her post.

References

Andreeva, Ekaterina (2012), *Ugol nesootvetsviya: Shkoly nonkonformizma Moskva–Leningrad, 1946–1991* (Moscow: Iskusstvo – XXI vek).

Ashton Sharp, Jane (2006), *Russian Modernism between East and West: Natalya Goncharova and the Moscow Avant-Garde* (Cambridge: Cambridge University Press).

Bauman, Zygmunt (1999), *In Search of Politics* (Cambridge: Blackwell Press).

Bauman, Zygmunt (2000), *Liquid Modernity* (Malden, Mass.: Polity).

Beumers, Birgit (ed.) (1999), *Russia on Reels: The Russian Idea in Post-Soviet Cinema* (London and New York: I.B.Tauris).

Beumers, Birgit (2005), *Pop Culture Russia! Media, Arts and Lifestyle* (Santa Barbara, Denver and Oxford: ABC CLIO).

Billington, James H. (2004), *Russia in Search of Itself* (Washington, D.C., Baltimore and London: Woodrow Wilson Center Press and Johns Hopkins University Press).

Bishop, Claire (2011), 'Zones of Indistinguishability: The Collective Actions Group and Participatory Art', in Boris Groys (ed.), *Empty Zones: Andrei Monastyrski and Collective Actions* (London: Black Dog Publishing), pp. 10–18.

Bobrinskaya, Ekaterina (2010), 'Moskovskaya kontseptualnaya shkola. Estetika i istoriya', in *Pole deistviya. Moskovskaya kontseptualnaya shkola i ee kontekst 70–80-e gody XX veka* [exhibition catalogue] (Moscow: Fond Ekaterina), pp. 15–25.

Bodin, Per-Arne (2009), *Language, Canonization and Holy Foolishness: Studies in Post-Soviet Russian Culture and the Orthodox Tradition* (Stockholm: Stockholm University).

Bolshoi gorod (2006), 'Diskurs glamura' [thematic issue], 6 December.

Bredikhina, Lyudmila et al. (eds.) (2007), *Oleg Kulik: Nihil inhumanum a me alienum puto/ Nothing Inhuman Is Alien to Me* (Bielefeld: Kerber Verlag).

Chernysheva, Vernika (2007), 'Bezobidnoe sverkhpotreblenie: Nikolai Uskov o putinskom glamure i moskovskoi svetskoi zhizni', *Nezavisimaya gazeta Antrakt*, 16 November, www.ng.ru/saturday/2007-11-16/13_consumerism.html.

Clark, Katerina and Dobrenko, Evgeny (eds.) (2007), *Soviet Culture and Power: A History in Documents, 1917–1953* (New Haven & London: Yale University Press).

Degot, Ekaterina (2006), *Borba za znamya: Sovetskoe iskusstvo mezhdu Trotskim i Stalinym 1926–1936* (Moscow: Izdatelskaya programma Moskovskogo muzeya sovremennogo iskusstva).

Degot, Ekaterina and Riff, David (2008), 'Ot krizisa do krizisa: glavnoe', *Open Space*, 25 December, www.openspace.ru/art/projects/132/details/7072.

Degot, Ekaterina and Zakharov, Vadim (eds.) (2005), *Moskovskii kontseptualizm* (Moskva: Izdatelstvo WAM 15/16).

Dondurei, Daniil (2007), 'Vse rasresheno', *Artkhronika* 6: 92–95.

Drugoe iskusstvo 1956–76. K khronike khudozhestvennoi zhizni. Tom I (1991a), (Moskva: Khudozhestvennaya gallereya 'Moskovskaya kollektsiya & SP 'Interbuk').

Drugoe iskusstvo 1956–76. K khronike khudozhestvennoi zhizni. Tom II (1991b), (Moskva: Khudozhestvennaya gallereya 'Moskovskaya kollektsiya & SP 'Interbuk').

Dubin, Boris (2009), 'Rezhim razobshcheniya', *Pro et Contra* 13(1): 6–19.–

Dubin, Boris (2011), *Rossiya nulevykh: politicheskaya kultura, istoricheskaya pamyat, povsednevnaya zhizn* (Moscow: Rosspen).

Dubin, Boris (2012), 'The Myth of the Russian "Unique Path" and Public Opinion', in Lena Jonson and Stephen White (eds.), *Waiting for Reform under Putin and Medvedev* (London and New York: Palgrave Macmillan), pp. 81–95.

Dugin, Aleksander. (2012), 'Statya Dugina o Surkove', 5 January, http://surkov.info/statya-dugina-o-surkove.

Erjavec, Ales. (2003), 'Introduction', in Ales Erjavec (ed.), *Postmodernism and the Post-socialist Condition: Politicized Art under Late Socialism* (Berkeley, Calif.: University of California Press), pp. 1–54.

Evans, Alfred B. (2013), 'Civil Society and Protest', in Stephen K. Wegren (ed.), *Return to Putin's Russia: Past Imperfect, Future Uncertain* (Lanham, Boulder, New York: Rowman and Littlefield), pp. 103–124.

Filippov, A.V. (2007), *Noveishaya istoriya Rossii 1945–2006: Kniga dlya uchitelya* (Moscow: Prosveshchenie).

Gerchuk, Yurii (2008), *Krovoizliyanie v MOSKh ili Khrushchev v Manezhe 1 December 1962* (Moscow: Novoe literaturnoe obozrenie).

Gerner, K. (2011), *Ryssland: En europeisk civilisationshistoria* (Russia: A European Civilization History) (Lund: Historiska Media).

Gill, Graeme (2013), *Symbolism and Regime Change in Russia* (Cambridge and New York: Cambridge University Press).

Golomstock, Igor (2011), *Totalitarian Art in the Soviet Union, The Third Reich, Fascist Italy, and the People's Republic of China* (New York and London: Overlook Duckworth).

Goscilo, Helena and Strukov, Vlad (eds.) (2011), *Celebrity and Glamour in Contemporary Russia: Shocking Chic* (London and New York: Routledge).

Groys, Boris (1992), *The Total Art of Stalinism: Avant-Garde, Aesthetic Dictatorship and Beyond* (Princeton and Oxford: Princeton University Press).

Groys, Boris (2008), *Art Power* (Cambridge, Mass. and London: MIT Press).

Groys, Boris (2010), *History Becomes Form: Moscow Conceptualism* (Cambridge, Mass. and London: MIT Press).

Groys, Boris (2011a), 'Art Clearings', in Boris Groys (ed.), *Empty Zones: Andrei Monastyrski and Collective Actions* (London: Black Dog Publishing), pp. 6–9

Groys, Boris (ed.) (2011b), *Empty Zones: Andrei Monastyrski and Collective Actions* (London: Black Dog Publishing).

Gudkov, Lev (2009), 'Priroda putinizma', *Vestnik obshchestvennogo mneniya: Dannye. Analiz. Diskussiya* 3(101) (July–September): 6–21.

Gudkov, Lev (2012), 'The Nature and Function of Putinism', in Lena Jonson and Stephen White (eds.), *Waiting for Reform under Putin and Medvedev* (London and New York: Palgrave Macmillan), pp. 61–80.

Gudkov, Lev (2013), 'Otnoshenie k Stalinu v Rossii i stranakh za-Kavkazya', Moskovskii tsentr Karnegi, 5 March, www.levada.ru/sites/default/files/stalin.pdf.

Gurianova, Nina (2012), *The Aesthetics of Anarchy: Art and Ideology in the Early Russian Avant-Garde* (Berkeley: University of California Press).

Hayoz, Nicolas (2012), 'Globalization and Discursive Resistance: Authoritarian Power Structures and the Challenges of Modernity', in Lena Jonson and Stephen White (eds.), *Waiting for Reform under Putin and Medvedev* (London and New York: Palgrave Macmillan), pp. 19–37.

Hosking, G. (1997), *Russia. People. Empire, 1552–1917* (London: Fontana Press).

Izvestiya (2005), 'Muzikant Konstantin Kinchev "Ya zhe derzhavnik"', 11 November, www.izvestia.ru/news/308193.

Iskusstvo (2012), Nenuzhnoe, zabytoe, nedootsennoe [special issue] 4.

Jonson, Lena (1980), *Den politiska oppositionen i Sovjet* (Stockholm: Prisma Verdandi).

Jonson, Lena (2010), 'Historieundervisning som patriotisk fostran', *Historisk Tidskrift* 130(2), www.ui.se/eng/upl/files/80479.pdf.

Kabakov, Ilya and Kabakov, Emiliya (2008), *Alternative History of Art* [exhibition catalogue in two volumes] (Moscow: Kerber Art).

Kaftan, Larisa (2004), 'Zamestitel glavy administratsii prezidenta RF Vladislav Surkov: Putin ukreplyaet gosudarstvo, i ne sebya', Interview with Vladislav Surkov, *Komsomolskaya pravda*, 29 September, www.kp.ru/daily/23370/32473.

Kharms, Daniil (1991), *Gorlo bredit britvuyu: Sluchai, rasskazy, dnevnikiovye zapisi* (Glagol. Literaturno-khudozhestvennyi zhurnal 4:5–236) (special issue of journal).

Kobyakov, A.B. and Averyanov, V.V. (eds.) (2008), *Russkaya doktrina* (Moscow: Yauza Press).

Kovalev, Andrei (2005), *Imennoi ukazatel* (Moscow: Novoe literaturnoe obozrenie).

Kovalev, Andrei (2007a), 'Na svobodu: s chistoi sovestyu', *Artkhronika* 9: 32–39.

Kovalev, Andrei (ed.) (2007b), *Rossiiskii aktsionizm, 1990–2000* (Moscow: Izdatelstvo WAM no. 28–29).

Kovalev, Andrei (2007c), 'Zhest vremeni i vremya zhesta', in Andrei Kovalev (ed.), *Rossiiskii aktsionizm, 1990–2000* (Moscow: Izdatelstvo WAM), pp. 5–15.

Kozlova, Olga (2008), 'Klassik Borya and pobedivshii kontseptualizm', *Artkhronika* 9: 106–113.

Kozyrev, Oleg (2008), 'Pod izmenchivyi mir: Internet prostilsya s Makarevichem ne prostiv ego', *The New Times,* 17 March, www.newtimes.ru/articles/detail/4624.

Krug, Pavel (2008), 'Molodye, umnye, pravoslavnye', *Nezavisimaya gazeta NG-Religiya*, 5 March, www.ng.ru/society/2008-03-05/4_moda.html.

Kukulin, N. (2007), 'Alternativnoe sotsialnoe proektirovanie v sovetskom obshchestve 1960–70-kh godov, ili Pochemu v sovremennoi Rossii ne prizhilis levye politicheskie praktiki', *Novoe literaturnoe obozrenie* 88: 169–201.

Kutlovskaya, Elena (2008), 'Nichego ne stroit i ni na chto ne nadeyatsya: Filosof Boris Groys o sovremennoi rossiiskoi tsivilizatsii', *Nezavisimaya gazeta*, 12 September, www.ng.ru/antrakt/2008-09-12/groyts.html.

Litnevskaya, E.I. (2010), 'Stilevaya neodnorodnost teksta kak norma, kommunikativnaya neudacha, yazykovaya primeta idiostilya', in *Mir lingvistiki i kommunikatsii: elektronnyi nauchnyi zhurnal* (Tver: TGSKhA, TIPLiMK), http://tverlingua.ru/archive/21/2_21.pdf.

Lomasko, Viktoriya and Nikolaev, Anton (2011), 'Aktsionizm i artivizm', *Grani*, 7 June, www.grani.ru/users/lomaskonikolaev/entries.

Lyotard, Jean-Francois (1988), *The Differend: Phrases in Dispute* (Minneapolis: University of Minnesota Press).

Lyubarskaya, Elena (2005), 'O chem poyut deti Sorokina?', *Lenta.ru*, 11 March, http://lenta.ru/articles/2005/03/11/bolshoi.

Manevich, G. (1991), 'Khudozhnik i vremya ili Moskovskoe "podpole" 60-kh', in *Drugoe iskusstvo. Moskva 1956–76* (Moskva: Khudozhestvennaya galereya "Moskovskaya kollektsiya", SP "Interbuk"), pp. 13–20.

Melikova, Natalya (2006), 'Pomolimsya o gospodine prezidente', *Nezavisimaya gazeta*, 24 April, www.ng.ru/politics/2006-04-24/2_church.html.

Melikova, Natalya (2007), 'Putin v "Luzhnikakh" prizval golosovat za "Edinuyu Rossiyu"', *Nezavisimaya gazeta*, 22 November, www.ng.ru/politics/2007–11–22/1_ole.html.

Nakov, Alexei (2010), *Svart och vit: Om Malevitj* (Stockholm: Moderna Museet).

The New Times (2007), 'Iosif Bakshtein: "Istochnik magii – eto dengi"', (9) 9 April, reposted on www.media-online.ru/index.php3?id=89408.

The New Times (2008), 'V Rossii massovaya kultura pobedila okonchatelno (iskusstvoved Boris Groys)', 22 September, www.newtimes.ru/articles/detail/3585.

Pain, Emil (2006), 'Ot Tretego Rima k grazhdanskoi natsii', *Nezavisimaya gazeta*, 14 February, www.ng.ru/ideas/2006-02-14/1_3rdrome.html.

Pain, Emil (2008), 'Vyzovy vremeni i inertsiya traditsii. Sdvinetsya li Rossiya s "osobogo puti"', *Nezavisimaya gazeta*, 26 February, www.ng.ru/ideas/2008-02-26/14_traditions.html.

Pain, Emil (2009), 'Politicheskii rezhim v Rossii 2000-kh gg.: osobennosti nasledstvennye i priobretennye', *Vestnik obshchestvennogo mneniya. Dannye. Analiz. Diskussiya* 4(102) (October–December): 38–49.

Pelevin, Viktor (1999), *Pokolenie P (Generation P)* (Moscow: Vagrius).

Pelevin, Viktor (2006), *Empire V: The Tale of a Real Super Man Empire V* (Povest o nastoyashchem sverkhcheloveke) (Moscow: Eksmo).

Pipes, Richard (1990), *Russia under the Old Regime* (London: Penguin Books).

Pipes, Richard (2005), *Russian Conservatism and Its Critics: A Study in Political Culture* (New Haven and London: Yale University Press).

Podrabinek, Aleksander (2009), 'Kak antisovetchik k antisovetchikam', *Ezhednevnyi zhurnal*, 29 September, www.ej.ru/?a=note&id=9467.

Pole deistviya. Moskovskaya kontseptualnaya shkola i ee kontekst 70–80-e gody XX veka (2010), exhibition catalogue (Moscow: Fond Ekaterina).

Putin, Vladimir (2005), 'Poslanie Federalnomu Sobraniyu', 25 April, http://archive.kremlin.ru/appears/2005/04/25/1223_type63372type63374type82634_87049.shtml.

Rekonstruktsiya/Reconstruction 1990–2000 (2013), exhibition catalogue (Moscow: Ekaterina Cultural Foundation, Garage Center for Contemporary Culture, XL Projects).

Remington, Thomas F. (2013), 'Parliament and the Dominant Party Regime', in Stephen K. Wegren (ed.), *Return to Putin's Russia: Past Imperfect, Future Uncertain* (Lanham, Boulder, New York: Rowman and Littlefield), pp. 45/62.

Riasanovsky, Nicholas V. (2005), *Russian Identities: A Historical Survey* (Oxford and New York: Oxford University Press).

Rubinshtein, Lev (2009), 'Semechki glamurnye', 9 February, www.grani.ru/Politics/Russia/m.147372.html.

Sakwa, Richard (2008), *Putin: Russia's Choice* (London and New York: Routledge).

Sakwa, Richard (2010), *Russian Politics and Society* (London and New York: Routledge).

Selunskaya, Natalya and Toshtendal, Rolf (2005), *Zarozhdenie demokraticheskoi kultury. Rossiya v nachale XX veka* (Moscow: Rosspen).

Shalin, Dmitry N. (1996), 'Intellectual Culture', in Dmitri N. Shalin (ed.), *Russian Culture at the Crossroads: Paradoxes of Postcommunist Consciousness* (Boulder: Westview Press), pp. 41–97.

Shevtsova, Lilia (2005), *Putin's Russia* (Washington, D.C.: Carnegie Endowment for International Peace).

Shusharin, Dmitrii (2002), 'O sovetskoi literature', *Russkii zhurnal*, 19 July, http://old.russ.ru/ist_sovr/20020719.html.

Shusharin, Dmitrii (2009), 'Derzhava bez derzhavina', *Grani*, 16 July, http://grani.ru/Politics/Russia/m.154011.html.

Sorokin, Vladimir (2006), *Den oprichnika* (Moscow: Zakharov).

Sokolov, K.B. (2007), *Khudozhestvennaya kultura i vlast v poststalinskoi Rossii: soyuz i borba (1953–1985gg.)* (St Petersburg: 'Nestor-Istoriya').

Surkov, Vladislav (2007), 'Russkaya politicheskaya kultura: Vglyad iz utopii' [Speech at the Russian Academy of Sciences], 16 June, http://surkov.info/russkaya-politicheskaya-kultura-u-vzgla-utopii-nenauchnyj-razgovor-chast-1/#more-337.

Todorov, Tzvetan and Walker, Gila (2010), *The Limits of Art* (London: Seagull Books).

Uskov, Nikolai (2006), 'Suverennyi glamur', *GQ* [journal], July. Posted on gq-live.livejournal.com&6340.html.

Uskov, Nikolai (2008a), 'Sgin simulyakr', *Nezavisimaya gazeta*, 23 May, www.ng.ru/people_regulations/2008/05/23/17_simulakr.html.

Uskov, Nikolai (2008b), 'Konets glamura', *Nezavisimaya gazeta Antrakt*, 16 May, www.ng.ru/people_regulations/2008-05-16/17_glamour.html.

Vinogradov, Mikhail and Bolotova, Olga (2005), 'Bez dorogi', *Izvestiya*, 16 December, www.izvestia.ru/news/309505.

Volkov, Solomon (2008), *The Magical Chorus: A History of Russian Culture from Tolstoy to Solzhenitsyn* (New York: Alfred A. Knopf).

Vsegda drugoe iskusstvo. Istoriya sovremennogo iskusstva Rossii. Sobranie Viktora Bondarenko (2010), (Moskva: Knigi WAM).

Wallach, Amei (1996), *Ilya Kabakov: The Man Who Never Threw Anything Away* (New York: Harry N. Abrams).

Washington Post (2007), 'Putin's Prepared Remarks at 43rd Munich Conference on Security Policy', 10 February, www.washingtonpost.com/wp-dyn/content/article/2007/02/12/AR2007021200555.html.

Zubok, Vladislav (2009), *Zhivago's Children: The Last Russian Intelligentsia* (Cambridge and London: Belknap Press/Harvard University Press).

3 An Other gaze in art

The Russian art scene expanded in the first decade of the twenty-first century. Yet, as is discussed in Chapter 2, there was at the time a fear that post-Soviet art was too much directed at the new evolving commercial market. This view is examined in this chapter, which deals with the art of an 'other gaze'. As defined here, such art constitutes a subtle form of dissensus in art. Ambiguous in character, it can be interpreted as a diversion from the perceptions, approaches and perspectives of the official consensus.

The other gaze is contrasted to the discourse on identity in the evolving Putin consensus, and its aspects of 'we' described in Chapter 2. Consolidating the identity of a 'collective we' became a burning issue for the regime against the background of the differentiation, fragmentation and lost orientations in society, and the colour revolutions which took place in states on former Soviet territory. Many artists, consciously or unconsciously reacting to life around them, also responded to the official consensus that was being formed, and the position they took was reflected in their work.

A statement in a work of art must be interpreted by taking account of the context and the conditions in society at that specific time and place. According to Jacques Rancière (2006: 62), it is the social–political context that determines whether a painting or a film seems 'to harbour a political critique or appears . . . to be suited to an apolitical outlook on the irreducible chaos of human affairs or the picturesque poetry of social differences'. Only by taking into account the burning issues of a specific society – its myths, traditions and general debate – can a statement be identified. Even so, there are no fixed criteria. He writes that: 'The core of the problem is that there is no criterion for establishing an appropriate correlation between the politics of aesthetics and the aesthetics of politics' and explains that 'plastic and narrative devices can be identified with an exemplary political awareness of the contradictions inherent in a social and economic order. They can, however, just as well be denounced as reactionary nihilism or even considered to be pure formal machines without political content' (Rancière, 2006: 61). This is what he (2006: 49) calls the Janus face of political art. The interpretation of a specific work of art may well be negated by alternative interpretations.

To interpret art in the wider social context of its time, the analysis below draws on what artists, curators, gallery owners, art critics and opponents say about a

work. Thus, how artists wanted their work to be interpreted – judged from the title of the work, an explanatory text or the way in which the curator pitched the work – and how they were received in Russian society and reported in the Russian media will be the determining factors. Taking account of both the declared intentions and the public reaction of reviewers and opponents facilitates an understanding of the ideas that the individual work of art provokes.

It is worth repeating that artists can never predict or plan the resonance and effect of their artwork. The intention may be completely different from the way in which the artwork is received by the viewer. This also means that, although an artist might declare himself to be completely uninterested in politics and his work nonpolitical and without relation to social phenomena, its resonance in society may be both considerable and political.

The analysis rests on the assumption that artists relate and respond to crucial events and issues in the society of their own time. This is what makes up a 'generation' and distinguishes it from other generations that were influenced by other sets of events and issues. The artists discussed in this study were born in the 1950s–1980s and witnessed a rapidly changing society in which the issue of identity was crucial – as it is today. They experienced the Perestroika of the 1980s, the break-up of the Soviet Union and the market-oriented reforms of the early 1990s; the system of economic and political oligarchy that followed and the economic default of the late 1990s; and the authoritarian restoration in the name of 'stabilization' of the 2000s. Their reactions and responses varied as they interpreted these changes, but they all related to events in one way or another.

All the artists analysed in this chapter have an acknowledged status in the Russian community of contemporary art. They are laureates or nominees of the two most prestigious art awards or participated in important exhibitions in Moscow. Some of them have an international reputation through their participation in international exhibitions, such as the Venice Biennale of Contemporary Art.

The chapter depicts the art scene as a stage for evolving controversy and starts with a first, brief introduction to the conflicts that other chapters address in more detail. Then follows an analysis of art categorized as the 'other gaze'. The analysis relates thematically to the various aspects of the definition of 'we' in the Putin consensus addressed in Chapter 2: state nationalism; the nation and the Other; the Orthodox belief; and symbols of the state.

A stage set for controversy

As the new millennium began, Russian artists were in principle free to express whatever they pleased. However, as the new official consensus took form, new actors appeared who aggressively promoted it. Among them were radical rightist groups that blended patriotism and Orthodox religion. Some openly represented the church, while others existed as independent organizations but in symbiosis with the church. They mobilized an offensive against contemporary art and individual art exhibitions, and artworks became targets as controversies developed.

An important event occurred in 2003, when 'Beware! Religion', an exhibition at the Sakharov Centre that addressed the dual role of religion, was attacked and vandalized. A legal process followed not against the vandals, but against the organizers of the exhibition. Before the sentences were announced, a second important event occurred – the 'Rossiya 2' exhibition opened at the Central House of Artists in January 2005, a project as part of the programme of the First Moscow Biennale for Contemporary Art.[1]

The curator of 'Rossiya 2' was Marat Gelman, who had returned to his gallery business full-time in late 2004 after working for several years as a political consultant for the Eltsin and Putin regimes. He supported Eltsin's re-election campaign in the 1996 presidential election and also helped to facilitate the election of Putin as president in 2000.[2] He left political consultancy after disagreements with the Kremlin when he worked for its candidate in the 2004 Ukrainian presidential election. Before the exhibition opened, Gelman was warned by Russian officials that 'three subjects were not to be touched – Chechnya, the Orthodox Church and Putin'. However, Gelman did not heed these warnings. His exhibition was not official so he decided to include works on all three topics (FitzGerald, 2005).

The exhibition was named to emphasize the fact that it represented a different Russia from the official Russia, 'Rossiya 1' or Putin's Russia. It was a call for the establishment of a parallel cultural system as an alternative and free space.[3] Gelman wrote: 'Russia 2 exists within the geographical boundaries of the Russian Federation, but it is more democratic, international and receptive to the exploration of marginal themes and not closed off within the boundaries of the "officially" sanctioned'. The choice of name was a direct reference to a well-known study from the 1970s by Vladimir Papernyi, *Kultura Dva* (Culture 2),[4] which analysed the transformation from avant-gardist constructivism (Culture I) to Stalinist architecture and culture (Papernyi, 2007). Papernyi viewed architecture in its cultural and political context, which underwent drastic changes during this time. For him Culture 2 exposed the reactionary backlash of Stalinism; for Gelman Rossiya 1 represented the conservative backlash of the Putin system.[5]

The text presenting the 'Rossiya 2' project read like a manifesto against the Putin regime and political developments since 2000. It reacted against a number of key features: 'the so-called managed democracy . . . the love for the president in office . . . the patriotic zeal and the search for the enemy within . . . the cult of the past . . . the rapprochement of church and state . . . [and] the drastic loss of prestige in the creative, artistic and scientific fields'.[6] Nonetheless, Gelman emphasized that the project was not an opposition platform, but a call for the creation of what he called a free alternative space. He wanted people to conceptualize the future, regardless of the 'here and now', and to be 'prepared to propose alternatives when the time comes'. The project was to be implemented in various forums – Internet sites, exhibitions, literature anthologies, meetings and performances. He saw the task of creating such a space in three parts: (a) conceptualization, creative thinking about new ideas for an alternative future; (b) reflection, including political and economic aspects, academic and aesthetic analysis and an emotion-free and

detached deconstruction of the official 'Russia 1' system; and (c) raising the status of aspects of people's lives that are ranked low on today's agenda, such as profession, family and friendship.[7] Gelman's stand is interesting because it reflected a more general mood in Russian society in the middle of the first decade of the new century. As an independent gallery owner, he had an excellent sense of what was new and interesting in contemporary art. As a former political consultant, he was good at analysing society.

More than 30 Russian artists and art collectives participated in the 'Rossiya 2' exhibition, providing works specifically made for the exhibition.[8] Many already had a reputation, but the fame of all of them would increase in the years to come. Their works for the exhibition critically reflected on society – first and foremost on the present. Taken together they also provided a picture of expectations of Russia's future. That picture was not bright.

Shortly after 'Rossiya 2' closed, about 200 artists from the traditionalist Moscow Union of Artists published an open letter in which they accused the exhibition of blasphemy and extreme immorality (*Russkii Vestnik,* 2005). The letter mentioned five works in particular: (a) Avdei Ter-Oganyan's 'Radical Abstractionism' (see Figure 3.25); (b) the AES group's 'Moscow 2006', from the series 'Islamic Project', showing the Kremlin with mosques and minarets instead of churches and with a green flag flying over the Kremlin (see Figure 3.18); (c) Marina Koldobskaya's 'Everything Needed for Life', the face of Jesus portrayed on a television screen alternating with advertisements; and two works by Gor Chakhal, (d) 'The Names of God' (see Figure 3.14) and (e) 'The Sun of Truth, Good, and Beauty' (see Figure 3.15).

The letter was soon followed by calls for prosecution. An initial investigation found that no criminal act had been committed and closed the case. Several months later a new lawsuit was begun in a Moscow district civil court, but Gelman was acquitted.[9] The exhibition had been taken to court by an alliance of Orthodox activists, among them Narodnyi sobor, the conservative Moscow Union of Artists and the nationalist Rodina group in the State Duma. The political atmosphere in Russia was obviously changing.

The arts community did not respond to Gelman's call to create a 'free space' for critical discussion in the light of strengthening authoritarianism. It was difficult to tell how serious Gelman was; he was clearly no dissident. He would later argue that the manifesto was ambiguous.[10] In March 2005 the trial of the organizers of the 'Beware! Religion' exhibition ended in a guilty verdict. They were found guilty of causing division and hatred between religious groups and offending the feelings of believers, and were sentenced according to article 282 of the Russian Criminal Code, part of Russia's legislation against extremism. The organizations which had instigated the legal process now felt that they had the legal and political wind beneath their Orthodox-patriotic wings. This was one reason for the silence of the wider art community – they feared that to do otherwise would only cause them trouble.

In the autumn of 2005, the 'Russian PopArt', or Sots-Art, exhibition opened at the Central House of Artists. It was curated by Andrei Erofeev, head of the section

on latest trends in art at the Tretyakov Gallery. The Sots-Art exhibition complemented an exhibition about Andy Warhol at the Tretyakov Gallery at the same time.[11] Most of the exhibited Sots-Art was made in the 1970s, 1980s and early 1990s, but Sots-Art still evoked strong emotions. Three days before the exhibition opened, the director of the Tretyakov Gallery had to remove Aleksander Kosolapov's work 'Icon–Caviar' (see Figure 4.2) at the request of representatives of the Orthodox Church (Kommersant Vlast, 2007).[12] In March 2007, a large follow-up exhibition of Sots-Art took place at the Central House of Artists as part of the programme of the Second Moscow Biennale.[13] By now a number of younger artists were working in this tradition. Some of their pieces were openly critical of the political and military leadership, but these works were removed before the exhibition opened (see the discussion on the PG art group in Chapter 5).

These works were shown instead in the 'Forbidden Art' exhibition at the Sakharov Centre in the same month (see Chapter 4). This exhibition was also curated by Andrei Erofeev and organized by the director of the Sakharov Centre, Yurii Samodurov. Its purpose was to discuss issues of administrative censorship and self-censorship in museums and state cultural institutions. The exhibition caused a scandal. Orthodox activists again reacted strongly and took the organizers to court. As a result, state museums became more cautious about what they exhibited. Prestigious private art galleries, however, continued to exhibit individual controversial works of art. Such artworks attracted media attention – an understandable priority for a commercial gallery.

In 2007 there were art scandals not only inside the country but also with regard to foreign partners of Russian art museums and galleries. Just as the Sots-Art exhibition was due to open in Paris, it became clear that the Tretyakov Gallery had censored material by attempting to remove works from the freight. These works were still exhibited in Paris, and the scandal only added to their reputation and increased interest in the Paris exhibition. The informal censorship of art by overambitious bureaucrats and groups of religious fanatics provoked a reaction and stimulated counter-actions from the art community.

Against this background artworks of the 'other gaze' were exhibited. In spite of the fact that the dissensus of this art was mostly subtle, it contributed to a diversity of views in society at a time when public debate was closing down. Although it did not set out to cause controversy, it sometimes did.

Discourse: 'State nationalism'

A discourse on state nationalism is to a large extent about the past, present and future of the state. Every vision of the future depends on how the past is viewed; every understanding of the past sets the parameters for the future. At the same time, perceptions of the past and future colour the way in which the present is viewed. Like the Soviet tradition, the Putin discourse on state nationalism tells of a linear development towards a bright future, emphasizing the bright side of life while ignoring the dark sides. This section searches for the 'other gaze' in art with regard to understandings of the past, present and future. While the official

nationalism referred to the state rather than the individual in its narratives, art focused on individuals and their inner and outer worlds.

Understanding the present

Although the Putin consensus contains no distinct vision of the future, it increasingly emphasizes the glorious past of the Russian state and transfers this glory into expectations of the future. The future will be as glorious as the past once had been. Thus, without offering a utopian ideal, the future was declared to be a better version of the present – in other words, more of the same. The present was thus characterized in official discourse by the buzzword 'stability', which depicted a static state of no-change as 'normality'.

In their works, however, many artists expressed a feeling of insecurity and fear of an unidentified threat lurking in a dark and unknown space. They emphasized the fragility of life in the big cities as well as the vulnerability of individuals. These feelings were along the same lines of what Zygmunt Bauman describes as a feeling of 'liquidity' and 'liquid society' (see Chapter 2). Bauman uses *Unsicherheit* (fear and uncertainty) to describe the feeling that flows from this state of society – a term that well describes the state of Russian society in the 2000s where the return to an authoritarian policy added to the insecurity of the deformed market economy that had rapidly penetrated all corners of Russian society.

The strong 'existentialist' trend in Russian contemporary art of the early 2000s can be interpreted as psychological reactions to and perceptions of what was happening in society, according to Andrei Erofeev (2011a). Aleksander Brodskii, whose main theme is frailty and vulnerability, was part of this trend. Born in 1955 and an architect by profession, he was already well known in the 1980s as a 'paper architect', whose radical plans won international awards even though there was no will and no money to implement them in his own country.[14] He had participated in exhibitions in the West with Ilya Kabakov as far back as 1990, and his work reflected criticism of utopian dreams, be they socialist or capitalist (Rapoport, 1990: 128).[15]

Brodskii depicts the frailty and vulnerability of the city and the individual, often with an 'air of eternity and of otherworldly melancholy'.[16] 'The Penultimate Day of Pompeii' (see Figure 3.1) was a model in unfired clay showing a beautiful, grand old building, with statues along its roof, sinking into the mud. Brodskii explained that the unfired clay was important: 'The feeling that all this is made of dust and at any moment can again turn to dust is crucial in these works. However, if you handle these objects carefully, they may live forever. Besides this, unfired clay is a material that can be used endlessly. Any of my sculptures can be soaked and something else modelled from it. . . . And herein there is also something' (*Artkhronika*, 2010: 46–53). Brodskii's installation could be viewed as a paraphrase of one of the most famous Russian paintings of the nineteenth century, Karl Bryullov's 'The Last Day of Pompeii' (1830–33). Painted against the backdrop of the political unrest in Europe and Russia at the time, Bryullov's painting became a sensation and came to be regarded as a model for how paintings can express

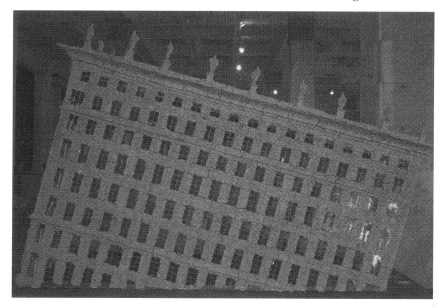

Figure 3.1 Aleksander Brodskii, 'The Penultimate Day of Pompeii' (Predposlednyi den Pompei) 1997/2008 (unfired clay, video projection)

Note: 'The Penultimate Day of Pompeii' Part of the installation 'Turnoff Points', 1997.
Source: Courtesy of A. Brodskii.

catastrophe – political or natural. It depicted the fall of a civilization following the eruption of Vesuvius, and the masses' feelings of shock and fear. Although it was open to interpretation, many, in particular Alexander Herzen, claimed that it reflected the political atmosphere in tsarist Russia after the failed mutiny by the Decembrists in 1825 (Boime, 2004: 267–269). Brodskii drew a parallel with the break-up of Soviet civilization.

Brodskii pursued the theme of vulnerability. In 2009, at the third Moscow Biennale, his installation '20 Dust Bins' portrayed the frailty of the metropolis. Inside the huge metal dustbins, each with its lid slightly open, he created the illusion of a big city and its shimmering skyscrapers (Martin and Mead, 2009: 56). The vulnerability of the individual was also the topic of his large installation 'The Night Before the Attack' at the Vinzavod in 2009. Brodskii created the illusion of small groups of people sitting around fires in the dark cellar exhibition hall. The illusion of fire came from enlightened paper strips blown by a fan. The title at first encouraged the visitor to see the people around the fires as preparing an attack. They were resting close to the warmth of the fire, as if focused on what awaited them the following morning. The installation imparted a feeling of insecurity and unease, as if there was a genuine threat lurking in the dark. After a while, the viewer realized that the figures were targets rather than attackers. The visitor could see how vulnerable and small they were, spread throughout the hall, completely

uncoordinated and under no one's command. In the dark cellar hall of the Vinza-vod, by the light of the small fires, the visitor felt a silent threat like waiting in the pre-chamber of death. The related text seemed to be an understatement: 'The motif of uncertainty is very important for the artist' (Brodskii, 2009).[17]

In his installation 'The Cell' (see Figure 3.2), Brodskii created the illusion of living on the edge. In this living space there was an opening to the sky instead of a ceiling, and a hole filled with dark black water instead of a floor. On the walls there were ladders connecting his bed, writing desk, kitchen and toilet, all located at different levels. This was literally life on the edge, next to a void that created a claustrophobic feeling. Another work, the installation 'The Road', was awarded the Kandinsky Prize in 2010. It gave the illusion of an ordinary Soviet train carriage, lit as at twilight. There were four groups of three-tier bunk beds with striped mattresses. Between them, lightboxes gave the impression of windows over small tables with white tablecloths blowing in the wind. On the tables were tea-glasses in holders and jingling teaspoons. Pairs of identical men's slippers waited under the beds. Sound effects contributed to the illusion of movement.[18] The installation was made from the perspective of the 'little man' travelling to an unknown destination. It expressed a feeling of loneliness in the midst of other people, similar to the feeling of living in a Soviet kommunalka as described by Kabakov. The installation indicated movement, hopefully forward, but the old slippers and the simple conditions revealed that not much had changed over the years.[19]

Other artists also communicated feelings of insecurity and unidentified threat, although they did not have Brodskii's touch of melancholy. The group Sinii sup (Blue Soup) comes into the same category, but its work is darker and more pessimistic.[20] Formed in 1996, the group made dystopic video works such as 'Black River', which depicts a desolate moor and a brand new but abandoned car next to a river blackened by oil.[21] Their video 'Cargo' (Echelon), from 2006, encouraged feelings of unease by showing mysterious transports of unknown goods by rail and road through snowy landscapes in the dead of night.[22] Commenting on the atmosphere of uncertainty and hopelessness that most people felt when viewing their works, the artists said: 'things that seem inviolable today often disappear tomorrow. And it is this instability that proves so fateful to so many people. Each person controls his own life the best he can. But basically, the world is constructed so that in the final analysis one can control neither one's own life to the full, nor the surrounding reality'.[23]

The video 'The Lake' (Ozero) was awarded the Innovatsiya Prize in 2007 (see Figure 3.3). It portrayed a small lake at the edge of a forest at twilight.[24] Observed from one static point, the water in the lake slowly disappears and darkness falls until nothing remains of the lake but a black hole. Then, gradually, the lake is refilled with water, the darkness slowly dissipates and the trees in the forest are again reflected in the water. This goes on and on in a cycle. At one moment the water takes on a mysterious kind of inner light in the surrounding darkness. The spectator feels the threat but cannot define it, and instead stands watching and waiting almost paralysed in front of the video screen. The video 'Hurricane' (Metel) also depicted a snowy landscape, but this time along the banks of a frozen

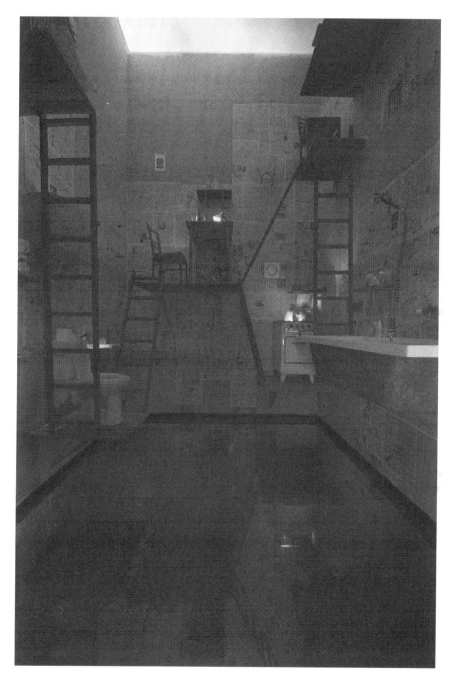

Figure 3.2 Aleksander Brodskii, 'The Cell' (Kamera) 2008/2010 (installation, furniture, objects)

Source: Courtesy of A. Brodskii.

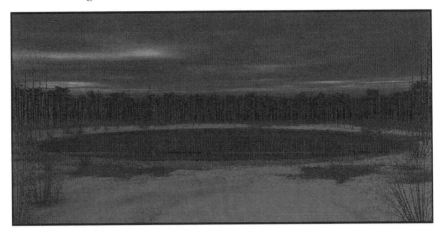

Figure 3.3 Group Sinii sup (Blue Soup), 'The Lake' (Ozero) 2007 (video)
Source: Courtesy of Sinii sup.

river or lake with mighty trees moving in the wind and small human figures rush-
ing into the woods. It, too, transmitted a feeling of threat. The press release noted:
'it creates the same feeling of expectation that something is about to happen that
haunts us in real life, which means it creates the same feeling of discomfort and
weakness because we have no idea what is awaited. After all we can exist only in
the present'.[25]

These artworks all had an existentialist core in common. Erofeev argues that
they provoked psychological reactions similar to those which people feel having
spent a considerable time in an enclosed space:

> 'Some feel suffocated from claustrophobia.... The cages, lattices, nar-
> rowed spaces, burrows, deaf walls, mountains of boxes into which the
> viewer is crushed as he wades through the newest installations which elo-
> quently express these experiences of physical malaise. But the nausea and
> despair, experienced and transferred to us by the artist, are now born not by
> kitschy etiquettes of detergents, social calamities, or political cataclysm and
> natural disasters, but by contemplation of one's existence as sunken in the
> Void, in the galloping and final stream of personal time.'
>
> (Erofeev, 2011b)

The same feeling of being stuck is expressed by Andrei Kuzkin (born in
1979), who in the performance 'Along the Circle' (Po krugu) (see Figure 3.4)
walked slowly for hours in a giant circular tub filled with thin mortar. Shambling,
exhausted and nearly falling, he communicated a feeling of hopelessness – of 'no
way out'.[26] For this work he was awarded the Innovatsiya Prize in 2008 in the
category 'The New Generation'.[27]

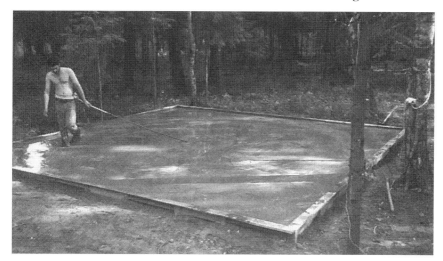

Figure 3.4 Andrei Kuzkin, 'Along the Circle' (Po krugu) 2008 (performance)
Source: Courtesy of A. Kuzkin.

In contrast to the 'existentialists', another group of the younger generation instead referred to the external world around them. Erofeev calls these artists 'locality-ists' (in Russian 'lokalisty' from the English word *locality*) and argues that they had a conceptual approach to reality that observed the constants in the local context of conscience, taste and behaviour: 'Their works express resignation rather than criticism with regard to the fact that Russian life and society do not change'. The constants of daily life, 'which we ourselves perceive as defects and faults (poverty, devastation, trash, etc.) . . .' [the locality-ists] 'transform into visual form, thereby rehabilitating them ethically and aesthetically, and making them into worthy museums of local culture' (Erofeev, 2011a).

Among these artists was Anya Zhelud (born in 1981). Zhelud's breakthrough came at the Aidan Gallery in 2007. Her installations of thin metal thread outlining the contours of furniture, clothes, hangers and other objects seemed to reflect a meditative harmony beyond catastrophe, free from conflict, according to the art critic Anna Tolstova (2008). They seemed well suited to a fashionable gallery, but Tolstova found in these objects 'a critical gaze on consumer society'. A few years later, Zhelud's critical gaze became more pronounced. Her works reflected chaos and disorder in the environment. As Erofeev later wrote (2011a), she was expressing a reaction to the general atmosphere of the time. In her works, '[t]he world changed into its opposite and appeared as the incarnation of an unruly and frightening formlessness. Chaos became the theme of her works' (Erofeev 2012b) (see Figure 3.5). In her installation 'Communications', shown at the 2009 Venice Art Biennale, she used rusty wire coils hung from the ceiling like broken cables of interrupted communication. Like her oil paintings of objects of everyday life in the tradition of the 1960s Soviet underground artist Mikhail Roginskii, her

Figure 3.5 Anya Zhelud, sketch from the series 'Room Plant: Full Version' (Komnatnoe rasstenie. Polnaya versiya) (2009)

Source: Courtesy of A. Zhelud.

installations reflected the existential conditions of life – hard, lonely and rough – but at the same time an unexpected beauty. In April 2011 she was awarded the Innovatsiya Prize in the category 'the New Generation' for her work 'Exhibition continues', which she said was an 'exposition of emptiness' (Zhelud, 2011: 92–93).

This group of artists also includes Irina Korina (born in 1977). Her installation 'Moduls', first exhibited at the 2005 Moscow Art Biennale, showed models of cars that had crashed into each other. There was nothing horrible in this crash, she explained, 'no shards of glass, no blood. It looked like a mushroom patch or something that had simply grown in this way originally. My idea was that catastrophe was part of the process'.[28] In her work 'Show Process' (see Figure 3.6), nominated for the 2010 Innovatsiya Prize and the 2011 Kandinsky Prize, the perspective changed from an exposed, passive target to a subject reacting to what was going on. The huge installation consisted of a cage made of wooden bars and chicken wire, stuffed with colourful plasticine that looked like a dynamic mass trying to break out of the metal cage that held it back. It seemed like a metaphor for the flow of life restrained by force. The artist argued that 'the title, "Show Process", can be seen as a kind of "quiet resistance". The installation is concerned with freedom and overcoming fetters and barriers, not through active moves but rather by means of a kind of amorphous strength – in this case due to the softness and fluidity of

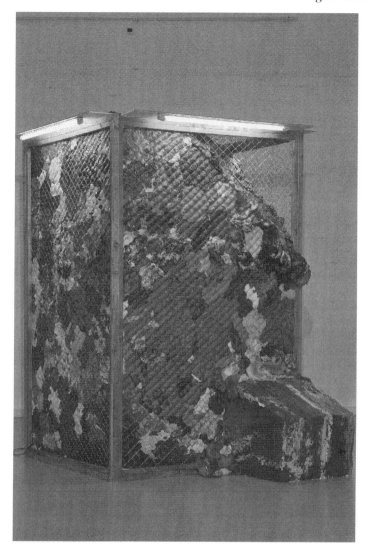

Figure 3.6 Irina Korina, 'Show Process' (Pokazatelnyi protsess) 2010 (installation)
Source: Courtesy of I. Korina.

the material' (Korina, 2011: 48–49). The work seemed to be a comment on the situation in society and a social climate in which protest was handcuffed.

Other artists depicted the current state of society more directly. One of them, Diana Machulina (born in 1981), examined the contradictions and absurdities of a society obsessed with money, greed, egoism and stupidity in visual form. She was awarded a Kandinsky Prize in 2008 in the category of young artists for her huge photo-realism oil painting of a doctored photograph of a meeting of the Soviet

political leadership in the 1980s. In 2010 she addressed contemporary Russian society in a series of oil paintings of architectural features observed in Moscow.[29] One painting depicted a brand new staircase that was impossible to climb, since it was too narrow at the top. Another showed two escalators in a shopping mall running up to a concrete wall with no exit for shoppers (see Figure 3.7). Taken from specific examples of reality, they became metaphors for society. Her 2011

Figure 3.7 Diana Machulina, 'The Mall' (2010) from the series 'In Praise of Folly' (oil on canvas)

Source: Courtesy of D. Machulina.

Figure 3.8 Diana Machulina, 'Stability' (2011) from the series 'In Praise of Folly' (acrylic, pastel, paper)

Source: Courtesy of D. Machulina and Galerie Stanislas Bourgain.

exhibition, 'In Praise of the Folly: the Architecture of Russian Capitalism', was inspired by Erasmus of Rotterdam, the philosopher of the northern Renaissance of the sixteenth century, who dealt with the stupidities of his time in satirical form (Machulina, 2011).[30] In the exhibition catalogue she explained that 'architecture reveals the deep patterns along which our state functions. It is proof that buildings are models of social relations poured into concrete' (Machulina, 2011). Her work 'Stability' expressed this concept as contrary to movement, development and change (see Figure 3.8). A carousel in a children's playground is solidly anchored to the ground in order to stabilize the construction, thereby preventing all movement. No words were necessary to explain its meaning.

At the peak of the 'years of glamour' in October 2008, just before the international financial crisis hit Russia, Marat Gelman organized the exhibition 'Russkoe bednoe' (Russian Poor Art) in Perm, which a year later participated in the Third Moscow Art Biennale.[31] Gelman called the exhibition a statement against the glamorous way of describing the present (Gelman, 2008). Gelman brought together artists according to

their choice of material: 'stones, boulders, machine parts, bags, iron and other items, the value of which consisted in their essence separated from the real context'.[32] He saw similarities with the 1960s Italian art movement, Arte Povera (Poor Art), and therefore called his exhibition 'Russkoe bednoe'.

This use of simple materials to project feelings of melancholy and decay but also beauty was seen by many art critics as representing a national trait. One review of the exhibition was called 'A War against Glamour: Searching for a National Identity' (Semenova, 2008). Other critics regarded the exhibition as a social statement and found in the asceticism of the works a national identity in the closeness to the people and to nature (Balakhovskaya, 2008). Undoubtedly, the exhibition was expressing a different gaze from the dominant one in society, but it caused no controversy. On the contrary, it was an enormous success. Among the participating artists, Aleksander Brodskii attracted the most attention. He was said to meet all the criteria of Russian Arte Povera, as he worked in simple materials and always expressed their beauty, had a narrative and related to the local context (Erofeev, 2011a; Erofeev, 2011b: 6–7).

Although the works mentioned above were ambiguous and open to various interpretations, they could be interpreted as reactions to and reflections on existential conditions of life, including the 'dark sides' of life and society. In a 'social' reading of these works, they transmitted feelings and images that differed from official conceptions and discourses. The official consensus aimed to persuade everyone that everything was moving forward, was getting better and would last forever, but these artists contradicted this analysis.

Understanding the past

The more the official consensus emphasized the glorious sides of Russia's past, the more history, and Soviet history in particular, became a highly controversial topic. There had been no *Vergangenheitsbewältigung*, as in Germany, in the sense of coming to terms with the dark past of the country. Instead, the official consensus worked against such an outcome. Individual Russian historians who continued to critically investigate the past worked against the growing mainstream. Few if any among Russian visual artists in the 2000s dealt explicitly with the dark aspects of the Soviet past. However, references to the failed utopian dream and descriptions of a void in life and society were one way of dealing with the past and could be viewed as a possible first step in working through memory of it.

In April 2004 Putin characterized the collapse of the Soviet Union as 'the biggest geopolitical catastrophe of the twentieth century' (Putin, 2005). Almost a year later three artists participating in the 'Rossiya 2' exhibition dealt directly with the break-up of the Soviet Union and its consequences, reflecting on the trauma that followed. Their perspective was different: they emphasized the impermanence of empires and states, and their inevitable decay and fall.

A fascination with ruins, decay, transiency and the extinction of civilizations could be found already in the Soviet underground.[33] Valery Koshlyakov (born in 1962), a participant in 'Rossiya 2', was above all obsessed with the beauty of the

ruins of classical architecture, such as the Coliseum and the villas of Pompeii. His works were made of cardboard, corrugated paper and brown Scotch tape, which he found reflected lost grandeur and beauty in decay. As he explained, 'I work in cardboard, a material with a short life which exists today but whether it will exist tomorrow is unknown. As a rule the major part of my work is destroyed after the exhibition. Herein lies a symbolism, too' (Stabrovskii and Prizyuk, 2010).

Koshlyakov, who in the late 1980s had belonged to an art group in Rostov with Avdei Ter-Oganyan and Yurii Shabelnikov, among others (Golovanova, 2009), had started painting the decaying beauty of his homeland in the early 1990s. In his 1994 project with Vladimir Dubossarsky, 'Dark Alleys', he showed the beauty of Stalinist Moscow incarnated in granite embankments, high-rise blocks and inhumanly broad streets. Like the short story 'Dark Alleys' by the Russian Nobel Prize laureate Ivan Bunin (1938),[34] Koshlyakov's works expressed the melancholy of the flight of time, of death and of a past that is lost and dreams that never come true.

Koshlyakov's works have been seen as comments on a past that is no more and will never return. According to the art critic Sergei Khachaturov, he deals with collective and individual memory (Amirsadekh, 2011: 146).[35] Nonetheless, Koshlyakov's work is unsentimental and expresses no longing for the past:

> I deal with a purely dreadful category, which is inaccessible to the human being – the tragedy of dying, extinction. What was yesterday is no longer. The human being carries this drama all through life, and everything is dedicated to it, regardless of whether it is Greek ruins or your Soviet personal life, which turns to dust, your memory, health, everything. It is an eternal human theme. And the paintings are a metaphor for this thought. Like mourners [crying over the dead].[36]

His works are reflections on something that has clearly become history.

Overall, the disintegration of the Soviet Union was surprisingly peaceful, but not in all parts of the empire. The violence of the war in Chechnya was illustrated by Aleksei Kallima (born in Groznyi in 1969) in his 2004 painting 'Metamorphoses' (see Figure 3.9). This painting, also shown in the Rossiya 2 exhibition, portrayed a bird's eye perspective of a Russian soldier and a Chechen man, the latter dressed in striped sportswear, fighting each other. The lines of their bodies, with the soldier hunched with his head down and the arm of the Chechen swinging a dagger, together formed a hammer and sickle – once a symbol of the union between workers and peasants. The title 'Metamorphoses' gives an indication of how to understand the painting, although it is open to more than one interpretation. Kallima's intention, according to Khachaturov, was to make Chechens visible and understandable rather than to make a statement on the war as such (Khachaturov, 2007: 452–457). As Kallima himself said several years later, the major challenge had been to draw a metaphor for the social situation – a break-up fraught with conflict. His primary interest was in drawing human beings in motion under extreme situations, which explains why he chose themes of fights or collisions.[37] The fact

Figure 3.9 Aleksei Kallima, 'Metamorphoses' 2005 (mural)
Source: Courtesy of A. Kallima.

that one of the two men was Chechen was secondary to him. The Chechen pro-
vided an abstract image of the enemy in a conflict.[38]

A more straightforward comment on the Chechnya conflict and the politically
sensitive idea of terrorism was made by Oleg Kulik at the same exhibition in
2005.[39] The installation 'Bus Stop' depicted a contemporary Moscow bus shelter
(see Figure 3.10). On one of its glass walls, where commercial posters usually
hang, was a huge photograph of a young woman sleeping in an armchair. As beau-
tiful as a Madonna, but dressed as a terrorist with a suicide bomb strapped around
her waist and a gun in her hand, she sat under a dilapidated statue of Boris Eltsin.
The installation illustrated chaos and violence and was a clear reference to the acts
of suicide bombers in Moscow at the time, some of whom were young women. At
the time, people feared the bombers and the authorities had intensified their anti-
terrorist campaign. The installation had a strong emotional effect. Nothing like it
on the theme of Chechnya was ever publicly exhibited again.

Figure 3.10 Oleg Kulik, 'Bus Stop' 2005 (installation, photograph)
Note: Installation, mixed media.
Source: Courtesy of O. Kulik.

The works of Koshlyakov, Kallima and Kulik were not statements for or against the disintegration of the Soviet Union. Rather, they commented on the consequences of a break-up that was already a historical fact. There were no hidden messages of longing for the restoration of the empire and no statements on Chechnya. There was once an empire but now it belonged to the past. The views of these artists differed from the official consensus, in which regret for the fall of the empire was the standard position. Nonetheless, the artists' comments on such a

delicate topic as the Chechnya war were enough to attract criticism. Kulik abandoned the Chechnya topic while Kallima continued his Chechnya series but along less controversial lines. Themes more directly related to efforts to come to terms with the dark sides of the Soviet past were absent from Russian contemporary art in the first decade of the twenty-first century. These would appear only in the 2010s (see Chapter 9).

Into the future

The evolving Putin consensus had no distinct vision of the future. The future was presented as a promise of a much better version of present-day life. Russian artists of the 2000s were like most of their international colleagues – highly suspicious of any lofty promises for the future. Mistrust of utopian ideas was also deeply embedded in Russian society. The Soviet utopia had crashed, with practical and far-reaching implications for the nation as well as the individual. The ideological void in society, however, gave birth to lofty ideas about the future. The search for visions of a future society was also reflected in contemporary art.

The most distinct in this regard, and the first to formulate such visions, were groups from the political right. They supported Putin but what he offered was not enough for them. Aleksei Belyaev-Gintovt (born in 1965) was an artist who exploited the conservative dream of the future. On the one hand, he fell into the pattern of the aesthetic Soviet retro-trend, following the general nostalgia in society in the early 2000s. On the other hand, his aesthetics, themes and perspective seemed to be those of a radical conservative. He demonstrated an admiration for a strong state, hierarchy, subordination and discipline – seeing Russian and Soviet civilization as a third Rome. His vision resided in the glory of the past. Belyaev-Gintovt drew on an ambiguity that led people to interpret his work in various ways.

Therefore, when he was awarded the Kandinsky Prize in December 2008, this created a scandal in the arts community. Belyaev-Gintovt had submitted two paintings reminiscent of Stalinist aesthetics, that is, of the Stalinist Grand Style (Bolshoi stil) of the post-war years. Both paintings were on the patriotic theme of defence of the country. 'Motherland-Daughter' was a detailed depiction of the great Soviet Second World War memorial of the waiting mother (Mother Motherland). The Russian nationalist Egor Kholmogorov explained that the title was a metaphor for the new relationship between the country and its people. He said that it illustrated the attitude that current generations ought to adopt towards the Russian Motherland. Since the country was currently both weak and vulnerable, the mother metaphor no longer worked. Instead, Russia was like a daughter – the only one on earth you would never betray: 'It is not so much that she gave birth to us, as we give birth to her. It is not that she brings us up, as we are called on to bring her up, feed her, protect her, and create from this still weak and almost defenceless existence a future bride, a mother, someone who will give birth to sons of her own and become the Motherland–Mother' (Kholmogorov, 2008).

In the second painting, 'Brothers and Sisters' (see Figure 3.11), grey anonymous masses look stunned and solemn while demonstrating their strength through

Figure 3.11 Aleksei Belyaev-Gintovt, 'Brothers and Sisters' (Bratya i sestry) 2008
Note: Gold leaf, black printers' ink, canvas, prints
Source: Courtesy of A. Belyaev-Gintovt and Triumph Gallery.

collective mass. They listen to Stalin's speech to the Soviet people of 3 July 1941, held after Nazi Germany attacked the Soviet Union.[40] The title refers to the way Stalin addressed the population – not just the usual 'comrades', but adding 'brothers and sisters' (Bratya i sestry) as in a church address.[41] Using gold leaf, usually identified with icon painting, and red and black printers' ink on a large canvas, Belyaev-Gintovt's painting became a manifesto.[42]

In the 1980s and 1990s, Belyaev-Gintovt had been a member of the group around the artist Timur Novikov in Leningrad/St Petersburg. Influenced by Novikovs's postmodernist plays, and classical ideals of beauty in the art groups 'New Academism' and 'New Seriousness', he developed his own version of new seriousness. Because of his background, art critics often concluded that Belyaev-Gintovt exaggerated his motif and aesthetic form on purpose. They viewed his praise of state power, discipline and hierarchy as ironic and parody, in the style of *styob,* that is, as mockery of the sacred status of – in this case – a past culture.[43] 'Some of his glorifications of national and Soviet myths are obviously intended as comic caricatures' is one such opinion (Noordenbros, 2011).[44] While an interpretation of Belyaev-Gintovt's intentions as a postmodern game cannot be excluded, it is worth noting that he was and continues to be politically active on the extreme right in the Eurasian Youth Union. Another analyst writes that to Belyaev-Gintovt and the Eurasian Movement, the use of elements of ambiguity, irony, play and a certain coyness are necessary techniques to achieve 'a New Seriousness and positive spirit" (Engström, 2012). Together with the philosopher Aleksander Dugin, in 1998 Belyaev-Gintovt left the National Bolshevik Party,

which Dugin had created with Eduard Limonov, to set up the Eurasian movement (the Eurasian Party by 2002). Belyaev-Gintovt became the art designer of the movement. This explains why Anatolii Osmolovskii shouted 'Shame! Fascist' at him when he received his award.

Belyaev-Gintovt was obsessed with the greatness of the state and inspired by the Soviet empire. Utterly pessimistic about the current state of Russia, he strongly believed in a future Russian 'come-back'. To him, history consists of cyclical movements downwards and upwards but in the direction of 'eternal return'. An opponent of modernization in the Western sense, he declared himself to be a proponent of a 'conservative revolution' (Semikin, 2010). As a romantic eschatological neo-classicist, to him the God Apollo symbolized the ruler – the symbol of order, discipline and beauty. His choice of form, language and themes reflected his admiration for power, the strong state and the subordinated masses. In his own words:

> The essence of the empire is the Grand Style. Looking back we find the general traits of the grand project in the Russian and Soviet great powers. The polar-paradise civilization in Soviet society took the form of the concept of 'Delayed Happiness'. The anonymous will, collectivism, selfless work for the benefit of future generations, when it is already known that the goals will not be achieved during one's lifetime. The project involves self-sacrifice and dreams. The mystery of history comes true. Everybody is included in building the empire. The creative forces of art are needed by the state, or by the state in the making – this is the Grand Style of the given territory. The classics cannot be marginalized. Classicism gives a feeling of the centre, a sense of the capital as it is located in close connection with the landscape, opening the way for city planning of sustainable development. The basic concepts of the Grand Style are – hierarchy, canon, order. The signs of the style are usefulness, durability and beauty. Apollo is with us.
>
> (Belyaev-Gintovt, 2004)

In the 'Novonovosibirsk' project of 2001 he had presented a vision of a city of Apollo as the Siberian capital of a future great Russia.[45] Novosibirsk, together with the nearby closed town of Akademgorod, was the centre of science and knowledge in Soviet times, and played an important role in the late Soviet myth of constructing the future. It also played a symbolic role for Dugin, who proposed that Novosibirsk should become the new Russian capital (Billington, 2004: 81; see also Dugin, 1999). The grandeur of the new state was expressed by Apollo, portrayed by Belyaev-Gintovt as the protector of the new Novosibirsk city, with nuclear arrows in his quiver, and gigantic buildings in neoclassical Stalinist style in the background (Romer, 2001).

In a later project, 'The Victory Parade 2937', he painted the victory parade that would take place in Moscow, the capital of the future Eurasian state, in 2937 (see Figure 3.12).[46] It symbolized the empire of victory over chaos (Engström, 2012, 2013; Poletaev, 2010). Soldiers and/or mutants with eagles' heads parade against

Figure 3.12 Aleksei Belyaev-Gintovt, 'The Victory Parade 2937' (Parad pobeda 2937) 2010

Source: Courtesy of A. Belyaev-Gintovt and Triumph Gallery.

the background of the Kremlin wall. The city centre is occupied by the Ministry of Cosmic Space, the Ministry of Truth, the Ministry of Struggle against Chaos and the Ministry of Love (Engström, 2013: 113). In 2012 he followed up on the theme of Moscow as the futuristic future capital of the empire to come.[47] Belyaev-Gintovt's art is here included among art of an 'other gaze' due to the discussion around it. He visualized a vision of the future that partly overlapped with the official Putin consensus but mainly went far beyond it. The issue of his political engagement is returned to in Chapter 6.

The vast majority of Russian artists and curators remained highly sceptical about any kind of utopia, but the theme of a failed utopia was endlessly fruitful for exhibitions. At the same time, many felt that the absence of a vision was a problem. Towards the end of the decade, curators searched for the basis for a new optimism. Against the feeling of a society trapped in a cul-de-sac, they tried to inject some optimism into the world of exhibitions. The 'I Believe' exhibition, curated by Oleg Kulik in 2007, was given the subtitle 'a project of artistic optimism'. Kulik explained that 'the time has come to look at the human being and the world around . . . with a principally new view – for contemporary art – of the human being as someone who believes in life in all its aspects'(Kulik, 2007). Olga Sviblova, the director of the Moscow Museum of Multimedia Art and curator

of the Russian Pavilion at the Art Biennale in Venice in 2007, gave the Russian exhibition the title 'Click, I Hope', in which she wanted to rebrand Russia as a country with a technically advanced future (Kravtsova, 2007). For the next Venice biennale, she chose the title 'Victory over the Future'. The title referred to the futurist opera 'Victory over the Sun', which contained premonitions of impending catastrophe and upheaval. 'Today, at the outset of the twenty-first century, society is again in crisis, paralysed more by fear of the future than by economic stagnation' (Sviblova, 2009: 10). This future she understood in terms of catastrophe, and the title 'victory over the future' was therefore to provide hope that better times were coming. The title, however, was ambiguous and the purpose of the exhibition was presented as questioning 'how the future is revealed through the past'. A year earlier, she had explained that her original idea was to juxtapose the irony of contemporary postmodernism with optimism.

In the spring of 2010 a large exhibition at the Garazh Centre for Contemporary Art once again addressed the issue of life 'among the ruins of great utopias' (Futurologia, 2010; Russian Utopias, 2010). This ambitious exhibition asked what comes next after the failure of utopia. The curators wrote: '. . . today utopia is more frequently perceived in the context of failure, and Russia has valuable historical experience in this respect'. The curators, however, wanted to address the idea of utopia from a European philosophical tradition using 'its potential for critically dissecting current reality'. Referring to Karl Mannheim, they wrote: 'the utopian mentality sees only things that do not actually exist and, therefore, utopia is inevitably critical. In this way, utopia does not limit itself to an imaginary design of a possible world, but constitutes a method of learning about today's reality and analysing it. The tension that arises between reality and the imaginary utopia makes it possible not only to show contradictions between the real and the desirable, but also to understand the boundaries of our present-day thought' (Aksenova and Volkova, 2010: 18). The exhibition was in two parts: 'Futurology: Contemporary Russian artists and the heritage of the avant-garde', by French curators, and 'Russian Utopias', by Russian curators.[48] The participating artists, however, focused on aspects of the crash of utopian illusions rather than using utopia to reflect on the boundaries of today.

The idea of using past experience not only to criticize the present but also to reflect on a desirable future was used by the Russian curator Viktor Miziano in his 2007 project 'Progressive Nostalgia', with participating artists from the countries of the former Soviet Union (Miziano, 2008: 13).[49] He described the trend for returning to the past during the 2000s and criticized the ideology of stabilization, which 'uses history to legitimize the order of things. It constructs an alternate history and an idyll by appealing to military victories and industrial statistics, to an authentic national habitus, to princes, tsars and Gengis Khan' (Miziano, 2008: 12).

Miziano contrasted this official nostalgia with an approach that sees history not as monument but as drama and utopia. He called the latter 'progressive nostalgia' and a 'strategy of resistance.' He claimed that one important consequence of such a view is that a distance is created from the here-and-now. Such a detached gaze gives art a role in questioning the ideological perceptions that had come to

dominate since the fall of the Soviet Union – for example, 'that a direct relationship exists between individualization and prosperity, the market and democracy, fullness of human life and consumption, the dismantling of the state and the flowering of culture'. This critical, detached gaze, he claimed, brought back ideas that 'identify democracy with human solidarity, the meaning of existence with intellectual exploration, culture with utopia'. A critical view of the Soviet experience, he argued, could thus link what was creative, human and valuable during the Soviet period with criticism of current society as well as reflections on the future (Miziano, 2008). 'Progressive nostalgia' was presented as an alternative to what he called the mainstream of 'commercialized culture' and its obsession with 'glamour' in today's Russia. His words are worth quoting at length:

> Why is nostalgia for the Soviet civilization so important in my project? Because now there is a certain resistance evolving against the mainstream. And this anti-glamour resistance is looking for a prehistory and a tradition; it needs some basis. Contemporary culture, which is looking for some basis, some tradition, finds it in the Soviet space because Soviet civilization rested on the very cult of innovation, on the utopian cult of a breakthrough into the future. That is why the Soviet aesthetic resource, the Soviet resistance resource inevitably becomes more and more topical for artists of both 'Leftist' and 'Rightist' political sympathies, even on the unconscious level. The void of glamour and the lack of perspectives get an alternative rebuff from the Soviet past. It is not a discussion about any reanimation of the totalitarian political system. It is a question about aesthetics. What is the object of the creative attention of contemporary artists? The mastering of spaces of non-objects, working with everyday life, private life, nonsense, crankiness and private stupidities that are difficult to convert into glamour – this aesthetical search for the unexplainable, the non-perceptible is not at all politicized but, on the contrary, is a highly intimate form of resisting glamour.
>
> (Kutlovskaya, 2008)

Nostalgia deals with the relationship between the personal and collective memory. The US-Russian scholar Svetlana Boym (2001) makes a distinction between two different kinds of nostalgia – restorative and reflective. Miziano's words are reminders of reflective nostalgia. Such nostalgia, according to Boym, can present an ethical and creative challenge because it combines a longing for the past with critical thinking.

Miziano, as the chief editor of the theoretical Russian art journal *Khudozhestvennyi zhurnal,* for more than 20 years, had a considerable following of like-minded artists. Arsenii Zhilyaev (born in 1984) worked along similar lines of thought to Miziano. He participated in the 'Russian Utopias' exhibition in 2010, exhibiting 'Time Works for Communism' (see Figure 3.13), which consisted of old, stripped furniture frames formed into words in the style of Russian constructivism.[50] His point was not to propagate communism but to emphasize a belief in a future that rested on lessons of the past. In his own words – but echoing Miziano – he

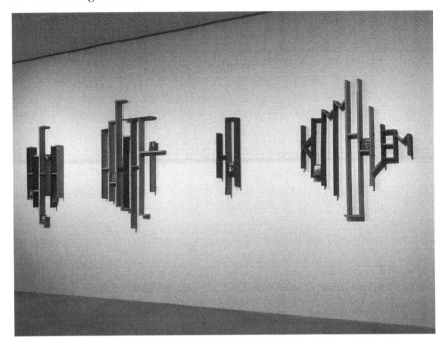

Figure 3.13 Arsenii Zhilyaev, 'Time Works for Communism' (Vremya rabotaet na kommunizm) 2010 (installation)

Source: Courtesy of A. Zhilyaev.

said: 'My works tell stories of opportunity and hope. I want to believe that this is a version of history, of the future made by past and present mistakes. . . . I think that utopia is the continuous building of the future without breaks. The way I see it, today's construction site is the daily formation of subjectivities. In fact, my project is a small sketch of this endless process' (Zhilyaev, 2010: 34).

A completely different vision of the future was reflected in the work of Gor Chakhal (born in 1961). He wanted to establish a dialogue between artists and the church in order to overcome the developing conflict between them. He wanted to join ethics and aesthetics into a single whole, and therefore sought a new language of art that could express religious feelings and belief. Such efforts were not always met with understanding by the church.[51] Chakhal participated in Gelman's 'Rossiya 2', exhibiting two objects from his project 'The Sun of Truth, Goodness and Beauty' (see Figure 3.14). The title of the project referred to the transfiguration of Christ as told in the Bible. The first object, which shared the title of the project, was a projection of the transfiguration seen from three sides. The second object, 'The Names of God' (see Figure 3.15), listed all the names of God that appear in the Bible. According to Chakhal, the project reflected 'the developing crisis of humanity in contemporary secularized society' and the knowledge that a 'kind of renaissance of culture is necessary, capable of resisting the inevitable

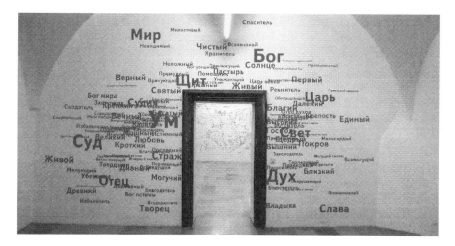

Figure 3.14 Gor Chakhal, 'The Sun of Truth, Good and Beauty' 2003 (C-print on canvas, 3 parts)

Source: Courtesy of G. Chakhal.

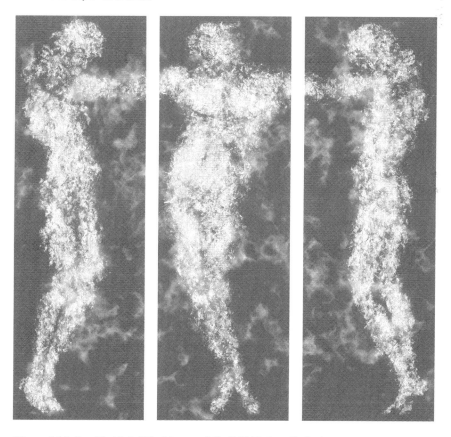

Figure 3.15 Gor Chakhal, 'The Names of God' 2003 (installation)

Source: Courtesy of G. Chakhal.

approaching non-human (post-human) global techno-civilization'. He added a warning that: 'the enemy is at the gates!' ('V istinu, Vrag u vorot!').[52] Before his personal exhibition 'Bread and Wine and Damp Mother Earth',[53] shown at the Vinzavod in 2008, he asked the Patriarchate for an endorsement. In order to obtain this, two artworks were removed (Krug, 2008). His exhibition 'Heaven's Bread' (Khleb neba) at the Tretyakov Gallery in late 2010 continued his investigation of the sacred using the language of contemporary art. This time, however, Chakhal seemed to have deviated from his original ambition, towards the tradition of religious art and the naturalist school of painting.[54]

Finally, a dystopic premonition of the future as a void, full of violence and sudden, unmotivated aggression, can be found in Aleksei Kallima's series 'Darkness Longer than Night' from 2010. It depicts fights between groups, first and foremost gangs of young men. These works could be interpreted as sketches from the artist's fantasy, from the reality outside the window of his studio, or of a premonition of unrest, instability and violence. According to Andrei Erofeev, they reflect fear of a future where 'the street decides' and various political passions seethe in the chaos of a revolution (Erofeev, 2012b).

Kallima himself explained the title of his series as 'the murk of the human soul reminiscent of the darkness that remains after sunrise' and brings unprovoked and inexplicable aggression. His paintings were not about specific situations but rather

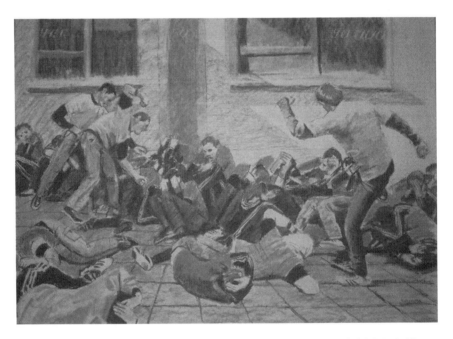

Figure 3.16 Aleksei Kallima, from the series 'Darkness Longer than Night' (Mrak dlinnee nochi) 2010

Source: Courtesy of A. Kallima.

about a state of mind where people and society exist in disharmony and aggression and enmity predominate between people.[55] As an attentive observer of the psychological mechanisms of conflicts and the manipulation of people in conflicts, Kallima gave them visual form.

Thus, fragments of different ideological, political and philosophical standpoints could be found in art related to the future of Russia. Nonetheless, the spectator could never be sure what was meant to be taken seriously and what was meant to be playful. As the processes of politicization and polarization intensified in Russian society, it became more common to read political statements into this art. In contrast to Putin's discourse on state nationalism with its emphasis on continuity, a glorious past and a promising future, art of an other gaze questioned official images of the past, present and future. The ideological void in society also gave nourishment to radical dreams and visions of a future society, some of which were reflected in the art scene.

Discourse: The nation and the 'Other'

As the Putin regime searched for an answer to the question, 'Who are we, the Russians?', contemporary art also investigated this issue. While the official consensus tried to identify a collective communitarian identity, the arts community focused on the identities of individuals.

According to Zygmunt Bauman, the search for a collective identity, 'communitarianism', becomes stronger in a fluid situation when everything seems to be in a process of accelerating 'liquefaction' (2000: 170). 'Men and women look for groups to which they can belong, certainly and forever, in a world in which all else is moving and shifting, in which nothing else is certain'.[56] In the nationalist narrative, 'belonging' is a fate rather than a chosen identity. Biological heredity and racist versions of nationalism may seem outdated but they reappear in the form of 'cultural heredity as in the presently fashionable "culturalist variant of nationalism"', he says. Thus, the '"we" of the patriotic/nationalist creed means people *like us*, and the "they" means people who are *different from us*' (Bauman, 2000:175, emphasis in original). Thus, potential differences within our group will be regarded as of no relevance in comparison to the way *they* differ from *us*. Hence, the other side of the search for a collective identity is the exclusion of everyone defined as the Other.

A collective identity cannot satisfactorily answer the question: 'Who am I?' Such was the message of the exhibition 'Identity Crisis' in 2009 (Tamruchi, 2009).[57] The curator, Natasha Tamruchi, described the ongoing process of collective identity-building as both voluntary and enforced. The trend to voluntarily identify with a collective is strong and starts with an understanding of a common historical past, cultural heritage, religious belief or something similar, she argued. A forced identification process takes place when people are involuntarily included in a collective. This happens when people by definition are excluded from one group or included in another, as some people speak in the name of a whole group. Her conclusion was that '[b]road characteristics – racial, national

or confessional – can in principle never be homogenous' (Tamruchi, 2009). Only the individual answer to the issue of identification is relevant in contemporary society.

A focus on individuals in the collective characterizes works by Olga Cherny-sheva (born in 1962). In 1999, she was the first Russian artist to make documentary video art. She was interested in the period of transition through which she was liv-ing, and focused on anonymous people she saw in sudden coincidental meetings in the street or in the Moscow metro. In the chaotic surroundings of contemporary Russian life, she watched individuals searching to find their place in the world. In the words of Viktor Miziano, she looked into the eyes of these people 'to restore the broken bonds of the world, its lost harmony, luminosity and warmth' (Miziano, 2006).[58]

Her project 'The Steamboat "Dionysius"' showed a group of Russian tourists relaxing on a river boat in northern Russia (see Figure 3.17). The atmosphere reflected the state of post-Soviet chaos and social differentiation – a quartet of young ballet dancers performed on the upper deck, while loud music was playing and people were drinking vodka from plastic mugs on the lower deck. The camera followed a couple who were looking deeply into each other's eyes, catching the gaze of the lovers and the chaos around them. Miziano explains that, according to the ontology of Chernysheva, the elements of the world are connected randomly and indirectly. Bonds are not predetermined but formed spontaneously through

Figure 3.17 Olga Chernysheva, 'The Steamboat "Dionysius"' (Teplokhod 'Dionisii') 2004 (video)

Source: Courtesy of O. Chernysheva.

efforts by the individual to by-pass obstacles. Her investigation of 'insights of the everyday' and the technique of following a gaze make her 'unique in Russian art' (Miziano, 2006).[59] As an answer to the question 'Who are we?', Chernysheva's works speak of the inclusion of everybody – beyond any snobbery or restrictions – with a focus on fellow citizens rather than the collective.

In contrast to the contemporary art scene, the traditional Russian art scene, represented by the majority of the members of the Moscow Union of Artists, was strongly influenced by the Russian nationalist discourse. Artists following such a discourse often emphasized Russianness in the choice of themes, symbols and signs, while contemporary artists were interested in playing on stereotypes (on the Russian nationalist discourse, see Chapters 5 and 8).

The Muslim as the Other was brought up early by the AES+F group playing with stereotypes in the project 'AES: Witnesses of the Future, Islamic Project', 1996–2003 (see Figure 3.18). The project aimed to illustrate the myths of Muslims as the other in perceptions among Russian and Western populations, that is, 'to visualize fears in Western and Russian society about Islam'.[60] In photomontages, mosques and minarets were inserted into well-known tourist spots in the non-Muslim world, such as Red Square in Moscow and the Statue of Liberty in New York. According to the art critic Mariya Kravtsova (2008), 'While some viewed the project as a joke, to others it was a provocation (the Islamic Project was prevented several times from being exhibited in the USA) but after 11 September

Figure 3.18 AES+F, 'Moscow Kremlin' 1996

Note: From the project 'AES: Witnesses of the Future, Islamic Project 1996–2003'
Source: Courtesy of AES+F.

2001 the project took on a new meaning and was perceived as prophetic'. The AES+F group were the most successful Russian artists internationally in the first decade of the twenty-first century.

The Muslim theme was treated differently by Aidan Salakhova, a Moscow artist of Azeri extraction, daughter of the Soviet painter Tair Salakhov and owner of the Moscow Aidan gallery. She often referred to the life of Muslim women in her art, showing them with their faces and bodies covered by a niqab while symbolically indicating situations such as childbirth, sex and violence (Ozerkov, 2010: 74–77). In her series 'Predestination' (see Figure 3.19), she told the life story of a Persian beauty from her birth, through adolescence, marriage, pregnancy, childbirth, old age and finally death.[61] From her perspective as a contemporary

Figure 3.19 Aidan Salakhova, from the series 'Predestination' 2009–2010 (oil, acrylic, canvas)

Source: Courtesy of A. Salakhova and Aidan Gallery.

Russian woman with roots in a Muslim context, Salakhova was an insider challenging taboos of what can be visualized according to Muslim tradition. The series included paintings of a phallic minaret, representing a meeting with the beloved; a white sheet, representing the traditional control of her virginity; and the scene of her labour, giving birth to a child. Aidan played on the beauty and mysticism of the 'East', but still her gaze presented the Muslim Other as an internal Other which, while distinctly different, was nonetheless part of a 'we'. Her themes and her aesthetic style integrated the 'other' through the language of contemporary art. While many artists might have experienced problems dealing with such topics, her background and status seemed to shield her from criticism from the Russian Muslim community.[62]

Moscow in the 2000s saw an inflow of migrant labour from the Russian North Caucasus as well as from Central Asia and the South Caucasus. The plight of immigrants had become a sensitive political issue that brought old prejudices and nationalist xenophobic sentiments to the fore. Most artists did not explore these themes, but one exception was Khaim Sokol. He raised the issue of the outcast in society – in this case, immigrants – treating them as a metaphor for the existence of human beings in Russian society.

Sokol had experience of being an 'other'– as a Jew born in Arkhangelsk in 1973 and while living as an immigrant in Israel, where he had moved with his parents. When he moved back to Russia in 2006, he noticed Central Asian immigrants sweeping the streets of Moscow, sweeping backyards, working on construction sites, cleaning the city and being treated as a second-rate people. To ordinary Russians, these individuals were invisible.

This realization, together with his interest in aspects of time and memory, came to influence his art. In his series 'The Foundation Pit' (Kotlovan), which was nominated for the Innovatsiya Prize in 2008 (see Figures 3.20 and 3.21), he used old zinc buckets to create the illusion of dilapidated, dirty backyards. Each bucket was a small world of its own. The title helped viewers to see his work as illustrations for a 1930 novel by Andrei Platonov of the same name. Those were the years of brutal collectivization and construction works, and Platonov's novel was a harsh criticism of the utopian dream of creating a new world, a dream that came to nothing. Sokol agreed with his work being interpreted along the lines of Platonov's novel,[63] but his objective had been to depict the conditions of life of people who were excluded from the community – the Kyrgyz, Tajik and Uzbek migrants in Moscow. Most of all, however, his works referred to human existence in general.[64]

Sokol continued working on this theme in his exhibition 'Witness', shown at the Gelman Gallery in 2011 (see Figure 3.22). By making a homeless dog the witness of life on the streets of Moscow, he made the migrant a metaphor for the 'extraordinary situation' of the outcast – an 'object of endless and complete violence'. Influenced by the Italian philosopher Giorgio Agamben, Sokol referred to power as the authority to decide over the organization and control of 'bare life' – that is, of the basic functions for the existence of life.[65] According to Agamben, the concentration camp is the manifestation of the ultimate state of exception. Sokol therefore made the concentration camp a metaphor for the situation of immigrants. Agamben's (and

Figure 3.20 Khaim Sokol, from the project 'The Foundation Pit' (Kotlovan) 2009 (installation zinc wash-tub) (the dark one)

Source: Courtesy of Kh. Sokol.

Primo Levi's) concept of a 'grey zone', where the executioner and the victim change places, was used by Sokol to show the inhabitant of the contemporary city – Moscow – who like a werewolf transforms sometimes into a homeless dog that anyone may kick and sometimes into the owner of the boot (Sokol, 2010). There was a washed-out red flag on the floor of the exhibition hall where the grey tone stood for the faded ideas of internationalism and solidarity across nations. Sokol's metaphor and engagement surprised art critics. In *Nezavisimaya gazeta* one reviewer wrote, 'The genre of social statement, unusual for the poet Sokol, turned into a not well-founded comparison' (Kurdyukova, 2011). Sokol, on the other hand, claimed that the artist must be a witness: it is the artist's obligation not only to inform, but also to provide testimony as a direct participant in life.[66]

In line with the idea that the bare life existence is a non-existence, another installation at the exhibition, 'The Hole' (see Figure 3.22), consisted of rags

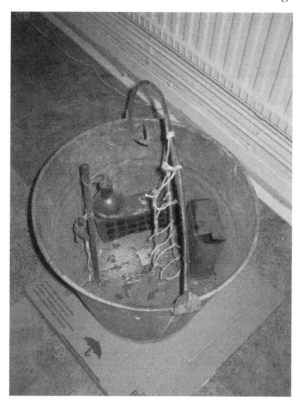

Figure 3.21 Khaim Sokol, from the project 'The Foundation Pit' (Kotlovan) 2009 (installation zinc wash-tub) (the light one)

Source: Courtesy of Kh. Sokol.

normally used for sweeping floors, stitched together. A silhouette of Russia was cut out from the middle of the stitched fabric. Sokol not only told about the life of the 'other'; he used the 'other' to highlight the conditions of 'we' as both victims and executioners.

Thus, in contrast to the evolving Putin discourse emphasizing a uniform national Russian identity, contemporary art emphasized heterogeneity and searched for a commonality that allowed difference. To the artist, the creation of a collective identity along national–ethnic lines seemed irrelevant. The concepts of 'I', 'we' and 'the other' were instead interpreted in existential terms.

For a multi-ethnic state like the Russian Federation, national ethnic criteria are dangerous, as they can help to split the nation. Ethnic concepts therefore constituted a dilemma for the official discourse and were to be avoided. Because such sentiments were rapidly growing in society, it seemed unavoidable, however, that sooner or later they would penetrate the Putin consensus.

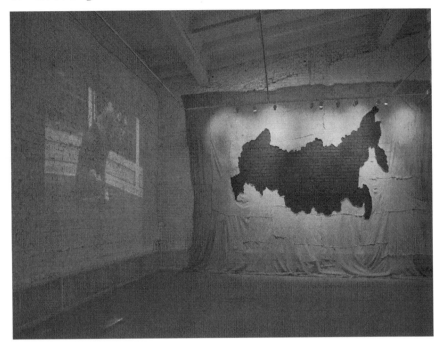

Figure 3.22 Khaim Sokol, 'The Witness' (Svidetel) 2010 (video) (left); and 'The Hole' (Dyra) 2010 (installation, cloths) (right)

Source: Courtesy of Kh. Sokol.

Discourse: A nation of orthodox believers

The position of the Russian Orthodox Church strengthened remarkably in the first decade of the twenty-first century, and the church demonstrated its ambition to make Orthodox belief the basic criterion for national identity. According to the church, Orthodoxy is the foundation of the Russian nation and state and the major element of Russian identity. This view was to a large extent encouraged by the state, although the Russian Constitution prescribes the separation of church and state. The Orthodox discourse gradually penetrated the state, which accepted many of its claims, agreed to the restitution of church property, invited senior representatives of the Patriarchate to state ceremonies, accepted Orthodox priests into the army and permitted religion to be taught in schools. All this was proof of the new, important role of the church and its dogma in the Putin consensus.

The church claimed to be the legitimate authority for the interpretation of everything associated with religion and morality. As a result, a conflict soon developed between the church and the contemporary art community. This conflict found its first expression in 1998 and 2000 but, since the accused artists fled the country and thereby avoided being put on trial, the trials of the organizers of exhibitions

in 2003 and 2007 became the first occasions for serious and direct confrontation. These cases are described in Chapter 4.

The conflict between art and the church also encouraged artists to enter into a dialogue with religion in order to bridge the gap and try to reach beyond the art world. In 2004, at the initiative of Viktor Bondarenko, a businessman and collector of icons, the artist Konstantin Khodyakov (born in 1945) exhibited his project, 'Deisis/Predstoyanie' (In the presence of God). Khodyakov constructed portraits of Russian saints by using digital images of contemporary Russians, which he manipulated and blended using computer technology. The result was a series of portraits with traits of suffering and patience carved on their faces (Kravtsova, 2004: 66–75). Archpriest Chaplin, deputy head of the Section for External Contacts at the Moscow Patriarchate, very much admired the exhibition (*Artkhronika*, 2004: 73).

If the Deisis project emphasized mysticism, so too did the exhibition 'I Believe' (Veryu), curated by Oleg Kulik. It opened at the Moscow Vinzavod in February 2007, just before the opening of the 'Forbidden Art' exhibition at the Sakharov Centre. About 60 artists had been invited to participate.[67] The exhibition was supported by the Moscow City Government and the Moscow Museum of Contemporary Art. The title of the exhibition suggested a religious aspect but with a more general spiritual meaning: 'In the project the issue is not about religious dogmas. Its focus is not on the believer, who already knows the truth, but on the sceptic seeking truth. It is about that feeling of shuddering when facing the mystery of life, a feeling akin to a religious revelation' (Kulik, 2007). According to Kulik, 'for some, the sacred-artistic and the sacred-religious seem to be absolute opposites, but for others these concepts intersect, grow into one another, and sometimes even coincide'. While some artists responded to his call in a religious way, most artists did not. What constitutes belief was a question interpreted in various ways.

While the exhibition projected a general feeling of spirituality, several made references to Orthodox discourse. As visitors entered the large, dark underground exhibition hall in the basement of Vinzavod, with its high arches and exposed, rough brick walls, they were met with an enormous picture of the feet of Christ after he had been taken down from the cross, with the open scars visible. It was an enlarged detail made by Dmitrii Gutov from the painting 'The Dead Christ' by Andrea Mantegna (1506). A second work, an installation by Anatolii Osmolovskii, 'Bread' (see Figure 3.23), consisted of large wooden pieces that seen close up seemed to be huge slices of dark Russian bread, but from a distance gave the impression of a wall of icons. The work therefore combined what are perceived as genuinely Russian symbols – the icon and bread. Osmolovskii was awarded the Kandinsky Prize in 2007.

By bringing together contemporary artists for discussions and lectures in the six months preceding the opening of the exhibition, Kulik brought spiritual and religious issues to the art scene.[68] Kulik had previously been a target of patriotic–religious criticism, most notably for his projects on animals and human beings.[69] Now, in 2007, his grand exhibition managed to satisfy the demands of the local Moscow authorities and the Patriarchate.

Figure 3.23 Anatolii Osmolovskii, 'Bread' (Khleba) 2003–2006 (wood, installation)
Source: Courtesy of A. Osmolovskii.

With the 'I Believe' exhibition, Kulik surpassed Gor Chakhal, who had for a long time seriously nourished the idea of entering into a dialogue with the church. Chakhal had also been a target of patriotic–religious criticism in 2005. His triptych 'The Sun of Truth, Good and Beauty' was not controversial in itself, but religious activists blamed him for the reading of a poem, which they considered blasphemous, in front of the painting.

Chakhal had been concerned about the schism between religion and contemporary art since the performances by Avdei Ter-Oganyan in 1998, Oleg Mavromatti in 2000 and especially the 'Beware! Religion' exhibition in 2003 (see Chapter 4), and took it on himself to try to bridge the gap (Chakal, 2010: 64–69). He met with the Vsevolod Chaplin from the Patriarchate, with Marat Gelman acting as middleman. Chakhal suggested a joint exhibition, but the church was slow to react. At about this time, Kulik announced his exhibition at Vinzavod. Since Chakhal did not like Kulik's concept, he continued with his own plans. The fact that both Kulik and Chakhal came up with the idea of an exhibition on a religious theme demonstrates the strong religious trend in society at that time.

Chakhal initiated cooperation with the deacon of a small church at the Moscow State University, the Church of the Holy Martyr Tatyana. Together, they planned an exhibition and asked the Patriarchate for permission. The Patriarchate remained neutral, not opposing the exhibition but declaring that the decision rested with the head of the specific church, who would be held responsible if the exhibition went wrong in any way.

Together, Chakhal and the deacon selected works. It was a delicate task, but they included a few works that had previously been accused of being blasphemous. The exhibition 'Dvoeslovie/Dialog' opened in May 2010.[70] Among the works were huge canvases by Dmitrii Vrubel and Viktoriya Timofeeva from their 'Evangelical Project' (2008), hyper-realistic remakes of photographs from news agencies showing human suffering caused by war, violence and poverty. These pictures were complemented by quotations from the New Testament, which gave a contrasting but deeper meaning to both the quotations and the pictures. Figure 3.24 shows 'Portrait of a Sinner', a young woman with a black eye, with the accompanying text fragment: 'Woman! Where are they? Has no one condemned you?' The text refers to an incident in the New Testament in which a woman has committed adultery. When the scribes and the Pharisees suggest stoning her, Jesus says: 'Let he who is without sin cast the first stone'. In answer, they all leave. Jesus then tells her: 'Then nor do I condemn you. Go now and leave your life of sin'.[71]

Other artists treated the religious theme in different ways. Aleksander Sigutin displayed a banner with the apocalyptic text 'Save yourself, he who can' (Spasaisya kto mozhet) in an old Church-Slavic font.[72] Konstantin Zvezdochetov

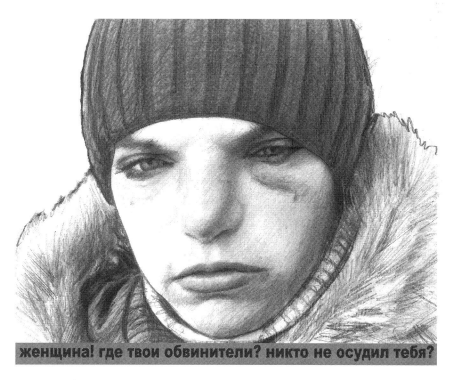

женщина! где твои обвинители? никто не осудил тебя?

Figure 3.24 Dmitrii Vrubel and Viktoriya Timofeeva, 'Portrait of a Sinner' (Portret blud-nitsy) from the series 'Evangelical Project' (2008)

Note: The text reads: 'Woman! Where are they? Has no one condemned you?'
Source: Courtesy of D. Vrubel and V. Timofeeva.

placed a model of a church on top of a pile of apples to represent the Transfiguration Feast in honour of the Holy Trinity, which takes place in August. People call it Yablochnyi spas (from the word 'apple') and bring apples as a symbol of life. Nikita Alekseev visualized the Holy Trinity in three canvases using trees to envisage the holy three; a video by the Blue Soup group showed the parting of the Dead Sea; a photograph from a 1999 action showed the cupola of the Moscow Planetarium covered with the letters 'Kh.V' (Khristos Voskres, Christ is resurrected); and finally there was Chakal's own installation, 'The names of God' (Balakhovskaya, 2010).

In spite of Chakhal's efforts to open a dialogue, the exhibition was heavily criticized by influential conservative church groups. The curators were condemned as heretics, Satanists and the Antichrist, and the exhibited works were called 'degenerate art'.[73] The deacon with whom Chakhal worked had said in a premonition of the criticism to come that both the Russian Orthodox Church and the Russian people were characterized by strong conservatism. This conservatism, he said, had helped the Orthodox Church remain intact over the centuries, but it had, on the other hand, distanced the church from new ideas. In this regard, the Russian church differed from the Western church, as the latter, he claimed, was 'more plastic, more responsive to new ideas and did not fear them' (*Newsroom*, 2010).

While Andrei Erofeev did not believe in a dialogue with the church, Gelman seemed to do so. He surprised the art community by assisting Archpriest Chaplin in early 2012, after the latter had announced he wanted to create an Orthodox Centre for Contemporary Art.[74] Conservative groups within the church were strongly against Gelman, but Gelman continued to organize exhibitions touching on religious themes.

In sum, the reaction of the arts community to the increasing influence of the church on society was not intended to be confrontational. The organizers of the 'I Believe' exhibition tried to capitalize on the growing religious influence by giving the exhibition a general spiritual theme. The 'Dialogue' exhibition was a serious attempt to bridge the gap between contemporary art and the church. These exhibitions demonstrated efforts by artists to modify the church's dogmatic interpretation of art, but their efforts were in vain. The tension between contemporary art, on the one hand, and a church supported by the state, on the other, did not disappear. Instead, it intensified and a mob of Orthodox fanatics was on the move in the shadow of the evolving church–state alliance.

Discourse: Symbols of power

Throughout the Eltsin presidency, satirical pictures and texts about the political leadership were common. The television programme 'Kukly' ('Dolls'), shown on NTV in 1994–2002, mocked Eltsin without any repercussions for its producer. With Putin it was different. The way he, his office and state symbols were depicted visually and textually gradually became highly sensitive. This made artworks portraying Putin or state symbols vulnerable. Yet, as such art was ambiguous and

carried contradictory messages, it was difficult to tell the serious and sympathetic from irony and parody.

Artists enjoyed the playfulness. Nonetheless, problems arose when the authorities interpreted a piece of art literally. This problem was illustrated in a series called 'Radical Abstractionism' by Avdei Ter-Oganyan, shown at Gelman's Rossiya 2 exhibition (see Figure 3.25). Ter-Oganyan had been forced to flee Russia in 1999, threatened with court action by religious activists. He lived in exile in Prague, but Gelman continued to exhibit his works in Moscow. Radical Abstractionism was a

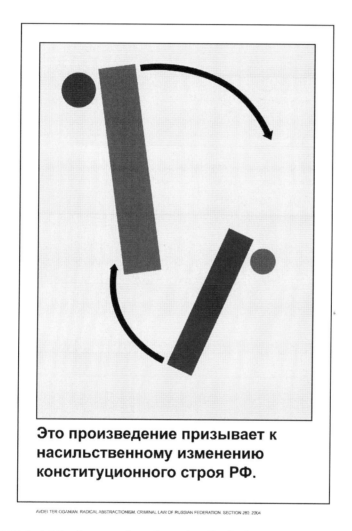

Это произведение призывает к насильственному изменению конституционного строя РФ.

AVDEI TER-OGANIAN. RADICAL ABSTRACTIONISM. CRIMINAL LAW OF RUSSIAN FEDERATION. SECTION 280. 2004

Figure 3.25 Avdei Ter-Oganyan, from the project 'Radical Abstractionism' 2004 (print on canvas)

Note: The text reads: 'This work calls for violent change of the Russian constitutional order'.
Source: Courtesy of A. Ter-Oganyan.

series of posters of geometric figures, using triangles, circles, quadrants and lines. The abstract motif was complemented by excerpts from the Russian Criminal Code. The text on each of the works told how it violated an article of the code: 'This work calls for violent change of the Russian constitutional order'; 'This work calls for hatred between religious groups'; 'This work facilitates the creation of criminal groups'; 'This work mocks the national emblem and the flag of the Russian Federation'; 'This work seeks to degrade the ethnic dignity of people of Russian and Jewish nationality'; 'This work calls for attempts on the life of V.V. Putin in order to prevent him from governmental and political activities'; and 'This work is created in order to provide aesthetic enjoyment'.[75]

The target of Ter-Oganyan's criticism was the authorities who viewed art as a criminal act. He targeted their narrow interpretation of art and illustrated how absurd a literal interpretation could be. The images on his posters had nothing to do with the accompanying texts, but instead undermined the text and thereby completely neutralized it.[76] Nonetheless, this series of works would soon suffer from a too-literal interpretation by the authorities.

The interest of artists in depicting state symbols can be interpreted as an expression of society's preoccupation with state power, which is beyond the reach of the citizens. The key state symbol in Russia is the double-headed eagle – the national emblem – holding a sceptre and an orb, with a crown on each head and a third crown above. Once a state symbol of the Byzantine empire, it was introduced to Russia by Tsar Ivan III in 1497 (Bodin, 2013).

The double-headed eagle made by Yurii Shabelnikov in 2004 was reminiscent of the national emblem but at the same time sent an ambiguous message (see Figure 3.26). It was a stuffed eagle body with two preserved eagles' heads. Against a quadrangle aluminium background from which the contours of the state regalia had been cut out and with the empty claws spread out, the eagle looked alive and as if it was about to leave the old, stiff frame. Shabelnikov later explained that his purpose had been to show how people live surrounded by myths. The eagle is a mythological creature but the myths are very much alive.[77] Whether the myth or the eagle was taking on a life of its own or the eagle was liberating itself from the stiff myth was left to the eye of the beholder.

The double-headed eagle was also found in the installation 'The Throne' by Sergei Shekhovtsov (born in 1969), who was nominated for the Kandinsky Prize in 2008 (see Figure 3.27). It consisted of a powerful and beautifully ornamented throne, sculpted in white polystyrene foam, with the eagle on the backrest. In front of the throne, light tubes created the illusion of a red carpet. On each side at the back of the throne, two surveillance cameras (in the same material) were directed towards anyone who dared to approach. Inspired by the 1982 US film 'Tron', Shekhovtsov explained that he was reflecting on the relationship between power and the crowd.[78] The first exhibition of 'The Throne' opened on the day of the presidential elections in 2008. According to the art critic Sergei Khripon, 'The symbol of power, the Tron-throne, dominates the crowd, lost in curved reflections. The unreachable, gorgeous, superhuman chair with an autonomous power supply

Figure 3.26 Yurii Shabelnikov, 'Without Title' 2005/2011 (mixed technique)
Source: Courtesy of Y. Shabelnikov and Marat Gelman Gallery.

is empty, waiting for the chosen one. Red light tubes resemble the coordinate grid of virtual reality as imagined in the classic cyberpunk movie Tron'.[79] The film contains a supposedly superhuman android, the Ruler, mastering the ascent to power in the authoritarian system.

The primary symbol of state power is of course the president, and portraits of Putin became a genre of their own.[80] In late 2004 a portrait of Putin was removed from an exhibition in St Petersburg after the City Committee on Culture intervened, claiming that the painting 'insulted the Russian people'.[81] It showed Putin in classic panegyric style, a naked torso with sheep and angels all around him, putting on the main symbol of the tsarist autocrat, 'the Cap of Monomakh' (after Vladimir Monomakh).

The portrait was made for an exhibition earlier that year in which artists reflected on the future of Russia.[82] The exhibition took place at about the time that Putin was elected for a second term. The artist, Sofiya Azarkhi, called it 'A Project for the Future of Russia: Monarchy, the Coronation of the President as Tsar' (see Figure 3.28). As she later explained, she felt that the atmosphere in society was politically and aesthetically changing in a direction reminiscent of the time of Alexander III (1881–1894)—that is, of reactionary restoration. She visualized

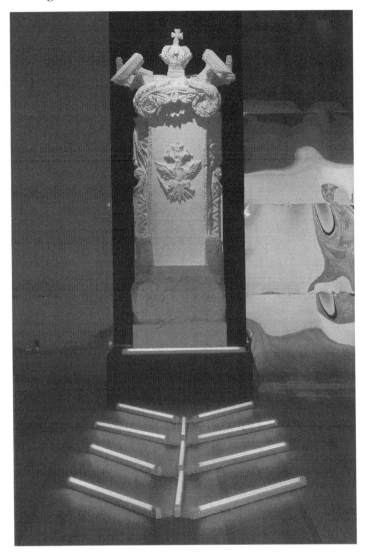

Figure 3.27 Sergei Shekhovtsov, 'The Throne' (Tron) 2007 (installation)
Source: Courtesy of S. Shekhovtsov.

her prognosis of Russia's future in a photo collage of mixed techniques, using the composition of Raphael's 'Sistine Madonna'. Adding a snake and a sheep to the composition, she made Putin not only the victor over all enemies but also the good shepherd. Over one of the sheep she wrote 'self-portrait', as the old masters used to do. A journalist from the St Petersburg section of *Novaya gazeta* commented that it was hard to tell whether presenting Putin as a half-naked antique hero 'was a joke or a serious act' (Ivanov, 2005). When, six years later, Azarkhi offered to gift

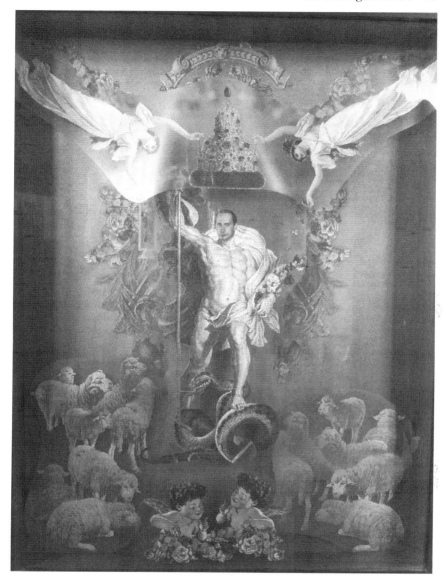

Figure 3.28 Sofiya Azarkhi, 'A Project for the Future of Russia: Monarchy, the Coronation of the President as Tsar' 2004 (mixed technique)

Source: Courtesy of S. Azarkhi.

this piece to the Museum of Political History, the staff declined, asking in surprise: 'You made this in 2004? Weren't you afraid?'[83] The times were rapidly changing.

Putin was immediately recognizable in the portrait 'Putkin', made in 2004 by Konstantin Latyshev (born in 1966). Playing with the classical slogan 'Pushkin

is Our Everything' (see Figure 3.29) and referring to a famous nineteenth century portrait of Pushkin, Latyshev replaced Pushkin's face with that of Putin. Just as Pushkin was presented as the first among Russian poets, Putin was now the first of his kind of Russian leaders. Like the work by Azarkhi, Latyshev's work was ambiguous. He named his style 'ironic conceptualism' and claimed that 'all jokes stem from paradise'.[84] Latyshev had been a member of the performance group 'Champions of the World' in the late 1980s and early 1990s. This work, however, did not escape the eye of the authorities. In May 2007, 'Putkin' was confiscated by the Russian customs authorities on its way to an exhibition in Dresden (Golynko-Volfson, 2008). It was claimed that the painting 'contributed to international criticism' of Russia.[85]

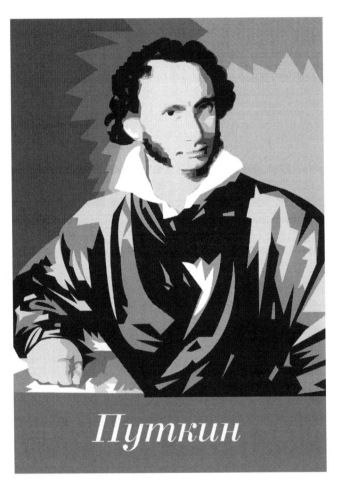

Figure 3.29 Konstantin Latyshev, 'Putkin' 2004 (C-print on vinyl)
Source: Courtesy of K. Latyshev.

In contrast, the portraits by Dmitrii Vrubel and Viktoriya Timofeeva at first appeared neutral in the way they depicted Putin in a highly photo-realistic way.[86] When the portraits were exhibited separately, they created the impression that they were made by loyal court artists. However, when several Putin portraits were exhibited together, they became unctuous and bordered on parody and *styob*. When exhibited with portraits of other well-known people from news reports of the time, such as the jailed businessman Mikhail Khodarkovsky and the former KGB spy Aleksander Litvinenko dying in his hospital bed in London, they became a testimony of their time. Vrubel and Timofeeva were nominated for the Kandinsky Prize in 2007.[87]

Conclusions

An 'other gaze' was developing on the dynamic Moscow contemporary art scene of the early 2000s. Famous art galleries favoured such art with new approaches and perspectives. So did the juries of the Innovatsiya and Kandinsky Prizes. The depiction of the art scene as glamorous, mainstream and conformist was obviously not the whole story. When Iosif Bakshtein said that 'contemporary art is a sphere of freedom', he put his finger on a characteristic that also partly explains why art exhibitions and activities at galleries and art centres became so attractive to young people. Websites reporting on contemporary art raised the level of interest in art. The Internet informed people about the what, where and when of the various art events taking place. Among these sites, *Open Space* (2008–2012) played a central role. *Grani* (since 2000), the website of the monthly journal *Artkhronika*, should also be mentioned – especially after 2006 – and of course the trendy magazines *Afisha* and *Time Out*. By 2010 the Moscow arts community was also using Facebook to disseminate information, analysis and debate.

The works of art described in this chapter were not political in the sense of portraying a political position, but political in Rancière's meaning – they reflected dissensus in relation to the official consensus. Although this art can be interpreted in more than one way, it differed from the established view and the mainstream. While the central task of the official consensus was to form a collective 'we' that could unite citizens and create a feeling of belonging, the artists of an 'other gaze' questioned the official consensus on state nationalism and its views on the past, present and future of the state and society. They looked at the issue of 'Who are we, the Russians?' differently and rejected simplified identification along ethnic or religious lines. Instead, they emphasized the identity of individuals and looked for common denominators in the Other's individuality and heterogeneity. Bauman described such an approach as an opportunity: 'people may belong together while staying attached to their differences, cherishing and cultivating them'. He concluded that 'their togetherness, far from requiring similarity or promoting it as the value to be coveted and pursued, actually benefits from the variety of lifestyles, ideals and knowledge while adding more strength and substance to what makes them what they are – and that means, to what makes them different' (Bauman, 2000: 177).

Breaking up major narratives, questioning established truths, relativizing what previously were considered absolute values and playing with the surface, symbols and signs had all become part of a general trend in global postmodernist art. In the local Russian context of authoritarian developments, such approaches and activities could be full of meanings. Against the background of the state's and the church's efforts to formulate a new conservative consensus, even the subtle protest of the art of an 'other gaze' had a mind-liberating effect.

These artists looked for the extraordinary but questioned the attraction to glamour; they referred to the past but did not fall into the trap of praising it; they touched on religious themes but reacted against the quest for supremacy by the church; they delved into all that is Russian but opposed declarations on a single Russian identity; and they kept their distance from the state and its leader.

Notes

1 The Rossiya 2 exhibition, 18 January–15 February 2005 at the Central House of Artists (TseDeKha), Moscow. The exhibition was later shown in the USA in parallel with the official Russian exhibition, '1000 years of Russian art'. A catalogue was published in English for the New York exhibition, 8 December 2005–11 January 2006 (Russia 2, 2005). See also Molok (2005).
2 He became the deputy director of Channel 2 television in 2002.
3 Marat Gelman (2005) tells about the exhibition.
4 'Two Again', interview by Vladimir Papernyi in the magazine *Bolshoi gorod*, reprinted in *Russia 2* (2005).
5 Papernyi told Gelman: 'As the author of the term "Culture 2" I have an objection. Culture 2 is a consolidation, a stop, a look at the past, a hierarchy, a sacralization of borders, everything that is typical of Russia 1 in your description'. Gelman answered: 'You understand that your book just gave us the impetus. We are living in a different context. You were like a spy for the international culture inside this Culture 2. But for us now it is a gesture of self-preservation. Russia 2 will be a summons for Russia 1. But they will not swap places. Culture 2 was Soviet culture. But it is worth recognizing that Putin's Russia is Russia 1'. 'Two Again', in *Russia 2* (note 1).
6 'Marat Guelman on Russia 2: Starting point', *Russia 2* (note 1).
7 'Marat Guelman on Russia 2: Art of the Possible', *Russia 2* (note 1).
8 The following artists participated in the Moscow exhibition: AES, Viktor Alimpiev, Petr Belyi, Sergei Bratkov, Aleksander Brodskii, Petr Bystrov, Aleksander Vinogradov + Vladimir Dubossarsky, Dmitrii Gutov, Aleksei Kallima, Marina Koldovskaya, Aleksander Kosolapov, Valerii Koshlyakov, Oleg Kulik, Tatyana Liberman, Anton Litvin, Maksim Mamsikov, Miroslav Nemirov, Icing Architects, Avdei Ter-Oganyan, Gosha Ostretsov, 'Osten-gruppe' and Khorovskii, PG group, Blue Noses, Blue Soup, Andrei Filippov, Vasily Tsagolov, Gor Chakhal, Yurii Shabelnikov, Aleksei Shulgin. There were performances by Dmitrii Prigov, among others. See www.guelman.ru/gallery/moscow/russia2.
9 'Moskovskii soyuz khudozhnikov vynashival obidu 9 mesyatsev', Gif 8 November 2005, www.gif.ru/themes/society/isk-mosha; '"Rossiya 2", Galereya Gelmana i TsDeKha vyigrali sud', 1 February 2006, www.gif.ru/themes/society/sud-finished.
10 Author's interview with Marat Gelman, Moscow, April 2013.
11 See the joint catalogue of the two exhibitions: *Endi Uorkhol: khudozhnik sovremennoi zhizni* (Andy Warhol: an artist of contemporary life)/*Russkii pop-art* (Russian Pop-Art)

(2005), catalogue prepared for the exhibitions at the Tretyakov Gallery, Moscow, 13 September–13 November.

12 Kosolapov's work was, however, included in the exhibition catalogue.

13 See the exhibition catalogue of *Sots-art: Politicheskoe iskusstvo v Rossii* (2007) at the Tretyakov gallery at Krymskii val, Moscow, 2 March–1 April 2007.

14 Brodskii participated in more than 50 architecture exhibitions and exhibitions of visual art. He won awards in international contests such as 'Cristal Palace' (Japan 1982) and the Grand Prix exhibition of contemporary European art (Milan, 2001).

15 Alexander Rapoport wrote in 1990 about etchings by Brodskii and Ilya Utkin: 'Their etchings retain the gloomy characteristics of all previous historical periods, the fruits of senseless efforts to create something which comes out of the framework of simple human needs. . . . The fundamental archetype of utopian fantasies which crowns the biblical allusions to these prophecies is the Tower of Babel. Although destroyed millennia ago, this construction continues to disturb the human spirit and its rivalry with the sky.'

16 See the catalogue prepared for the exhibition *Russkoe bednoe* (Russian Poor Art) in Perm, 2008 and Moscow, 2009, pp. 36–37.

17 Aleksander Brodskii's exhibition 'Noch pered nastupleniem' (The Night before the Attack) took place on 26 September–25 October 2009 in the large hall of the wine store at the Vinzavod Art Centre. See www.gif.ru/afisha/2009–09–24–3moscowbiennale/brodsky/view_print/.

18 *Kandinsky Prize 2010: Exhibition of the Nominees.* Moscow, 17 September–13 October.

19 He was awarded the Innovatsiya Prize in 2012 for 'The Cistern' (*Open Space*, 2012; Kabanova, 2012).

20 The group consisted of Daniil Lebedev (born 1974), Aleksei Dobrov (born 1975), Aleksander Lobanov (born 1975) and Valeriya Patkonen.

21 The Blue Soup, 'The Black River', 2003, Lightbox, 85 x 300 cm.

22 About this project by the Sinii sup, see 'Sinii sup, Eshelon', http://xlgallery.artinfo.ru/authors?vid=22&theme=works&id=78; 'Bluesoup, Echelon', *Urban Formalism* (2007), Catalogue prepared for the exhibition at Moscow Museum of Modern Art, Ermolaevskii pereulok, that opened 28 February 2007, p. 29.

23 *Urban Formalism* (2007), 'Interview with Blue Soup members Aleksei Dobrov, Daniil Levedev, Aleksandr Lobanov', 14 November 2006, Moscow, p. 32.

24 See Sinii sup, Innovatsiya 2007, www.ncca.ru/colitem?filial=2&id=1084&aid=475.

25 'Sinii sup: Metel', press release, 26 September 2009, www.homepage.ru/events/233527-siniy-sup-metel.

26 Kuzkin's performance is available at www.open-gallery.ru/text/artists?pid=10&version=RU.

27 Andrei Kuzkin, 'Alone, or Secret Life' (Odin, ili tainaya zhizn), *Kandinsky Prize* 2010, Exhibition of Nominees. Moscow, pp. 112–13. Nominated for the Kandinsky Prize in 2010, he exhibited a vacuum-sealed metallic cube from within which the artist struggled, tossed and cried.

28 Interview with Irina Korina, Moscow (*Urban Formalism*, 2007: 36).

29 Author's interview with Diana Machulina, Moscow, April 2012.

30 Compare Erasmus (2003). Machulina finds similarities in the apocalyptic descriptions of Erasmus and the environment of the contemporary Russian city.

31 The following artists and art collectives participated in the exhibition in Perm: AES, Yurii Albert, Vladimir Anzelm, Vladimir Arkhipov, Andrei Basanets, Petr Belyi, Aleksander Brodskii, Sergei Volkov, Sergei Gorshkov, Dmitrii Gutov, Anya Zhelud, Zhanna Kadyrova, Aleksei Kallima, Vladimir Kozin, Irina Korina, Aleksander Kosolapov, Valeryi Koshlyakov, Anton Litvin, Igor Makarevich, Pavel Makov, Maksim Mamsikov, Anatolii Osmolovskii, Nikolai Polisskii, Vlata Ponirovskaya, Recycle (Vlokhin and

Kuznetsov), Aleksander Sigutin, Sinie nosy, Leonid Sokov, Khaim Sokol, Vitas Sta-syunas, Avdei Ter-Oganyan, Ilya Trushevskii, Olga and Aleksander Florenskii, Yurii Khorovskii, Yurii Shabelnikov and Sergei Shekhovtsov.

32 Among them were Nikolai Polisskii, Aleksander Brodskii, Yurii Albert, Dmitrii Gutov, Anatolii Osmolovskii, Petr Belyi, Vladimir Arkhipov, Sinie nosy, Irina Korina and Anya Zhelud.

33 Among them were the Sots-Art artists Komar and Melamid, who painted 'ruins' of old Greek buildings as well as the 'future ruins' of the Soviet Union (Thomas, 2009).

34 Ivan Bunin's novel *Dark Alleys* (or *Dark Avenues*/Temnye allei) was written in 1937–44.

35 According to Amirsadekh (2011), Koshlyakov deals with 'unpacking the baggage of a collective and individual memory locked away in cultural icons dotted throughout history, he unlocks and releases these icons back into the social consciousness with a powerful new energy'.

36 On Koshlyakov see *Russkoe Bednoe*, Perm, September 2008, www.bednoe.ru/koshlyakov.html. See also the interview in *Artkhronika* (2007: 78–83).

37 Author's interview with Aleksei Kallima, Moscow, 9 April 2013.

38 The perspective from above, of bodies in motion, was a challenge for Kallima, who sees drawing as a 'bridge', in the professional sense, between realist painting and the use of minimal means to achieve maximum expressiveness.

39 On Kulik see Evgenii Mitta's documentary film 'Oleg Kulik: Vyzov i provokatsiya' (2008).

40 The speech took place more than a week after the attack.

41 'Kogda Stalin skazal "bratya i sestry"', www.ntv.ru/novosti/158825.

42 Presentation of the artist by Maya Kononenko in *Kandinsky Prize: Exhibition of Nominees*. 2008 Catalogue, Moscow, pp. 14–15.

43 Compare the definition by Birgit Beumers (2005: 245). *Styob* is mockery and profanity but also a remake where the author plays a game with the public and creates a new myth based on the sacred status of a past culture.

44 He continues: '. . . while other paintings appear to be serious improvizations in a Socialist Realist style'.

45 Project with Andrei Molodkin and Gleb Kosorukov.

46 'The Victory Parade 2937' exhibition took place at the Triumph Gallery in Moscow in May–June 2010.

47 The exhibition '55¤ 45′ 20.83′′ N, 37¤ 37¤ 03.48′′ E' took place at the Triumph Gallery in Moscow on 31 March–15 April 2012.

48 'Russian Utopias', curated by Yulia Aksenova and Tatyana Volkova. Participating artists: Yurii Avvakumov, Kirill Ass and Anna Ratafeva, Vyacheslav Akhunov, Aleksei Buldakov, Dmitrii Gutov, Arsenii Zhilyaev, Inspection Medicine Hermeneutique Group, Ilya Korobkov, Valerii Koshlyakov, Where the Dogs Run Group, Andrei Kuzkin, Igor Makarevich and Elena Elagina, Boris Orlov, Nikolai Polisskii, Dmitrii Prigov, Sinie nosy, Khaim Sokol, Avdei Ter-Oganyan, Stas Shuripa. 'Futurologiya': curated by Herve Mikaeloff and Pierre Lefort. Participating artists: Sergei Bugaev, Petr Belyi, Irina Korina, Andrei Molodkin, Pavel Peppershtein, Olga Chernysheva, Electroboutique, Victor Alimpiev, Sergei Bratkov, Ilya Gaponov and Kirill Koteshov, Olga Kisseleva, Diana Machulina, Ivan Plyushch, Recycle Group and Aidan Salakhova.

49 'Progressive Nostalgia' was exhibited in several European cities. The Russian-English exhibition catalogue was printed in Russia. The participating artists born in Russia were: Vladimir Kupriyanov, Olga Chernysheva, Maksim Karakulov, Aleksei Buldakov, Irina Korina, Nikolai Oleinikov, Vasilii Tsagolov, Sergei Bratkov, Dmitrii Prigov, Georgii Pervov, Stanislav Shuripa, Vadim Fishkin, Petr Bystrov, Yurii Albert, Valerii Chtak, David Ter-Oganyan, Aleksandra Galkina, Anatolii Osmolovskii, Viktor Alimpiev, Dmitrii Gutov, Leonid Tishkov, Kerim Ragimov, Vladimir Arkhipov, Evgenii Fiks, Elena Kovylina, the group Chto delat, Gloklya & Tsaplya and Olga Kiseleva.

50 He was awarded the Innovatsiya Prize for his work 'Reasonable Egoism' (Razumnyi egoism) in April 2011.
51 For more on these efforts and the conflict with the church, see below and Chapter 4.
52 Chakhal, Gor, 'Solntse pravdy, dobra i krasoty' (no date), www.chahal.ru/data/texts/tsun_of_truthr.htm.
53 'Khleb i vino i Mat-Syra-Zemlya'. Damp Mother Earth (Mat-Syra-Zemlya) is considered the oldest deity in Slavic mythology.
54 Compare the analysis by Aleksei Lidov, available at www.taday.ru/text/632049.html. He concluded that Chakhal's exhibition was 'a direct continuation of the tradition of Russian religious art'. For a presentation of the exhibition, see the article 'Gor Chakhal "Khleb neba"', vystavka v Tretyakovskoi galeree, 17 sentyabrya 2010–30 yanvarya 2011', *Ezhednevnye novosti iskusstva*, September, www.artinfo.ru/RU/news/main/Chahal-GTG-2010.htm.
55 Author's interview with Aleksei Kallima, Moscow, 9 April 2013.
56 Bauman (2000: 175–176); Bauman is quoting Hobsbawm (1996: 40) that 'just as community collapses, identity is invented'; see also Bauman (2004).
57 Tamruchi, Natasha, 'Introduction', catalogue prepared for the exhibition 'Krizis samoidentifikatsii' ('Identity Crisis'), Otkrytaya gallereya, Moscow, 30 June–31 July 2009. Texts were written by Natasha Tamruchi, Lev Rubinshtein, Khaim Sokol and Ilya Kukulin. The contributing artists were Yurii Albert, Andrei Kuzkin, Igor Makarevich, Vlad Monroe, Khaim Sokol, Vera Khlebnikova and Maria Chuikova.
58 See also the analyses by Keti Chukhrov (2005–2007) and by Kirill Svetlyakov (2005–2007).
59 See the interesting discussion on Steamboat 'Dionysius' at Cine Fantom, "10 videorabot Olgi Chernysheva"', 3 May 2006, www.cinefantomclub.ru/znamenitye-obsuzhdeniya/613–10-videorabot-olgy-chernyshevoj.html. An analysis of her work can also be found in Svetlyakov, 2009.
60 The homepage of AES+F is www.aesf-group.org/index.php?PHPSESSID=0azitf2ROZ-DiIoqz94f,1&action=cats;cat_id=1;sub_cat_id=1.
61 For an analysis of the project, see Mariya Kravtsova at www.aidans.ru/works/jivopis/prednaznachenie.
62 At the Venice Biennale in 2011, Aidan was part of the Azerbaijan pavilion. She had to remove some of her works before the President of Azerbaijan visited the pavilion, to avoid upsetting the president.
63 See the presentation by Khaim Sokol in the catalogue of the 2010 exhibition 'Russkie utopii' (Russian Utopias), Garazh Center for Contemporary Culture, 2010, pp. 56–57.
64 Author's interview with Khaim Sokol, Moscow, September 2011.
65 Introductory sheet written by Khaim Sokol for the exhibition 'Witness', Gallery Gelman, Moscow, August–September 2011.
66 Author's interview with Khaim Sokol, Moscow, April 2012.
67 None of the artists who participated in the scandalous exhibition at the Sakharov Centre in 2003 was invited (Degot and Riff, 2012).
68 Discussions between and the reflections of the artists participating in the exhibition 'I Believe' are collected in *XENIA, ili Posledovatelnyi protsess* (2007).
69 See the presentation of his projects in Bredikhina et al. (eds.), 2007.
70 Press release, 'Dvoeslovie/Dialog', 24 May 2010, http://chahal.livejournal/com/357635.html.
71 John 8:10 quoted in the exhibition catalogue *Evangelskii proekt. Dmitrii Vrubel, Viktoriya Timofeeva*, 2009.
72 This can also be interpreted as 'Every man for himself and the devil take the hindmost'.
73 Archpriest Aleksander Shargunov directed harsh criticism against the exhibition (Shargunov, 2010). See also Andrei Erofeev (2010), who refers to the words of the Orthodox critics.
74 See, for example, Degot (2012).

75 Avdei Ter-Oganyan, Radical Abstractionism, 2004, Series of 14 works. Print on canvas.
76 He said later that the series had 'a purely political meaning' for him, referring to the criminal action brought against him on charges of stirring up religious enmity during his performance in 1998. Interview by Denis Mustafin with Avdei Ter-Oganyan, Vimeo, 2010, http://vimeo.com/10267185.
77 Author's interview with Yurii Shabelnikov, Moscow, April 2013. The first version of the eagle was made for the Rossiya 2 exhibition in 2005 and a second version for the Rodina exhibition in 2011 (see Chapter 8).
78 Sergei Shekhovtsov, 'Tron' (installatsiya), 2–23 March 2008, XL Gallery, http://xlgallery.artinfo.ru/past.exhibitions?lang=RU&id=161. The film 'Tron' was made in 1982 by the US director Steven Lisberger. In the film a computer programmer is transported inside the software world of a mainframe computer, where he interacts with various programs in his attempts to get out.
79 Presentation of Sergei Shekhovtsov by Sergei Khripun in the catalogue for *Kandinsky Prize 2007*. Exhibition of the Nominees (7–27 November) (Moscow: Vinzavod Contemporary Art Center, Moscow), pp. 34–37.
80 Among the artists portraying Putin were Dmitrii Vrubel and Viktoriya Timofeeva, Nikas Safronov and Zurab Tsereteli (see also Goscilo, 2011: 29–55).
81 The work by Sofiya Azarkhi 'Venchanie prezidenta na tsarstvo' (Dyakonov, 2007: 95).
82 Exhibition 'Reflections on the Motherland' ('Duma o rodine') at the Anna Akhmatova Museum, St Petersburg, 30 April–31 May 2004. See Tolstova (2004).
83 Sofiya Azarkhi, personal communication with the author, May 2013.
84 Interview with Konstantin Latyshev (*Artkhronika*, 2008: 78–83).
85 'Tamozhniki postigli azy iskusstvovedcheskoi tsenzury', 23 May 2007, www.gif.ru/themes/society/46541c823d875. The Customs confiscated the works and sent them to the Procurator's Office on suspicion that they 'insulted third persons'. The following day an unidentified gang stormed the Gelman Gallery, injuring him and destroying his office.
86 They made calendars: 'The President's Twelve Moods' (2001) and 'Putin and the Black Square' (2002). For an analysis, see White and McAllister (2003: 383–99).
87 *Kandinsky Prize 2007*, Exhibition of the Nominees (2007, 7–27 November) (Moscow: Vinzavod Contemporary Art Centre), pp. 34–37.

References

Aksenova, Yulia and Volkova, Tatiana (2010), 'Tributes: On the Ruins of Great Utopias' in *Russian Utopias* [catalogue prepared for the exhibition 'Russian Utopias, 5 March–23 May 2010] (Moscow: Garazh Center for Contemporary Culture), pp. 18–19.

Amirsadekh, Hossein (ed.) (2011), *Frozen Dreams: Contemporary Art from Russia* (London: Thames & Hudson).

Artkhronika (2004), 'Proekt "Deisis/Predstoyanie" kommentiruet dlya "Artkhronika" protoierei Vsevolod (Chaplin)', 4: 73. (Chaplin was the deputy head of the Section for external church contacts of the Moscow Patriarchate).

Artkhronika (2007), 'Valerii Koshlyakov: "Ya oboznachayu tyagu k vechnomu idealu"' 6: 78–83.

Artkhronika (2008), 'Konstantin Latyshev: "Ya kartinshchik, rabotayu s galereishchikom"' 6: 78–83.

Artkhronika (2010), 'Aleksander Brodskii: Lyubuyu iz moikh skulptur mozhno razmochit, i vyletit iz nee chto-to drugoe' (interview with Aleksander Brodskii) 12: 46–53.

Balakhovskaya, Faina (2008), 'Bednoe: no nashe', *Vedomosti*, 30 September, www.gif.ru/themes/culture/russian-poor/bednoe-no-ne-nashe.

Balakhovskaya, Faina (2010), 'Vysokie otnosheniya: Sovremennoe iskusstvo na doroge k khramu', *Vremya novostei*, 3 June, www.vremya.ru/2010/95/10/255079.html.

Bauman, Zygmunt (2000), *Liquid Modernity* (Cambridge: Polity Press).

Bauman, Zygmunt (2004), *Identity* (Cambridge, UK and Malden, Mass.: Polity).

Belyaev-Gintovt, Aleksei (2004), 'My. Oni nemy', *Khudozhestvennyi zhurnal* 54, http://xz.gif.ru/numbers/54/my-oni-nemy.

Beumers, Birgit (2005), *Pop Culture Russia!* (Santa Barbara, Calif.: ABC Clio).

Billington, James H. (2004), *Russia in Search of Itself* (Washington, D.C.: Woodrow Wilson Center).

Bodin, Per-Arne (2013), 'Dubbelörnen i det postsovjetiska Ryssland. Gamla traditioner och dubbla budskap', in *Kungl. Vitterhets-, Historie- och Antikvitets Akademiens Årbok 2013* (Stockholm:KVHAA), www.vitterhetsakad.se/ckreditor_assets/attachments/248/8_kvhaa2013_bodin.pdf.

Boime, Albert (2004), *Art in an Age of Counterrevolution, 1815–1848* (London and Chicago: University of Chicago Press).

Boym, Svetlana (2001), 'Nostalgia', in *Atlas of Transformation,* http://monumenttotransformation.org/atlas-of-transformation/html/n/nostalgia/nostalgia-svetlana-boym.html.

Chakal, Gor (2010), 'Est massa sluchaev mirotocheniya tipografski razmnozhennykh reproduktsii ikon', *Artkhronika* 4: 64–69.

Chukhrov, Keti (2005–2007), 'Art and Its Thresholds', *Khudozhestvennyi zhurnal, 2005–2007* (English Digest), http://xz.gif.ru/numbers/digest-2005–2007/art-and-its-thresholds.

Degot, Ekaterina (2012), 'Gelman i Chaplin: novyi alyans?', *Open Space*, 21 March, www.openspace.ru/art/events/details/35307.

Degot, Ekaterina and Riff, David (2012), 'Ot krizisa do krizisa: glavnoe', *Open Space*, 25 December, www.openspace.ru/art/projects/132/details/7072.

Dugin, Aleksander (1999), *Osnovy geopolitiki: Geopoliticheskoe budushchee Rossii. Myslit prostranstvom* (Moscow: Arktogeya-tsentr).

Dyakonov, Valentin (2007), 'Klevetniki Rossii', *Artkhronika* 11: 95.

Engström, Maria (2012), 'Forbidden Dandyism: Imperial Aesthetics in Contemporary Russia', in Peter McNeil and Louise Wallenberg (eds.), *Nordic Fashion Studies* (Stockholm: Axl Books), pp. 179–99.

Engström, Maria (2013), 'Military Dandyism, Cosmism and Eurasian Imper-Art', in Birgit Bumers (ed.), *Russia's New Fin de Siècle: Contemporary Culture between Past and Present* (Bristol and Chicago: Intellect), pp. 99–118.

Erasmus, Desiderius (2003), *In Praise of Folly, 1511* (New York: Dover Publications).

Erofeev, Andrei (2010), "Chada nerazumnye", *Artkhronika* 7/8: 20–21.

Erofeev, Andrei (2011a), 'Krizisnyi etalon', Artkhronika 11: 24–25. Reposted as 'Brodskii kak etalon', 20 March, www.aerofeev.ru/content/view/293/1.

Erofeev, Andrei (2011b), 'Triumf plokhoi veshchi', *Artkhronika* 6–7: 18–19. Reposted on art-novosibirsk.ru/applications/articles/articles.php?id=8.

Erofeev, Andrei (2012a), 'Khudozhniki i revolyutsiya', 15 March, www.aerofeev.ru/index.php?option=com_content&view=article&id=311:khudozhniki-i-revolyutsiya&catid=3&Itemid=72.

Erofeev, Andrei (2012b), 'Poiski poryadka v besporyadke', *Artkhronika*, 4 June, www.artchronika.ru/kolonki/order-in-disorder.

Evangelskii proekt: Dmitrii Vrubel, Viktoriya Timofeeva [exhibition catalogue] (Perm: Perm Museum of Contemporary Art).

FitzGerald, Nora (2005), 'The Rebirth of Discontent', *Financial Times*, 8 February, www.ft.com/intl/cms/s/0/232f2e0a-7976-11d9-89c5-00000e2511c8.html/.

Futurologia: Contemporary Russian Artists and the Heritage of the Avant-Garde (2010), exhibition catalogue (Moskva: Garazh Center for Contemporary Culture).

Marat Gelman (2005), 'Marat Gelman o "Rossii 2" ', *Zhurnal-katalog Rossii 2,* 19 January, www.gif.ru/themes/culture/russia-2/marat-text.

Gelman, Marat (2008), 'Iskusstvu krizis ne pomekha' (interview with Marat Gelman), *Chastnyi korrespondent,* 20 November, www.chaskor.ru/article/marat_gelman_ iskusstvu_krizis_ne_pomeha_1215.

Golovanova, Olga (ed.) (2009), *Group Art or Death, 1987–1990,* catalogue prepared for the exhibition 'Group Art or Death', State Museum of Contemporary Art of Russian Academy of Fine Arts, Moscow.

Golynko-Volfson, Dmitrii (2008), 'Potselui militsionera: est li v Rossii (bio)politicheskogo tsenzura?', *Neprikosnovennyi zapas* 57(1), www.nlobooks.ru/sites/default/files/old/ nlobooks.ru/rus/nz-online/619/828/843/index.html.

Goscilo, Helena (2010), 'The Ultimate Celebrity: VVP as VIP Objet d'Art', in Helena Goscilo and Vlad Strukov (eds.), *Celebrity and Glamour in Contemporary Russia. Shocking Chic* (London and New York: Routledge), pp. 29–55.

Hobsbawm, Eric (1996), 'The Cult of Identity Politics', *New Left Review* 217 (May–June), http://newleftreview.org/I/217/eric-hobsbawm-identity-politics-and-the-left.

'I Believe: A Project of Artistic Optimism' (2007), catalogue prepared for the exhibition 'I Believe', Vinzavod Art Centre, Moscow City Committee for Culture and Moscow Museum of Modern Art, Moscow.

Innovatsiya. All-Russian Contemporary Visual Art Competition. Nominees (2005, 2006, 2007, 2008, 2009, 2010, 2011, 2012), exhibition catalogues (Moscow: National Centre for Contemporary Art).

Ivanov, Andrei (2005), 'Putina venchali na tsarstvo v Piterskom Manezhe. Putiniana v iskusstve mozhet zatmit leninianu', *Novaya gazeta,* 5 May, www.novayagazeta.spb. ru/2005/03/5.

Kabanova, Olga (2012), 'Vruchenie "Innovatsiya": Aleksander Brodskii poluchil glavnyi priz', *Vedomosti,* 5 April, www.vedomosti.ru/lifestyle/news/1605825/opyat_brodskij.

Kandinsky Prize Catalogue: Exhibition of the Nominees (2007, 2008, 2009, 2010, 2011, 2012, 2013) (Moscow: Artchronika).

Khachaturov, Sergei (2007), *Phantom Fact: 15 G Guelman,* catalogue prepared for the 15th anniversary of the Gelman Gallery and the Jubilee Exhibition at the Marble Palace of the State Russian Museum, Moscow, pp. 452–57.

Kholmogorov, Egor (2008), 'Premiya Kandinskogo. Rodina-doch', published on the website of Belyaev-Gintovt, www.doctrine.ru/zavtra/kandinsky/008.

Kommersant Vlast (2007), 'Etim lyudyam naplevat na iskusstvo', 10 December, www. kommersant.ru/doc/834133.

Korina, Irina (2011), 'Show Process', in *Innovatsiya 2010: VI All-Russian Contemporary Visual Art Competition, Nominees for 2010* [exhibition catalogue] (Moscow: National Centre for Contemporary Art), pp. 48–49.

Kravtsova, Mariya (2004), 'Deisis: Krov. Pot. Slezy', *Artkhronika* 4:67–75.

Kravtsova, Mariya (2007), 'Teknika na grani fantastiki', *Artkhronika* 7–8: 72–77.

Kravtsova, Mariya (2008), 'Goskollektsiya ili chastnye ruki?', *Artkhronika* 9: 86–95.

Krug, Pavel (2008), 'Tserkov napugala "Vinzavod": Dve raboty snyaty s vystavki Chakhala po nastayaniyu pravoslavnykh revnitelei blagochestiya', *Nezavisimaya gazeta Antrakt,* 19 September, www.ng.ru/theme/2008-09--19/100_vinzavod.html.

Kulik, Oleg (2007), 'I Believe: A Project of Artistic Optimism', catalogue prepared for the exhibition 'I Believe', Vinzavod Art Centre, Moscow, Moscow City Committee for Culture and Moscow Museum of Modern Art, Moscow.

Kurdyukova, Darya (2011), 'Strannoe svidetelstvo: The artist Khaim Sokol vystupil s rezkim sotsialnym vyskazyvaniem', *Nezavisimaya gazeta*, 11 August, www.ng.ru/culture/2011-08-11/8_sokol.html.

Kutlovskaya, Elena (2008), 'Made in the USSR: Miziano protiv meinstrima', *Nezavisimaya gazeta*, 12 September, www.ng.ru/theme/2008–09–12/21_ussr.html.

Martin, Jean-Hubert and Mead, Elizabeth (2009), *Against Exclusion: Third Moscow Biennale of Contemporary Art* (Moscow: Artchronika).

Miziano, Viktor (2006), 'Intimnaya ontologiya Olgy Chernysheva', *Khudozhestvennyi zhurnal* 77/78, http://xz.gif.ru/numbers/77–78/miziano.

Miziano, Viktor (2008), 'Nostalgiya for the Future' in Viktor Miziano (ed.), *Progressive Nostalgiya: Contemporary Art of the Former USSR* (Moscow: VAM), pp. 9–13.

Molok, Nikolai (2005), 'Marat Gelman otkryl glaza', *Izvestiya*, 20 January, www.izvestia.ru/news/298691.

Newsroom (2010), 'Patriarkh razreshil provesti vystavku aktualnogo iskusstva v khrame, no ona grozit konfliktom', 31 May, www.newsru.com/religy/31may2010/st_tatiana.html.

Noordenbros, Boris (2011), 'Ironic Imperialism: How Russian Patriots Are Reclaiming Postmodernism', *Studies in East European Thought* 63: 147–58.

Open Space, ' "Innovatsiya" poluchil Aleksander Brodskii', 3 April 2012, www.openspace.ru/news/details/35655.

Ozerkov, Dimitrii (2010), 'Aidan Salakhova', in *Futurologia: Contemporary Russian Artists and the Heritage of the Avant-garde* (Moscow: Garazh Centre for Contemporary Culture), pp. 74–77.

Papernyi, Vladimir (2007), *Kultura Dva* (Moscow: Novoe literaturnoe obozrenie).

Poletaev, Artyom (2010), 'Parad pobedy', www.doctrine.ru/zavtra/victory/006.

Putin, Vladimir (2005), 'Poslanie Federalnomu Sobraniyu', 25 April, http://archive.kremlin.ru/appears/2005/04/25/1223_type63372type63374type82634_87049.shtml.

Rancière, Jacques (2006), *The Politics of Aesthetics: The Distribution of the Sensible* (London and New York: Continuum International Publishing Group).

Rapoport, Alexander (1990), 'Concepts and Reality', in David A Ross (ed.), *Between Spring and Summer: Soviet Conceptual Art in the Era of Late Communism*, Tacoma Art Museum (Washington, D.C.: Institute of Contemporary Art; Boston, Mass: MIT Press), pp. 121–134.

Romer, Fedor (2001), 'Skazanie o Zemle Novonovosibirskoi donesut do prezidenta Putina', *Kommersant*, 12 May, www.kommersant.ru/Doc/264412.

Russia 2 (2005), exhibition catalogue in English (New York: White Box).

Russian Utopias (2010), exhibition catalogue (Moscow: Garazh Center for Contemporary Culture).

Russkii pop-art (2005), catalogue prepared for the exhibition *Russkii pop-art* at the Tretyakov Gallery, Tretyakovskaya galereya, Moscow.

Russkii vestnik (2005), 'Sataninskaya vystavka', 22 February, www.rv.ru/content2.php3?id=1409.

Russkoe bednoe (2008), exhibition catalogue (Perm: Projekt Sergeya Gordeeva).

Semenova, Elena (2008), 'Russkoe bednoe – russkomu vechnomu! Voina glamuru, ili Poisk natsionalnoi identichnosti', *Nezavisimaya gazeta Antrakt*, 3 October, www.ng.ru/antrakt/2008-10-03/13_perm.html.

Semikin, Anton (2010), 'Nagloe obayanie totalitarizma. Grazhdanskaya voina kak forma prinuditelnogo uchastiya v modernizatsii', *Kasparov.ru*, 18 October, www.kasparov.ru/material.php?id=4CBC0A71415DD. Also available at http://rossia3.ru/culture/cinema/nagloeobaianie.

Shargunov, Aleksander (2010), 'Vystavka v khrame pri MGU', *Pravoslavie*, 6 June, www.pravoslavie.ru/polemika/35585.htm.

Sots-art. Politicheskoe iskusstvo v Rossii (2007), catalogue for the exhibition 'Sots-Art. Political Art in Russia' at the Tretyakov gallery at Krymskii val, Tretyakovskaya galereya, Moskva.

Stabrovskii, Aleksander and Prizyuk, Vitalii (2010), interview with V. Koshlyakov in 'Dostich nedosyagaemykh', *Sol*, 16 September, www.saltt.ru/node/4432.

Svetlyakov, Kirill (2005–2007), 'Distantsii Olgi Chernyshevoi', *Khudozhestvennyi zhurnal*, http://xz.gif.ru/numbers/77–78/svetlyakov.

Sviblova, Olga (2009), 'Victory over the Future', catalogue prepared for the exhibition at the Russian Pavilion, 53rd International Art Exhibition, La Biennale di Venezia.

Tamruchi, Natasha (2009), 'Introduction', in *Krizis samoidentifikatsii/Identity Crisis*, catalogue prepared for the exhibition of the same name, Otkrytaya gallereya, Moscow, 30 June–31 July, pp. 3–17.

Thomas, Joe (2009), 'Komar and Melamid: The Future Memory of International Modernism', Kennesaw State University, www.academia.edu/1041323/Komar_and_Melamid_The_Future_Memory_of_International_Modernism.

Tolstova, Anna (2004), 'Svobodnye radikaly: Sovremennye khudozhniki razmyshlyayut o sudbakh Rossii', *Kommersant St Peterburg*, 30 April, www.kommersant.ru/doc/471575.

Tolstova, Anna (2008), 'Gnutaya velichina: Anna Zelud v galeree "Aidan"', *Kommersant*, 15 October, www.kommersant.ru/doc/1040928?isSearch=True.

Urban Formalism (2007), catalogue prepared for the exhibition at the Moscow Museum of Modern Art at Ermolaevskii pereulok, Moscow Museum of Modern Art, Moscow.

White, S., and McAllister, I. (2003), 'Putin and his Supporters', *Europe-Asia Studies* 55(3), 383–99.

XENIA, ili Posledovatelnyi protsess (2007) (Moskva: Pravitelstvo Moskvy, Komitet po kulture goroda Moskvy i Moskovskii muzei sovremennogo iskusstva).

Zhelud, Anya (2011), '. . . exhibition continues', *Innovatsiya 2010*, catalogue prepared for the exhibition of nominees, National Centre for Contemporary Art, Moscow.

Zhilyaev, Arsenii (2010), *Russian Utopias* (Moscow: Garazh Center for Contemporary Culture).

4 Art on trial

Religion was a central dimension of the building of an official identity. As the Russian Orthodox Church strengthened its position, one result was an open and sharp conflict in relations between the church and members of the arts community, many of whom were themselves Orthodox believers. One event was particularly significant for the development of a counterculture among the arts community – the trial of the organizers of the exhibition 'Forbidden Art' at the Sakharov Centre in March 2007. They were accused of blasphemy by groups within church, and found guilty by the court of inciting hatred on religious grounds. The arts community's reaction to the trial and the verdict was strong, especially when seen against the background of the weak response to previous cases of conflict between the arts and the church in post-Soviet Russia. To understand the magnitude of the conflict, this chapter opens by telling the story of a foreign exhibition that took place in a Moscow gallery just after the guilty verdict had been confirmed. Then follows a brief overview of earlier conflicts in post-Soviet times, an analysis of the trial of the Forbidden Art exhibition, and an examination of the way in which the arts community reacted to the process and the verdict.

The trial of the 'Forbidden Art' exhibition was a formative event for the arts community. It became a learning experience in the sense of forming a political generation, obliging people to re-evaluate their views and perspectives and reflect on the state of society.[1] Two circumstances made the trial important: criticism of the exhibition came from small but loud and militant groups that had the support of both church and state; and the trial made people in the arts community realize that they had a common interest in defending the accused, thus contributing to the development of a counterculture.

'Their' art not 'Ours'

Paradoxically, in the tense atmosphere of the autumn of 2010, immediately after the Moscow court had confirmed the district court's guilty verdict, an exhibition by the leader of the radical Vienna Actionists of the 1960s, Herman Nitsch, opened in Moscow.[2] Mounting 'A Theatre of Orgies and Mysteries' was audacious in the context of tensions between the arts and the Orthodox Church. The exhibition, held at the prestigious private gallery the Stella Art Foundation, included first

and foremost videos and photographs of Nitsch's performances. Based on the mythology of sacrifice in Christianity and pageantry, his major performances suggested images of religious ritual, in which huge butchered and bloody ox cadavers together with humans dressed in white kaftans stained with blood were tied to wooden crosses. Any exhibition by Nitsch, who has been arrested because of his work several times in his own country, could be expected to be highly controversial in the Russian context.

The exhibition took place in the centre of Moscow, but without any street advertisements. The gallery door was locked and opened only on request.[3] It was evident that the gallery had taken precautions against reactions from a critical public. Inside the gallery, guards carefully explained that the exhibition might be morally and emotionally upsetting. Only after they were convinced that visitors understood these conditions were they escorted into the exhibition.

Against such a tense background, the exhibition was an important event in Moscow cultural life. It was a statement from an influential gallery owner in support of freedom of expression in art. It highlighted the experience of other countries, where relations between the arts and the church were not as poisoned as they were in Russia. The church in Austria and elsewhere in Europe has generally accepted the principle of free expression in art and adheres to the idea that society consists of different spheres, discourses and debates. Surprisingly, Russian Orthodox–patriotic activists did not react, probably because the existence of the exhibition was known only to the narrow world of contemporary art, but also, and more likely, because Nitsch, as a foreigner and Westerner, was considered to be of little relevance to Russia.

Early post-Soviet conflicts between art and the Russian Orthodox Church

Some kind of reaction to the Nitsch exhibition might have been expected because there is a history of conflicts with a religious dimension going back to 1998, 2000, 2003 and 2007. The 1998 conflict was the first of its kind in post-Soviet society. It was over a performance at the 'Art Manezh' art fair in December of that year by Avdei Ter-Oganyan, one of the leading radical Actionists on the Moscow art scene in the 1990s. For his performance 'The Young Godless' (Molodoi bezbozhnik), he invited his audience to destroy paper reproductions of icons with a hammer. When no one did so, he did it himself. He later explained that the purpose of the action was to protest against the commercialization of spiritual life.[4] The church reacted strongly. Religious activists, led by the Committee for Moral Revival of the Fatherland (Za nravstvennoe vozrozhdenie otechestva), an organization established by the Patriarchate and led by Archpriest Aleksander Shargunov (head of the Church of St Nicholas in Pyzhi), immediately condemned the action.[5] Shargunov campaigned for legal action and mobilized his parishioners to send letters of protest to the prosecutor's office.

By the time of the preliminary court hearings in 1999 to prepare a charge according to article 282 of the Russian Criminal Code addressing 'incitement of feelings of hatred and enmity on the basis of social, religious and ethnic belonging', the campaign

against Ter-Oganyan was in full swing. 'Workers' appeared and almost smashed a television camera in front of the police, shouting 'Get lost, you Jewish fascist!' one eye-witness reported (Kovalev, 2003).[6] What had started as a reaction by a few radical Orthodox activists developed into a campaign by groups of Orthodox churchgoers and ended up as a legal case. As the Moscow district court prepared the case, in 1999 Ter-Oganyan fled to the Czech Republic, where he was granted political asylum.[7]

Ter-Oganyan's performance stirred up strongly negative reactions in the arts community and among the intelligentsia. Many found it hard to comprehend, or did not consider it art; they thought he should be reprimanded but nonetheless opposed a trial (Dyakonov, 2007: 95). One artist wrote,

> The action . . . was performed in the context of art and has to be approved or condemned only according to the laws of art. I do not like what Ter-Oganyan did, and I would suggest that the arts community gives him a sharp reprimand and bans him for some time from participating in exhibitions, in other words, takes appropriate measures. The Orthodox Church can, like any other social organization, exclude Ter-Oganyan as he was christened as a child in the Orthodox belief.[8]

The next major conflict involving art and religion erupted in 2000. After a performance, Oleg Mavromati, another radical Actionist of the 1990s, was forced to flee the country when threatened with legal action. In April that year, Mavromati performed 'Do not believe your eyes' as part of the screening of a film he made. The performance took place in the courtyard of the Institute of Cultural Studies, next to the Church of St. Nicholas on Bersenevka, with the newly built cathedral, Christ the Saviour, as a backdrop on the other side of the river. Dressed in a white T-shirt with the text 'I AM NOT GOD'S SON' carved out on his skin in a triangle shaved on his hairy back, Mavromati was 'crucified' on a T-shaped wooden cross using steel nails through his hands. A portrait of Charles Darwin was pinned on a tree to his right (Salnykov, 2001). A television crew documented the event. When the footage was broadcast one week later, there was strong reaction from believers. To them, this was an act of blasphemy and Satanism.

In order to understand the context in which Mavromati's performance took place and the intention behind his work, it is interesting to note the words of the art critics Boris Groys and Andrei Kovalev. First, Groys on the tension between art and church in Russia:

> Russian art, from the age of icons to our time, seeks to speak of another world. . . . Culture comes out as the guardian of original revelation and also as the mediator of new revelations. The language of art differs from everyday language not because it speaks of the world in a more elegant and beautiful way or discloses the 'internal world of the artist'. What makes it different is the message it has to convey about the other world – something that only art can say. . . . What is the other world? It is the world opened up to us by religion. It is the world that opens itself to us only through the medium of art. It is also the world that is situated at the point where those two worlds intersect.

This is why there is so much tension in the relationship between art and faith in Russia. At all events, the other world is neither the past nor the future. It is rather the "other" presence in the present into which we may withdraw without reserve. . . . All you need to do is to take one sideward step and you find yourself in another place.

(Groys, 2010: 51, 54)

Kovalev, speaking specifically about Mavromati's performance, found three rationales for it: '(1) an effort to create an ideal frontline action-situation; (2) reflections on pain as an aesthetic category . . . ; and (3) a search for the gesture that connects the profane and the sacred to the same degree as the crucifixion was specifically carried out at the border (fence) between the profane (secular) Institute of Cultural Studies and the sacred Church of St. Nicholas on Bersenevka'. Nor was the date of the action – 1 April – accidental but selected as a frontier (the fool's day at the beginning of the fourth week of Lent). All this seemed to the artist to present an opportunity to physically unite with the help of frontier mega-gesture 'art that had lost its belief with religion that had lost its intellect and skill' (Kovalev, 2007: 383).

The Committee for the Moral Revival of the Fatherland mobilized again.[9] The first district court investigator, however, found nothing criminal and decided not to commence legal proceedings (Kovalev, 2003).[10] Nonetheless, renewed efforts by Shargunov led the Moscow City Prosecutor to bring the Mavromati case to court. He contacted Duma deputies and with their help activated the Moscow Prosecutor.[11]

Some in the art community viewed Shargunov's activities as a worrying sign of the growing influence of the church. Therefore, in September 2000 Mavromati was invited to repeat his performance at Gallery Marat Gelman. This time the artist was tied to wooden boards nailed together in an X, and nails were driven through his hands. As part of the 'installation', mirrors were placed along the walls to catch the reaction of the audience (Grebelnikov, 2000).[12] The *Izvestiya* journalist present declared that, '[T]his action has nothing to do with art'. She recalled how she watched in horror as Mavromati, 'pale, blood-stained, frightened and attached by nails, shouted "Art is pain!"'(Kabanova, 2000).[13]

Mavromati was charged under the same paragraph 282 of the Russian Criminal Code as Ter-Oganyan had been. The prosecutor allowed him to travel to Bulgaria for a festival and, when Mavromati heard the prosecutor describe him as a dangerous madman on Russian television, he decided not to return to Russia. Several years later, Mavromati compared his performance with those by Herman Nitsch and concluded that his own actions had included components that art history had never seen before. He found Nitsch's work 'different, theatrical, in a different context, of Dionysian mysteries'. Nitsch had had a person tied by rope, 'but nobody had had nails driven through their hands. . . . Such an event art history never had heard of before' (Volchek, 2010).

Aleksander Shargunov was to play a role also in future conflicts between church and the art community, but by then more actors had appeared on the scene with whom he could cooperate.

Art on trial I: The case of 'Beware! Religion'

In January 2003, the exhibition 'Beware! Religion' opened at the Sakharov Centre with paintings, photographs and installations by 40 artists. The press release for the exhibition described religion as something important to defend, but at the same time warned against the excesses of religion. The exhibition encouraged reflection on these issues.

> The name of the exhibition reflects an obvious duality of intention: it is both a call for a cautious, delicate and respectful relation to religion, belief and believers; and a sign of "warning, danger!", when it is a question of religious fundamentalism (Muslim or Orthodox) and when religion intertwines with the state or obscurantism. Freedom of conscience can result in spiritual depth and selfless devotion, but also in fanaticism and hatred of people who believe or think in a different way, in cynicism and emptiness. Freedom of conscience and the diversity of dogma and religious authorities give human beings a choice: what to believe in, to belong to a church or religious community, or not to believe at all and become an atheist.[14]

Elaborating on the intellectual and political framework and the purpose of the exhibition, Anna Alchuk, the coordinator of and a participant in the exhibition, said that for her the interesting question was the history of the long relationship between art and religion (Alchuk, 2003). She argued that after modernist art, which had cultivated the idea of the artist as a kind of demiurge who repeatedly creates the world in his works, postmodernist art acts as a critical appropriator of cultural values. In this context, religion becomes an object of critical artistic investigation. She mentioned the artists Herman Nitsch and Francis Bacon,[15] argued that Russian artists in the post-Soviet period – with the exception of a few artists such as Oleg Mavromati, Aleksander Brenner, Oleg Kulik and Avdei Ter-Oganyan – had seldom taken on a critical discourse and asked if it is possible to talk about any contemporary art without critical functions. Defending Mavromati, she said that the top of the church hierarchy had not been able to distinguish between an act of blasphemy and a symbolic artistic act, which moreover was carried out in a public place and not on the sacred ground of a church. She mentioned Ter-Oganyan's performance in an exhibition hall, but also Aleksander Brenner, who in 1995 ran up to the altar of a Moscow church shouting and distributing flyers calling for an end to the First Chechnya War. The 'Beware! Religion' exhibition, she said, calls on artists 'not to lose the critical distance in relation to the church, which has completely lost its autonomy in relation to the state and blesses violence' (Alchuk, 2003). With these words she aroused the hatred of religious activists.

One scholar analysing the trial concluded that 'Most of the exhibits could be interpreted in two different ways: on the one hand they point to the risk of exchanging Christian values for capitalism, consumerism, eroticism or even science ... while on the other hand they suggest that the Orthodox faith contains the same sort of authoritarian discourse as other ideologies' (Bodin, 2009: 262).[16] An example of

criticism of the new consumerism was expressed in Aleksander Kosolapov's work 'This is my Blood', showing Jesus against the background of the Coca-Cola logo.

Art critics were not particularly impressed by the exhibition at the time. *Nezavisimaya gazeta* wrote, 'But it surely seemed that the criterion of heresy was exhausted to the end, and the revolt "on that theme" is no longer timely' (Arkhangelskaya, 2003). However, the theme of heresy seemed not at all exhausted. Four days after the exhibition had opened and after only about 70 visitors had seen it, six protestors defaced most of the paintings with spray paint and graffiti. On the walls they wrote: 'rascals', 'blasphemers', 'bastards', 'sacrilege' and 'you hate Orthodoxy, damn you!'(Kulik, 2003). The female guard locked them in the exhibition hall and called the police. The intruders told the police that they were members of the congregation at the Church of St. Nicholas in Pyzhi and wanted to protest against the blasphemy they found in the exhibition. A few days later they were charged with hooliganism according to paragraph 213 of the Russian Criminal Code, but a judge acquitted them on the grounds that their actions had been provoked by the exhibition. On 3 February 2003, at the urging of officials of the Russian Orthodox Church, the Russian State Duma adopted a resolution calling for the Procurator General 'to take necessary measures' against the organizers of the exhibition, and an investigation was opened. The Committee for Moral Revival of the Fatherland sent a letter to President Putin asking him to close down the Sakharov Centre.[17]

As a result of this campaign Yurii Samodurov, the director of the Sakharov Centre; his co-organizer of the exhibition; and the coordinator, Anna Alchuk, were charged under article 282 of the Russian Criminal Code. Two years later, in March 2005, guilty verdicts were announced against the two first. The prosecutor had demanded three years in a penal colony, but instead they were each fined 100 000 roubles. Alchuk was acquitted (Maslova and Ursulov, 2008).

This was the first political–ideological trial against culture since the Sinyavskii and Daniel case in the 1960s. Lev Ponomarev, the chair of the Organization for Human Rights, called it 'the first ideological trial in democratic Russia'. He added, 'We consider this process a landmark that for many years will define the relationship between state and society, and the state and the creative intelligentsia'.[18] The verdict had an immediate effect on cultural life. Three days after the 'Russian Pop-Art' exhibition opened in the summer of 2005, the director of the Tretyakov Gallery removed Aleksander Kosolapov's 'Icon–Caviar' after he received a letter signed by the Priors of four Moscow churches and several churchgoers affirming that 'this object excites social and religious hatred in the authors of this letter'. On removing the object, the director declared that the Tretyakov Gallery, as a state museum, had no right to provoke conflict in society (Shtutina, 2008).

Art on trial II: The 'Forbidden Art' exhibition

The exhibition 'Forbidden Art – 2006' opened at the Sakharov Centre in March 2007. The organizer was again the director of the centre, Yurii Samodurov, and the curator was this time Andrei Erofeev, head of the department dealing with

the newest tendencies in art at the Tretyakov Gallery. In a little over three weeks (7–31 March 2007) the exhibition had around 1000 visitors, but its resonance was much greater. The purpose of the exhibition was different from the January 2003 exhibition at the centre. It was intended to address the questions of censorship, self-censorship and the administration of the arts at state museums.[19] All 24 artworks on show had been removed or denied exposition during 2006 after decisions by the administrative leadership or Cultural Council at state institutions. The organizers intended to continue to monitor censorship in the field of art and to regularly organize similar exhibitions in the future.

The exhibited works were produced between 1972 and 2005 by artists such as Ilya Kabakov, Leonid Sokov, Mikhail Roginskii, Aleksander Kosolapov, Mikhail Roshal-Fedorov, Avdei Ter-Oganyan, Dmitrii Gutov, the PG group and the Sinie nosy.[20] Some works were made in the Soviet underground, others in post-Soviet days. The common feature was that they included, in one way or another, critical comments on trends in society and the politics of the time. The works needed to be interpreted in the specific context in which they were made. This helps to explain the use of religious symbols to critically express secular thoughts and criticism of Soviet ideology as well as post-Soviet commercialization. None of the works was directed against the church or religion. In the context of the growing role of the church during the 2000s, however, this art was interpreted differently. The works now caused controversy, and wary museum administrators therefore removed them rather than risk controversy.

Not all the artworks were censored due to religious symbolism. Andrei Erofeev explained that by 2006 there were three categories of censored works: those that used the rough language of the street, those with religious signs and symbols and those depicting erotic fantasies. Only in 2007, he said, was a fourth category added – those with political references. Common to all of them was the ironic tone of carnival culture, which, he argued, runs like a red thread through the history of Russian culture (Zaitseva, 2009).[21]

As part of the dramaturgy of the exhibition, all the works were shown behind constructed fake walls. The only way to view them was through a small hole in the wall, one for each work of art. Photography was forbidden, and it was made clear that the exhibition was not recommended for children under 16 years of age (Khachaturov, 2008).

Protest against the exhibition

The most active protesters against the exhibition were Narodnyi sobor (Popular Assembly), its sub-organization Narodnyaya zashchita (Popular Defence) and Obedinennaya Pravoslavnaya molodezh (United Orthodox Youth). Their leaders were among those people who had taken the previous exhibition at the Sakharov Centre to court. One of them had even been among the intruders at the 2003 exhibition. This time, however, the exhibition was not destroyed but legal means were used.

On 28 March 2007, Vladimir Sergeev of Narodnaya zashchita and Mikhail Nalimov of Pravoslavnaya molodezh organized a demonstration outside the

Sakharov Centre. As Nalimov later stated in court, the ultimate aim of the action was to force the centre to close. He called the centre 'a cloak, where anti-Orthodox, anti-governmental and anti-Russian elements gather, meet with sponsors, and shoot [drugs]' (Vasileva, 2009). In preparing the legal case, Sergeev sent his wife to take photographs of all the exhibited works and attached them to the letter that the couple took to the investigator at the procurator's office (Vasileva, 2009).[22] They started a campaign among parishioners of the Church of St Nicholas in Pyzhi to mobilize them against the exhibition.

The preliminary investigation of the district procurator's office found nothing criminal in the exhibition. Only after the Sergeev couple met with the Duma delegate, Aleksander Chuev, did the process start moving forward.[23] In June 2007 the Taganskii Court decided to open an investigation. In order to increase the number of 'victims of the exhibition', that is, people who felt offended, in November 2007 *Narodnaya zashchita* used its website to encourage all those 'who are not indifferent' to acts of blasphemy to give evidence to the investigator at the Taganskii Court. The website explained clearly how to contact the investigating officer and emphasized that even people who had not visited the exhibition would qualify as witnesses.

Towards the end of 2007 the Taganskii Court informed Erofeev and Samodurov about the upcoming process. The indictment was signed by the district procurator in May 2008, but the first court sessions started only a year later in May 2009.[24]

Arguments and images

The major argument made by the organizations that brought the case to court was that the exhibition 'offended the feelings of Orthodox believers' and 'degraded' their human dignity. The May 2008 report of the procurator's investigation stated that sacred Christian symbols and signs had been combined in a collage technique with various profane and vulgar images from the culture of consumerism or anti-religious images. The intention behind the collages was, the report said, to create the idea of 'ideational "deletion", negation, destruction of the thought and meaning of Christian sacred symbols, and consequently the destruction of the Christian belief and thereby a direct and public insult to Christians as carriers of this belief'.[25] In the courtroom, witnesses accused the exhibition organizers of blasphemy and Satanism for using religious symbols and signs in a secular context. The procurator referred to article 282 of the Criminal Code, part of Russian legislation against extremism. In court the witnesses had difficulties explaining how the exhibition evoked hatred against Orthodox belief or hatred between different religions.[26] Of the 134 witnesses for the prosecution, only three had visited the exhibition (*The New Times*, 2010).

Narodnyi sobor, Narodnaya zashchita and Pravoslavnaya molodezh declared that their goal was to restore Russia on the basis of the traditional spiritual–moral values of Russian civilization, which they defined as Orthodoxy.[27] According to Sergeev, Orthodoxy constitutes the very basis of the state, so the exhibition was therefore offensive not only to Orthodox believers but also to the Russian state

(*Grani*, 2009). Moreover, he claimed that Orthodoxy stands above the law and the Constitution.

This view had been presented in early 2006 in an 'Open letter to the President, the Procurator, the Ministry of Culture and the State Duma', published in *Narodnaya zashchita*. The letter called for a new law that would defend 'religious sanctities and sacred symbols and introduce the strictest censorship'. The authors of the letter claimed that the existing law was insufficient: 'To defend the feelings of Orthodox believers is nowadays practically impossible, since it is impossible to prove that images and symbols that are sacred for an Orthodox believer are in fact sacred Christian images and symbols' (Drevo, 2006).[28] The letter had the character of a policy document advocating the restoration of Russian values against destructive external forces. A struggle against such destructive forces was being waged in the field of art. 'It is no secret', the document stated, 'that bearers of a culture and ideology that are alien to us are striving to destroy Russia, and subjugate it'. The major target of this foreign effort to destroy the Russian people, it was claimed, was Russian youth: 'The major blows against Russian youth are being carried out by so-called contemporary "art" and "literature"'. Therefore, according to the authors, a law of the strictest censorship was needed to prevent 'the flow of indecencies from the television screen, exhibition halls and book shops. Our direct task is to defend our children from corruption [of the soul] and our holy sites from desecration'.

Considerable time was spent during the court proceedings discussing the essential difference between an icon and a painting, whether religious symbols and signs can ever be used in a non-religious context, and whether they can be considered sacred if used in a secular context. The prosecution considered any sign, even one that slightly resembles a religious symbol, to be forbidden for use outside the context of religion. The defence looked at it differently, and claimed that it is the right and freedom of artists to use any signs or symbols to express their thoughts and emotions.[29]

The prosecution paid no attention to the purpose of the exhibition, that is, to discuss the issue of censorship and self-censorship in the field of culture and art. None of the witnesses was aware of this purpose. Moreover, when they were told, they saw it as completely irrelevant. As a consequence, the interpretation of individual works of art differed considerably between the two sides. Several works were highlighted in the prosecution's report as directly offending Orthodox believers: 'Icon–Caviar' by Aleksander Kosolapov (1994); two works by Aleksander Savvich (Savko) from his series 'Travels by Mickey Mouse Through the History of Art' (1995), made after the famous gravures and paintings by the German artist Julius Schnorr von Carolsfeld (1794–1872); a photo collage by Vagrich Bakhchanyan, showing Christ on the cross but with the face of Lenin (1985); Mikhail Roshal-Fedorov's work 'Let Us Overfulfil the Plan for Coal!' (1972); and last but not least Kosolapov's print 'Advertisement for McDonald's', showing the face of Christ and the words 'This Is My Body' against the background of the McDonald's logo (2000). Of the exhibited works, four were considered vulgar because they included swear words, and here Kabakov, Sokov, Roginskii and Ter-Oganyan

were especially singled out. Of most concern to the prosecution was the installation by Sokov, 'Monument' (2002), with metal letters piled on top of each other forming the word 'khui' (prick). This word is not only in frequent use in Russian street language, but also figures in countless new words. Surprisingly, works by the PG group showing military officers in obscene situations, from the series 'Slava Rossii' on corruption in the army, were not criticized.[30]

The interpretation of the pieces in the exhibition differed considerably. While the prosecution could not understand metaphors and viewed everything literally and in a religious context, the defence highlighted the role of metaphors in art. Kosolapov's photo print on canvas of a golden icon frame filled with black caviar (see Figure 4.1) was explained by the art critic Andrei Kovalev: 'This work was made in 1995. It is exclusively criticism of black marketeers trading in caviar and icons' (*The New Times*, 2010). The prosecution's experts subscribed to a different interpretation. One expert psychologist argued that it was a blasphemous parody of an icon and a conscious act of contempt for religious values, abuse of the religious feelings of believers and humiliation of their human dignity motivated by

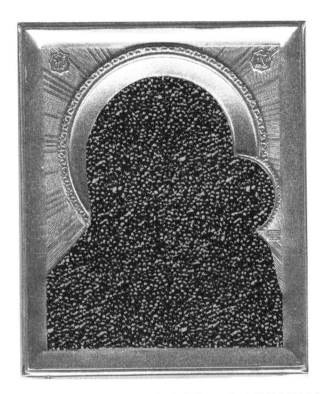

Figure 4.1 Aleksander Kosolapov, 'Icon–Caviar' (Ikona–ikra) 1989/1994 (photo print on canvas)

Source: Courtesy of A. Kosolapov.

religious intolerance and hatred (Sakharov Centre, 2007). The art expert appointed by the court, from the Institute of General History of the Academy of Sciences, found that the 'blackness' of the caviar represented the antithesis of the 'purity' that Christianity associates with this icon. She also saw another possible antithesis of 'greed' against the 'aescetic ideal' of the Christian doctrine (Sakharov Centre, 2007). Kosolapov himself described his work as in dialogue with Andy Warhol's 'romantic' view of US consumerism and his ideas of beauty and equality as linked to consumption. The Caviar project was 'ironic' with respect to Warhol's 'romantic notion' but: 'In the context of today's Russia the project reveals the connection between the revival of Russian national (Orthodox) symbols or signs and the strategy of consumption'.[31]

The prosecutor viewed Mikhail Roshal-Fedorov's work 'Let Us Overfulfil the Plan for Coal!' as mockery of an icon of Christ. The defence explained that it was a self-portrait by the artist with what only seemed to be a nimbus, and that the letters at the top were his personal initials and not letters representing Christ. Yurii Samodurov explained that, 'It is clear that this represents mockery of Soviet ideology which at that time was mocked in any way possible, and at the same time gained a de facto sacral status' (*RIA Novosti*, 2007).

The organizers of the exhibition defended the right of art to free expression and claimed that, in a state where the constitution separates state affairs from religious affairs, artists have the right to express themselves without restrictions from the church on how art is to be interpreted. This was a confrontation between two different worldviews.

Instigators of the trial

The instigators of the legal proceedings against the organizers of the Forbidden Art exhibition were the same people who had acted against the 'Beware! Religion' exhibition. They managed not only to persuade the court to open a case, but also to win it. The largest of these organizations was Narodnyi sobor. Created in 2005, it claimed to be an umbrella organization for 200 smaller patriotic–religious organizations throughout Russia.[32] Its declared goal was to 'reorganize Russia on the foundation of the traditional spiritual-ethical values of Russian civilization'. Oleg Kassin, a co-chair of the organization and chair of its Executive Committee, demonstrated a keen interest in contemporary art in the sense that he had repeatedly tried to take legal action against art exhibitions and people in the cultural field.[33]

As the defence pointed out, Oleg Kassin had a remarkable background for someone who claimed to be a defender of religion, morals and traditional values. In the 1990s, Kassin was a deputy chairman of the well-known fascist organization Russian National Unity (Russkoe natsionalnoe edinstvo, RNE), chairman of the Moscow branch of the organization and the right-hand man of its leader, Aleksander Barkashov. In the 1999 Duma elections, he was a candidate for SPAS, the front organization with which RNE cooperated. Before the presidential election of 2000 he led a committee that worked to nominate Barkashov as a candidate for

president. After he split from Barkashov, he created his own patriotic–religious organization. In 2005 he was one of the founders of Narodnyi sobor, which established contacts with the Patriarchate. Representatives of the Orthodox Church participated in the first Congress of Narodnyi sobor in 2006.[34]

The smaller organization, Narodnaya zashchita, was closely linked to Narodnyi sobor.[35] It described itself as an Orthodox human rights organization.[36] Led by Vladimir Sergeev, it defended its members who were in trouble with the authorities and took action against art exhibitions that were not to its liking. Obedinennaya pravoslavnaya molodezh appeared out of nowhere in 2006. Its leader, the businessman Mikhail Nalimov, became known when he demonstrated outside the Sakharov Centre against the 'Forbidden Art' exhibition.[37] How could these organizations, marginal as they seemed, take the exhibition to court? Many saw the hand of the state authorities, while others saw the Patriarchate behind it all. The issue, however, was complicated.

Before the trial began an intensive mobilization campaign took place. The exhibition immediately became like a red flag for conservatives of all kinds and colours. Influential conservative and nationalist journalists helped to stoke up public opinion against the organizers. The television journalist Mikhail Leontiev wrote an article entitled 'To beat the provocateurs is of no use: they must be jailed for a long time', which resonated with society. He characterized the exhibition as blasphemous, and demanded that it be closed down immediately and all the exhibited artworks seized as 'criminal tools'. He emphasized that the organizers should be handed such a hard sentence that they would never repeat the crime (Leontiev, 2007).

Both Erofeev and Samodurov claimed that the state supported these organizations. The fact that the legal system allowed a legal process based on weak evidence and witnesses who had not visited the exhibition was regarded as an indication that the state had a direct interest in the outcome of the case. Samodurov also accused the Patriarchate of direct and active involvement in support of the prosecution and pointed out that Archpriest Chaplin had repeatedly expressed his opinion that the exhibition was 'a clear violation of the law'.[38] Samodurov also highlighted direct links between the Patriarchate and Narodnyi sobor. In his court testimony, Kassin claimed that he regularly reported to the Patriarchate on the court proceedings. The Patriarchate, however, did not confirm this. It was therefore interpreted as a worrying sign when in the final stages of the trial a representative of the Cultural Council of the Patriarchate repeated in court the words of Narodnyi sobor, condemning the exhibition and its organizers (Erofeev, 2010). So did Patriarch Kirill – but only after the verdict was made public.

The trial and the verdict

Court proceedings began in June 2008.[39] The detailed report from some of the sessions set out below illustrates the tense atmosphere in the courtroom and the absurd character of the case. The legal proceedings took more than two years, with 134 witnesses for the prosecution and only about 10 for the defence.[40] The

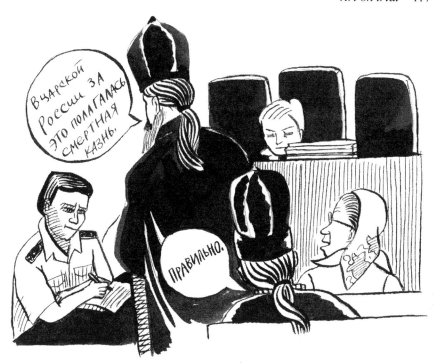

Figure 4.2 Viktoriya Lomasko, 'Priest at the Court' from the series 'Forbidden Art' 2009
Note: The quote from the priest says: 'In Tsarist Russia this would have brought a death sentence'. The second priest comments: 'Correctly'.
Source: V. Lomasko and A. Nikolaev, *Zapretnoe iskusstvo* (St Petersburg: Bumkniga, 2011). Courtesy of V. Lomasko.

imbalance in the number of witnesses quite naturally influenced the atmosphere of the courtroom.

Sergeev from Narodnaya zashchita and Nalimov from Pravoslavnaya molodezh were present for most of the sessions. During breaks, groups of elderly female followers gathered around them. Standing outside the courtroom, the leaders gave instructions to people who were about to give evidence.[41] During the sessions, the believers, a majority of the audience in the courtroom, read holy texts or prayed quietly, some with crosses or images of Christ on their laps. As emotions ran high, some of them shouted 'blasphemy', 'work of Satan' and 'Satanism' until the judge told them to be silent or a guard asked them to leave the room. Chatting outside the courtroom during the breaks, they discussed the latest church news or the 'Jewish conspiracy', which they believed was behind the exhibition, and sang religious songs.

The proceedings continued as absurd theatre as witnesses gave testimony on an exhibition they had never visited.[42] They said that they had been informed about a 'blasphemous exhibition' by the religious radio channel 'Radonezh'; the liberal

Figure 4.3 Viktoriya Lomasko, 'The Head of Narodnaya zashchita with Followers' from the series 'Forbidden Art' 2009

Note: The text is: 'They Spit on you'.
Source: V. Lomasko and A. Nikolaev, *Zapretnoe iskusstvo*, (St Petersburg: Bumkniga, 2011). Courtesy of V. Lomasko.

'Ekho Moskvy'; the Internet, even though it was obvious that most of them hardly used either the Internet or computers; or through friends. They also told how the investigating officer at the procurator's office had kindly shown them photocopies of the artworks and helped them to draft the text of the necessary documents.[43]

As a leader of Narodnyi sobor, Oleg Kassin's testimony was important. He initially gave a fairly detailed description of the objects on display, claiming that he had been at the Sakharov Centre. He described how some objects had been placed behind false walls, while others had been directly exposed on the floor. Among the latter, he mentioned the three metallic letters on top of each other (Sokov's work), which together formed the hooligan word that he did not even

want to utter (khui – prick). This description came to play an important role later in his cross-examination.

Towards the end of the session, the defence again brought up the issue of how the works had been displayed in the exhibition hall. Kassin repeated his view that not all the objects had been behind false walls, and insisted that the letters of the uncensored word had been standing freely on the floor. He was embarrassed when Samodurov and Erofeev said that all objects, without exception, had been behind false walls as high as 2.5 metres. This, they said, was something that nobody visiting the exhibition could have missed. Thus, they concluded, the witness was lying and obviously had not even been at the exhibition. Erofeev asked the witness to swear on the Bible that he was telling the truth. Kassin responded that, 'I don't remember details . . . all this happened two years ago'. The judge paid no attention to this obvious lie.[44]

The court proceedings finally came to an end on 12 July 2010. Outside the Taganskii Court 200 people had gathered to wait for the verdict to be announced (*Grani*, 2010c). There were supporters of both sides – people from the arts community in support of Erofeev and Samodurov and followers of different Orthodox–patriotic organizations, including an ultra-rightist Orthodox organization called the 'Crusaders' or the 'Union of Orthodox Banner Bearers' (Soyuz pravoslavnykh khorugvenostsev). Their leader was dressed in black and his T-shirt bore the legend: 'Orthodoxy or Death' (Demidova, 2010).[45] The atmosphere in the courtroom and in the courtyard outside the building was extraordinarily tense.

The judge announced the verdict of guilty according to article 282 (2) (Vasileva, 2010) and stated that their acts had had a 'cynical and contemptuous attitude to the religious feelings of Orthodox believers' (*Grani*, 2010c). The prosecution had demanded three years in a penal colony, but the final verdict prescribed a fine of 200 000 roubles for Samodurov and 150 000 roubles for Erofeev. The prosecution was dissatisfied with the sentence. The defence appealed to the Moscow City Court, a higher court, which confirmed the verdict on 10 October 2010 (*Interfax*, 2010).

The trial of the 'Forbidden Art' exhibition had been won by the prosecution. The process therefore showed a way forward for patriotic–religious organizations in their ideological struggle: to bring cases to court instead of taking illegal action, and to make the organizers of exhibitions responsible rather than individual artists. Thus, the formula was taking shape: you are free to make whatever kind of art you want as long as it is not exhibited in public.

Reaction from the arts community and the intelligentsia

The trial of the 'Forbidden Art' exhibition mobilized protest in the arts community to an unprecedented extent. The performances of Avdei Ter-Oganyan and Mavromati in 1998 and 2000 and the conflicts they aroused had confused many artists and made them reluctant to defend these actions. The exhibition 'Beware! Religion' was different, since it involved several better-known artists and took place at the Sakharov Centre, an institution with a record of defending human rights.

Even so, the reaction from the arts community came late, only when a guilty ver-
dict seemed a real possibility.[46] This kind of conflict seemed to leave a bad taste
in the mouth for many people, especially against the background of the growing
influence of the church in society. Neither activists nor intellectuals wanted to
challenge the authorities.

When the organizers of the 'Forbidden Art' exhibition were taken to court, a
reaction from the art community was only to be expected. The exhibition's choice
of topic – censorship – was a concern for all artists. There was an immediate reac-
tion from the arts community in the form of open letters. In late November 2007,
as police carried out searches of the Tretyakov Gallery and the Sakharov Centre,
17 well-known Russian artists, poets and critics wrote an open letter in defence
of Samodurov and Erofeev (*Grani*, 2007). At about the same time, another open
letter was published calling on people to sign up in support of Erofeev. By July
2009, 622 people from the arts community had signed the petition.[47] At a public
meeting in late May 2008 yet another letter was signed, calling for an end to the
legal proceedings. It was sent to President Medvedev and the Ministry of Culture
by the directors of the National Centre for Contemporary Art (NCCA) and well-
known gallery owners (Khachaturov, 2008).

Reaction was still limited to a narrow group of people, however, and no efforts
were made to reach out to groups in wider society or to inform people about what
was happening. One art critic wrote how surprising it was to find at the press con-
ference that almost none of the artists participating in the exhibition had turned
up – and that the media representatives were mainly Western: 'This means that the
radical idea is no longer able to unite people' (Khachaturov, 2008).

Two groups of performance artists, Voina and Bombila, were the most active
in demonstrating their support for Erofeev and Samodurov. In May 2008, Voina
performed in the street outside the Taganskii Court. Under their self-appointed
leader at that time, the linguist and philosopher Aleksei Plutser, they shouted slo-
gans and hung banners, such as 'Shame on Censorship' (Tsenzura – pozor), on a
van which they parked in the street, stopping the traffic (*Grani*, 2008). In May
2009, posing as music students, Voina brought musical instruments and mobile
amplifiers into the courtroom and started to sing 'All cops are bastards, remember
this'.[48] In July 2009 the Bombila group carried out an action outside the court.
Under the slogan 'A trial of artists is violence against justice', a person posing as
a Nazi officer, wearing an SS armband, whipped the goddess of jurisprudence, in
this case a male art activist, draped in white carrying a pink sword of Justice, while
loudly reading a poem about Russian history (*Grani*, 2009). One eyewitness wrote
in *Vremya novostei* that:

> The first I saw when I entered the courtyard of the Taganskii District Court
> was Themis (Femida), in torn clothes, being dragged out of the court build-
> ing by the guardians of law and order. The goddess of jurisprudence was
> being forced to leave, showing in farewell the fresh, bleeding scars on her
> flogged back. As it turned out, this striking metaphor for the trial of art was
> a natural end to the performance by the young artists of the Bombila group

Figure 4.4 Viktoriya Lomasko, 'Femida at the Taganka Court' from the series 'Forbidden Art' 2009

Source: V. Lomasko and A. Nikolaev, *Zapretnoe iskusstvo* (St Petersburg: Bumkniga, 2011). Courtesy of V. Lomasko.

using genuine birches in the beating of the allegorical Themis. This metaphor does not seem exaggerated. Under the conditions of a legal case being opened against the Forbidden Art exhibition there are so many inconsistencies that it is hard to talk about impartiality.

(Machulina, 2009)

At the final session on 12 July 2010, members of Voina released cockroaches on the stairway inside the court building. When the militia dragged a member of the group out of the building, he shouted to the people in the courtyard: 'The whole world is watching. We brought 1500 cockroaches to demonstrate that it is a cockroach-court that sentences Samodurov and Erofeev'. The religious–patriotic activists of the 'Crusaders' in the courtyard watched, brandishing their crosses as if to shield themselves from the influence of Satan (*Grani*, 2010b).

Nonetheless, Samodurov in particular was disappointed that the arts community did not pay more attention to the main issue raised by the exhibition – censorship.[49]

He found that people ignored the issue, instead supporting them to prevent a harsh sentence. He argued that the issue of censorship seemed to be taboo in Russia (Samodurov, 2009). However, the journal *Artkhronika* published several articles in support of the exhibition, on the issue of taboos and censorship in art history and invited artists and gallery owners to comment on the trial. Kosolapov commented that there was no space in Russia for art to discuss the problems of society in an aesthetic language, and that without such space any piece of art that comments on religion or other delicate issues becomes political (Fedotova and Kravtsova, 2008). Gelman highlighted the fact that the two were charged under the criminal code and not the civil or administrative codes, and that this was a decision by the state prosecutor. The website *Open Space* declared its support for the organizers, although it did not regularly report on the case.

As the end of the trial approached, the fear intensified that there would be a guilty verdict, and that the prosecutor would have it his way and Samodurov and Erofeev would be sent to a penal colony for three years. The threat against Samodurov was greater as he had been sentenced in the previous trial. Representatives of the arts community and intellectuals mobilized.

On 6 July 2010, one week before the verdict was announced, 12 artists sent an open letter to President Medvedev demanding that the legal case be stopped and all accusations dropped. The artists were well known internationally, among them Emilia and Ilya Kabakov, Oskar Rabin, Oleg Tselkov, Erik Bulatov, Vitalii Komar and Aleksander Melamid. They claimed that 'a guilty verdict would be a verdict against the whole of Russian contemporary art and one more step in the direction of the introduction of censorship in culture'.[50] Two days later, 100 well-known intellectuals, scholars, journalists, politicians, human rights activists and people from the arts demanded that Samodurov and Erofeev be acquitted.[51] The letter stated that, according to the Russian Constitution, 'artists and heads of secular cultural institutions have the right to freely display artworks independently of any judgements by external observers under the condition that the authors of the works concerned, specialists on contemporary art, and heads of cultural institutions where these pieces of art are exhibited are of the opinion that the works are not intended to humiliate the personality or the personal dignity of citizens'. They concluded that the 'Forbidden Art' exhibition had had no such intention.

The mobilization of the arts community was also reflected in Marat Gelman's public declaration that in the event of a guilty verdict he would reopen an extended version of the 'Forbidden Art' exhibition at his gallery at the Vinzavod. He warned that a guilty verdict would cause great harm to the image of Russia with the result that no foreign artist would want to participate in the next Moscow Art Biennale (*Grani*, 2010a). In the autumn of 2009, he had talked to members of the presidential administration about the possible repercussions of a guilty verdict and he therefore did not expect such a verdict.[52] Later, when the verdict was announced and only fines issued, Gelman did not live up to his promise to remount the exhibition. Nonetheless, his statement was a gesture of support at the time.

Independent commentators believed that the outcome of the legal process was decided at the highest political level, but that there had been uncertainty over the

possible consequences of a severe sentence. Before the verdict was announced, the Minister of Culture, Aleksander Avdeev, a former Ambassador to Paris, condemned the exhibition but emphasized that in his opinion the organizers should not be sent to a penal colony.[53] Vladimir Vigilyanskii, head of the press service of the Patriarchate, said the same (*Grani*, 2010c).

The arts community was relieved that the sentence meant only fines, but it was still a guilty verdict. The artist Dmitrii Vrubel expressed the opinion of many when he said that he was surprised that the state had sided with one party in this legal conflict:

> What happened was nothing more than an ideological or aesthetic dispute. There is one position and there is another. And this is absolutely normal. It is absolutely normal that there are people who hate contemporary art. This is the case not only in Russia but also in the whole world. Any new experimental thing is hated at the beginning, and after some years it is accepted. But most strange and horrifying to me is that the state took the position of one side in this ideological and aesthetic dispute, and called the position of the other side a criminal act.[54]

The ruling establishment in the country seemed satisfied with the verdict. The head of the Orthodox section of the pro-Putin youth organization Nashi, Boris Yakimenko, stated: 'People were responsible for blasphemy. Such a tangible punishment, I believe, will force these people to think next time what to exhibit and what reaction to expect. As soon as they want to provoke anybody, this punishment will arise before their eyes'.[55] After the verdict was announced, Patriarch Kirill felt free to publicly condemn the organizers of and the artists in the exhibition. He compared them to an infection in a human organism and argued that society must defend itself from such activities: 'When we see that an artist behaves vulgarly and, moreover, gushes out such nastiness and dirt –*chernukha* in today's parlance – then by all this he also contaminates others'.[56] Therefore, he said, society needs to confine infections when an artist provokes aggression, violates the spiritual–moral climate in society and creates conflicts between different religious and ethnic groups.

Conclusions

The convictions further heightened tensions. The Orthodox–patriotic activists felt encouraged to more actively try to bring the organizers of exhibitions, gallery owners and art journals to court. Anton Nikolaev, who together with Viktoriya Lomasko had reported from the trial and was responsible for a controversial street art exhibition in 2010, became one of their next targets. Another target was the Moscow Museum of Contemporary Art, where two sculptures in the courtyard incurred the wrath of churchgoers in the nearby church, who now started regular demonstrations in the museum courtyard. One of the sculptures, 'Crucifixion', showed Christ on a metal cross, while the other was named after the saint 'Sergei

Radonezhkin'. The museum removed both sculptures to avoid further conflict.[57] A third target was the prestigious journal *Artkhronika*, which had published a photograph of Kosolapov's 'Icon–Caviar' on the cover of its April 2010 issue (*Artkhronika*, 2010). Since this artwork had been involved in a case on extremism, the picture was now at risk of being regarded as an extremist picture. In September 2010 the offices of *Artkhronika* were raided by the Moscow Police unit on combating extremism (*Grani*, 2010e).

Even if many found the trial of the 'Forbidden Art' exhibition absurd, the guilty verdict negatively influenced the political atmosphere. Several art scandals followed in 2010. Works by Ter-Oganyan were seized by the Russian customs authorities in transit to an exhibition at the Louvre in Paris. Mavromati was refused an extension of his Russian passport in Bulgaria. Thus, previous art conflicts were given a second wind. The new director of the Tretyakov Gallery, Irina Lebedeva, declared that 'before exhibitions which are thematically connected with Christianity or religion as a whole, round-table discussions will be organized with representatives of the Russian Church'.[58]

Many from within the intelligentsia considered the trial political and disagreed with the verdict. Their view was expressed by a professor at the Institute of Cultural Studies: '[T]his is a case of political censorship which will not contribute to the stability of the country. Banning artistic statements has the most negative influence on culture and society' (Lebedev, 2010). It seemed that opinion against the verdict was spreading to wider society. *Time Out Moskva*, which did not normally deal with politics but only reflected what was on the minds of young cosmopolitan professionals, published a long report about the trial, illustrated by Viktoriya Lomasko's drawings direct from the courtroom. This was a clear statement of support for Erofeev and Samodurov. The article concluded that the trial had compromised the state, de facto deprived it of its status as secular, free and civilized, and violated common sense. Moreover, the procurator had not even followed the official line of the church, but had accepted the dicta of 'marginal figures and their utterly ignorant understanding of art' (Balakhovskaya, 2010).

The verdict was a sign of where the regime was heading. The criticism of the exhibitions at the Sakharov Centre had a religious–patriotic character and was in line with the ongoing process of forming an official Russian identity. It reflected an Orthodox construction of a 'We', promoted by the church and supported by the state authorities. Nevertheless, by the time the guilty verdict was announced protests against the trial were developing into criticism of the state authorities. The trial of the organizers of 'Forbidden Art' became a watershed in awakening the arts community and the intelligentsia. The trial contributed immensely to the formation of a counterculture within these groups.

Notes

1 For a discussion of 'generations', see Abrams (1982: 258), Edmunds and Turner (2002a and b), Roseman (1995) and Luecke (2003).
2 Hermann Nitsch (2010), 'Das Orgien Mysterien Theater' ('A Theatre of Orgies and Mysteries'), exhibition at the Stella Art Foundation, 2 October–14 November.

Paintings, photographs and videos of different actions, including the 122nd action at the Burgtheater in Vienna, 19 November 2005.

3 For reviews, see Soloviev (2010: 4).

4 *Utro. Ezhednevnaya elektronnaya gazeta* (2010).

5 See address of the Committee of Moral Revival of the Fatherland and Archpriest Aleksander Shargunov in *Russkii vestnik* (1999).

6 Reprinted at www.atheism.ru/Kovalev_1.phtml.

7 Although Ter-Oganyan lives in Prague, he remains part of the Moscow art scene thanks to Marat Gelman. His works are shown in various exhibitions, he has been nominated for arts prizes and he has participated in Russian exhibitions abroad. In the autumn of 2009 there was a large retrospective of the 1980s artists' collective 'Art or Death', of which Ter-Oganyan had been a member, at the State Museum of Contemporary Art of the Academy of Arts at Gogolevskii bulvar.

8 Nikita Alekseev (1999) in *Inostranets*, 27 January. Quoted by Andrei Kovalev (ed.) in *Moskovskii aktsionizm* (2007: 339).

9 'Za nravstvennoe vozrozhdenie otechestva, komitet', Zapreshchennoe iskusstvo, http://artprotest.org/index.php?option=com_content&view=article&id=293&chtoto=-q-q&catid=2&obvinitelirus&ordering2=2.

10 The mezhmunitsipalnaya prokuratora is the procurator of several districts.

11 See the 2008 interview with Oleg Mavromati at http://plucer.livejournal.com/86080.html.

12 Reprinted at www.guelman.ru/gallery/moscow/chelovek-x/view_print.

13 Reprinted at www.guelman.ru/gallery/moscow/chelovek-x/view_print.

14 Taken from the press release for the exhibition, www.old.sakharov-center.ru/museum/exhibitionhall/religion_notabene/hall_exhibitions_religion_reliz.htm.

15 For example, the painting by Francis Bacon (1953) that deconstructs the image of Pope Innocent X from a painting by Diego Velasquez (1650).

16 See Bodin (2009: 258–62), especially the chapter 'The Russian Court: Orthodox Church and Art, On the Exhibition "Ostorozno, Religiya!"'.

17 'Obshchestvennyi komitet 'Za nravstvennoe vozrozhdenie Otechestva', 2 February 2003, http://komitee.r2. ru/news_03_0202_Muzei_close.htm. Reprinted at: old.sakharov-center.ru/museum/exhibitionhall/religion_notabene/hall_exhibitions_religion_closemuesuem.htm.

18 'Tvocheskaya intelligentsiya o sude po delu vystavki 'Ostorozhno, religiya!', Publikatsii SMI 10 October 2008, www.demos-center.ru/publications/416.html. Quoted in Per-Arne Bodin (2009: 267–68).

19 For documents related to the exhibition, see http://old.sakharov-center.ru/museum/exhibitionhall/forbidden-art.

20 Other participating artists were: Vyacheslav Sysoev, Aleksander Savko, Vagrich Bakhchanyan and Vikentii Nilin. All the works can be viewed at www.aerofeev.ru/index.php?option=com_content&view=article&id=303&Itemid=165.

21 Author's interview with Andrei Erofeev, Moscow, December 2009.

22 As told by Sergeev and Nalimov at the session of the Taganskii Court on 19 June 2009.

23 'Narodnaya zashchita: Glumlenie nad pravoslavnymi svyatynyami – eto prestuplenie', *Pravoslavnoe informatsionnoe agentstvo Russkaya liniya*, 19 November 2007, www.rusk.ru/newsdata.php?idar=174266.

24 'Tekst obvineniya peredannyi Taganskoi prokuratoroi g. Moskvy v sud: Dokumenty po ugolovnomu delu No 402588 o vystavke "Zapretnoe iskusstvo – 2006" poluchennye iz prokuratury', http://old.sakharov-center.ru/news/2007/forbidden-pollice/accusation-samodurov.php.

25 The investigator's report by the Procuracy of 15 May 2008 is available (in Russian) at old.sakharov-center.ru/news/2007/forbidden-pollice/1505posttext.php.

26 Paragraph 2 of article 282 refers to the use of one's official administrative position.

27 See the manifesto in the journal *Narodnyi sobor* no. 1 (2009), which calls for a political system based on Russian Orthodoxy.

28 Narodnaya zashchita: Gosudarstvo dolzhno zashchitit nashikh detei ot rastleniya, a nashi svyatyni – ot poruganiya', *Drevo, Russkaya pravoslavnaya entsiklopediya*, 2 February, drevo-info.ru/news/31.html.

29 Author's notes of the proceedings.

30 The objects at the exhibition can be viewed at www.aerofeev.ru/index. php?option=com_content&view=article&id=303&Itemid=165.

31 Aleksander Kosolapov, personal correspondence with the author, 24 January 2014.

32 'Chto takoe Narodnyi sobor?' (2011), http://mosnarodsobor.ru/?page=articles&id=1.

33 Since 2004 he had tried to take action against the gallery owners Marat Gelman and Aidan Salakhova, the 'Proun' gallery, the artist Elena Kheidiz, the Kaliningrad Puppet Theatre, the Academician Vitalii Ginzburg, the National Centre for Contemporary Art, the writer Viktor Erofeev, and Andreii Erofeev for the exhibition Sots-Art and the 'Forbidden Art' exhibition (Machulina, 2009).

34 See 'My ne tolko nauchilis soprotivlyatsya, no i oderzhivaem pobedy', *Pravaya.ru. Radikalnaya ortodoksiya*, no. 6, June 2006, http://pravaya.ru/word/586/7885.

35 Oleg Kassin is also the director of Narodnaya zashchita. Sergeev is a major figure in Narodnyi sobor.

36 See the Narodnaya zashchita website: http://maponz.info/index.php.

37 For an overview of such organizations, see Soldatov (2007).

38 Compare 'Gelmana i Samodurova tolko mogila ispravit', *Pravoslavnoe informatsionnoe agentstvo. Russkaya liniya*, 17 March 2007, rusk.ru/newsdata.php?idar=170933.

39 By the time the trial started, both Samodurov and Erofeev had lost their jobs.

40 Calculated by the defence lawyer Anna Savitskaya (*The New Times*, 2010).

41 Author's notes of the proceedings, September 2009.

42 For reports of the court proceedings, see the reports by Vera Vasileva on www.hro.ru and such as Vasileva (2010a); see also Aisenberg (2010) and *The New Times* (2010).

43 For Nalimov and Sergeev, the court case was a serious battle. As Sergeev left court after one session in which the witnesses had been embarrassingly weak, he told his followers that the heavy artillery would be brought out next time. The heavy artillery was Oleg Kassin, a co-chairman of Narodnyi sobor.

44 From the author's reports from the trial.

45 For more about the Orthodox Banner bearers, see Engström (2011).

46 On 20 March 2003 a letter of protest was sent to the Taganka Court, signed by more than 30 artists and people from museums; see http://old.sakharov-center.ru/museum/ exhibitionhall/religion_notabene/hall_exhibitions_religion_pismo_hydognikov.htm. Nonetheless, the reaction remained low-key until 2004. A petition in support of the organizers was started in December 2004, and within three months more than 400 people from Russia and abroad had signed it. 'Obrashenie tvorcheskoi intelligentsii po povodu presleduvaniya ustroitelei i uchastnikov "Ostorozhno, religiya"', http://old. sakharovcenter.ru/museum/exhibitionhall/religion_notabene/obrash271104.htm.

47 See the letter in support of Andrei Erofeev, 'Pismo v zashchity Andreya Erofeeva', www.gif.ru/themes/society/erofeev/list.

48 Author's interview with Petr Verzilov, Moscow, August 2011.

49 Author's interview with Yurii Samodurov, Moscow, July 2009.

50 'Obrashchenie khudozhnikov k prezidentu v zashchitu Yuriya Samodurova i Andreya Erofeeva. 6-ogo iyulya 2010'. Text on the website of Ekho Moskvy. Accessed through 'Khudozhniki poprosili Medvedeva ostanovit presledovanie organiztorov "Zapretnogo iskusstva"', Organization for Human Rights, 6 July 2010, www.hro.org/node/8678.

51 'Otkrytoe obrashchenie v svyazi s sudom nad organizatorami vystavki "Zapretnoe iskusstvo-2006" 8.7.2010', Organization for Human Rights, 8 July 2010, www.hro. org/node/8705.

52 Author's interview with Marat Gelman, Moscow, December 2009.

53 'Ministr kultury: nelzya primenyat ugolovnyi kodeks v dele o "Zapretnom iskusstve"', Organization for Human Rights, 29 June 2010, www.hro.org/node/8622.

54 'Delo protiv Erofeeva i Samodurova imeet yavnuyu politicheskuyu podopleku', Organization for Human Rights, 9 July 2010, www.hro.org/node/8711.
55 'Radioprogramma "Grani vremeni". Itogi sudebnogo protsessa po delu organizatorov vystavki 'Zapretnoe iskusstvo' obsuzhdaem s odnim iz podsudimykh Yuriem Samodurovym i rukovoditelem pravoslavnogo obshchestva "Radonezh"', Evgeniem Nikiforonovym, 12 July 2010, www.svobodanews.ru/content/transcript/2099008.html 12 July 2010.
56 RIA Novosti quoting Patriarch Kirill, 22 July 2010, accessed through *Grani* (2010d).
57 'Moskovskii muzei sovremennogo iskusstva ubral oskorbitelnuyu dlya pravoslavnykh skulpturnuyu kompozitsiyu', Interfax, 22 July 2010; 'Pobedil bog i proslavlen bog: koshchunstvennye skulptury v tsentre Moskvy demontirovany', Russ-front. Informatsionnyi pravoslavnyi vestnik, 21 July 2010, www.rusfront.ru/108-pobedil-bog-i-proslavlen-bog-koshhunstvennye-skulptury-v-centre-moskvy-demontirovany. html. A whole campaign had preceded this event, including letters to the Patriarch pleading for assistance; see www.ortdx.ru/forum/jnrhfnhfgjhgj/.
58 See www.bogoslov.ru, 21 July 2009, quoted by Bode (2010: 68).

References

Abrams, Philip (1982), *Historical Sociology* (Somerset, UK: Open Books Publishing), p. 258.

Aisenberg, Valerii (2010), 'Protsess', *Open Space*, 23 October, www.openspace.ru/art/projects/132/details/13101/page1. Reposted on os.colta.ru/art/projects/132/details/13101

Alchuk, Anna (2003), ' "Ostorozhno, religiya". Predvaryayushchie vystavku, teksty uchastnikov proekta' (Sakharov Centre), www.old.sakharov-center.ru/museum/exhibitionhall/religion_notabene/hall_exhibitions_religion3.htm#alchuk.

Arkhangelskaya, Alla (2003), 'Ostorozhnei s ikonami', *Nezavisimaya gazeta*, 17 January, www.ng.ru/culture/2003–01–17/7_extremism.html.

Balakhovskaya, Faina (2010), 'Delo Erofeeva i Samodurova', *Time Out Moskva*, 5–11 July, www.timeout.ru/journal/feature/12274.

Bode, Mikhail (2010), 'Neulovimye zapretiteli', *Artkhronika* 12: 68.

Bodin, Per-Arne (2009), *Language, Canonization and Holy Foolishness: Studies in Postsoviet Russian Culture and the Orthodox Tradition* (Stockholm: Stockholm University).

Demidova, Elena (2010), 'Vinovny bez sroka: Spory vokrug "Zapretnogo iskusstva" ne zakonchatsya s prigovorom suda', *Nezavisimaya gazeta*, 21 July, www.ng.ru/authors/14764.

Drevo. Russkaya pravoslavnaya entsiklopediya (2006), 'Narodnaya zashchita: Gosudarstvo dolzhno zashchitit nashikh detei ot rastleniya, a nashi svyatyni – ot poruganiya', 2 February, drevo-info.ru/news/31.html.

Dyakonov, Valentin (2007), 'Klevetniki Rossii', *Artkhronika* 11: 95.

Edmunds, June and Turner, Bryan S. (2002a), *Generations, Culture and Society* (Philadelphia, Penn.: Open University Press).

Edmunds, June and Turner, Bryan S. (eds.) (2002b), *Generational Consciousness, Narrative and Politics* (Lanham, Md.: Rowman & Littlefield).

Engström, Maria (2011), 'Ortodoxi eller död: Den ryska ortodoxa radikalismen', www.ucrs.uu.se/digitalAssets/51/51638_OrtodoxiEllerD_dMariaEngstr_m.pdf.

Erofeev, Andrei (2010), 'Otkrytoe pismo Patriarkhu Moskovskomu i vseya Rusi Kirillu', *Grani*, 8 June, www.grani.ru/blogs/free/entries/178759.html.

Fedotova, Elena and Kravtsova, Mariya (2008), 'Kuratorov nazvali obvinyaemymi', *Artkhronika* 6: 68–71.

Grani (2007), 'V zashchitu svobody tvorchestva', *Grani*, 29 November, http://grani.ru/Politics/Russia/p.130621.html.

Grani (2008), 'Sobytiya: Aktsiya v podderzhku Andreya Erofeeva i protiv tsenzury v iskusstve', 22 May, http://grani-tv.ru/entries/301.

Grani (2009), 'Sobytiya: Sud nad Samodurovym i Erofeevym: aktsiya khudozhnikov', 29 May, http://grani-tv.ru/entries/773.

Grani (2010a), 'Marat Gelman gotov povtorit vystavku "Zapretnoe iskusstvo, 2006"', 23 June, http://grani.ru/Culture/art/m.179203.html.

Grani (2010b), 'Sobytiya: Sud nad "Zapretnym iskusstvom": den prigovora', 12 July, http://grani-tv.ru/entries/1250.

Grani (2010c), 'Zashchita organizatorov "Zapretnogo iskusstva" obzhalovala prigovor', 13 July, www.grani.ru/Culture/art/m.179787.html.

Grani (2010d), 'Patriarkh: Obshchestvo dolzhno zashchitit sebya ot pakostnichayushchikh khudozhnikov', 23 July, www.grani.ru/Culture/art/m.180095.html.

Grani (2010e), 'GUVD Moskvy proveryaet zhurnal "Artkhronika" na extremizm', 9 September, www.grani.ru/Politics/Russia/m.181495.html.

Grebelnikov, Igor (2000), 'Dvazhdy pribitomu khudozhniku shyut statyu', *Kommersant Vlast*, 3 October, reprinted at www.guelman.ru/gallery/moscow/chelovek-x/view_print.

Groys, Boris (2010), *History Becomes Form: Moscow Conceptualism* (Cambridge, Mass. and London: MIT Press).

Interfax (2010), 'Prigovor organizatoram vystavki "Zapretnoe iskusstvo" vstupil v silu', 4 October, www.interfax-religion.ru/bel/?act=news&div=37634.

Kabanova, Olga (2000), 'Geroi i antigeroi na art-stsene', *Izvestiya,* 26 September, reprinted at www.guelman.ru/gallery/moscow/chelovek-x/view_print.

Khachaturov, Sergei (2008), 'Otkole "dokole"?', *Vremya novostei,* 30 May, www.vremya.ru/2008/94/10/205009.html.

Kovalev, Andrei (2003), 'Ne vedayut, no tvoryat', *Kommersant-Vlast*, 10 February, reprinted at www.atheism.ru/Kovalev_1.phtml.

Kovalev, Andrei (ed.) (2007), *Moskovskii aktsionizm* (Moskva: Izdatelstvo WAM).

Kulik, Irina (2003), 'Blagochestivyi pogrom', *Kommersant*, 20 January, www.kommersant.ru/doc/359786.

Lebedev, Aleksei Valentinovich (2010), 'Nelzya sudit tvortsa: Zapret na svobodu samovyrazheniya i ego posledstviya', *Nezavisimaya gazeta*, 7 July, www.ng.ru/events/2010-07-07/3_sud.html.

Leontiev, M. (2007), 'Provokatorov bit bespolezno: nuzhno sazhat i nadolgo', 26 March, http://uncensored.km.ru/index.asp?data=23.03.2007%2017:35:00&archive=on, available at radonezh.ru/monitoring/11168.html.

Lomasko, Viktoriya and Nikolaev, Anton (2011), *Zapretnoe iskusstvo* (Sankt Petersburg: Bumkniga).

Luecke, Tim (2009), 'Generations and Change in International Politics: The Case of the Generation of 1914', www.learningace.com/doc/6029509/.

Machulina, Diana (2009), 'V otsutsvie femidy. Sud nad Andreem Erofeevym i Yurem Samodurovym perenesli v tretii raz', *Vremya novostei*, 1 June, www.stengazeta.net/article.html?article=6216.

Maslova, Evegeniya and Ursulov, Dmitrii (2008), '"Khuliganskoe" iskusstvo', *Kasparov. ru,* 29 May, www.kasparov.ru/material.php?id=483EA9D81876C.

New Times (2010), 'Iskushenie iskusstvom: Blizitsya k zaversheniyu protsess nad organizatoram vystavki "Zapretnoe iskusstvo"', 28 June, http://newtimes.ru/articles/detail/23753.

RIA Novosti (2007), 'Intervyu Yuriya Samodurova, direktora Muzei imeni Andreya Sakharova: "Menya khotyat posadit"', 15 June, http://old.sakharov-center.ru/news/2007/forbidden-pollice/texts.php?subaction=showfull&id=1181898900&archive=&start_from=&ucat=1&.

Roseman, Mark (ed.) (1995), *Generations in Conflict* (Cambridge: Cambridge University Press).

Russkii vestnik (1999), 'Satanisty. Obrashchenie obshchestvennogo komiteta "Za nravstvennoe vozrozhdenie Otechestva" (Address of the Committee of Moral Revival of the Fatherland and Archpriest Aleksander Shargunov). Reprinted http://krotov.info/acts/20/1990/1998oganyan.htm.

Sakharov Centre (2007), 'Tekst obvineniya peredannyi Taganskoi prokuratoroi g. Moskvyvsud: Dokumenty po ugolovnomu delu No 402588 o vystavke "Zapretnoe iskusstvo, 2006"' peredannyevsud', http://old.sakharov-center.ru/news/2007/forbidden-pollice/accusation-erofeev.php.

Salnykov, Vladimir (2001), 'Kultura ili kult?', *Khudozhestvennyi zhurnal* 32, www.guelman.ru/xz/362/xx32/xx3217.htm.

Samodurov, Yurii (2009), 'Vystuplenie na presskonferentsii 27 May 2009', Paper distributed by Yurii Samodurov, 'Iskusstvo tabu', 6 August 2009, www.kasparov.ru/material.php?id=4A7AA264EDC1B.

Shtutina, Yuliya (2008), 'Neostorozhnoe iskusstvo', *Lenta.ru*, 13 May, http://lenta.ru/articles/2008/05/13/trial/.

Soldatov, Alexander (2007), 'Ne dadim v obidu Boga! . . . ', *Ogoniok* 33, www.ogoniok.com/5009/14/.

Soloviev, Sergei (2010), 'Krovavyi rezhim', *Novye izvestiya* (6 October): 4.

Utro. Ezhednevnaya elektronnaya gazeta (2010), 'Rossiiskie khudozhniki obyavili Luvru boikot', 27 September, www.utro.ru/articles/2010/09/27/925032.shtml.

Vasileva, Vera (2009), 'Komu meshaet Sakharovskii tsentr?', 22 June, www.hro.org/print/5842.

Vasileva, Vera (2010), 'Taganskaya Femida razocharovala vsekh', 12 July, www.hro.org/node/8730.

Volchek, Dmitrii (2010), 'Vertikal dlya khudozhnikov. "Dela zhurnala Artkhronika" i videoartista Olega Mavromati', *Radio Svoboda*, 16 September 2010, www.svobodanews.ru/content/transcript/2159819.html.

Zaitseva, Natalya (2009), '7 voprosov Andreyu Erofeevu, iskusstvovedu: o zapretnom', *Russkii reporter*, 23 July, www.rusrep.ru/articles/2009/07/23/7qest_erofeev.

5 Dissent in art

The performances by the Voina and Bombila art groups outside the Taganskii Court in support of the accused in the trial of the 'Forbidden Art' exhibition were part of an evolving phenomenon in Russian contemporary art – an expression of open dissent in relation to the dominant official consensus. In contrast to the more subtle art of the 'other gaze', discussed in Chapter 3, dissent art is defined by a pronounced disagreement with the 'proper order of things'. It is not political in the traditional sense. Moreover, it cannot be interpreted literally. This ambiguity is used by the artist or the curator as a shield against criticism from the authorities, but it can also attract criticism from friends and supporters that the statement is not spelled out clearly enough.

First and foremost, this art plays on phantasmagoria, the absurd and laughter. Dissent art follows the tradition of the 'ontological anarchism' of the early avant-garde of the 1910s, and the joke, irony, parody and mockery of the Sots-Art of the 1970s and 1980s. In her study of the early Russian avant-garde, Nina Gurianova defines ontological anarchism as a 'variant of anarchism . . . inspired not by a notion of social utopia, which inevitably calls for a temporal, epochal 'closure', but rather a by-product of philosophical anarchism, namely dystopia, with its paradoxical mixture of nihilism and "openness"' (Gurianova, 2012: 7). The early avant-gardists sought freedom for creativity and took a stand on breaking down fixed myths, perceptions, concepts and norms. Gurianova describes their views as 'the politics of the non-political', in that they took a social and ethical stand without spelling out their political sympathies (Gurianova, 2012: 10). Drawing a clear line between ontological anarchism and political anarchism, she says that, if anything, the political views of the early avant-gardists were closest to an individually based anarchism. The underground Sots-Art of the 1970s and 1980s continued the tradition of the early avant-garde, as do the artists of dissent art presented in this chapter. Like their predecessors, the dissent artists of the 2000s conveyed their disagreement with contemporary society without making political demands.

This art also refers back to the carnival culture of medieval times of jokes, mocking, parodying and laughing at everything sacred and established represented by the authorities, church or state (Ozerkov, 2009). The carnival culture created an anti-world – a world of topsy-turvy – in which the world of the real,

with its pretensions of decency, organization and cultivation, was replaced by its mirror image of a chaotic, unstable world of the ugly, low and indecent (Yurkov, 2003). The contemporary Russian understanding of carnival culture is heavily influenced by Mikhail Bakhtin. Bakhtin used the term *carnival* both in the sense of the popular culture of the marketplace, fairs and celebrations and of developments that make use of the carnival spirit. Both senses assume a split between official and unofficial ideologies (Platter, 2001: 55).[1]

The risk that a work of dissent art might be interpreted literally and seriously and thereby be misinterpreted was illustrated by Avdei Ter-Oganyan and his Radical Abstractionism series (see Chapter 3). His combination of geometric shapes and abstract statements giving the triangles, circles, squares and lines an anti-constitutional content had an absurd dimension. The contrast between the stated content and the image made it obvious that they could not be interpreted literally, although that is precisely what occurred when the works were caught up in scandal. Commenting on the reaction to his series, Ter-Oganyan explained, 'A work of art should be seen in the context of art. . . . If one were to take works from my Radical Abstractionism series at face value, I could be accused of a number of charges, from abetting the use of drugs to genocide (actions aimed at complete or partial annihilation of a people). This work is definitively provocative, so if anyone wants to take me to court, please do' (Ter-Oganyan, 2010: 58). He was proved right – the work became a target of the authorities because they interpreted it literally. In 2010, it was explained that action had been taken to prevent the series from being sent to an exhibition in Paris because 'there were doubts that the texts would be properly interpreted by a broad, unprepared audience . . . by individual unprofessional or partisan media representatives'.[2]

A distinction is made below between gallery dissent art and dissent art that was exhibited or performed outside a gallery, such as street art, performances and graffiti.

Gallery art

The group 'Sinie nosy' (Blue Noses) has followed from its very beginning in the tradition of the trickster with deceptions, jokes and provocations.[3] Created in Novosibirsk in 1999 by Aleksander Shaburov (born in 1965) and Vyateslav Mitin (born in 1962), they showed the series 'Mask Show: Political Dances' at the 'Rossiya 2' exhibition in 2005.[4] In photomontages, Putin was shown in bed with various international celebrities, such as George W. Bush, Osama bin Laden and Yulia Timoshenko (see Figure 5.1). The artists claimed that they told the naked truth. Concerning themselves with contemporary art and using the techniques of the twentieth century, they transform the 'actual visuality' from the television screen by reducing it to absurdity. Choosing a popular form that anybody can understand, they show the world the way they understand it.[5] Their pictures gave the viewer a good laugh, although some interpreted them as provocative and irreverent. Sinie nosy belonged to the Gelman Gallery and their works were exhibited there after they were removed from exhibitions at state museums.

Figure 5.1 Sinie nosy, 'Mask Show: Political Dances' 2001 (colour photography)
Source: Courtesy of Sinie nosy.

A portrait of two male policemen in uniform kissing each other in a typical Russian landscape of birch trees and snow, called 'The Era of Mercy', made Sinie nosy world famous in 2007 (see Figure 5.2). This was very much thanks to the then–minister of culture, who reacted strongly, calling it 'pornography' and a 'shame on Russia' (GiF.ru, 2007). In fact, the work was an homage to the British graffiti artist Banksy, who in 2004 had made his 'Kissing Bobbies'. Dmitrii Golynko-Volfson explained the minister's negative reaction: 'The censor's indignation towards Sinie nosy was motivated by the circumstance that the artists (possibly unaware of doing so) painted the authorities the way they never want to see themselves – weak, sentimental, desirous, incoherent and merciless, that is, the way they are nonetheless seen in contemporary cultural mythology' (Golynko-Volfson, 2008).

Sinie nosy also played with the Russian nationalist discourse. The photo collage 'Inno, Nano, Tekhno' (2008) by the group referred to a piece of classical Russian art, 'Three Bogatyrya', the famous painting from the late nineteenth century by Viktor Vasnetsov of three medieval warriors from Russian folk legend. Sinie nosy replaced the warriors with three fat, bare-breasted women on horseback, dressed only in traditional knitted folk headgear (kokoshniki). The inscription, Inno, Nano, Tekhno, was an ironic play on the then–President Medvedev's buzz words – innovation and nanotechnology.

Figure 5.2 Sinie nosy, 'The Era of Mercy' 2007 (colour photography)
Source: Courtesy of Sinie nosy.

The group became known in early 2000 and participated in most large exhibitions of contemporary art at home and abroad, such as the 2003 and 2005 Venice Biennales of Contemporary Art. The authorities, however, did not want such works exhibited abroad. Consequently, the 'Mask Show' was confiscated at Sheremetevo Airport in October 2006, when a British gallery owner tried to take it to a London exhibition. Similarly, in May 2007 the Russian customs authorities confiscated another work by Sinie nosy that was on the way to an exhibition in Dresden.[6] In October 2007 the work 'The Era of Mercy' was seized while being transported to an exhibition about Sots-Art at the Louvre in Paris (Golynko-Volfson, 2008; Artinfo.ru).

Setting an agenda of anarchism

Another example of gallery dissent art was the group PG. The acronym has been variously interpreted as Prestupnaya gruppa (Criminal Group), Protivotankovaya gruppa (Anti-tank Group) or Pozharnyi gidrant (Fire Hydrant) (Degot, 2000). Formed in 1998, the group was invited to mount its first exhibition at the New Tretyakov Gallery in 2003.[7] By the second half of the first decade of the twenty-first century, it had established a wide reputation in the Moscow art world.

Radical in its artistic gestures and positions, the group took a clear leftist anarchist position in the European tradition, in the sense of being anti-establishment, anti-authoritarian, anti-fascist and anti-racist. It opposed the political establishment, the art establishment and the commercialization of art and society, and questioned established norms and concepts. Even so, the group became the darling of the contemporary art scene. In spite of the radical political gestures, PG was perceived first and foremost as an art group (*The New Times*, 2009). The group consisted of Ilya Falkovskii, Aleksei Katalkin and Boris Spiridonov, although some of the names used were aliases (Degot, 2000).

The group drastically exaggerated both form and language, and took its messages to the extreme. Ilya Falkovskii explained that irony and jokes were the best instruments for expressing serious ideas. 'We considered that serious things are better presented through the prism of irony. What is said with pathos, people usually receive badly'.[8] '[A]rt is for us a method to initiate discussion about serious things on topics we find important'. The group's approach was outspokenly political: 'We are in favour of an art that is subordinated to goals that are important to us. These are freedom of conscience, anti-totalitarianism, anti-fascism, anarchy and a future society without hierarchies in a national, religious, state or intellectual sense'.

According to Falkovskii, art played the role of a convenient cloak for their ideas.[9] PG wanted its art to expose myths, prejudices and concepts that were contrary to its understanding of freedom, equality and justice. Russia has always been obsessed by myths about 'strangers', he said, and the task of the group was to deconstruct these myths: 'Russians find Zionists, immigrants, Americans and whoever else to be dangerous enemies in a conspiracy against Russia'. PG exposed these prejudices, myths and fears, and played on them: 'There is a fear of a "Yellow Threat", we show it. There is a fear of civil war, we expose it'.[10] He saw the task of PG as a kind of medical treatment for prejudices: 'When people see their fears, view them from the side, view themselves and their fears – this can have a therapeutic effect', Falkovskii added with a smile. 'Art', he continued, 'is like a barometer of fears and social moods in the minds of people'.[11]

Falkovskii's interest in socially oriented art and his anti-hierarchical approach made the PG group opposed to art institutions of 'high culture', or museums and galleries that show contemporary art for a narrow audience. The PG members wanted their art to be understood by everyone, but they were also against mass culture for which the purpose is only entertainment. Declaring that they were trying to find a new language of art, one that could easily be understood by the people outside the galleries, PG spoke of a child as the ideal viewer – someone free from preconceptions. The new language should be cleansed of conventional symbols that build on domination, subordination and intellectual superiority (*Almanakh PG*, 2009).

As radical anarchists in many aspects of life, PG group members turned their backs on the system, including the official gallery world, and urged others to do the same. Falkovskii wanted to see a process of self-organization take place among artists, where they would come together, discuss, organize exhibitions,

make films and act together: 'The purpose of art is to provide a space for communication'.[12] Therefore, the system of power became an object for investigation: 'We are interested in the phenomenon of power in any country – and not only the phenomenon of political power, but one person's power over another person. We are interested in how this power is created, how it is demonstrated in everyday life, and how it is expressed in prejudices – for example, against people of a different religion, nationality, against gays and lesbians. . . . We are against every kind of centralized power and all hierarchies'(*The New Times*, 2009).

They played a role of artists at the margins of society, but had an established position in the art world, with exhibitions in Moscow and Paris. Their genre became a kind of multimedia comic in which photographs and graphics were presented together with video and the group's music. They often acted as in a role play, playing the role of terrorists or bandits, or whatever was needed for the project. The contemporary art community did not take their calls for revolution too seriously but found their provocations exciting. Even so, their art had a political edge.

Their art works also met with resistance. The 2003 exhibition at the Tretyakov Gallery was closed due to the reaction to one work about the sexual and drug fantasies of a teenager. In the spring of 2007, the group was invited to participate in the Sots-Art exhibition at the Second Moscow Biennale of Contemporary Art. At the last minute, however, its contribution, a series of photographs called 'Slava Rossii'– a play on words that can be translated as Glory to Russia or Glory of Russia – was removed from the exhibition (Droitkur, 2007: 104–5).[13] The series included comments on burning topics. Their allusions to corruption and nepotism, and depictions of men in military uniform, dollar bills and naked women made the photographs highly controversial (see Figure 5.3). The photographs were instead shown at the 'Forbidden Art' exhibition at the Sakharov Centre in March that year, and thus became part of the scandal that followed. In October, the group became the target of another scandal when the authorities tried to prevent the Slava Rossii series and works on the topic of a Chinese invasion from being sent to the Paris exhibition on Sots-Art (*Art-info*, 2008).

Nonetheless, in 2008 PG was awarded the Kandinsky Prize in the category Best Media Art Project for a work called 'Mounting Mobile Agitation', a two-sided installation of lightboxes. The PG group described the work in the exhibition catalogue as combining:

> . . . actual and imagined reality. The hero of the installation is the contemporary Russian teenager, despairing of his existence in the closed world of the everyday – he is the little man, the average man, who dreams about another reality in the future. But his illusory reality is aggravated by collective fears, phobias, the fear of the strange and unknown – the individual consciousness is not simply penetrated by clichés of the mass media consciousness but is produced by them, and it is impossible to distinguish the individual himself from the image created by mass communications. So in the imagination of our hero, the hope for liberation turns into the expectation of global warming,

Figure 5.3 PG Group, from the series 'Slava Rossii' (text reads 'Glory of Russia/Glory to Russia') 2007 (photo collage)

Source: Courtesy of I. Falkovskii.

and apocalyptic pictures of fratricidal war alternate with scenes of a possible Chinese invasion. The assimilation of cognitive space ended long ago, the circle has closed and there is nowhere to break out of it – and, in fact, there is no one to do it.

(*Kandinsky Prize*, 2008).

On one side of the installation, graphically depicted in comic book form, was the lost hero and his fantasies, mainly of a sexual nature. The other side consisted

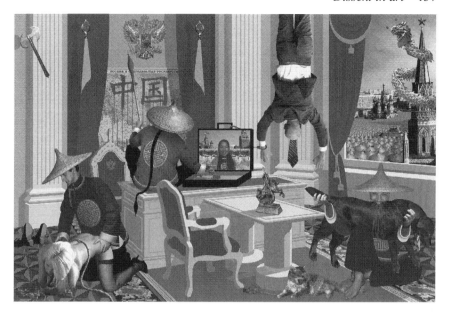

Figure 5.4 PG Group, part of 'Mounting Mobile Agitation' 2008 (mixed media)
Source: Courtesy of I. Falkovskii.

of a lightbox showing fantasies of a Chinese invasion of the presidential office in the Kremlin, with Red Square full of Chinese soldiers visible through the window (see Figure 5.4). The Chinese invaders were depicted raping and hanging the Russians in the office.[14] PG had thereby managed to combine and present two works that had previously been removed from exhibitions and have them awarded the prestigious Kandinsky Prize.

At the prize ceremony, the group members mounted the stage wearing balaclavas, to the amusement of an audience consisting of members of the art community and the business elite, as well as art dealers and collectors.[15] From the stage they declared that those sitting in the audience did nothing but live as if they were on an island of stability. Falkovskii recalled his own words: 'We have an ongoing crisis. Unpleasant and deadly boring. Uninvited and unexpected . . . it is there nonetheless. And nobody knows what will come next. In about three to four months. Just imagine, we say that people will take to the streets. People like us. People in masks, people without faces. Those who now return by metro and trains to the suburbs. Just think about that. At least for a minute . . .' As the group members recalled, 'The audience in their chairs applauded. We turned and left the room.'[16]

Another multimedia work, 'Purification', exhibited in 2009 at the Krasnyi Oktyabr art centre, was an uncompromising attack on the art establishment (see Figure 5.5). In an installation of lightboxes and a video, the screen at the top showed people gathering for a fancy vernissage of an art exhibition in the presence of well-known figures from the art and business establishment. The mid-level

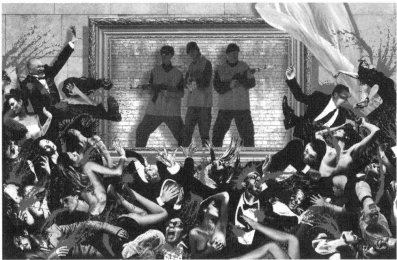

Figure 5.5 PG Group, 'Purification' (Ochishchenie) 2008 (mixed media)
Source: Courtesy of I. Falkovskii.

screen showed people mingling in front of a large painting, waiting for it to be unveiled. On the lower-level screen, a video showed a group of terrorists bursting from the frame of the painting, shooting. Well-dressed people lay dead on the floor in front of them.

Falkovskii was both surprised and disappointed when the gallery owner approached him after the exhibition, asking to buy the work for a client. The PG group wanted to make a statement against the commercialization of the art world and to start a discussion. Instead, they were being asked to sell the work to one of those being criticized. Their work had become one more commercialized product on the art market.[17]

The liberal intelligentsia regarded PG as avowedly anti-racist and anti-fascist. *The New Times* (2009) called them 'artists with a civic position'. Ilya Falkovskii was also behind a handbook for anti-fascists, which was published on the Internet and played a significant role in the creation and practical work of anti-fascist groups throughout Russia.[18]

In October 2009, the group's 'This Is the End' exhibition was part of the programme of the Moscow Art Biennale at the Vinzavod and the newly opened Zhir Gallery, which specialized in protest art. One of the exhibited works, 'The Death of Gods', dealt specifically with the issue of racism and xenophobia. A multimedia video and music lightbox showed two black men walking peacefully through a suburb being attacked and killed by a gang of white racist skinheads.[19] The work was extremely violent, but the message was anti-racist and anti-fascist.

PG produced works of art with a radical anarchist message that at the same time carried complicated layers of meaning and interpretation. They played excessively on symbols of aggression, frustration and violence, directed against the system, the establishment, and their myths and concepts. It is intriguing that the group was so well received in the art community. They were appreciated not only for their professional skill, but also for their irreverent play in which they lived out forbidden fantasies.

In parallel with the art exhibited in galleries, PG also presented works on its website which intended to depict fantasies and the fear of civil war but also reflected weapon fetishism and romanticized violence. The video 'PG Dreli Vampyre' shows a young man in a balaclava entering an apartment next to the Kremlin who starts shooting through the window at the presidential motorcade to the background music telling how the former girlfriend had left him.[20] In another video, 'Somalia is Already Here', group members dressed as terrorists fake an attack on the president's motorcade and on official buildings.[21] Other works contained outright criticism of Putin: one photo montage included genitals illustrating the most humiliating Russian swearwords (Quenelle, 2011). Even though people in the Moscow art world knew that these pieces could not be interpreted literally, they gave rise to an intense debate. They would also later cause trouble for Falkovskii. The authorities already had their eye on the group. By then, however, Falkovskii had become disillusioned about the possibility that art could contribute to a serious discussion of societal issues.[22]

Against the lifestyle of the establishment

In line with the anti-establishment focus of PG, the Protez art group consciously provoked different aspects of what could be called the conventional bourgeois way of life. The Protez group was formed in St Petersburg in April 2006 by Grigorii Yushchenko, Igor Mezheritskii and Aleksander Vilkin. Yushchenko (born in 1986) became the best-known member of the group and was nominated for the Kandinsky Prize in 2008 and 2010.[23] The Protez group declared that its purpose was to expose the 'total idiocy in the surrounding reality'. They were, therefore, as they explained, carrying out a kind of anthropological study of human life. As early as 2006, in their first large exhibition, the group demonstrated its favourite themes – 'sex, violence, drugs, madness and war' (NOMI, 2008). Their genres included remaking advertising posters by painting over what they found in the street. The group became part of the established art world at an early stage, first in St Petersburg and later in Moscow.

In April 2008, Protez caused a scandal in St Petersburg with the exhibition 'Advertisement for Drugs'. The exhibition consisted of paintings on posters, with the logos of the original advertisement left visible. The paintings and texts were satirical and provocative in both form and content. Most of the drugs were legal products that could be bought at any Russian pharmacy. Acetone, for example, was called 'an old friend in a new package'. A painting about cocaine had the accompanying text: 'not on sale everywhere: Ask for it in elite institutions in the city' (see Figure 5.6).[24] The State Committee Against Drugs considered the exhibition propaganda for drugs and an unhealthy lifestyle. The exhibition was closed after a local television channel broadcast details of its content. The paintings were made on old advertisements for pop concerts and similar events. The names of the musicians were still visible, and they were furious about being drawn into the scandal (*Gazeta St Petersburg*, 2008). Works from another of Yushchenko's projects were nominated for the Kandinsky Prize and shown in Moscow in the autumn of 2008.[25]

In October 2009, Protez exhibited at the Gelman Gallery in Moscow. This exhibition, 'Pornoholocaust', took the group deep into the dark sides of society. The idea emanated from six months of media reports about rape, battery and sexual mutilation (see Figure 5.7). The result was ten large paintings intended as homage to 'the victims of all the sex massacres taking place daily'. The exhibition got its name from the biblical word for massacre or sacrifice, to which the group added the prefix 'porno'.

Protez existed in the world of gallery art and their works were exhibited in established commercial galleries. In one interview, its members were asked whether their art could be considered commercial. They answered that art can only be either qualitative or non-qualitative art, interesting or uninteresting, with content or without content (*Chastnyi korrespondent*, 2009).

Against the police

PG early on reflected frustrations in forms and content that were full of aggression. One specific target was the police force (militsiya), and it soon became a target in works by several artists. In 2009–2010, lack of trust in the police reached

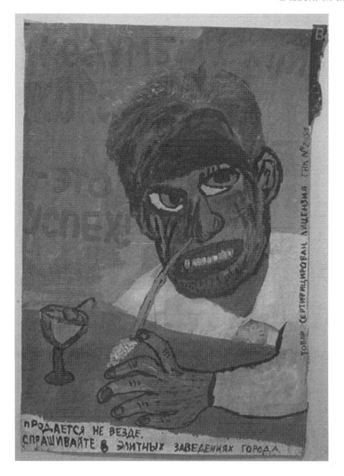

Figure 5.6 Grigorii Yushchenko, 'Colombian Cocaine' 2006 (acrylic, paper)

Note: The text is: 'Colombian cocaine – a success. Not for sale everywhere. Ask for it in elite institutions of the city'.

Source: Courtesy of G.Yushchenko.

a peak in society after several scandals involving policemen.[26] The media reported cases of police corruption and cases in which policemen beat detainees to death or went berserk in public places killing innocent bystanders.[27] The PG installation 'A Defeated Policeman', shown in October 2009 at the Gallery Zhir, therefore came at an opportune time. It realistically showed a policeman lying with his face on the ground and an axe through his uniform cap and head.

The installation was heavily criticized, but was defended by the art critic Andrei Erofeev. He considered that the installation was 'implemented fantasy' and argued that art cannot ignore 'the field of the wild, non-cultivated, "nature"-life, which from time to time flushes up as uncontrolled passions and aggression'. He answered those critics who claimed that PG's work encouraged hatred in society by claiming that 'hooliganism in culture, embodied in

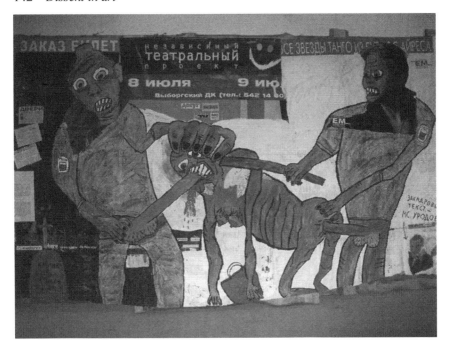

Figure 5.7 Grigorii Yushchenko, 'The Demobbed Gerontophiles' (Dembelya gerontofily) from the series 'Pornoholocaust' 2009 (acrylic, paper)

Source: Courtesy of G. Yushchenko.

illusionary images and playful behaviour, on the contrary sublimates these acute phenomena of human nature. After having experienced a catharsis in front of the grotesque image of the "defeated policeman", the viewer will leave liberated from the yoke of hostile feelings. He will be open again to friendly contacts' (Erofeev, 2010). Herein lies the therapy of mass culture, he said. Not everyone in the art community found this argument convincing. Many found the work one-dimensional. When compared with 'Era of Mercy' by Sinie nosy, which had upset the Russian Minister of Culture, Aleksander Sokolov, in 2007, 'A Defeated Policeman' reflects a shift in the social climate from joyfully mocking the police to frustration and hatred.

Grigorii Yushchenko produced a series of works clearly directed against the police but in a playful, absurdist and grotesque form. The series 'Magical Psychedelic Police' was nominated for the Kandinsky Prize in 2010 (see Figure 5.8). It consisted of nine oil paintings and videos. Using his own specific language and bright colours, Yushchenko alluded to the activities of policemen in their offices, high on acetone, mushrooms and drugs. While the effect seemed comical to some viewers, others considered the paintings offensive to

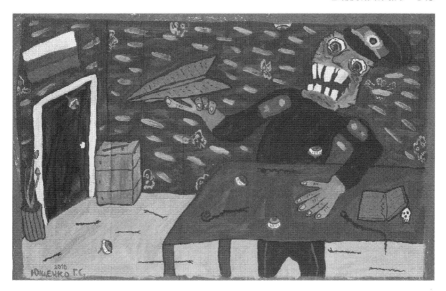

Figure 5.8 Grigorii Yushchenko, 'The Young Lieutenant Nikolai Anashkin Launches a Paper Aircraft made from a Page of the Russian Constitution' from the project 'Magic Psychedelic Police' 2010 (cardboard, oil)

Source: Courtesy of G. Yushchenko.

the police. Yushchenko's own text for the exhibition catalogue underscored the irony behind the project:

> The focus of the project 'Magic Psychedelic Police' is to create a new positive image of Russia and the Russian militsia. Everybody knows that in 2009–10 the Russian police force was a victim of persecution. Every day the mass media told us about crimes in which its men were involved. Russian people now have a picture of the militsia as a vicious, uncontrollable force that kills, rapes and is never punished. I want to offer an alternative vision. In this project I show the militsia as men who are carrying out magical and psychedelic practices. I show that police officers are something like a sainted caste. They are engaging in strange practices and bloody rituals to save us all. Look at their hats – they have an image of a third eye. Policemen are not ordinary men. They are the Magic Psychedelic Police.
>
> (*Kandinsky Prize*, 2010)

When Yushchenko's works were exhibited at the Perm Museum of Contemporary Art later in 2010, the head of the police in the region took the exhibition to court, but the only criminal charge he could come up with was misuse of the Russian flag. Yushchenko had painted the Russian flag on the wall of the police

station in all the paintings, and Russian law forbids the non-sanctioned use of the state symbol. In February 2011, however, a magistrate concluded that Yushchenko had not violated the Criminal Code and closed the case (*Lenta*, 2011).

Thus, criticism of the police had become a theme in the gallery world. Criticism of the police would, however, be taken to new heights outside the galleries in the art of the streets by a new wave of Actionism (see below).

Against the authorities

As is noted above, the most radical anarchist works directed against the authorities were produced by the PG group. Their works demonstrated frustration and desperation, as well as a kind of romanticism of rebellion, aggression and violence. They played with symbols from a globalized world but also from Russian reality. Konstantin Latyshev mocked the authorities and the system but from a different position than that of PG and Protez. His pictures of Russian life were made as if by an observer using techniques from advertisements, such as distinct lines, bright colours and cogent texts. They were ironic and sad commentaries on Moscow life. In his personal exhibition at Gallery Aidan in October 2011, two works stood out. The first, a view of Moscow with a multi-lane highway in the foreground and a Stalin-era skyscraper in the background, reflecting a heavy authoritarian atmosphere, was accompanied by the text 'This is not the Third Rome, this is the Third World'– a play on the words *Rim* (Rome) and *mir* (world).

The second painting, in the tradition of Sots-Art, showed two identical Lenin mausoleums – one dedicated to Putin and the other to Medvedev (see Figure 5.9)

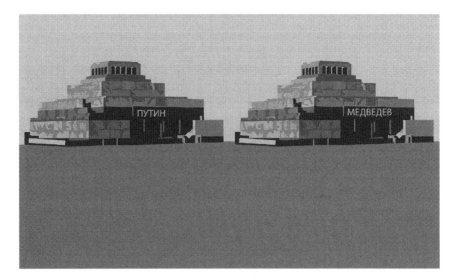

Figure 5.9 Konstantin Latyshev, 'The Mausoleums' 2010 (oil on canvas)
Source: Courtesy of K. Latyshev.

(Tolstova, 2011). The painting conveyed a strong feeling of stagnation, a stagnated state power system and leaders far beyond the reach and influence of the people.

A more subtle political gesture directed against the authorities was made by Yurii Albert in his work 'Moscow Poll'. First exhibited in 2009, it achieved a breakthrough in 2011 when he won the Kandinsky Prize in the category Project of the Year. Albert, a leading figure of the middle generation of Moscow Conceptualists of the 1990s, never engaged in any kind of politicized art. This piece referred to the world of art but had a clear political subtext that targeted Russian political life. It consisted of a series of posters with questions to the onlooker on contemporary art. Among Albert's questions were: 'Do you believe that the quality of a work of art depends on your opinion of it?'; 'Are you certain that you can distinguish a good work of art from a bad one?'; 'Does the intensification of censorship and self-censorship affect the quality of contemporary Russian art?'; 'Do you believe that a good work of art can change your life for the better?'; and 'Would the fact that no Russian artists protested against the war with Georgia cause you to change your attitude towards contemporary Russian art?'. Each question was followed by the request: 'If "yes", please place your ballot in the left box; if "no", in the right box' (Yurii Albert, 2011).

Writing in the catalogue for the 2009 exhibition, the art critic Ekaterina Degot argued that contemporary art usually asks questions but is seldom interested in the responses, and the viewer remains passive. When a 'political artist' asks questions, most viewers consider it their right not to respond. Therefore, it is extraordinary when an artist is able to break these unwritten rules. She gave the example of the artist Hans Haake, whose contribution to an exhibition in New York in 1971 had been a public poll on political topics. Haake's purpose had been the provocative act of asking a direct political question on the sensitive issue of US involvement in the Vietnam War, but the answers from the visitors were less interesting to him. Yurii Albert, on the other hand, asked for answers, and Degot said that it would be interesting to know the answers to his intriguing questions. While Haake, said Degot, knew that questions critical of the government were perceived by the viewer as a political act because in the West art exists in a public space, nothing similar existed in the Soviet Union, and the artists of the 1970s and 1980s could not hope to ask questions or receive responses. She rhetorically asked: 'Can Russian art today hope for this?'(Degot, 2009).[28]

Haake was a relevant reference. To Albert, Haake represented an interesting kind of political art because the latter's works functioned in two directions. According to Albert: ' . . . politics becomes a metaphor for art, and art becomes a metaphor for politics' (Albert, 2011a). And he added that he doesn't like works that function only in one direction, asking political questions from the territory of art but without functioning the other way around.

Albert's work was first exhibited during the Moscow Biennale of 2009 against the background of the Moscow regional elections that year, which were criticized by the non-governing political parties for numerous violations, although the public did not react at the time. His piece was nominated for the Kandinsky Prize in the autumn of 2011, just before that year's parliamentary elections. In his speech

at the award ceremony, about ten days after the elections, he referred directly to them and said that art consists of a dialogue among artists and between the artist and the viewer. 'My installation "Moscow Poll" is an imitation of elections or a public opinion poll. I had in mind that when we are standing in front of any art-work, we are always in the situation of choice. The ballot box in my installation was a metaphor. The conditions turned out such that my metaphor gained direct meaning, and the question of imitation of the elections arose' (Albert, 2011b).

Albert's work had an intriguing structure of perceptions and understandings. In the politically heated atmosphere of December 2011 it was read primarily as a political piece of art and even a political act. His work demonstrated that even the conceptualist artist not normally interested in political art had now entered the field of dissent in art.

Beyond the galleries

Russian performance art was revived in the second half of the first decade of the twenty-first century, as a new generation took over. The Moscow Actionists of the 1990s disappeared as the new millennium opened and Vladimir Putin became president in 2000. While in the 1990s the police had to a great extent tolerated the Actionists because they were artists, the Putin regime did not tolerate any unsanctioned street activities. The common denominator of the new socially oriented art developing outside of galleries was the way this art sometimes wildly exaggerated and at other times calmly underlined the absurdity of real life. While not always directly addressing the authorities, the authorities indirectly became the target of this art.

In an analysis comparing the Actionism of the 1990s with the Actionists of the first decade of the new century, Viktoriya Lomasko and Anton Nikolaev (2011) claimed that the new generation was more politicized than its predecessor. The Actionists of the 1990s had been strongly influenced by the heritage of Soviet non-conformist art in the sense that they did not want to intervene in politics. Their main purpose had been to defend art. Osmolovskii had made statements in the 1990s in which he claimed that the territory of art had vanished and the political field lay open for the artist, but this did not result in artists' involvement in politics (Lomasko and Nikolaev, 2011). The new generation of Actionists is different in this regard, since they 'make politics': '[I]f previously we saw an artist whose statements give rise to social and political thought, we now see groups of politicians and social consultants in disguise, using artistic means' (Lomasko and Nikolaev, 2011). Lomasko and Nikolaev called this new phenomenon 'artivizm'. Although their words seem to better apply to art of engagement (see Chapter 6), they also provide a key to dissent art activism.

The contemporary activists searched for tactics and techniques that would help them attract public attention. In contrast to the Actionists of the 1990s, the new generation actively strove to go beyond the narrow art community and reach out to a wider audience. They found a language that allowed them to be both political and non-political at the same time, an ideal combination for working under the conditions of the Putin era – and they knew how to work with the Internet.

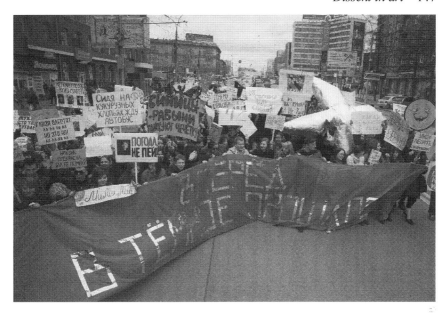

Figure 5.10 'Monstratsiya' in Novosibirsk, 1 May 2013

Note: The text of the banner is 'Forward to the Dark Past'.
Source: Courtesy of A. Loskutov.

Performance in the provinces: The Monstratsiya

In 2004 the artist Artem Loskutov and the group of artists known as Babushka posle pokhoron (Grandma after the Funeral) organized an event in Novosibirsk called Monstratsiya (*Regnum*, 2004). It was something between a demonstration and a carnival.[29] Acting like a flash mob in carnival dress, and spouting absurd slogans, they joined the Communist Party May Day demonstration. Over the next few years the Monstratsiya gathered momentum; more people either joined in or carried out their own demonstrations. By 2009 it had spread to other cities, and in 2010 the Monstratsiya took place in cities throughout Russia, such as Moscow, St Petersburg, Volgograd, Omsk, Perm, Vladivostok, Krasnoyarsk, Novorossiisk and Belgorod (Loskutov, 2010) (see Figure 5.10). The absurdity of the slogans was reminiscent of the Russian Futurists of the early twentieth century. Against the background of the authoritarian trend of the Putin regime, the poetry of nothing-ness of the Monstratsiya slogans was full of meaning.

'He died for 'Y'' (On umer za 'Y')
'Know your place!' (Zdes vam ne tut)[30]
'Vera, don't drink!' (Vera, ne pei)
'I have crocodiled, I am crocodiling and I will crocodile'
 (Krokodil, krokodilyu i budu krokodilit)

'So what?' (Nu i chto)
'Contract is evil' (Kontrakt – zlo)
'I don't know what to shout' (Ya ne znayu, chto orat)

(Chastnyi korrespondent, 2010)

Loskutov explained the purpose of Monstratsiya as: 'an effort to get hold of some autonomy, an autonomous statement to say that we are not interested in political games. It is an effort to not play according to their rules, to work neither for the authorities nor against them but to create a different system of mutual relations, and gather people for whom this is important' *(Chastnyi korrespondent*, 2010).

After starting out as a group in the Communist May Day demonstration, Monstratsiya later convened separately. In both 2007 and 2008 they applied for permission from the authorities. Permission was reluctantly granted. The Novosibirsk authorities were deeply concerned about the Monstratsiya demonstration held in their city, and in 2009 tried to deny permission by claiming that another rally was scheduled to take place at the same place and time. The authorities' fears were reflected in the words of a local official, quoted on one of the banners, 'If everybody starts to march like this it will end up in anarchy'.

In an indirect and non-political way, Monstratsiya exposed the authorities' restrictions on the right of assembly and to hold public meetings as well as the unprofessional handling by the police of cases of supposed extremism. The local police – in particular its new anti-extremist unit, Unit E, set up in 2008 – soon had its eye on Loskutov and began to harass him (*Grani*, 2009). The police found it difficult to understand the kind of activities he was carrying out. They were mystified by a slogan like 'Don't teach us how to live, or else we'll teach you' (Ne uchite nas zhit, a ne to my nauchim vas) (Golunov, 2009). In 2009, Loskutov was arrested and accused of 'preparing organized mass disturbances'. In police reports, he was described as 'a leader of a criminal group of young people with the purpose of organizing mass disturbances, destroying shops, offices and preparing arson' (Machulina, 2009). In an attempt to understand and explain why the local authorities were so strongly against Loskutov, Diana Machulina wrote:

> In Loskutov's actions there is an element of Sots-Art, a deconstruction of the language of ideology, when an absurd action by some people demonstrates the absurdities in the actions of others. The slogan 'Y' hardly threatens the existence of the centre 'E'. And there is no official edict that 'it is forbidden to crocodile in the streets'. The arm of the law, however, suspects that behind these actions there is a hidden, incomprehensible threat. It is possible that the tough penal measures against Monstratsiya this year were taken for some ridiculous reason. When the mayor's office refused to give permission to the 'monstrants', the youth came up with the idea of carrying out single-person pickets: every participant was to go to the mayor's office and with the strength of their thought try to levitate the building 100–500 metres, and hold it up there for some time while the Monstratsiya took place on the

liberated territory below. Obviously, the joke was interpreted as a genuine action comparable to the seizure of railway and telegraph stations. It is nice that official structures believe to such a degree in the power of thought, but the fact that they consider thoughts to be extremism and want to control them is hardly honourable for a state which calls itself democratic.

(Machulina, 2009)[31]

In the end the authorities did not succeed in taking legal action against Loskutov for preparing illegal acts, but instead convicted him in 2009 for the possession of marijuana. Loskutov was fined 20 000 roubles, but denied the accusations and, with his lawyer, appealed to a higher court.

In April 2011, Loskutov won the Innovatsiya Prize in the category Best Regional Project. The National Centre for Contemporary Art (NCCA) citation stated that:

Monstratsiya is a playful act without a prepared scenario, close to a happening, a mass artistic act in the form of a demonstration with slogans, which the participants in the project come up with. . . . Monstratsiya as a form of public art is located in the space between artistic activities, social activism and political gesture. By making doubt and travesty 'serious' political demonstrations, Monstratsiya becomes a distinctive protest against the lack of public politics in the country, and not only demarcates the borders of civil liberties but also broadens these borders, thereby becoming a school of solidarity, creative activity and civil liberty.[32]

Performances at the centre: The Voina group

Throughout this period, a number of small groups of art activists were becoming established in Moscow and St Petersburg. The 'Bombily' group (2005) and the 'Trade Union of Street Artists' (2007) were set up by Anton Nikolaev (known as Bezumets, Madman) and Alexander Rossikhin (known as Supergeroi, Superhero). They were both familiar with the history of Moscow Actionism from their previous work with Oleg Kulik.[33] Nikolaev contributed to the formation of the Voina group in February 2007, but the groups went their separate ways in 2008.[34]

One of the best-known actions by Bombily was a performance action in April 2007, 'The Auto Race of the Dissenters' (Nesoglasnykh). A small Zhiguli car was driven slowly through the centre of Moscow at night with a mattress tied to the roof and a naked young couple on top of it. While stopped at a filling station, the young couple started to make love. The idea for the project had come after a March of Dissenters (Marsh Nesoglasnykh), in which they had participated earlier in the day. The action was considered a continuation of the demonstration and a kind of break away from the control of society, symbolized by breaking society's control of sexuality. Recalling this action a few years later, Nikolaev said that demonstrating sexual freedom 'is the only possible protest which will not be engaged in a political paradigm'.[35] A video of the action rapidly spread on the Internet. Nikolaev continued to write about performance art and to carry out

actions, including the Femida action outside the Taganskyi Court in protest against the trial of the organizers of the 'Forbidden Art' exhibition.

Formed in February 2007, Voina (War) initially consisted of a core of former and current students of philosophy. The group developed into the most success-ful art group at raising public attention and transgressing the sphere of art. At first highly controversial within the art community, Voina became a recognized part of it. Nonetheless, the group members repeatedly stated that they were not artists.

Voina's actions were intended from the start to create a shock effect in order to attract the attention of the media. With Oleg Vorotnikov and Petr Verzilov as front figures, one of the first actions consisted of throwing cats on the counter of a McDonald's restaurant in central Moscow in May 2007.[36] The group managed to break the wall of silence created by the mainstream media. Their action at the Timiryazev Biological Museum in Moscow in March 2008, a few days before the presidential election, was the big breakthrough for the group with the Russian media. With this action Voina began a new era of political art provocation. Every-one knew before the presidential election that Dimitrii Medvedev, the appointed candidate of Vladimir Putin, would win. The action 'Fuck for the Heir Puppy Bear' (Ebis za naslednika medvezhonka) was a clear reference to the upcoming elections and to Medvedev as the presidential candidate. Medvedev's surname is derived from the word for bear (*medved*), but a bear is also the symbol of the pro-Putin political party. Five young couples, among them a young woman in the late stages of pregnancy, copulated or faked copulation in one of the museum halls. The action was filmed and uploaded to the Internet for all to see.[37] Part of the context of the action was that Putin had recently launched a national programme to raise Russia's birth rate. The performance can be interpreted in various ways, but it was obviously a mockery of the upcoming election.

The action created a scandal. The criticism centred on what was considered the amoral behaviour of the group rather than the implicit political criticism of how the elections were being carried out and the way the presidential candidate had been selected.[38] The patriotic Orthodox organization Narodnyi sobor, under the leadership of Oleg Kassin, tried to take Voina to court, but without success. Kas-sin wrote, 'I consider the actions of those who organized an orgy in the Biological Museum an act of hooliganism unprecedented in its cynicism, which seriously violates the social order, offends the morals of society and has been carried out by an organized group with direct intent and by previous concert. I am seeking to initiate a procurator's investigation and to bring the organizers of the orgy in the State Biological Museum to trial'.[39] Supporters of Kassin saw the performance as a great conspiracy: 'Exactly this "contemporary art" is continuously propagated in our electronic media. The purpose is obvious – to bring up Russian youth to be a generation of idiots for which "mass copulation" is the same as drinking a bottle of "Cola" or "eating Snickers". It is already obvious to everyone that a fully functional ideological machine is at work . . . and that "liberal standards" of "cool" daily behaviour are being hammered into the heads of children and

teenagers' (Ievlev, 2008). The prosecutor's office, however, found no legal basis in the Criminal Code to initiate legal action.

The University Council, which initially planned to expel the student members of the group, backed down because they feared the media attention on the university.[40] The university dean decided not to take any further action, and he was criticized for this in the media. In subsequent years Voina continued to carry out regular performances, which the group carefully documented and uploaded to the Internet. Thus, although only a few people actually witnessed the performances live, the documentation on the Internet allowed hundreds of thousands of visitors to view them. In this way, the Voina group became well known in wider circles.

Voina started as an art project with a general anarchist ambition. Their action 'Cop in a Priest's Cassock' (Ment v popovskoi ryase) was conceptually more sophisticated, although also scandalous in content.[41] Vorotnikov, dressed in a priest's cassock on top of the trousers and shirt of a policeman's uniform and a fake police cap, walked from the headquarters of the United Russia Party to a nearby supermarket, filled a basket with food and alcohol and left without paying. No one in the store stopped him, probably perceiving him to be a representative of the authorities. Voina thus found a way to mock and point the finger at the authorities on burning social issues. As one analyst wrote: 'The activists of Voina clearly felt the wider need to express hatred in relation to the authorities – and responded to this' (Epstein, 2012: 101).

In September 2008 Voina carried out an action 'In Memory of the Dekabrists' at the huge Ashan department store in Moscow. It took place on Moscow City Day and the group members went there under the pretext of filming a gift for the Mayor of Moscow, Yuri Luzhkov. They brought with them five people, three posing as Central Asian migrant workers and two as Russian gay activists. As they entered the store with their equipment, security personnel and representatives of the store approached them to ask what they were up to. The group had fake documents from the mayor's office that showed that they were allowed to film inside the store. As part of the action, Voina faked a legal process in which the Central Asians and Russian gay activists were 'sentenced to death'. The five men climbed a ladder, had a rope put around their necks, and were hanged with their bodies going into spasms as if dead.[42] The representatives of the store panicked, not knowing what to do. In the video, the group cut and edited the material as if the store representatives were part of the 'court', and verified that the five were dead. The action was framed as a commemoration of the failed Dekabrist revolt of 1825 against the authoritarian rule of the tsar, which resulted in the execution of five officers. Members of Voina carried a transparency with the text 'Nobody gives a fuck about Pestel'. Pestel was one of the executed officers, and the slogan was meant to show that today no one cares about the democratic values these officers once stood for. The film was dedicated to Mayor Luzhkov, described by the group as a violator of the rights of both migrant workers and gay people. Although the action was said to be directed against the xenophobia and homophobia of Mayor Luzhkov,

the way the group repeated the language of homophobia and xenophobia in the action raised questions.[43]

A central tenet of Voina was not to recognize the authorities but instead to demonstrate a lack of respect towards them. In the action 'Storming the White House' (Shturm Belogo Doma) of 2008 (see Figure 5.11), the group managed to put a huge laser light projector on the roof of Hotel Ukraina, in the neighbourhood of the White House, the government building in Moscow, and direct laser beams on the facade of the building in the form of a skull and crossbones.[44] The action took place on the night of 7 November, the date that commemorates the October Revolution. The use of a laser cannon, which is expensive and difficult to get hold of, raised questions about who was supporting the group.

Voina's actions were statements in the political realm, but the interpretation of the message behind the group's actions varied. Aleksei Plutser-Sarno, a self-appointed ideologue of the group, who cooperated with the group until early 2011, said that the action against the White House could be interpreted as a warning to the government that anarchy might result from its policies. He also explained the action by saying that 'contemporary art cannot paint canvas but needs to find a new language' and that he found the White House to be the best 'canvas' for the artist – and laser much better than oil paint. At the same time, the action against

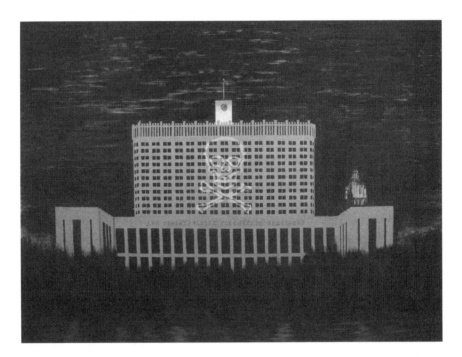

Figure 5.11 Rostislav Lebedev, 'Homage to Voina: View of the Government Building of the Russian Federation the Night between 6 and 7 November 2008' 2013 (oil on canvas)

Source: Courtesy of R. Lebedev.

the White House was 'empty' and 'open' to each observer to interpret, he said, and thus a mirror of the opinions and understanding of the onlookers.[45] The Voina group never explained their actions, however.

Due to its consistent artistic invention and demonstrable lack of respect towards the authorities, the group managed to take contemporary art out of the narrow world of the gallery and bring it to the attention of wider groups of the population. Voina won the respect of the art community and was represented at the 2009 Moscow Biennale by a portfolio on its actions. The group received support from leading figures on the Moscow art scene, such as Andrei Erofeev. After a confrontation between Voina and members of Orthodox–patriotic organizations at an open hearing about the trial of 'Forbidden Art', Erofeev wrote that the Voina group involuntarily involves people in its engaged actions and demonstrates 'the responsibility of the artist in a situation when a majority of citizens don't give a shit' (Erofeev, 2008).

However, Voina was also heavily criticized. One of its most prominent critics was Anatolii Osmolovskii (2010), a leading Actionist of the 1990s, who considered Voina's actions, in contrast to the actions he had himself carried out more than a decade earlier, not art.

In May 2010, Voina carried out the Blue Bucket action in Moscow, which brilliantly expressed the feelings of many citizens frustrated by the blue flashing light on the cars of senior officials (see Chapter 7). Misuse of the blue light was the cause of many traffic jams in the city. Leonid Nikolaev, who had a background in the liberal and democratic Solidarity movement, walked with a blue bucket on his head, symbolizing the blue lights on the roof of expensive VIP cars at traffic lights and crossroads in central Moscow.[46] The action, documented and shown on the Internet, was viewed by hundreds of thousands in only a few days.

With its actions, the Voina group tried to transgress art, taking it beyond its traditional sphere. This raised interesting questions about the confines of art. Leonid Nikolaev said in an interview that the task of an action is not to reduce options but to increase them. In this sense, the Voina activist is 'both an artist and a politician at the same time'.[47] As is mentioned above, at other times members of Voina refused to identify themselves as artists. They did not recognize museums and galleries, although they did agree to participate in exhibitions. In spite of this inconsistency over the identity of the group, it was as artists that they were judged, evaluated and supported by the arts community when the group ran into difficulties in November 2010.

The action that would bring the Voina group to the attention of people throughout Russian society was carried out in June 2010. Called 'Prick: Prisoner of the FSB' (Khui v plenu u FSB), it consisted of a 65-metre-high phallus drawn on the asphalt of the Liteinyi bridge in the neighborhood of the FSB building just before the bridge opened for night traffic on the river in central St Petersburg (see Figure 5.12). In a well-organized action, the group members managed to draw the phallus on the bridge in only 23 seconds. As the bridge opened, the phallus was raised high.[48] Although Voina never explains its actions, this one was perceived by many as a gesture of 'fuck you' directed against the FSB (Galperina, 2010).[49] One

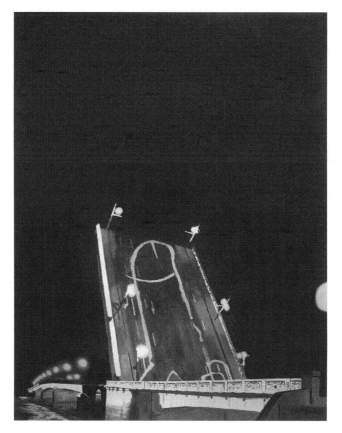

Figure 5.12 Rostislav Lebedev, 'Homage to Voina: View of the Liteinyi Bridge in St Petersburg the Night between 15 and 16 June 2010' 2012 (oil on canvas)
Source: Courtesy of R. Lebedev.

group member was detained by the police for two days, accused of vandalism and minor hooliganism, but he was later released.[50]

In September 2010, Voina ended its series of successful actions with 'The Palace Coup' (Dvortsovyi perevorot) at Mikhailovskii Castle in St Petersburg. The action, directed against police corruption, took place outside the building that over 200 years before had been the stage for an attempted coup d'état. The action was intended metaphorically to illustrate that the reform of the police force announced by President Medvedev needed urgently to be carried out. As part of the action, the group overturned a police car (*Rosbalt*, 2010). Waiting outside the castle until the policemen left their car and entered the building, members of Voina locked the gate and turned the police car upside down. The message seemed clear – in order to reform the police, you need a radical act. On the Internet, however, the action was presented as if a child had lost his ball under a police car and, as an act of

kindness, group members had turned the car over and politely handed the ball back to his mother. The group therefore played with different pretexts.[51]

In November 2010, Oleg Vorotnikov and Leonid Nikolaev were arrested for the 'Palace Coup' action and were detained until late February 2011. Many members of the contemporary art community, who had criticized this action believing that the group had violated the law and overstepped the borders of art, now saw the action in a different light. They opposed the arrest and detention of the two for something that had been mainly an artistic action. Thus, many in the contemporary art community now supported Voina. The art website *Open Space* interviewed people from the arts community about whether they supported Voina in this new situation, and they all confirmed that they did. One artist among the respondents explained: 'In general I am positive about the activities of the group although I have a lot of aesthetic and ideological questions for them. I think it is necessary to demonstrate solidarity first of all with the critical and protest impulses, which I want to believe is the basic content of their actions; and with the effort (successful or unsuccessful) to break out of the boundaries of the intellectual ghetto of contemporary art. Finally, with the utopian hope that art may be accessible to everybody as an instrument for overcoming restrictions dictated by the social order' (*Open Space*, 2010). A video was made in support of the two, with statements from several well-known people in the cultural sphere (*Grani*, 2011a; *Grani-TV*, 2010).

Vorotnikov and Nikolaev were accused of 'hooliganism followed by the use of violence or the threat thereof and damage to property', according to article 213, part 1, of the Russian Criminal Code. Such an accusation presupposes a 'crude lack of respect for society and violation of the social order'. Their detention was prolonged in January 2011, which caused a strong reaction from people in the arts community and human rights organizations such as Memorial and the SOVA Centre.[52] Marat Gelman expressed the concern of many in the contemporary art community when he declared that the penalty had to correspond to the misdemeanour: 'We are afraid that instead of an objective sentence for minor hooliganism there will be a monstrous trial, a revenge and we simply give notice that the art community will be absolutely on the side of the Voina group . . .' (Radio Svoboda, 2011a).

Vorotnikov and Nikolaev were released in late February 2011, still waiting for the legal process to start, after the world-famous graffiti artist Banksy intervened on their behalf to post bail for their release. The procurator closed the case about six months later. However, in the spring of that year the situation deteriorated for Vorotnikov when he was accused of violence against the police in another case. Wanted by the police, he went underground (*Grani*, 2011b).

Voina had split in late 2009.[53] The phallus on the bridge and Palace Coup had been carried out by the St Petersburg faction. Thus, while leading members of the Petersburg Voina were on the run, the Moscow faction continued its activities. They continued the theme of opposition to the militsiya, and ridiculed the reform of the police introduced by President Medvedev. In one action female members of the group took a number of female policemen by surprise, embracing and kissing

them in public places such as the metro.[54] In another action, in August 2011 they peacefully mocked the police by offering policemen food and drink at a traffic post. Voina members stopped passing cars to beg for money to help the families of the low-paid police.[55] This was a new strategy of non-aggressive offence.

The split in Voina was serious. Just before the Fourth Moscow Art Biennale in September 2011, the St Petersburg branch sent an angry letter to the organizers of the activist art exhibition 'Media Impact', which was part of the biennale, accusing the Moscow faction of being fake and a traitor to the original Voina. As the split deepened, the Moscow Voina more determinedly entered the political arena, politically supporting the liberal democratic opposition.

In early 2011, Voina was nominated for the prestigious Innovatsiya Prize for Contemporary Art by the NCCA. The NCCA is a federal state institution, and had tried to avoid the controversial nomination. Several hundred people from the Moscow art *tusovka* attended the award ceremony at the trendy Garazh art centre. Most were convinced that, for political reasons, Voina would not win the prize. However, the group enjoyed strong support from among the art experts on the jury. The audience was pleased but surprised by the announcement that Voina had won in the main category, 'Project of the Year'. The art critic Ekaterina Degot, a member of the jury, later explained that she saw Voina as a representative of all those who were not allowed a political voice in society. By the time of Voina's and Monstratsiya's nominations, however, two members of Voina and Artem Loskutov of Monstratsiya were under arrest and threatened with legal action (Radio Svoboda, 2011b).

The satisfaction at Voina's award was not shared by everyone in the arts community. Many were not happy that Voina represented the pinnacle of Russian contemporary art of that year. Conservative groups were most shocked. They saw the award as an offence against the state and its 'honourable institution, the FSB'. Some members of the Public Chamber, an advisory body of well-known people from social and cultural life, appointed by the president, issued a statement in the name of its Council. It called the granting of the prize to Voina 'a slap in the face of common sense', and the Ministry of Culture was criticized for not preventing it.[56] The pro-Putin youth organization Rossiya Molodaya held a demonstration outside the ministry, demanding that the ministry's budget should not be spent on Innovatsiya in the future.[57] The minister, however, stated that the ministry was not 'a censoring organ that questions a decision by professionals concerning laureates – which is the prerogative of experts – and [the ministry] by no means influences this process'.[58] While conservatives accused Voina of representing everything from the evil of post-modernism in general to a breakdown of all the norms of a decent, civilized cultural life, liberal critics of Voina highlighted the storm of conservatism that Voina had evoked through its actions. Voina members did not attend the award ceremony, and they donated the prize of 400 000 roubles to an organization that provides support and assistance to political prisoners in Russian jails.[59]

After the ceremony, there was much discussion about whether Voina's actions could be considered art. Boris Groys compared its art with Western political art

and, while still regarding Voina's actions as art, saw the group's activities as different from what is considered 'socially politically engaged art' in the West (*Kommersant Vlast*, 2011). Groys argued that in the West, social–political art includes democratization of the process of artistic production and wider participation in the project by the audience. What Voina does is different: 'it is by its nature an elite gesture, and it is directed towards creating an alternative social space. That is why the alternative Russian audience, which is an elite phenomenon, loves Voina. However such a marking of the alternative space is not the dominant strategy of contemporary social–political art. Quite the contrary' (*Kommersant Vlast*, 2011).

Institutionalization of activist art: Gallery Zhir

An important factor in the development of protest art after 2009 was Gallery Zhir, which was created in May 2009 from the small gallery Refleks at the Art-Strelka art centre.[60] Gallery Zhir was given its permanent physical space at Vinzavod in early 2010. Its chief curator, Tatyana Volkova, a former colleague of Andrei Erofeev at the Tretyakov Gallery, opened the gallery with support from the Ridzhina (Regina) commercial art gallery. The declared task of the new gallery was to create a non-commercial space for protest art – exhibiting and supporting it and providing a platform for discussion about art.[61] The gallery declared that it wanted to support a young alternative art environment in opposition to the mainstream art world. It would provide space for discussion by young artists and critics, to test new ideas free from the norms of society and the art world.[62] Volkova began exhibiting the work of Moscow activist artists as well as artists from the provinces. In September 2009 the gallery hosted an exhibition by the PG group within the framework of the third Moscow Biennale of Contemporary Art (the exhibition 'This Is the End'). Other exhibitions hosted the art group Bombily (Svinateka) in December 2009 and the Agenda group in January 2010. In April 2010, the exhibition 'Lawlessness' showcased several art groups and artists. In the 'Lawlessness' exhibition, the gallery asked the questions: How do you look on contemporary society? What would you like to change? How should it be?[63] The answers were formulated in an anarchist spirit.

Gallery Zhir was the organizer of the large 'Media Impact' exhibition in 2011. In October 2013 it held a festival of its own on protest and media art,[64] including first and foremost seminars and discussions, but also the exhibition 'Feminist Pen' (Feministskii karandash) (see Chapter 8).

Conclusions

The dissent art of the early 2000s demonstrated direct disagreement with the official consensus, and did so mainly from an ontological anarchist tradition. The efforts by the regime to create a consensus based on its version of a new Russian identity was answered by dissent art. As the social atmosphere changed during these years, such art was perceived as emphasizing the distinction between 'we'

and 'those in power', that is, as reflecting a widening gap between the leaders and the led. Dissent art played with political gestures and symbols. Under increasingly authoritarian conditions, in which public forums and the media could not conduct open political debate, dissent art – especially direct street art actions – replaced ordinary political protest.

Ekaterina Degot's explanation of why the Innovatsiya Prize jury voted unanimously to reward the Voina group is illustrative in this regard (Degot, 2011). She wrote that the performance 'Prick: Prisoner of the FSB' was successful because it expressed a mental state in Russian society at that moment: '. . . it seems that everyone is now in favour of Voina. Around Voina an unprecedented consensus has been formed in society, in contemporary art, and – I am sure – the authorities laughed. I believe they laughed out loud . . . before they officially condemned it'. Degot explained that, in a situation in which people's political rights were restricted and hatred of the authorities and senior leadership had reached such a pitch, the drawing of a phallus on a bridge became a sign of frustrated powerlessness and disagreement. The act became a political gesture that people loved.

'What can console millions of people who have been deprived of all political liberties? A phallus several metres long, which slowly rises as if it was the whole country, can give them comfort, that's what it is. . . . This strange situation reflects the [feeling] that has seized our political sphere'. The situation is paradoxical, she continued, when an official award is given to an anti-government group. 'It only shows that in Russia an individual has no possibility for legal political action . . . other than to be cunning and give the prize on behalf of the state (although not fully in its name)'. She concluded that 'Voina is art and nothing else' and added '[S]urprisingly this art is fairly conservative as it creates a kind of compensatory niche. Voina exists not in the political sphere, but *instead* of politics' (emphasis in original).

What followed in 2010 and 2011 was a wave of art activism that expressed the anti-establishment approach that was spreading among young artists. The general level of interest in performance and street art grew. The Garazh Centre of Contemporary Culture opened an international exhibition, '100 Years of Performances', which presented the international experience. Seminars and lectures on this topic were held at both the Garazh Centre and the NCCA. At the Fourth Moscow Biennale of Contemporary Art, the 'Media Impact' exhibition was dedicated to performance and street art with famous groups from Russia and elsewhere. This new interest clearly reflected a change in the atmosphere of Russian society. Debates intensified within the arts community. Taking an ethical position became more important.

Thus, art intervened in life. This was a highly relevant dimension for all art activists. Artists not only allowed life to influence their own activities but also wanted art to become a trigger for things to start happening in society and a movement to take off. Falkovskii, for example, had expected the provocative works of PG to initiate a discussion on the issues that he considered most relevant and topical. He was disappointed when people did not discuss the content of the works. The group tried hard to provoke a discussion but the serious issues went unnoticed. Voina's

phallus performance came later, when the time was ripe for such an act of outrageous frustration. Voina received a stronger response from society than any other art group in Russia at the time. Many came to the conclusion that since 2008–2009, individual art interventions had replaced the non-existent public political sphere. In the vacuum of a non-existent agora, art activists took over politics.

According to the poet Lev Rubinshtein in September 2011, that was why a group like Voina had to be supported: '[W]hen basic categories like dignity, conscience, empathy and honesty disappear . . . art takes on those functions of the social organism which are prevented from working'. This, he said, is sometimes done consciously but more often subconsciously, intuitively as the artist feels responsibility. This responsibility is taken as a question not of personal bravery, but of intuition, personal disposition and professional obligation. These artists fill the non-existent political life 'with content'.

> That is why I am so interested in radical forms and genres of contemporary street art, which I consider very important. This art works not only with things that society got tired of and rejected. It persistently and not always tactfully puts large mirrors in front of society from which the latter is not always able to turn away. Society usually does not like this, which is understandable, but therefore such art cannot but be persecuted as hooliganism or anti-social behaviour. Sorry, but art cannot behave differently. And it should not. If it did, it would no longer be art but design at best, just joy for the eye and a fondle for the ear.
>
> (Rubinshtein, 2011b)

Those people, he said, who take to the streets in order to make statements, risking their own health and personal safety, need everybody's support – in contrast to those who demonstrate under the aegis of the mighty state (Rubinshtein, 2011a). Clearly, by now, art activism had entered a new, more visible and openly expressive stage.

Notes

1　See Mikhail Bakhtin (2007).
2　Taken from the website of the NCCA, which was responsible for the exhibition, by Bode (2010: 68). However, it seems obvious that the NCCA had been told to make such a statement.
3　The name Sinie nosy (Blue Noses) is after the Soviet revolutionary acrobatic brigade of the 1920s – Sinyaya bluza (Blue Blouse).
4　A number of other artists have contributed to the group over the years, among them Dmitri Bulnygin, Evgenii Ivanov and Konstantin Skotnikov.
5　'Blue Noses, Naked Truth/the History of Our Times Seen with the Eyes of a Philistine. The "Shame of Russia" is now in Russia!', Material prepared for the exhibition at the Gelman Gallery, 12 December 2007.
6　The work 'Burn, my Candle, Burn' was confiscated by Customs when it was due to be sent to Germany for an exhibition (Aisenshtadt, 2007).
7　The 2003 exhibition was closed due to strong reaction to a work about the fantasies of a teenager.

8 Author's interview with Ilya Falkovskii, Moscow, 29 September 2011.
9 Interview with Ilya Falkovskii (2010), http://62.84.102.40/item.asp?id=151. Accessed December 2010.
10 Author's interview with Ilya Falkovskii, Moscow, 29 September 2011.
11 Author's interview with Ilya Falkovskii, Moscow, 29 September 2011.
12 Author's interview with Ilya Falkovskii, Moscow, 29 September 2011.
13 The series mocked the slogan (Slava Rossii), which had been coined by Russian fascists and was later picked up by the Putin regime. Author's interview with Ilya Falkovskii, Moscow, 29 September 2011.
14 When exhibited separately it is called 'Zapreshchennoe'.
15 See 'Borba za znamya: Nazvany laureaty Premii Kandinskogo' on the website of the Kandinsky Prize, www.kandinsky-prize.ru/hronika/ceremoniya-nagrajdeniya/2008.
16 'Konets kriticheskogo diskursa', 16 December 2008, www.pop-grafika.net/news/theend.html, accessed through www.pop-grafika.net/news.
17 Author's interview with Ilya Falkovskii, Moscow, 29 September 2011.
18 This work can be found as 'Dat pzdy': Istoriya antifa dvizheniya Rossii i Anglii 1994–2004, Podgotovil Ilyos Falkaev. Pri uchastii Aleksandra Litogo i Revy-Korovy 2004, at http://pop-grafika.net/pglitra/pizdi
19 The work can be viewed on www.pop-grafika.net/kunst.
20 PG Dreli-Vampir. The work can be viewed on www.pop-grafika.net/kunst/ and on You-tube at www.youtube.com/watch?v=jBJzWEPoYZo.
21 'Somali uzhe zdes' can be viewed at www.pop-grafika.net/kunst.
22 Author's interview with Ilya Falkovskii, Moscow, 29 September 2011.
23 See his works at http://picasaweb.google.com/g.yuschenko.
24 See http://picasaweb.google.com/g.yuschenko.
25 The project 'Ukusy nasekomykh' (Insect Bites), *Kandinsky Prize* 2008. Yushchenko's works can be viewed at http://picasaweb.google.com/g.yuschenko.
26 Opinion polls by the Levada Center showed decreased public trust in the police.
27 An infamous case is Denis Evsyukov, the head of the police department in a Moscow district, who went berserk in a supermarket in April 2009, shooting nine people. See, for example, 'Vmeste s maiorom, ustroivshim boinyu v supermarket, na vmenyaemost khotyat proverit vsekh moskovskikh militsionerov', 27 April 2009, www.newsru.com/russia/27apr2009/evsukov.html.
28 Ekaterina Degot, 'Iskusstvo pravilno zadat otvet', September 2009, material for Yurii Albert's exhibition 'Moscow Poll' at the Paperworks Gallery, Moscow, 25 September–25 October 2009. See also the interview with Albert (2011b).
29 See 'Za neskolko dnei do pervomaya v inete nachali povlyatsya slukhi o nekoi Mon-stratsii', 1 May 2004, www.monstration.narod.ru/monstration.html.
30 This was one of the aphorisms of the late prime minister Viktor Chernomyrdin, www.aphorism-citation.ru/index/0–375.
31 Loskutov (2010) told how his action was an homage to a famous event in art history which took place in the US in October 1967. This was an action called by the Youth International Party, known as the Yippies, whose leaders included Abbie Hoffman and Jerry Rubin, to encircle the Pentagon building in order to levitate it – through chants led by Allen Ginsberg and songs by the band the Fugs – in order to exorcise the evil spirit of the war machine. See Macphee et al. (2010: 202).
32 See the NCCA website, www.ncca.ru/innovation/shortlistitem.jsp?slid=69&contest=6&nom=4&winners=true.
33 'Moskovskii infantilizm', 8 July 2008, www.artstrelka.ru/galleries.page?exhibitionID=426&menu=3&id=6.
34 On this conflict in and the internal life of Voina, see Epstein (2012). Epstein followed the Voina group for four years and his book is based on private letters, emails, interviews and documents.

35 Interview with Anton Nikolaev by Denis Mustafin, Vimeo, 16 August 2010, http://vimeo.com/14173329.
36 Many of the group's actions are described in Plutser-Sarno (2009).
37 'Ebis za naslednika Medvezhonka!', http://plucer.livejournal.com/55710.html.
38 See, for example, Danilin (2008). In the otherwise liberal newspaper *Nezavisimaya gazeta*, Daniel Danilin wrote: 'With regard to issues of ethics, the situation looks more serious. Pornographers, brutalized in their efforts to become like animals, have trampled on all norms and morals of society. In recent decades we have become much more "politically correct", in the sense of "tolerant" to all kinds of filth. Yes, many now have nothing against homosexuals. Yes, there are many that consider pornography to be no sin. However, these are a minority. Basically, Russian society is healthy. Our society is moral. Morality is still highly esteemed. Unfortunately, in the media, on television and in other means of communication the situation is the opposite. The rules that feast on depravity, lust and adultery dominate. Any word about morals is met with laughter. He who talks about morality will be accused of being a holy fool. In the media coming together, vices are the norm. But feeling itself an unworthy part, a syphilitic in an environment of blossoming health, the media tries to infect society with its amorality applying the logic: if I am filthy, you also have to be filthy'.
39 Oleg Kassin in a letter to the Procurator of Moscow (see Ievlev, 2008).
40 Author's interview with Petr Verzilov, Moscow, 22 September 2011.
41 'Aktsiya 'Mento-Pop'! Art-anarkho-pank gruppa Voina – opasnye provokatory, sotrudnichayushchie s organami', http://plucer.livejournal.com/94884.html.http://plucer.livejournal.com/94884.html.
42 'Genotsid v Ashane. Chudovishchnaya aktsiya art gruppy Voina', 10 September 2008, http://nnm.ru/blogs/mobbi5/genocid_v_ashane_chudoviwnaya_akciya_artgruppy_voiyna.
43 See the discussion in Epstein (2012: 114).
44 See the action on http://halfaman.livejournal.com/124449.html#cutid1.
45 *Khudozhestvennyi zhurnal* No. 73/74, http://xz.gif.ru/numbers/73–74/plucer. Plutser later used fragments of aggressive statements by Orthodox–patriotic activists about Voina's action, which he compiled in a 'manifesto against contemporary art' read at the Art Moskva fair in 2008.
46 *Russia Today*, 'Blue Bucket-head attacks VIP-car opposite Kremlin walls', 24 May 2010, www.youtube.com/watch?v=Ae5O0U96CY4.
47 'Glava art-gruppy "Voina" dal intervyu', 4 August 2010, www.livejournal.ru/themes/id/21149.
48 See http://plucer.livejournal.com.
49 See also 'Khudozhniki ebut, FSB khuem, 19 June 2010, www.youtube.com/watch?v=Sw-rx6JqQIE&feature=player_embedded.
50 Told by Leonid Nikolaev. 'Novaya aktsiya gruppy "Voina": 65-metrovyi fallos narisovali naprotiv zdaniya FSB v Peterburge', www.newsru.com/russia/16jun2010/piter.html.
51 See www.youtube.com/watch?v=Ue_Wd2AjKAI.
52 'Press-konferentsiya "Chto poluchit art-gruppa Voina" – gosudarstvennuyu premiyu ili tyoremnyi srok?', 21 February 2011, www.sova-center.ru/misuse/news/persecution/2011/02/d21026.
53 Author's interview with Petr Verzilov, Moscow, 22 September 2011. See also Alex Epstein's book on Voina, where he describes in detail the inner tensions of the group (Epstein, 2012).
54 'Gruppa Voina zatselovyvaet mentov', 28 February 2011, www.youtube.com/watch?v=l0A8Qf893cs.
55 'Gruppa Voina i bespredel mentovskikh semei', 11 September 2011, www.youtube.com/watch?v=eV2Vwji7k1c.

56 'Zayavlenie Soveta Obshchestvennoi palaty RF', 12 April 2011, www.oprf.ru/newsblock/news/3865/chamber_news.
57 'Art-piket "Kh*i v nagradu Minkultu"', *Rossiya molodaya*, 14 April 2011, http://rumol.ru/news/7538.html.
58 'Minkultura ne budet osparivat pobedu art-gruppy "Voina" na "Innovatsii"', www.erzia-museum.ru/dannue/&view=Minkult-ne-budet-osparivat-pobedu-art-gruppi-Voyna-na-Innovacii.
59 '"Voina" otdala dengi za "Innovatsiyu" pravozashchitnikam', www.hro.org/node/11514.
60 Art-Strelka was established as a temporary art centre in part of Krasnyi Oktyabr in the latter years of the first decade of the twenty-first century. Among the curators at Art-Strelka, one should be singled out as important for the development of contemporary art in general and young activist art in particular – Olga Lopukhova, who died suddenly in 2009.
61 'Intervyu s kuratorom galerei aktivistskogo iskusstva "Zhir" Tatyanoi Volkovoi', 15 March 2011 at http://zhiruzhir.ru/cat/vistavki-zhir.
62 See www.zhiruzhir.ru.
63 'V nastoyashchee vremya v galeree Zhire prokhodit vystavka BESPREDEL', www.zhiruzhir.ru/post/1116.
64 Mediaudar.net.

References

Aisenshtadt, Daniil (2007), 'Litso Putina ne proshlo tamozhnyu', *Gazeta*, 11 October, www.gif.ru/themes/society/sotsart-censored/tamozhnya.
Albert, Yurii (2011a), 'Ya mechtal zanimatsya nastoyashchim iskusstvom: A poluchaetsya sovremennoe', *Artkhronika*, 5 December, www.artchronika.ru/vystavki.
Albert, Yurii (2011b), 'V poludemokraticheskom obshchestve sovremennoe iskusstvo prizhivaetsya s trudom', *Open Space*, 15 December, reposted on http://os.colta.ru/art/events/details/32827.
Almanakh PG (2009), 'Besslovesnyi rebenok iskusstva', Moscow, www.pop-grafika.net/magazine.
Artinfo.ru.Ezhednevnye novosti iskusstva (2007), 'Sots-Art. Politicheskoe iskusstvo v Rossii. Vystavka v Parizhe, v galleree 'Mezon Rozh' 21 oktyabrya 2007–20 yanvarya 2008', October, www.artinfo.ru/ru/news/main/Sots-Art_Paris-07-Erofeev.htm.
Bakhtin, Mikhail (2007/1965), *Rabelais och skrattets historia* (Riga: Anthropos).
Bode, Mikhail (2010), 'Neulovimye zapretiteli', *Artkhronika* 12: 68.
Chastnyi korrespondent (2009), 'Grigorii Yushchenko: Pishu svoyu istoriyu mirskogo bezumiya. Uchastnik art-gruppirovky Protez: posle vystavki Pornokholokost', 3 December, www.chaskor.ru/article/chetverggrigorij_yushchenko_pishu_svoyu_istoriyu_mirskogo_bezumiya_12967.
Chastnyi korrespondent (2010), 'Artem Loskutov: Nas ne interesuyut politicheskie igry', 15 June, www.chaskor.ru/article/artem_loskutov_nas_ne_interesuyut_politicheskie_igry_17957.
Danilin, Pavel (2008), 'Etika i estetika. Pornografy ozvereli', *Nezavisimaya gazeta*, 20 March, www.ng.ru/non-fiction/2008-03-20/6_estetika.html.
Degot, Ekaterina (2000), 'Tvorcheskaya gruppa PG', www.gif.ru/people/pg.
Degot, Ekaterina (2009), 'Iskusstvo pravilno zadat otvet', material distributed at Yurii Albert's exhibition 'Moscow Poll' at the Paperworks Gallery, Moscow, 25 September–25 October.

Degot, Ekaterina (2011), 'Pochemu ya golosovala za Voinu', *Open Space*, 13 April, reposted on os.colta.ru/art/projects/89/details/21790.

Droitkur, Brain (2007), 'Biennale bez tsensury', *Artkhronika* 4: 104–5.

Epstein, Alek (2012), *Totalnaya 'Voina': Art-aktivizm v epoke tandemokratii* (Jerusalem, Moscow, Riga: Izdatel Georgii Eremin Umlyaut Network).

Erofeev, Andrei (2008), 'Gruppa "Voina" i obshchestvennyia moral', 16 June, p. 34, www.aerofeev.ru/index.php?option=com_content&view=article&id=209:e-lrr&catid=62&Itemid=157.

Erofeev, Andrei (2010), 'O prilichiyakh v "pablik arte" ', *Personalnyi sait*, 15 January, www.aerofeev.ru/index.php?option=com_content&view=article&id=262:o-prilichiyakh-v-pablik-arte&catid=3&Itemid=72.

Galperina, Marina (2010), 'Why Russian Art Group Voina "Dicked" a St Petersburg Bridge', 16 June, www.animalnewyork.com/2010/why-russian-art-group-voina-dicked-a-st-petersburg-bridge.

Gazeta St Peterburg (2008), 'Vystavku "Reklama narkotikov" zakryli', 9 April, www.gazeta.spb.ru/37135–0.

GiF.ru informagenstvo kultura (2007), 'Ministr Sokolov protiv "Sinie nosy" ', 9 October, www.gif.ru/themes/society/blue-noses.

Golunov, Ivan (2009), 'Prava ili trava', *Bolshoi gorod*, 26 June, http://bg.ru/society/prava_ili_trava-8176.

Golynko-Volfson, Dimitrii (2008), 'Potselui militsionera: est li v Rossii (bio)politicheskogo tsenzura?', *Neprikosnovennyi zapas* 1(57), http://magazines.russ.ru/nz/2008/1/vo15.html.

Grani-TV (2010) 'Monitor: Svobodu "Voine" ', 17 December 2010, http://grani-tv.ru/entries/1530/.

Grani (2011a), 'Sud prodlil srok aresta aktivista art-gruppy "Voina" Olega Vorotnikova', 15 January, www.grani.ru/Politics/Russia/m.185368.html.

Grani (2011b), 'ESPCha zaregistriroval zhalobu aktivista "Voiny" Olega Vorotnikova', 31 August, www.grani.ru/Politics/Russia/Politzeki/m.191076.html.

Gurianova, Nina (2012), *The Aesthetics of Anarchy: Art and Ideology in the Early Russian Avant-Garde* (Berkeley, Calif.: University of California Press).

Ievlev, Boris (2008), 'Provokatsiya performansom: Na dnyakh Moskvu potryasla ochered-naya art provokatsiya', *Stoletie.Informatsionnaya-analiticheskoe izdanie fonda Istoricheskoi perspektivy*, 11 March, www.stoletie.ru/tekuschiiy_moment/provokaciya_perfomansom.htm.

Kandinsky Prize. Exhibition of Nominees Catalogue (2008), 'Gruppa PG' (Moscow: Artkhronika).

Kandinsky Prize. Exhibition of Nominees Catalogue (2010), 'Grigorii Yushchenko' (Moscow: Artkhronika).

Kommersant Vlast (2011) [interview with Boris Groys], 'Nichego "aktualnogo" v sovre-mennom mire bolshe net', 21 February, www.kommersant.ru/Doc/1580687.

Lenta (2011), 'Permskii muzei vyigral delo o psikhodelicheskikh militsionerakh Yush-enko', 11 February, http://lenta.ru/news/2011/02/11/victory.

Lomasko, Viktoriya and Nikolaev, Anton (2011), 'Aktsionizm i artivizm', *Grani*, 7 June, http://grani.ru/users/lomaskonikolaev/entries/html.

Loskutov, Artem (2010) [interview], 'V predverii vystavki 14.07 v galeree ZHIR intervyu s Artemom Loskutovym', *Zhir. Blog aktivistskogo iskusstva*, 5 July, http://zhiruzhir.ru/post/1332.

Machulina, Diana (2009), 'Iskusstvofobiya: Prostranstvo iskusstva ne yavlyaetsya bezopasnym', *Vremya novostei*, 27 May, www.stengazeta.net/article.html?article=6200.

Macphee, Josh and Greenwald, Dara (eds.) (2010), *Signs of Change: Social Movement Cultures 1960s to Now* (Oakland, Calif.: AK Press and Exit Press).

New Times (2009), 'Antifashistskii vernisazh: Gruppa "PG", khudozhniki s grazhdanskoi pozitsiei', 16 March, http://newtimes.ru/articles/detail/2863.

NOMI (Novyi mir iskusstva. Zhurnal kulturnoi stolitsy) (2008), ' "Protez": nashi radikaly', 73–74, www.worldart.ru/files/64.pdf.

Open Space (2010), 'Nuzhno li proyavit solidarnost s gruppoi "Voina?" ', 22 November, reposted on http://os.colta.ru/art/projects/160/details/18823.

Osmolovskii, Anatolii (2010), 'O gruppe "Voina" i ne tolko o nei', *Open Space*, 10 December, reposted on http://os.colta.ru/art/events/details/19135.

Ozerkov, Dmitrii (2009), 'Khudozhnik – trikster', *Artkhronika* 5: 54–63.

Platter, Charles (2001), 'Novelistic Discourse in Aristophanes', in Peter I. Barta, Paul A. Miller, Charles Platter, David Shepherd (eds.), *Carnivalizing Difference: Bakhtin and the Other* (London and New York: Routledge), pp. 51–78.

Plutser-Sarno, Aleksei (2009), 'Gruppa "Voina" kak zerkalo russkoi skitsofrenii: opyt metareprezentatsii', *Khudozhestvennyi zhurnal* 73–74, http://xz.gif.ru/numbers/73–74/plucer.

Quenelle, Benjamin (2011), 'Russie: Poutine assailli par les artistes', *Alternatives Internationales* (December): 72–75.

Radio Svoboda (2011a), 'Voina pod zashchitoi obshchestva', 14 January, www.svobodanews.ru/content/article/2276445.html.

Radio Svoboda (2011b), 'Oskorblennaya vlast protiv Artema Loskutova', 3 March, www.svobodanews.ru/content/article/2326561.html.

Regnum (2004), 'V Novosibirske militsiya razognala demonstratsiyu antiglobalistov', 1 May, www.regnum.ru/news/255846.html.

Rosbalt (2010), 'Militsiyu obezdvizhili tsinizmom', *Rosbalt*, 21 September, www.rosbalt.ru/2010/09/21/773563.html.

Rubinshtein, Lev (2011a), 'Marginalnaya ulichnost', *Grani*, 5 May, www.grani.ru/Culture/essay/rubinstein/m.188297.html.

Rubinshtein, Lev (2011b), 'Kogda nachinaetsya iskusstvo?', *Grani*, 9 September, www.grani.ru/Culture/essay/rubinstein/m.191289.html.

Shusharin, Dmitrii (2009), *Grani*, 25 May, http://grani.ru/Politics/Russia/m.151560.html.

Ter-Oganyan, Avdei (2010), *Russian Utopias* [exhibition catalogue] (Moscow: Garazh Center of Contemporary Culture).

Tolstova, Anna (2011), 'Dekonstruktsiya modernizatsii: Konstantin Latyshev v galeree "Aidan" ', *Kommersant*, 28 August, www.kommersant.ru/doc/1756015.

'Yurii Albert', *Kandinsky Prize 2011. Exhibition of Nominees* [exhibition catalogue], pp. 10–13.

Yurkov, S.E. (2003), ' "Smekhovaya" storona antimira: skomoroshestvo', in S.E. Yurkov (ed.), *Pod znakom groteska: antipovedenie v russkoi kulture (XI-nachalo XX vv.)*. (St Peterburg), pp. 36–51, http://ec-dejavu.ru/s/Skomoroh.html.

6 Art of engagement

A counterculture in the making?

Art of engagement is socially oriented, interventionist in the public sphere and contains a direct political statement. In addition to introducing art of engagement, this chapter asks whether there were signs of an evolving counterculture in the Moscow contemporary art scene after 2009. Counterculture is defined as a socially constructed identity based on a rejection of the values and norms of the established society. The term sometimes creates associations with alternative lifestyles in Western societies, such as the hippie culture of the 1960s and early 1970s. However, it developed into a generic concept based on conflicts over values. It therefore differs from subculture, which represents the values of a specific group and challenges neither the dominant culture nor its fundamental value orientation.[1]

Something significant happened to the social atmosphere in Russia in 2009. 'Towards the end [of the year] it became completely obvious that something had changed in Russia', wrote Konstantin Remchukov, the chief editor of the daily *Nezavisimaya gazeta*, in his reflection on the year. He likened the change to 'when you use a needle to make a little hole in a balloon. Gas disappears slowly but steadily. Not everybody is aware of the size of the leak, but yesterday's confidence that the airship is ascending is gone' (Remchukov, 2009).

Dimitrii Medvedev was elected president in the spring of 2008. Most people believed that Putin would remain in control in his capacity as Prime Minister. Russia went to war with Georgia over South Ossetia in the summer and in the autumn the international financial crisis hit the country. In September 2009 Medvedev published his article 'Forward, Russia'. It emphasized the need for modernization, criticized the state of the country and encouraged reform.[2] His article came as a surprise. In his Speech to the Nation two months later, Medvedev did not follow up his ideas with any specific proposals about how to carry out a modernization. Soon after the speech, Putin's United Russia Party adopted a programme of 'Russian Conservatism' (Benediktov, 2010; Veretennikova, 2009). Although this illustrated the difficulties of introducing a reform programme, Medvedev's words evoked hopes and expectations among intellectuals that reform was possible.

The political leadership seemed to fear an impending crisis in Russia but was paralysed by indecision. In his summary of 2009 Remchukov said:

I do not fully understand what in Russia of 2009 constitutes the text and what constitutes the subtext. If the article by Dimitrii Medvedev is the text, then the subtext is expectations of change and a goodbye to Putin's epoch. If you regard the text to be the prime minister's talk with the people, then the subtext definitely sounds like this: I am back, calm down, we will modernize in a conservative way. For some neither text nor subtext exists. Only the context. And somebody already thinks that in two years the text, the subtext and the context will coincide. In one person.

(Remchukov, 2009)

Remchukov's words reflected the general political uncertainty over where Russia was heading. Like a doctor, Remchukov diagnosed the specific state of society and captured the sense of insecurity prevalent most of all among the intellectuals. This uncertainty was also reflected in the dystopic novels and films of the time.[3]

An arts community awakening to common interests?

In December 2009 a public roundtable discussion, 'Art and Politics: A New Apathy?', was organized at the Moscow Non-fiction Book Fair (*Open Space*, 2010f).[4] The issue under discussion was whether the 'stagnation' of the Brezhnev years some 30–40 years before had any parallels with the current experience. Was a new underground developing similar to the one of those years, or instead was a new apathy spreading? The very fact that issues related to the wider political and social context of the arts were being debated in a public roundtable discussion was brand new.

The discussion took place against the background of a blog article published about a month earlier by the writer Vladimir Sorokin. He wrote that in the stagnated time of 'late Putinism', he, like many other people including the young who were not around in Soviet times, was now longing for the Soviet underground. In the heavy atmosphere of that time, the underground had been like a free space that filled its participants with euphoria 'like after heavy rain, atomic oxygen is formed which is *terrifyingly* pleasant to breathe. Ozone makes the world beautiful' (emphasis in original). This air, he said, had been for him 'not only a means of survival in an environment that was hostile to any expression of individualism, it had been like a free university, the opportunity to meet with people with the same ethical and aesthetic views'. This air was as necessary today for a young person as it had been for him at that time. He continued: 'A longing for the Underground is now awakened among the young generation. They have not breathed such ozone. They have only heard about it. Usually these are young families, who do not watch our TV, who despise Russian authorities, are on the Internet, and read a lot. They want their blood to boil. And you can understand them. But now the talk is not about the underground (andergraund) [in the arts], but about to go into the underground (podpole) [of oppositional activities]' (Sorokin, 2009).

Discussing the question of whether the art field was heading towards a new apathy or a new underground, the discussants at the roundtable seemed to agree

that Russian society had entered a period of stagnation like the one during Brezhnev times, albeit with all the differences between the so-called late state socialist era and the Putin capitalist era taken into consideration. The question was how far Russia had gone in that process. Was it at the beginning, the middle or the end? The answer would determine whether or when a new perestroika might begin. All agreed that for artists, especially young artists, working conditions were difficult under Russian capitalism. The ongoing process of the 'privatization of capitalism' was rapidly reducing the public sphere, with negative consequences for art. What used to be common territory was now becoming private and closed territory. Russia lacked the common territory that in European societies is provided by institutions and museums that are financially supported by the state but independent and free to oppose the interests of both private capital and the state. In Russia, even the idea of such a free public zone does not exist. This situation, it was said, made it especially difficult for young artists to find their way as private galleries were closed to them and they received no support from the state.

This description conveyed a feeling of hopelessness and of being trapped. Nonetheless, the participants found some basis for optimism. They praised the initiatives by young artists who, when their art did not fit the prevalent political or commercial discourses, organized their own exhibitions beyond the purview of museums and galleries, in whatever places they found. A new trend for exhibitions in private homes had been noted a few months earlier in *The New Times*. It was compared to the Ap-art movement of the 1970s and 1980s, in which artists of the Soviet underground had exhibited at home when locked out elsewhere (Levkovich and Samkova, 2009: 13–15; Rukhina, 2010: 71). The new generation of art activists did not, however, restrict themselves to the closed sphere of private homes, but also invaded the streets and other public places without asking for permission. They were also bringing up directly political and other burning topics.

The year 2010 witnessed an evolving civic engagement in the sphere of culture. The trial of the 'Forbidden Art' exhibition focused attention on article 282 of the Criminal Code. In January 2010 an exhibition was organized in the home of two young artists to protest against article 282. Well-known artists participated, such as Ter-Oganyan, Mavromati, Sinie nosy, Shabelnikov and the Protez group, and lesser-known young artists also exhibited. The publicity for the exhibition 'Freedom' read like a manifesto, stating that it was 'a reaction to the ongoing changes in society in general, and in the art sphere in particular where prohibitions and the authorities' rejection of criticism resulted in self-censorship among artists. It has become normal to keep quiet, especially about critical themes, and to tactically avoid sensitive topics in society, even though the task of an artist is to highlight exactly such problem zones'.[5]

After the Forbidden Art verdicts had been confirmed by the Moscow City Court in October 2010, a seminar was organized at the Sakharov Centre to discuss article 282 and its consequences for art. Several well-known people from the arts community participated (*Open Space*, 2010e).[6] Denis Mustafin, the initiator of the discussion, tried to bring special attention to the situation of Ter-Oganyan and Mavromati, whose cases were still open (see Chapter 4). He argued that artists

must show solidarity and defend colleagues who are threatened by the authorities. A somewhat different position argued that the legitimacy of article 282 as such should be questioned instead of the way it was being implemented with regard to individuals and the art scene. 'We need to stand up principally against the formulation of the text of the law that restricts freedom of speech which used to relate to "the direct causing of injury" but has been replaced by a formulation about the potential "insult of feelings". . . . We need to defend not the freedom of art but the freedom of criticism'(Degot, 2010). The law was previously applied primarily to nationalists, racists, fascists and the National Bolsheviks. Now it was also being applied to the art world.[7]

There was growing concern in the arts community for artists threatened by judicial proceedings. In 2000, only a small group of people had supported Mavromati. Support came late for those prosecuted in the trial of the exhibition 'Beware! Religion'. In contrast, the trial of the 'Forbidden Art' exhibition mobilized support for Erofeev and Samodurov. The two Voina group members also received backing after their arrest. It had become a matter of principle – artists ought not to be arrested for an art action. The support for the Voina members also reflected the shift in public opinion towards mistrust of the authorities, primarily the police. At the time of the arrest of Vorotnikov and Nikolaev, more conflicts around art were piling up.

When in the middle of January 2011 Ilya Falkovskii of the PG group received a surprise visit at his studio from the FSB and the special forces of the Interior Ministry, this was seen as another sign of a hardening of official policy. Armed units searched his studio for several hours, confiscated material, including his computers and drawings, and interrogated and threatened him. The FSB officer made it clear that he did not like the art projects of the PG group and accused Falkovskii of being a terrorist. When he failed to make Falkovskii sign a document of collaboration, the latter was told that the authorities would follow his every step in future. Falkovskii was also accused of helping to organize a meeting in support of the arrested Voina members and of collecting material about the trial of the 'Forbidden Art' exhibition. Immediately after the FSB visit, he left Russia for some time.

When in March 2011 Andrei Erofeev told *Artkhronika* what had happened to Falkovskii, he concluded that the time for irony, jokes and ridicule was over (*Artkhronika*, 2011). Others in the arts community had come to the same conclusion. One art critic wrote: '. . . from the viewpoint of Russia in 2011, old and well known works by the PG group. . . , which made us laugh some years ago, now seem unbelievably courageous – all this is now already unthinkable' (Kostyleva, 2011). She concluded: 'If previously the authorities calmly let it pass as adolescent art and in its essence anarchist art, they now send punitive units to investigate anyone who draws a cunt or a cock. The authorities want to scare these people, force them to cooperate, press them, break them and recruit them'. The visit to Falkovskii by the FSB was, she said, a 'signal to society that the safe space for making statements from a civic position has shrunk'. If previously, she continued, you had to enter into an open conflict with the authorities in order to expect

inconvenience from people in black, now only your own creativity or your support for someone in jail would be enough. As a result of this development, she said, '[A]nyone can expect "guests". Environmentalists wait as do antifascists, human rights activists wait, anarchists and Limonov supporters wait, poets, satirists, rock musicians wait, publishers and owners of bookshops wait as do gallery owners and curators, bloggers, journalists, television channels and journalists, so do bakers, local historians and owners of aquariums' (Kostyleva, 2011).

Against this background, the award of the Innovatsiya Prize to the Voina group and Artem Loskutov in April 2011 was an audacious move by the NCCA. It was sensational for a federal art institution to reward artists who were under arrest or accused of breaking the law. The decision, made by the jury of art experts, signalled to society that the art community was prepared to defend artists under threat. This was a conscious act of protest by the arts community against the authorities. It reflected a growing urge to take a civic stand. The authoritarian state was rapidly losing its legitimacy, and the arts sector seemed like a hole in the fabric of regime control through which discontent and protest were leaking out. The similarity to Remchukov's punctured balloon was obvious.

Politicization of art

The discussion of art and politics has a long history among the Russian creative intelligentsia. While some people now chose to side with the authorities, as for example the film director Nikita Mikhalkov, who in 2007 pleaded in public for the president to stand for a third term and in 2010 wrote a conservative manifesto in support of the regime,[8] others took a critical stand against the authoritarian state. The relation of the arts vis-à-vis power and art vis-à-vis life had been part of the discussions of the pre-Soviet avant-garde as well as the Soviet underground. The immediate post-Soviet conditions had moved this discussion into the background, but now it was back on the agenda.

Taken as a whole, this discussion had many aspects. The relationship between art or artists and those in power, the state authorities, was central. This relationship had seemed less of a problem in immediate post-Soviet times, when the state apparatus was weak and had no wish to control the art scene. Gradually, however, the picture changed. Other actors evolved. Among them was private capital – which initially seemed a blessing, since it helped to create the art market, private galleries and private museums, but eventually brought harsh conditions to the art world. Another important actor was the Orthodox Church, with small but active conservative religious–patriotic groups under its protection. Two legal trials against art exhibitions demonstrated that reactionary activist groups could act as proxies for the church and the state. Where was power located in these circumstances? How was the artist to behave in these new conditions?

The artists of the Soviet underground of the 1970s and 1980s had lived their lives in parallel with official society. Their strategy had mainly been to reject cooperation with the Soviet state in the same way as the state rejected underground art, although many of the non-conformist artists managed to have a foot in

both camps. In the new capitalistic conditions of post-Soviet Russia, the question of the relationship between art and power needed to be posed again.

In the summer of 2010 former Actionist Anatolii Osmolovskii was invited to the pro-Putin youth camp at Seliger to give an art lecture. He was heavily criticized by colleagues, who accused him of abandoning his previously critical stance on the government. Osmolovskii, however, argued that he was giving a talk about art and found no specific ideology being expressed at the camp. He declared that he was still a 'leftist' and critical of both the regime and the capitalist system (Postnikova, 2010). Osmolovskii suggested a leftist strategy of entryism, that is, penetrating the organs of power from within, in order to change the regime (*Open Space*, 2010b). Entryism, he argued, had been successfully used by the leftists in France after the May 1968 revolt. Obviously, this was how he saw his own participation in the Seliger camp – as a kind of third way between the options of either rejecting cooperation with the authorities or collaborating with them.

Osmolovskii's position could be regarded as the pragmatism required to survive in an authoritarian capitalist society. However, his standpoint was more principled and seemingly based first and foremost on his views on art. He argued in favour of the autonomy of art and for an art beyond politics. He declared himself one of the 'new formalists', a group of artists who preferred pure aesthetics and experimentation in art over socially concerned art. In October 2010, Osmolovskii launched the first issue of *Baza*, a journal dedicated to art theory. Its first issue included translations of texts by Clement Greenberg, a US art critic active from the 1930s to the 1980s and best known as an ideologue of formalism in art. Osmolovskii argued that the artistic process needs to break with the context in which it exists. Creativity needs to be de-contextualized and political, social and economic components made secondary. 'It is precisely the radical distancing from the surrounding context that dialectically can highlight its real importance' (Osmolovskii, 2010).[9]

Erofeev, who favours socially oriented art, criticized artists who like Osmolovskii wanted to separate art from the social context: 'If it is possible to talk about any kind of spiritual sin or temptation that lies in wait for an artist, this is, to my mind, the very exit into the "pure" field of one's talent' (Erofeev, 2011b). He described the new formalist tendency as a wish to withdraw and live in isolation from the rumble of Moscow streets, concentrate on the inner problems of art, and become part of the flow of international contemporary art. He said, '. . . a shadow of (perhaps unjustified) suspicion of excessive opportunism and servility falls' over these artists (Erofeev, 2011a). What Osmolovskii found to be a tendency for expressing a reflective mood (Osmolovskii, 2011), Erofeev considered to be hiding from social responsibility.

Osmolovskii's idea of 'penetrating' organs of power is a strategy that also characterized Marat Gelman's activities. Gelman's political contacts from his life as a political spin doctor together with his position as a controversial gallery owner made such a strategy possible. After he was appointed the director of the Perm Museum of Contemporary Art in 2008, he adopted a complicated strategy of manoeuvring by which he presented the regional authorities with a strategy of art as a factor for economic change in economically and culturally stagnant

environments.[10] He argued that Perm could become a dynamic cultural capital by using art and culture as instruments for investment and economic development. At the same time he emphasized that only an independent art, free from political interference, would provide the region with the best outcome. With the help of good friends in the presidential administration, most notably its deputy head and chief ideologue, Vladislav Surkov, and among the regional decision makers – the governor, the local senator and the local minister of culture – he attracted Moscow artists, musicians and people from theatre and film to Perm. Between 2010 and 2012 his 'Cultural Alliance' cooperated with the United Russia Party, and he was appointed a member of the consultative Public Chamber and of Medvedev's 'large government'. Nonetheless, he maintained his image as a controversial gallery owner supporting radical and rebellious art and promoting contemporary art in the regions. He made enemies among conservative politicians but also met scepticism from many in the arts community due to his close links with the Russian elite, and was accused of stirring up conflicts for the sole purpose of publicizing the artists in his own gallery.

The discussion of autonomy in art and the issue of 'pure art' had old roots and included questions such as: To what extent should art and life be related? Should life intervene in art? Should art intervene in life? Can the interpretation of a work of art and its aesthetics be isolated from its social context? Can art exist autonomously, outside society? This discussion became heated after Belyaev-Gintovt was awarded the Kandinsky Prize in 2008. Should the political opinions of an artist be taken into account when his art is evaluated? Can his political views be ignored, or does the aesthetics of his art inevitably reflect his political ideas?

Aleksander Borovskii, a member of the Kandinsky Prize jury, was among those who believed that Belyaev-Gintovt only manipulated the political content of his paintings for the purposes of his artistic project: 'I see in this an ironic distance' (Borovskii, 2008). Borovskii claimed that he was playing with 'étatist aesthetics', in the sense of an aesthetics that beautifies the power of the state. Borovskii was criticized by Ekaterina Degot, among others, who warned about the view that art is beyond politics. She argued that: 'to restrict oneself to a formal analysis of Belyaev-Gintovt's works would be nothing but a legitimization of a shameful phenomenon of our time' (*Open Space*, 2009b). Social context must be taken into consideration and Belyaev-Gintovt should be evaluated in the context of the growing influence of the Eurasian movement: 'Today the Eurasian nationalism of [the radical conservative thinker] Dugin is no longer the marginal frenzy of a frustrated loser'. Instead, she claimed, he is now recognized and published in all kinds of publications: 'It is nowhere said that this is the official ideology but in reality that is the case. A revanchist ideology of the great power, strengthened by anti-enlightenment, obscurant and mythological ideas, serves as the consolidation of the mono-nation. This is not Russian fascism but nourishes it. And fascism is impossible without those who accept it, subordinate themselves to it and take it to power' (Degot, 2008). She asked rhetorically: 'How did this happen?'

Was his award a political act by the Kandinsky Prize jury? It was claimed that the international members of the jury who voted for Belyaev-Gintovt had been

unfamiliar with the Russian situation and did not understand his underlying political ideas. They were ignorant of the political references in the aesthetics of the works, and therefore judged from what they saw – ignoring the historical-political context. Others claimed that the jury had been well aware of the political content and therefore balanced the decision to award Belyaev-Gintovt with prizes for artists with opposing political leanings, such as the anarchist PG group and the activist Diana Machulina (Khachaturov, 2008). Most people were of the opinion that the Kandinsky Prize had become far too politicized.

Belyaev-Gintovt himself seemed to share the opinion that art should be interpreted in its socio-political context. Two months after he was awarded, he led an action of Eurasianist sympathizers against what he called 'degenerate art' and 'the enemies of the Russian people in the field of culture'. He identified these enemies as Andrei Erofeev, Anatolii Osmolovskii, Marat Gelman and Ekaterina Degot (*Open Space*, 2009a; 2009b). These discussions further politicized the art sphere but also added a new consciousness of the political aspects of art. The view that artists have a responsibility became more the focus of discussion.

Erofeev praised the Sots-Art artists who had once abandoned the idea of the purity of art and 'introduced to the canvas the dirt of context and sharp, almost mocking, political comment'. In this context, Erofeev drew a parallel with the Voina group, whose actions were a direct response to the context (Erofeev, 2008).

Voina thus became the catalyst for a new twist in the discussion on the responsibility of the artist. In May 2010 Lev Rubinshtein, who would soon strongly and distinctly formulate the ethics of engagement in the evolving protest movement, gave a warning about mainstream apolitical art: 'Today it seems to me that the most dangerous and lousy mainstream is the apolitical. And this [the apolitical] has to be deconstructed. If the time has come for direct statements, it is with regard to these themes. The new mainstream has been encouraged by the authorities, which keep on saying: "guys, all this is of no concern to you, we will decide by ourselves and you continue having fun"' (Rubinshtein, 2010).

Thus, the discussion within the arts community, if not an expression of a counterculture in full bloom, clearly reflected that changes were on their way. In this specific social situation, a rift was appearing and a reconfiguration of the meaning of 'us' and 'them' was taking place.

Art of engagement

How to understand social–political engagement in art? As is discussed in Chapter 4, several art performances were carried out by the Bombila and Voina groups in the courtyard of the Taganskii Court building and in the courtroom during the legal action taken against the organizers of the 'Forbidden Art' exhibition. The guilty verdict initiated a further wave of engaged art performances. This was an art of a new kind – art of engagement – not only reflecting disagreement with the official consensus, but also including a strong political component.

This was not art that connected with any political or grassroots movements,[11] and it could not be compared to participatory art in the West in which people

constitute the central artistic medium and material – that is, the public becomes part of the creation of the piece.[12] Russian art of active engagement is not based on collaborative relationships between the artists and other participants. Nor is it engaged with communities or groups working together on issues of concern.

In the 2000s, one of the first groups to transgress art and politics and create a greater awareness of the theoretical sources of art activism was 'Chto delat?' (What Is to Be Done?). Formed in 2003 in an effort to create a synthesis of art, political theory and practice, it numbered art philosophers, critics and artists among its members. The name of the group came from the book by the nineteenth-century Russian writer Nikolai Chernychevskii, which once had an impact on young revolutionaries, later became compulsory reading for Soviet schoolchildren, but also expressed two key questions in Russian history: 'What is to be done?' and 'Who is to blame?' (Kto vinovat?). The art group represented art activism of Central and East European leftists. In Russia it centred around *Khudozhestvennyi zhurnal* (*Open Space*, 2010a), an art journal with a socialist agenda based on ideas of self-organization and collectivism that promoted art for social change but was preoccupied mainly with art theory.[13] Works by Voina, Sinie nosy and PG were considered 'scandalous, glamour–political', according to one of its leaders (*Open Space*, 2010a). Although he valued the works and views by these groups more than most other groups at that time, he thought that Voina and others did not make clear enough the values on which their works were based.

One local source of inspiration for art of engagement came from the actions carried out in the late 1990s and early 2000s by the anarchist National Bolshevik Party – a political organization with a highly confused mix of political–ideological thought. Although a political organization, its actions and propaganda stood out as aesthetic experiments. Its actions were daring and cheeky and it often ended up in court and in convictions. The party was proscribed in 2007. Party members sometimes played with double meanings and references to Russian cultural history.[14] Their actions are remembered most for the energy and vitality they brought. At a roundtable discussion about street art in April 2011 the 'energy of opposition' (oppotsionnost) that the National Bolsheviks created was referred to: 'It seems to me that what is important is not the political opposition [as such] but the kind of energy of opposition – to be at all times in opposition, to create a vitality for society'.[15]

Art of engagement is the result of a counterculture. A counterculture, however, may be a wide spectrum from anarchists and the left to radical conservatives on the right. Although the counterculture that developed during these years in the art community was mainly leftist–liberal, Belyaev-Gintovt represented the radical–conservative counterculture. After the Eurasian movement became supporters of Putin, it acted more like a radical lobby group, pressing the official consensus further. For this movement, art and aesthetics played a crucial role in promoting political–ideological ideas. The 'imperial conservatism' of Eurasianism was not just a political project. It was a search for a new aesthetics in support of a political vision in which authority, order, hierarchy and discipline were the key elements.

According to Aleksander Dugin, the ideologue, the purpose of the movement was first and foremost to influence, with the help of culture and art, the intellectual environment – that is, the world view of the elite and the masses (Engström, 2012,

2013). Writing in April 2012 about Belyaev-Gintovt's exhibition on Moscow as the capital of a future Eurasian Empire,[16] Dugin wrote:

> . . . Gintovt reconstructs. He creates from existing collections and triumphant hallucinations new grand series of visions, pictures and events. They softly but convincingly move aside the old narrative like a curtain to provide the place for a new narrative which this time is constructed according to all the principles of deep and finished reflection. This is Eurasianism and the Fourth Political Theory: we make a step forward, to the right and upwards, transgressing the contemporaneity which has become entangled in its dead-end self-references. . . . And we appear in the landscapes of Belyaev-Gintovt, at that very place, at the same latitude and longitude but obviously somewhere else as well. It is there and not-there at the same time, here and not-here. This is the fabric of the Eurasian dream.[17]

The examples of the art of engagement below come from liberal, leftist and anarchist political discourses. Unlike Belyaev-Gintovt, these artists had no intimate links with a specific social or political movement. They used art to try to direct public attention to specific political issues. The presentation focuses on performances, documentary art, political posters and graffiti. The group Pussy Riot is analysed separately as an example of how art becomes politics in action.

Performances and actions

The art of engagement that developed from 2009 was directly linked to political events and carried political demands. The guilty verdict in the 'Forbidden Art' trial initiated a wave of actions, which were carried out by individuals acting on their own.

One young artist who drew attention during these years was Denis Mustafin. He made opposition to article 282 and support for the organizers of the 'Forbidden Art' exhibition as well as Ter-Oganyan and Mavromati part of his artistic strategy. His 2010 performances in front of the Cathedral of the Saviour in Moscow,[18] and at the Garazh Art Centre where he contemplatively sat on the floor of an exhibition hall washing his face in blood, were a stark criticism of article 282.[19]

As part of the new interest in art activism, Mustafin and Anton Nikolaev organized a festival of young artists in the summer of 2010 as an alternative to the official youth biennale organized by the NCCA and the Moscow Museum of Contemporary Art since 2008. They gave it a name which was a play on the name of the official biennale 'Stoi! Kto idet?' (Stop! Who's there?), a phrase used by border guards. The name of the alternative festival was 'Poshel! Kuda poshel?', with its double meaning of 'where did he go?' and 'where to go?'[20] The manifesto of the alternative festival expressed a political purpose, declaring 'resistance against mercantilism, consumerism, banality, and despondency and conciliation. Away with narrow-mindedness. All power to the imagination'.[21] The alternative festival took place in public around the NCCA building, with the support of the NCCA

leadership, but also in the streets and pedestrian underpasses around the city, without the permission of the municipality. One exhibition in a pedestrian underpass of works by 50 artists, both lesser known and more famous (*Artkhronika*, 2010), immediately attracted the attention of the religious–patriotic Narodnyi sobor. A painting of a young woman holding a piglet in her arms was accused of blasphemy (*Open Space*, 2010c). The leader of Narodnyi sobor accused the exhibition of 'belittling Orthodox belief' and tried to start legal proceedings against Nikolaev. The court dropped the case after several months of investigation.

About this time, Mustafin also carried out an action in Red Square. Working with a small group, as a politically symbolic act, he threw a white flag in front of the Lenin Mausoleum. Seeking to explain the purpose of the action, he asked:

> Can one compare throwing a white flag under the red Kremlin wall to raising the black flag over one's head? This is a question which it is impossible to answer theoretically. To answer this question it is necessary to test. To throw the [white] flag is to return to the authorities their major gift – the right of the individual to capitulate. If you believe that the time for a 'reasonable' capitulation has passed and that the intellect has to stand in the service of resistance, then throw your white flag on their main square. This is a declaration of war against one's own conformism in relation to their power. This is a message sent to the main address that they should never count on you. From this day, on every thrown flag a black prick will grow and spread until it covers the whole flag. In the first decade of the 21st century we were all given the chance to capitulate without disgrace. The one who throws his white flag under their wall gives away this right. The social play is getting sharper and the relations of power no longer presuppose autonomy and deviation.
>
> (Mustafin, 2011b)

Mustafin favoured political art but emphasized above all imagination and fantasy. Called a 'liberal-anarchist' by one journalist (Tsvetkov-Mladshyi, 2011), he supported protest art 'as long as . . . the people in the hall . . . do not start screaming "look, this is art!"' (Mustafin, 2011a), but he also argued that 'Actionism is only preparations for a revolt camouflaged as art' (Tsvetkov-Mladshyi, 2011). Familiar with the ideas of the leftist Slovenian philosopher Slavoj Zizek as well as the ideas of 'creeping revolt' of the French autonomists, he became an artist for whom politics was a major source of inspiration. He was an example of the growing politicization of art into protest. An artist of a new kind, he played a role at that specific time.

In these new times art with a civic–political stand was needed. Gallery Zhir opened its discussion club in early 2011 and stated from the beginning:

> The importance of the developments taking place in the newest art is difficult to overvalue. A new kind of artist has appeared . . . who positions himself in contemporary society. Art that gets out to the streets and calls for social change is a recent phenomenon in our country. Artists create new forms of collective

existence, unite with subcultures and social movements, and declare themselves activists – active participants in contemporary socio-political life. The time is ripe to work out new theoretical platforms, a foundation for the next discursive phase devoted to contemporary art. This can take place only within artistic processes, with the direct participation of its major actors and with the support of and in the tradition of contemporary philosophy and Western experience.[22]

This was a bold but concise declaration. In September 2011 the gallery organized a major exhibition, 'Media Impact' (Media udar), within the framework of the Moscow Art Biennale (*Kommersant*, 2011). It exhibited projects by 70 participants, from a rapidly expanding number of Russian art activists in Moscow, St Petersburg, Novosibirsk, Krasnoyarsk and Perm, but also artists from New York, Warsaw, Berlin and Minsk. It was the first large exhibition of Russian and international activist art ever organized in Russia. To these artists the model was the Western art activism of the 2000s, as practiced by art collectives such as the US Adbusters and the Yes Men group, but also the experience of the Situationist International, the small European art collective created in 1957 that became a major source of inspiration to countercultural movements in the 1960s and 1970s – most notably the student movement in Paris in 1968.[23]

According to the *Kommersant* art critic, the 'Media Impact' exhibition was the best special project of the Moscow Biennale (Tolstova, 2011). With the 'Media Impact' exhibition in mind, *Time Out* wrote that the biennale not unexpectedly displayed a kind of fashion for socially concerned and activist art (*Time Out*, 2011). Activist art had obviously become the new trendy genre, and Gallery Zhir had helped it to develop by providing space and organizational assistance.

Documentary art

Documenting political and legal proceedings directly from the courtroom became a special form of art engagement.[24] Photography was not allowed in the courtroom but drawing was. A leading name in this genre was Viktoriya Lomasko, famous for her drawings of the trial of the organizers of the 'Forbidden Art' exhibition.

Lomasko's series of drawings from the 'Forbidden Art' trial was unique, as she documented the legal process from beginning to end with texts by Anton Nikolaev (Lomasko and Nikolaev, 2011). The drawings were like reportage, and excellently reflected the atmosphere of the courtroom (Chapter 4). In December 2009 Andrei Erofeev labelled this documentary genre a new and important trend in Russian contemporary art.[25] He described it as an effort by artists to understand what was happening around them. It included no analysis.

Lomasko and Nikolaev were nominated for the Kandinsky Prize in 2010 for their documentation of the 'Forbidden Art' trial. The series was exhibited along with other nominated works. Although recognized by the art community, the drawings remained highly controversial. Planned exhibitions of the series at Vinzavod and the Moscow Museum of Contemporary Art were both cancelled at the last minute.[26] Nonetheless, Lomasko and Nikolaev helped to introduce a new genre in Russian contemporary art.[27]

Figure 6.1 Viktoriya Lomasko, 'The Girls from Nizhnyi Novgorod' (Devochki Nizhnego Novgoroda) 2013
Source: Courtesy of V. Lomasko.

Lomasko developed her documentary style further and played a central role in the project 'We draw from the Court Room', which began in 2009. For her drawings from the trial of Mikhail Khodorkovskii and Platon Lebedev she was awarded a private art prize.[28] She later became one of the initiators of a feminist art festival of documentary drawing, 'Feminist Pencil' (Feministiskii karandash). Figure 6.1 is from her series on sex workers in Nizhnyi Novgorod.

Political posters and graffiti

In the second half of the first decade of the twenty-first century, graffiti developed as an art form in Russia and a number of graffiti festivals were organized. Political graffiti developed in parallel. However, in the atmosphere of evolving protest, political graffiti spread more in large cities outside the capital. It was used in calls to join political demonstrations, for example, in St Petersburg, where images from the world of comics were blended with the number 31 in a call by the opposition movement 'the Other Russia' to its demonstrations on the 31st of each month in support of article 31 of the Russian Constitution – the right to public assembly. Tags were painted together with slogans such as 'Don't be afraid to disagree!' and 'Wake up!' (Ne boisya byt nesoglasnym!, Prosnis!).[29] In Ekaterinburg a campaign of disobedience (the Chalk Revolution) took place in the summer of 2011, with political graffiti painted on the streets and walls and then posted on the Internet. This campaign started after Putin visited Ekaterinburg and two activists were arrested for chalking the slogan 'This regime must go' (*Grani*, 2011).

Moscow was not spared graffiti. In February 2011 a huge poster with photographs of Khodorkovskii and Putin, accompanied by the text 'Time for a Change', was hung from a bridge over the Moscow River close to the Kemlin. It did not hang there for long before the police took it down, but it was there long enough for photographs to be taken and later posted on the Internet.[30] In August the group Art-m2 painted 'Wht the Fuk?' on the wall of Lukoil headquarters in a protest against Lukoil and the scandals in which the company was involved at the time (see Figure 6.2). The protest took the form of an exclamation of 'How much do we have to put up with?'[31] Discussing how they decided to target Lukoil, the group explained that they considered targeting the police and the military to be 'unpatriotic', and the headquarters of the energy companies Gazprom and Rosneft were inconveniently located, so they chose Lukoil. The graffiti remained in place for only three minutes before it was removed.

In spite of the difficulties in carrying out this kind of action, Evgenii Flor (2011), an artist from St Petersburg, predicted that graffiti and street art were set to develop in Russia as a form of protest and a comment on reality: 'In a country where it is impossible to express protest or react to reality, autonomous protest

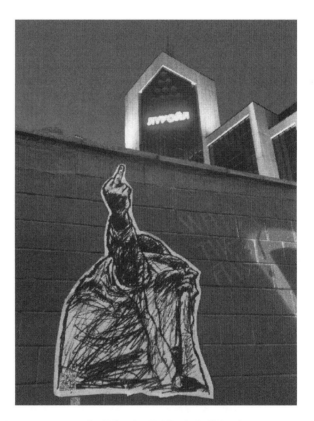

Figure 6.2 Art gruppa art m-2, 'Wht the Fuk?', Lukoil headquarters, Moscow, August 2011, www.grani.ru/blogs/free/entries/190844.html

remains the only possibility'. However, as graffiti increased in popularity as a genre and graffiti festivals were supported by the authorities, it developed first of all in its non-political form.[32] In St Petersburg, an international graffiti festival was organized in August 2012 at a location permitted by the local authorities.[33] In essence, however, graffiti remains a rebel activity since painting is an illegal act if is not done in a few specifically permitted places.

A new wave of politicized performance: Pussy Riot

On 21 February 2012, an act of protest took place that created a landslide of national and international reaction. The name of the feminist art punk group Pussy Riot became known instantly around the world. Their performance took place during the euphoria after the mass protests of December 2011. The Internet video shows the group members in front of the altar in the Cathedral of Christ the Saviour, the major cathedral in central Moscow, singing, dancing and falling to their knees in prayer to the sound of guitars, repeating the phrase 'Mother of God, Put Putin Away!' A female backing group in the form of a choir repeats the phrase directed at the Virgin Mary. The video on the Internet was a deliberately manipulated edit of different brief actions in two churches. The group did not play their guitars in the Cathedral and there was no choir – sound was added later. The video shows guards approaching the group as soon as they start their action and forcing them to leave. The girls escaped, but two members were arrested in early March and a third two weeks later. The idea behind the action was explained in their blog: 'Since the peaceful demonstration by 100,000 people did not achieve immediate results, we therefore before Easter ask the Mother of God to put Putin away'.[34]

Pussy Riot, formed in 2011, performed its first action in the autumn of 2011. Between five and eight young women would suddenly appear from nowhere in the most unexpected locations in the centre of Moscow, dressed in bright colours with their faces covered by balaclavas, carrying guitars and sound equipment. Their performances, which included visual impressions, punk music and texts, were posted on the Internet soon after each action. These actions were a feminist call directed against the presidency of Vladimir Putin and the senior political leadership.

The first actions took place on the roof of a bus and inside a metro station (7 November 2011), where they sang 'Raze the Pavement' (see Box 6.1) and on the roof of a construction site outside a fancy high-status boutique ('Kropotkin-vodka', 1 December). Then followed an action on top of a roof opposite the prison building where several leaders of the mass protest of 10 December were being held, 'Death to the Prison, Freedom for Protest' (14 December 2011). The action at the top of Lobnoe mesto right on Red Square 'Putin Chickened' took place in January 2012 (see Figure 6.3 and Box 6.2). These actions lasted only a few minutes before they were driven away by the police or security guards. The leitmotif of the songs was that Putin is nasty and macho, you have to fight the sexists, the police are aggressive and women need to start a revolution.

Their songs reflected an expectation that mass protests similar to those that took place in Tahrir Square in Cairo would happen in Moscow. In the November action 'Raze the Pavement' the text of the song ran: 'The Egyptian air is good

for the lungs. Do a Tahrir on Red Square'. In the January action at Lobnoe Place on Red Square, which took place after the mass protests in Moscow, Pussy Riot members assumed that Putin was frightened by the prospects of a Tahrir revolt coming closer in Moscow. Thus the text of the song 'Putin Chickened' (Putin zassal) called: 'Take to the streets, Live on the Red, Set free the rage, Of civil anger'.

Box 6.1 'Raze the Pavement' (extract from the song)

The Egyptian air is good for the lungs
Do a Tahrir on the Red Square
Spend a violent day among strong women
Look for scrap on the balcony, raze the pavement
It is never too late to become a dominatrix
The bludgeons are loaded, screams get louder,
Stretch the muscles of your arms and legs
The cop is licking you between the legs
The toilets are clean, chickens are in their civvies,
Specters of Zizek washed away in the toilets
Khimki Forest plundered, Chirikova banned from elections,
And the feminists sent home on maternity leave.

Source: http://freepussyriot.org/content/lyrics-
songs-pussy-riot.

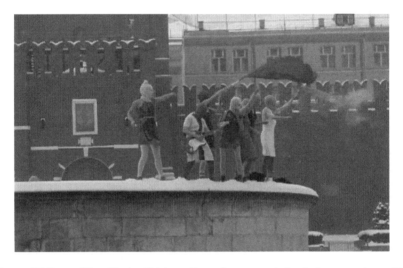

Figure 6.3 Pussy Riot, 'Putin Chickened', performance at the Lobnoe mesto on Red Square, 20 January 2012

Source: http://pussy-riot.livejournal.com/2012/01/20/. Courtesy of Pussy Riot.

Box 6.2 'Putin Chickened'

A rebellious column moves toward the Kremlin,
Windows explode inside FSB offices.
Bitches piss behind the red walls
Riot calls for the System's Abortion!
Attack at dawn? Am not against it,
For our joint freedom, a whip to chastise with
Madonna to her glory will learn to fight
Feminist Magdalene go demonstrate
Revolt in Russia – the charisma of protest
Revolt in Russia – pissed on by Putin
Revolt in Russia – We Exist!
Revolt in Russia – Riot! Riot!
Take to the streets
Live on the Red
Set free the rage
Of civil anger
(loss on the square)
Discontent with the culture of male hysteria
Wild leaderism devours brains
The Orthodox religion of a hard penis
Patients are asked to accept conformity
The regime heads toward censorship of dreams
The time has come for subversive clashing
A pack of bitches from the sexist regime
Begs forgiveness of a feminist wedge.
Revolt in Russia – the charisma of protest
Revolt in Russia – Putin got scared
Revolt in Russia – We Exist!
Revolt in Russia – Riot! Riot!
Take to the streets
Live on the Red
Set free the rage
Of civil anger

Source: http://freepussyriot.org/content/lyrics-songs-
pussy-riot. Accessed in January 2012.

The February action in the central Cathedral went further than previous actions as it directly challenged the authorities – the state as well as the church (see Figure 6.4 and Box 6.3). The text of the song was political but in the form of a prayer pleading that Putin be dethroned. Pussy Riot chose the cathedral as the venue,

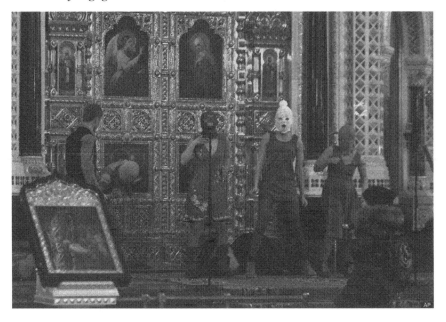

Figure 6.4 Pussy Riot, 'Mother of God, Put Putin Away', performance in the Cathedral of Christ the Saviour, Moscow, 21 February 2012

Source: Courtesy of Pussy Riot

but the action was not directed against religion. It was turned against the system of power with a 'KGB-chik' at the top, described Putin as a rotten dictator and accused the Patriarch, using his secular surname, of fraternizing with Putin and being corrupt. Of course, the text also included a feminist argument against the traditional role of women in the church (Krongauz, 2012). The text was a plea to a higher religious female authority to intervene in the worldly affairs of Russian politics.

Box 6.3 'Mother of God, Put Putin Away'

Virgin Mary, Mother of God, put Putin away
Put Putin away, put Putin away
(end chorus)
. . .
Black robe, golden epaulettes
All parishioners crawl to bow
The phantom of liberty is in heaven
Gay-pride sent to Siberia in chains
The head of the KGB, their chief saint,

Leads protesters to prison under escort
In order not to offend His Holiness
Women must give birth and love
Shit, shit, the Lord's shit!
Shit, shit, the Lord's shit!
(Chorus)
Virgin Mary, Mother of God, become a feminist
Become a feminist, become a feminist
(end chorus)
The church's praise of rotten dictators
The cross-bearer procession of black limousines
A teacher-preacher will meet you at school
Go to class – bring him money!
Patriarch Gundyaev believes in Putin
Bitch, better believe in God instead
The belt of the Virgin can't replace mass-meetings[35]
Mary, Mother of God, is with us in protest!
(Chorus)
Virgin Mary, Mother of God, put Putin away
Put Putin away, put Putin away
(end chorus)

Source: http://freepussyriot.org/content/
lyrics-songs-pussy-riot

The effects of the action were tremendous. It was extremely successful in the sense that it and all that followed placed the focus on a series of delicate issues in Russian society and politics – the lack of public political debate and lack of a voice in elections, the authoritarian character of the regime, the close links between the church and state, the political dependency of the courts, the growing influence of the church, the role and behaviour of the Patriarch, and corruption in both church and state. The action was like opening up Pandora's box. Once again, an art group had replaced non-existent political life.

The church was the first to react. The day after the action, 22 February, Arch-priest Vsevolod Chaplin called for harsher punishment than the Administrative Code prescribed. Pussy Riot, he said, had offended the feelings of believers: 'The norm [according to civil law] is of course far too mild since we are talking about actions that are capable of making the situation in the country explode. I am convinced that this has to be transferred to the Criminal Code. Let us see if the politicians are ready to do this – and if they condemn the action that was carried out'. He added an indirect warning that those who did not condemn the action 'could not count on the support of believers' in the future (*Grani*, 2012a).[36]

This statement was made just before the presidential elections. The pro-rector of the school of the Orthodox missionary of the Church of Apostle Foma contacted

the General Procurator, requesting an investigation into the actions of Pussy Riot due to the offence caused to the feelings of worshippers. So did Oleg Kassin, the leader of Narodnyi sobor, known for his active involvement in bringing the organizers of the 'Forbidden Art' exhibition to court (Abarinov, 2012). On 26 February it was announced that legal action would be taken against the three members of Pussy Riot under article 213, part 2, of the Criminal Code – organized group hooliganism, which could bring a sentence of as much as seven years in prison. Conservative patriotic journalists and politicians such as Maksim Shevchenko and Egor Kholmogorov condemned the group in astonishingly harsh terms, demanding severe punishment. The action was condemned as an act of 'blasphemy', and in the Duma a delegate of the United Russia Party, Aleksander Sidyakin, demanded that anyone offending religious objects or symbols in the future must be punished, and that a law must be enacted to that effect.[37]

Nearly a month after the action, the position of the church hardened still further. On 17 March, Chaplin called the text and video posted on the Internet 'extremist material': 'I am convinced that this text and the video film are extremist material, and their distribution is extremist activity. . . . Read the law about countering extremist activities and you will find that what is described there is exactly what we see in this video film and text . . . rousing hatred against Orthodox believers'.[38] He indicated that the church wanted the Pussy Riot activists to be charged under article 282 of the Criminal Code.

While most religious people condemned the action, many people expressed support as they found the prospect of a sentence of several years in jail unjustified. Human rights organizations defended Pussy Riot. Reaction from the contemporary arts community was strong. The performance by Pussy Riot did what no other art performance had done to such an extent before – it broke out of the art community into other layers of society. The action raised a storm of discussion.

Compared with previous court trials of organizers of art exhibitions, the trial led many in the arts community to close ranks in defence of what they considered the common interests of artistic freedom and freedom of expression. Marat Gelman emphasized the need for a sense of proportion between the act and the punishment. In May 2012, *Artkhronika* published a picture of the group in balaclavas on its front page and dedicated an article to it, 'Total Actionism: Art at the Barricades'. The first page of the Moscow journal *Bolshoi gorod* read 'Free Pussy Riot'. Actions in support of the group members were carried out more or less spontaneously. When their detention was extended in June 2012 emotions ran high on both sides. Street art festivals were organized in support of Pussy Riot with musicians, poets, artists, actors and activists.[39] In Novosibirsk an anonymous group placed copies of a naivist painting of a figure in a balaclava with a nimbus around its head in some light boxes intended for advertisements around the city (see Figure 6.5). To the left and right of the picture, the letters SVBD PSRT were visible – the consonants of the words 'freedom for Pussy Riot'. When the artist Artem Loskutov uploaded the picture on his website, he was summonsed to court.

Figure 6.5 Artem Loskutov/Maria Kiselyeva, 'The Miraculous Discovery of the Pussy Riot Icon' (Chudesnoe obretenie ikony Pussy Riot), (poster) in Novosibirsk 2012
Source: Courtesy of A. Loskutov.

Pussy Riot received strong support from 100 well-known members of the creative intelligentsia, who in June 2012 signed an open letter to the Supreme Court in which they protested about the legal case. The open letter demanded that the detained be freed and the case be transferred from being heard under the Criminal Code to a case under the Russian Administrative Code. It stated that the performance was not a criminal act, that making it a criminal case was compromising Russia and its legal system and that there were no legal grounds for detaining the group members. They argued that for as long as the girls were detained, the atmosphere in society was becoming increasingly intolerant, resulting in splits and radicalization (*Ekho Moskvy*, 2012). The list of signatories was a list of the cream of Russian cultural life, including many of the best known and most respected cultural figures in Russia, such as actors and theatre and film directors, writers and poets, musicians, artists and gallery owners.[40]

There was also protest in church circles. In June 2012 an open letter to Patriarch Kirill was published, signed by Orthodox believers who considered the Pussy Riot action blasphemous but asked the Patriarch to plead for mercy for the young women and the church to demonstrate Christian forgiveness. They asked for the immediate release of the Pussy Riot members. The signatories were more than 160 believers from the world of literature and music.[41]

In August, Nadezhda Tolokonnikova, Mariya Alekhina and Ekaterina Samutsevich were sentenced to three years in a penal colony. In October the appeal court

reduced the sentence to two years and released Samutsevich after her new lawyer clarified that she had not been directly involved in the cathedral action, since she had been removed by the guards at an early stage.

In court, the three spoke of the Russian tradition of democratic dissident intellectuals speaking out against the autocratic Russian state. Tolokonnikova criticized the Putin regime and the Patriarch, and quoted Aleksander Solzhenitsyn – that words will break cement. She described Pussy Riot as a link in a chain from the OBERIU group of the late 1920s (Kharms and Vvedenskii), who made art into history and 'paid with their lives'. Mariya Alekhina asked the rhetorical question: 'How did our performance, a small and somewhat absurd act to begin with, balloon into a fully-fledged catastrophe? Obviously, this could not have happened in a healthy society. The Russian state has long resembled a body riddled with disease' (Gessen, 2014). Pussy Riot's February action had caused a huge upheaval. It had the effect of 'removing the gloves' of the government and the church, demonstrating the authoritarian character of the state. International musicians and artists reacted strongly in support of the jailed group members. In July 2013, an open letter by Amnesty International pleading that the group members be set free was signed by more than 100 international artists, including Peter Gabriel, Elton John, Paul McCartney, Madonna and Yoko Ono. Pussy Riot had become an issue on the international agenda (*Grani,* 2013). Pussy Riot's performance in the Cathedral had also become a starting point for an enormous offensive by conservative–religious forces. It was as if the dark sediments of society had suddenly come to the surface (see Chapter 8).

Conclusions

Signs of a Russian counterculture in art were visible in the period 2009–2011. This change was reflected within arts community discussions at public round tables but first and foremost in articles and debates in newly created forums. One such forum was the Internet site *Open Space*, which began in June 2008 with Mariya Stepanova as chief editor until it closed down in the summer of 2012.[42] The *Open Space* website covered Russian art, film, theatre, literature, music, media and society using in-depth analyses, interviews and discussions, and publishing transcripts from seminars and round tables. It also referred to and summarized what was said in debates on other websites. It rapidly became an important and widely read intellectual resource. Other publications, such as *Artkhronika*,[43] the journal *The New Times* and the web publication *Grani*,[44] reflected the new propensity to take a civic position. Signs of a counterculture and an increasing value-conflict were clearly visible in these discussions. This also implied a tendency to draw a line between a 'we' and 'our interests' as opposed to those of the 'them' in power. The acts of members of the arts community in support of colleagues threatened by court proceedings reflected an awareness of such a divide. Many perceived a threat from the state, the church and extreme patriotic–religious groups acting together. A harsher state policy was being established, with existing laws applied according to more rigid and conservative interpretations. The space for humour and irony in art was being rapidly reduced.

A process of politicization and a shift in how art was viewed took place within the arts community. To many, the political stance of an artist became an important additional factor to consider when discussing the value of his or her work. This meant that an artist who was not socially oriented could be criticized for not taking a civic position. Art of engagement reflected the new counterculture. As is described in Chapter 5, activist interventions had helped to politicize art in Russia. Art of engagement now became a form of political statement. Nonetheless, it remained in the artistic field.

Like the performances by the Voina group, Pussy Riot's performances replaced political acts in a situation where people had no political voice. As the conflict between the arts and the authorities escalated after the arrest and sentencing of the members of Pussy Riot, it became more difficult for gallery owners and artists to compromise or to manoeuvre in relation to the state authorities.[45]The space for free speech was being reduced.

Against this background, it is not surprising that the experience of the West European art collective the Situationist International, which had been a source of inspiration to students in Paris in 1968, was now picked up and regarded as directly relevant to the evolving Russian protest movement. The first direct statement in this regard was made in an *Open Space* article of October 2011:

> Only the Situationist International, which is closely connected with 1968, can help to answer the challenges of modernity. In our country no 'revolution of 1968' took place – the international revolution in relations between people . . . that attacked the hierarchy of the social order from state management to family life and taught people to critically relate to the information boom that is but a promotion of commodities. In the 1980s something similar took place in Eastern Europe, while in the 1990s in Russia elements of such a revolution existed only in the cultural sphere without changing anything substantially in either politics or daily life.
>
> (Mitenko, 2011)

The Russian art scene, which in the middle of the first decade of the twenty-first century had seemed intoxicated with illusions of Putin glamour, had become politicized. This reflected processes in society as a whole, but the art scene was a frontrunner in this regard. The Innovatsiya Prize awarded to the Voina group in April 2011 and the Kandinsky Prize awarded to Yurii Albert in December the same year both illustrated this point. Albert's art showed how the politicization had reached the core of the generation of conceptualists. According to *Artkhronika*, 'Most interesting is . . . the tendency that is clearly visible from the shortlist of nominees. The 2011 Kandinsky Prize excellently reflects the new sentiments among a substantial part of the arts community: an interest in "socially relevant" art. Seven out of nine artists on the shortlist are interested in social problems. Every work is an investigation into an aspect of social relations starting from the relations between the sexes and ending with the topical issue of democratic choice' (*Artkhronika*, 2012). The scene seemed set for public demonstrations.

Notes

1 Compare Roberts (1978); Williams, (2011).
2 'Rossiya! Vpered! Statya Dimitriya Medvedeva', 10 September 2009, www.kremlin. ru/news/5413.
3 Among the novels depicting a dystopian future were Dmitrii Bykov's *ZheDe* (Living Souls) about the ordinary Russian man being squeezed over the centuries by a power struggle between two competing power groups using violence and money as their main tools. Olga Slavnikova's *2017* unfolded against a backdrop of popular unrest and revolt, which was brutally suppressed by a coup d'état 100 years after the Russian revolution.
4 The roundtable discussion 'Kruglyi stol: iskusstvo i politika: novaya apatiya?', organized by *Open Space*, took place in early December 2009 and published its results on 20 January 2010 (*Open Space*, 2010f).
5 Quoted by Podrabinek (2010).
6 Among the panel participants were Leonid Bazhanov (NCCA), Ekaterian Degot (*Open Space*), Andrei Erofeev (curator), Tatyana Volkova (Gallery Zhir) and Vinogradov (artist). Mavromati and Ter-Oganyan took part by Skype.
7 See, for example, the open letter of complaint from nationalist writers to President Putin which contained a request to repeal article 282, under which several nationalist activists had been jailed, 'Otkrytoe pismo russkikh pisatelei Prezidentu Rossii', 24 December 2007, http://slavyanin.org/forum/viewtopic.php?id=307. The critical attention on article 282 was followed up in 2011 by a case study of its implementation written by two former members of the Voina group (Epstein and Vasilev, 2011).
8 Mikhalkov asked Putin to stand for a third presidential term in an open letter of October 2007. In the same year, he praised Putin in a specially produced panegyric film about the leader on his 55th birthday. In October 2010 he published the conservative manifesto 'Law and Truth: Manifesto of an Enlightened Conservatism' (Mikhalkov, 2010). On reactions to the manifesto, see Levkin (2010).
9 See Osmolovskii's 'Introduction' to the first issue of *Baza*. On the journal, see *Open Space* (2010d).
10 Author's interview with Marat Gelman, Moscow, November 2009.
11 Compare Claudia Mesch writing about 'political art' in the West as art that connects to and engages with political and grassroots movements (Mesch, 2013).
12 Compare Claire Bishop (2012).
13 On the organization, see www.chtodelat.org. In early 2010 a Laboratorium for Critical Art (Laboratoriya kriticheskogo iskusstva, LKI) was created at the European University in St Petersburg. It was supported by the *Khudozhestvennyi zhurnal*, the Chto delat? group as well as the European Institute for Progressive Cultural Policies. The purpose of the Laboratorium was 'to study, systematize, and practically implement a series of research projects in the field of contemporary art'. The projects were initiated by artists who saw their task as analysing contemporary society and the place and role of art in the public space. See (Chto delat, 2009) and 'Laboratoriya kriticheskogo iskusstva v evropeiskom universitete, Gif.ruInformagenstvo', 17 February 2010, www. gif.ru/projects/lab-critical-art/.
14 Two examples illustrate this. In October 2008, a leaflet was distributed which included the text 'Kill the slave within you!' (Ubei raba v sebe), a reference to a quotation from Anton Chekhov 'to squeeze the slave out of oneself' (see Chapter 7 note 33). Linguistic experts in the Moscow court concluded that the context of the leaflet as a whole made these words a call to violence or murder (Epshtein and Vasilev, 2011: 47–49). The second example is a leaflet with the slogan 'Time for regime change' (Vremya menyat vlast). It was a call for people to join the Demonstrations of the Dissenters (Marsh Nesoglasnykh). In a photograph with the huge clock of the Spasskii tower in the Kremlin in the background, a man stands lighting a cigarette and waiting. His face is turned

to his left like the face of Lenin looking into the future on propaganda posters, and his pose is reminiscent of a well-known photograph of Mayakovskii, a film star, or an advertisement. The experts appointed by the court, however, found that the photograph 'had a remote resemblance to Vladimir Putin', thereby raising the suspicion that the leaflet constituted a threat to Putin (Epshtein and Vasilev, 2011: 49–50).

15 'Transkript audiozapisi diskussionogo kluba "Zhir": Ulichnoe iskusstvo segodnya', 12 April 2011, at the Gileya bookshop, http://narod.ru/disk/11364175001/VN680488. mp3.html, accessed through http://zhiruzhir.ru/post/2148#more-2148.

16 The exhibition by Aleksei Belyaev-Gintovt, '55¤ 45′ 20.83′′ N, 37¤ 37¤ 03.48′′ E' at Gallery Triumf, Moscow, 31 March–15 April 2012.

17 Dugin quoted in *Zavtra* (2012).

18 'Gruppa khudozhnikov, pozhelavshikh ostatsya anonimnymi, proveli segodnya anti-ortodoksalnouyu aktsiyu u khrama Khrista Spasitelya v podderzhku Olega Mavromati. Krestiki proigrali!', 3 October 2010, http://mnog.livejournal.com/245715.html.

19 Author's interview with Denis Mustafin, Moscow, 7 October 2010.

20 'Molodezhnyi festival nezavisimogo iskusstva 'Poshel! Kuda poshel?', www.facebook. com/group.php?gid=486193305248.

21 Manifesto of the youth biennale of independent art 'Poshel! Kuda poshel?', 26 March 2010, website of the festival, www.artyoung.ru. Compare the website of the official biennale: www.youngart.ru.

22 'Diskussionnyi klub "Zhir" v "Gilee"', posted on 12 February 2011 at http://zhiruzhir. ru/cat/vistavki-zhir, accessed February 2011. Reposted on http://zhiruzhir.ru/.

23 On media activism and the Situationists, see Özden Firat and Kuryel (2011), Brown and Anton (2011) and Lievrouw (2011).

24 See the website of such art with drawings from various legal processes, www. risuemsud.ru.

25 Author's interview with Andrei Erofeev, Moscow, 29 December 2009.

26 In the spring of 2011, a gallery at the International University in Moscow agreed to house an exhibition on art and reportage curated by Andrei Erofeev, which included Lomasko and Nikolaev's series from the 'Forbidden Art' trial. However, the exhibition was cancelled at the last moment. Lomasko and Nikolaev (2011). Later this was to be repeated at other venues.

27 In September 2011 they participated in the Moscow Art Biennale, exhibiting a series of drawings from a youth penal colony.

28 The contest was organized by the Sergei Kuznetsov Content Group together with the Sakharov Centre. 'V Moskve otkrylas vystavka po protsessu nad Khodorkovskim', 15 September 2009, http://vesti.kz/art/25234/; see also 'Risuem sud: vystavka v TsDeKha', 18 September 2009, www.youtube.com/watch?v=elECGz36Lc0.

29 A video presenting these works, 'Monitor: Piterskii strit art', can be found at http:// grani-tv.ru/entries/1804/ (posted in June 2011).

30 Photographs from this event can be found ('Pora podmenyat', posted on 20 February 2011) at http://zyalt.livejournal.com/357993.html.

31 'Dvoinoi fak', Blog Art-gruppa art-m2, 24 August 2011, www.grani.ru/blogs/free/ entries/190844.html.

32 See, for example, http://urbanroots.ru.

33 See www.agitclub.ru/museum/graffiti/graffiti2.htm.

34 'Segodnya v polden aktivistki Pussy Riot otsluzhili v khrame Khrista Spasitelya pank-moleben "Bogoroditsa, Putina progoni"', 21 February 2012, http://pussy-riot. livejournal.com/12442.html.

35 In November–December 2011 people were queuing outside the Cathedral of Christ the Saviour to see the casket and the supposed relics of a belt of the Virgin Mary.

36 Chaplin in the collective blog 'Pravoslavnaya politika', quoted in *Grani* (2012b).

37 In August he presented such a draft law (*Grani*, 2012c).

38 Quoted by Vladislav in Maltsev (2012).
39 See, for example, *Grani* (2012b).
40 Among them were the artists Yurii Albert and Dmitrii Vrubel, actors Evgenii Mironov, Chulpan Khamatova, and Liya Akhedzhakova; theatre directors Mikhail Ugarov, Kama Ginkas, Roman Vinchuk, Mark Zakharov, Andrei Konchalovskii, Kirill Serebrennikov, Dmitrii Bertman, Elena Gremina; film directors Fedor Bondarchuk, Eldar Ryazanov, Aleksei German Senior and Aleksei German Junior; writers Mikhail Zhvanetskii, Boris Strugatskii, Vladimir Voinovich, Boris Akunin, Dmitrii Bykov, Lyudmila Ulitskaya, Lev Rubinshtein and Yurii Arabov; rock musicians Yurii Shevchuk, Andrei Makarevich, Boris Grebenshchikov; composer Leonid Desyatnikov; and the gallery owners Marat Gelman and Elena Selina.
41 'Obrashchenie k Patriarkhu Moskovskomu i vseya Rusi Kirillu', published in 'Sbor podpisei okonchen, 29 iyunya pismo s imenami podpisavshikh peredano v Upravlenie delami MP', 19 June 2012, http://pechalovanie.livejournal.com/605.html.
42 It was replaced by Colta.ru in 2012.
43 *Artkhronika* changed its editorial policy in 2012 and closed down in 2013.
44 In spring 2014 the *Grani* website was blocked by the authorities in Russia.
45 Marat Gelman, for instance, said that after the Pussy Riot members were sentenced he no longer wanted to cooperate with the federal authorities: 'It became impossible for me. Everyone was looking at me, and I decided that I no longer had the right to cooperate with authorities who send people to jail'. Author's interview with Marat Gelman, Moscow, April 2013.

References

Abarinov, Vladimir (2012), 'Svyato mesto Pussy Riot', *Grani*, 27 February, www.grani.ru/opinion/abarinov/m.195956.html.
Artkhronika (2010), 'Kuda poshlo iskusstvo? V tonneli!', 18 September (online version).
Artkhronika (2011), 'Chistka peresmeshnikov: Andrei Erofeev o tom, kak pugayot khudozhnikov', 3: 20–21.
Artkhronika (2012), 'Proekt "Problema, ili Partiinoe iskusstvo"', 1: 22 December www.artchronika.ru/themes/проект-«проблема»-или-партийное-иск.
Benediktov, Kirill (2010), 'Kak edinorossy stali "konservatorami"', *Russkii zhurnal*, 21 January, www.russ.ru/pole/Kak-edinorossy-stali-konservatorami.
Bishop, Claire (2012), *Artifical Hells: Participatory Art and the Politics of Spectatorship* (London and New York: Verso).
Bolshoi gorod (2012), 'Free Pussy Riot', 4 April (cover page).
Borovskii, Aleksander (2008), 'Mozhno li ultrapravyi pochvennik poluchit premiyu Kandinskogo?', *Open Space*, 25 November, http://os.colta.ru/art/projects/160/details/6106?attempt=1.
Brown, Timothy and Anton, Lorena (eds.) (2011), *Between the Avant-Garde and the Everyday: Subversive Politics in Europe from 1957 to the Present* (New York and Oxford: Berghahn Books).
Chto delat? (2009), 'What is the use of art?' 1:25.
Degot, Ekaterina (2008), 'Mog li ultrapravyi natsionalist ne poluchit premiyu Kandinskogo?', *Open Space*, 11 December, www.openspace.ru/art/projects/89/details/6467/, reposted on http://os.colta.ru/art/projects/89/details/6467/.
Degot, Ekaterina (2010), 'Kritik pered litsom nasiliya', *Open Space,* 18 November, www.openspace.ru/art/projects/89/details/18780/?expand=yes#expand, reposted on http://os.colta.ru/art/projects/89/details/18780/.

Ekho Moskvy (2012), 'Obrashchenie deyatelei kultury v zashchitu Pussy Riot', *Intelligentsiya prizyvaet osvobodit Pussy Riot*, 27 June, www.echo.msk.ru/doc/903154-echo. html.

Engström, Maria (2012), *Proekt 'Imperiya': politicheskaya mifologiya Rossiiskogo neokonservatizma* (Stockholm: Stockholm Slavic Studies, Acta Universitatis Stockholmiensis).

Engström, Maria (2013), 'Military Dandyism, Cosmism and Eurasian Imper-Art', in Birgit Beumers (ed.), *Russia's New Fin de Siecle* (Bristol and Chicago: Intellect), pp. 99–118.

Epstein, Alek and Vasilev, Oleg (2011), *Politsiya myslei: Vlast, eksperty i borba v sovremennoi Rossii* (Moscow: Gileya).

Erofeev, Andrei (2008), 'Gruppa "Voina" i obshchestvennyi moral', *Artkhronika* 7–8, www.aerofeev.ru/index.php?option=com_content&view=article&id=209:e-lrr& catid=62&Itemid=157.

Erofeev, Andrei (2011a), 'Krizisnyi etalon', Artkhronika 11: 24-25. Reposted as 'Brodskii kak etalon', 30 March, www.aerofeev.ru/content/view/293/1/.

Erofeev, Andrei (2011b), 'Chistka peresmeshchnikov', *Artkhronika* 3: 20–21.

Flor, Evgenii, (2011), 'Perekhod na ulichnosti', *Grani*, 30 August, www.grani.ru/Culture/ art/m.191030.html.

Gessen, Masha (2014), *Words Will Break Cement: The Passion of Pussy Riot* (New York: Riverhead Books).

Grani (2011), Evgenii Legedin, 'Melovaya revolyutsiya', 12 July, http://grani.ru/blogs/ free/entries/189909.html.

Grani (2012a), 'Nakazanie za "tsinichnoe oskvernenie khramov" mogut uzhestotochit', 2 March, www.grani.ru/society/Religion/m.196112.html.

Grani (2012b), 'Zasedanie suda po arestu Pussy Riot pereneseno', 19 June, www.grani.ru/ Politics/Russia/Politzeki/m.198497.html.

Grani (2012c), 'Deputat Sidyakin gotovit proekt o bogokhulstve', 28 August, http://grani. ru/Society/Law/m.200053.html.

Grani (2013), 'Bolee sta vsemirno izvestnykh rok-muzikantov vyskazalis v podderzhku Pussy Riot', 22 July, www.grani.ru/tags/pussyriot/m.217120.html.

Khachaturov, Sergei (2008), 'Politicheskii kabare: Nazvany pobediteli premii Kandinskogo', *Vremya novostei*, 12 December. Reposted on stengazeta.net/?p=10005621.

Kommersant (2011), 'Grazhdanskaya mediaaktivnost "Mediaudar" v ArtPlay', 24 October 2011, www.kommersant.ru/doc/1789669.

Kostyleva, Elena (2011), 'Pochemu propal Falkovskii', *Open Space*, 18 March, reposted on http://os.colta.ru/society/russia/details/21216/?expand=yes#expand.

Krongauz, Ekaterina (2012), 'Kak mnogo devushek khoroshikh', *Bolshoi gorod*, 6 February, www.bg.ru/article/10024/.

Levkin, Andrei (2010), 'Osennyi krik Mikhalkova', *Open Space*, 29 October, www. openspace.ru/media/projects/17717/details/18467/?expand=yes#expand.

Levkovich, Evgenii and Samkova, Natalya (2009), 'Domashnaya stsena', *The New Times*, 5 October, www.newtimes.ru/archive/detail/6862/.

Lievrouw, Leah (2011), *Alternative and Activist New Media* (Cambridge, UK and Malden, Mass.: Polity, 2011).

Lomasko, Viktoriya and Nikolaev, Anton (2011), 'Pro otmennuyu vystavku i podlost tsenzury', *Grani*, 28 April 2011, http://grani.ru/blogs/free/entries/188149.html.

Lomasko, Viktoriya and Nikolaev, Anton (2011), *Zapretnoe iskusstvo* (Moscow: Bumkniga).

Maltsev, Vladislav (2012), 'Pussy Riot bet po bolnomu', *Nezavisimaya gazeta,* 21 March, http://religion.ng.ru/society/2012–03–21/1_pussy.html.

Mesch, Claudia (2013), *Art and Politics: A Small History of Art for Social Change since 1945* (London and New York: I.B. Tauris).

Mikhalkov, Nikita (2010), 'Manifest prosveshchennogo konservatizma. Pravo i pravda', *Polit.ru,* 26 October, http://polit.ru/article/2010/10/26/manifest/.

Mitenko, Pavel (2011), 'Chem nam mozhet pomoch nasledie situatsionizma?', *Open Space,* 20 October, www.openspace.ru/art/events/details/31205/page1, reposted on http://os.colta.ru/art/events/details/31205/.

Mustafin, Denis (2011a), 'Khudozhestvennyi protest v Rossii i v mire', Blog Denis Mustafin, *Grani,* 25 May, www.grani.ru/blogs/free/entries/188741.html.

Mustafin, Denis (2011b), 'Khudozhniki protiv gosudarstva', 29 June, www.grani.ru/blogs/free/entries/189614.html.

Open Space (2009a), 'Proidet marsh protiv sovremennogo iskusstva', 2 November, reposted on http://os.colta.ru/news/details/13328.

Open Space (2009b), 'Chto Vy dumaete o ´marshe degenerativnogo iskusstva´?', 4 November, www.openspace.ru/art/projects/160/details/13428/?expand=yes#, reposted http://os.colta.ru/art/projects/160/details/13428.

Open Space (2010a), 'Dmitrii Vilenskii: budushchee – v politicheskom realizme', 9 February, www.openspace.ru/art/projects/15960/details/16072/?expand=yes#expand, reposted on http://os.colta.ru/art/projects/15960/details/16072/?expand=yes#expand.

Open Space (2010b), 'Teoreticheskii entrizm and prakticheskii tantrizm: Anatolii Osmolovskii v permskoi internet-gazete "Sol"', 7 September, www.openspace.ru/art/projects/168/details/17737/?expand=yes#expand. Accessed September 2010.

Open Space (2010c), '"Narodnaya zashchita" otstoit veru v sude', 25 October, www.openspace.ru/news/details/18405/. Reposted on os.colta.ru/news/details/18405/

Open Space (2010d), 'Peredovoe iskusstvo nashego vremeni?', 26 October, www.openspace.ru/art/events/details/18416/. Reposted on os.colta.ru/art/events/details/18416.

Open Space (2010e), 'Dolzhny li khudozhniki byt sudebno neprikosnovenny? (Rossiiskaya versiya)', 3 November, www.openspace.ru/art/events/details/18528/. Reposted on os.colta.ru/art/events/details/18528.

Open Space (2010f), 'Kruglyi stol: iskusstvo i politika: novaya apatiya?', 20 January, www.openspace.ru/society/russia/details/15655/, reposted on http://litradio.ru/podcast/non_fiction_openspace/detail.htm.

Osmolovskii, Anatolii (2010), 'Vstuplenie', *Baza: Peredovoe iskusstvo nashego vremeni. Moskva* 1: 6–9.

Osmolovskii, Anatolii (2011), 'Venice Biennale: Exhibitions from Russia, Ukraine, Azerbaijan and 15 more countries', *Modernicon Art Guide,* Special issue.

Özden Firat, Begum and Kuryel, Aylin (eds.) (2011), *Cultural Activism: Practices, Dilemmas and Possibilities* (Amsterdam and New York: Rodopi).

Podrabinek, Aleksander (2010) 'Iskusstvo ukhodit domoi', 17 January, www.rfi.fr/acturu/articles/121/article_5225.asp.

Postnikova, Irina (2010), [interview with Anatolii Osmolovskii in] 'Tupye, navernoe. Knizhek ne chitayut', [Perm journal] *Sol,* 3 September, www.saltt.ru/node/4106.

Remchukov, Konstantin (2009), 'Tak zhit nelzya, ili vse-taki mozhno? O rossiiskoi politike 2009', *Nezavisimaya gazeta,* 15 December, reposted on www.ecoteco.ru/library/economics/tak-zhit-nelzya-ili-vse-taki-mozhno.

Roberts, Keith A. (1978), 'Toward a Generic Concept of Counter-Culture', *Sociological Focus* 11(2): 111–126.

Rubinshtein, Lev (2010), 'Seichas net sereznogo soprotivleniya', Besedu vedet Zara Abdullaeva, *Iskusstvo kino*, www.kinoart.ru/magazine/05–2010/now/rubinsh1005.

Rukhina, Eva (2010), 'Novye "kvartirniki"', *Artkhronika* 12: 71.

Sorokin, Vladimir (2009), 'Underground: O nem seichas vspomnili, Aktivno', Blog at *Snob*, 24 November, www.snob.ru/profile/5295/blog/9395.

TimeOut (2011), 'Media udar', 31 August, www.timeout.ru/exhibition/event/245171.

Tolstova, Anna (2011), 'Grazhdanskaya mediaaktivnost "Mediaudar" v Artplay', *Kommersant*, 10 October, www.kommersant.ru/doc/1789669.

Tsvetkov-Mladshyi, Aleksei (2011), 'Liberalnyi anarchism: Denisa Mustafina', *Open Space*, 12 February 2011, www.openspace.ru/art/projects/30045/details/32352/page1/, reposted on http://os.colta.ru/art/projects/30045/details/32352/.

Veretennikova, Kseniya (2009), 'Tory eshche budet. Edinaya Rossiya reshila stat partiei konservatorov', *Vremya novostei*, 9 October, www.vremya.ru/2009/186/4/239166.html.

Williams, J. Patrick (2011), *Subcultural Theory: Traditions and Concepts* (Cambridge: Polity Press).

Zavtra (2012), 'Futuropolis: Aleksei Belyaev-Gintovt v galleree "Triumf"', 14 April), http://zavtra.ru/content/views/futuropolis/.

7 Political action

The counterculture developing within the Russian art sphere reflected the evolving mood of frustration in part of society. Similar processes took place to varying degrees in other cultural spheres. This chapter examines how this counterculture was transformed into media activism and then into traditional forms of political action, such as demonstrations. The first section looks at protest tendencies in Moscow's cultural and intellectual circles beyond the art scene. It describes an evolving trend for social concern manifested by individuals who publicly took up civic positions questioning official state policy, not least through their cultural output. The second section investigates whether there were organizations capable of taking this frustration and transforming it into political action. The third section looks at the new media activism that helped to mobilize protest during the campaigns for the parliamentary elections of December 2011 and the presidential election of March 2012, and up to the inauguration of the president in May. Finally, the chapter discusses the role of people from the cultural sphere in this mobilization.

Towards social concern

Taking a civic position in public is a brave step in a society with a history of repression and fear. Therefore, when in 2010 and 2011 well-known cultural figures went public and criticized the authorities from an ethical and moral standpoint, this had an impact on public opinion. The legal case against Mikhail Khodorkovskii and Platon Lebedev was important in this regard.

The Russian tradition of writing 'open letters' to rulers replaces other protest activities that the state does not allow. The first Khodorkovskii-Lebedev trial resulted in several open letters in 2005. A polarization took place within the intelligentsia as some sided with the regime while others criticized official policy. Well-known people, such as the writer of children's books Eduard Uspenskii, the science fiction writer Boris Strugatskii and the actress Lilya Akhedzhakova, were among those demanding that Khodorkovskii be recognized as a political prisoner (*Grani*, 2005). It was not long, however, before another open letter was published in defence of the authorities, the work of the court and the legal system signed by among others Nikita Mikhalkov and Stanislav Govorukhin (*Izvestiya*, 2005).[1]

The second trial was no different in this regard. A letter in support of Khodorkovskii and Lebedev was published as the trial started in March 2009.[2] About a month before the verdict was announced, an open letter called for the two to be released (*HRO,* 2010). A few months later, a letter called for them to be granted the status of prisoners of conscience.[3] The fate of Khodorkovskii had by then become a concern of the cultural elite. One contributory factor was his book *Dialogues,* based on his correspondence with the writer Lyudmila Ulitskaya, which was awarded the *Znamya* literary prize in January 2010, a clear sign that Khodorkovskii had been recognized by the cultural elite (*Nezavisimaya gazeta,* 2010). The other side in this controversy was no less active. A letter was signed in March 2011 in defence of the court and accusing the supporters of Khodorkovskii of slander against the Russian legal system (Vlasenko and Shakirov, 2011). By then, however, this side had been compromised by a scandal in February 2011 over how signatures had been collected for the 2005 letter. More than five years after the first letter was published, a well-known ballerina announced that she had been tricked into signing. She left the United Russia Party in protest (Shakirov, 2011). Four more cultural personalities also retracted their signatures. This scandal had far-reaching consequences for the Putin regime among the intelligentsia.

By early 2011 the political temperature was rising in Moscow and in the country as a whole. The parliamentary and presidential elections were getting closer. They were of the utmost importance for the regime as the ruling power constellation would be defined for the next six years. In order to secure the desired outcome, the Putin regime took some nervous steps. In May 2011 the pro-Putin All-Russian People's Front was created and, in a landslide, public organizations became collective members of the Front. This, not surprisingly, led individuals to react. Among them was Evgenii Ass, the famous architect who publicly protested against being enrolled in the Front through his membership of the Union of Architects but without his personal consent. Instead of remaining quiet, he went public and criticized the practice (Treshchanin, 2011).

The poet Lev Rubinshtein, by now a voice of moral authority and protest, called in May 2011 for the support of people who dared take a stand in public, primarily arts activists (Rubinshtein, 2011a). In September 2011 he wrote about the importance of making a 'personal choice', and the decision that everyone must take in relation to what was going on in Russian society and political life. This choice, he said, was not just a question of responsibility but also one of how to behave, with a nod to Andrei Sinyavskii, who once said he had 'stylistic differences' with the Soviet regime (Rubinshtein, 2011b). Rubinshtein mentioned people not previously known for making public statements who now took a civic position. Besides Evgenii Ass, who objected to being enrolled into Putin's Front, he mentioned the classical composer Aleksander Manotskii who declared his participation in the protest meetings in Triumfalnaya Square on the 31st of each month in defence of political rights guaranteed by the Russian Constitution (Manotskov, 2011). To Rubinshtein, these people were demonstrating civic responsibility when they bravely defended their views in public and acted in opposition to the political mainstream (Rubinshtein, 2011b).

Among these people was also Leonid Parfenov, a television personality at the state-owned Channel One. In a speech in November 2010, made as he accepted the award for television journalism named after Vladislav Listev, the journalist and general director of the ORT television company murdered in 1995, Parfenov publicly criticized state television for censorship, propagandistic tendencies and extreme loyalty to the official line, views and versions of events.[4] His speech attracted much attention because he was considered part of the official media establishment. The federal television channels and the private–owned NTV found his criticism too severe to broadcast (Kotova, 2010).

By this time, many rock and rap musicians had gone public with their criticism on the Internet, and their declarations spread rapidly. One of the first was the popular rapper NOIZE MC (Ivan Alekseev), who in March 2010 uploaded his song 'Mercedes 666' on to the Internet. The lyrics were about an incident in which the Mercedes of a Lukoil deputy director killed two women, but the driver faced no legal sanctions.[5] It was a song about the arrogance of power and how power and money make a person 'untouchable'. The song put words in the executive's mouth: 'Let me introduce myself . . . I am a person on a different level, a being of a higher rank. I am unfamiliar with problems that cannot be resolved by bribery. I know no people whose lives are more important than my own interests. I don't care what the press writes about me. If you are in the way of my Mercedes, whatever happens you will be the one guilty of the accident. Mercedes S666, out of my way plebs! Don't climb under my wheels'.[6] In October he produced a follow-up song, 'Mercedes S777', when the court cleared the Lukoil deputy director of all charges.[7]

When NOIZE MC performed a song about police brutality in Volgograd in July 2010, he was arrested and detained for ten days. He was only released after he produced a written apology to the police. This, however, was full of sarcasm, and after his release he wrote a song that included the refrain, 'Goodbye city of Stalingrad. Now it is clear to me where the capital of our police state is located'.[8] The text and accompanying video dealt with police brutality and had more than 700 000 downloads in its first few days on the Internet. The lyrics of NOIZE MC put into words the feelings of hatred and mistrust of the police that many felt at the time. He was invited to the small, independent radio station Ekho Moskvy and became known to a wider as well as an older audience.[9]

Another musician who went public was the rock veteran Yurii Shevchuk. He was the leader of the band DDT, and known from the 1980s Soviet underground music scene. More than 20 years later his group could still attract 10 000 fans in Moscow without any conventional marketing. In March 2008 he was the first rock musician to participate in a demonstration organized by the political opposition group March of Dissenters (Marsh nesoglasnykh). He was therefore known for both his music and his civic position, and the audience knew well the refrain of one of his songs: 'Putin is travelling around the country but we are standing in the same place as previously in the . . . shit'.[10] In May 2010, at a live television broadcast of a meeting between Putin and cultural personalities in St Petersburg, his frank questioning of Putin and his criticism of the situation in the media, the

courts and civil society caused a sensation.[11] In the summer of 2010, Shevchuk joined the protest movement against the construction of a motorway through the Khimki Park on the outskirts of Moscow. This helped attract attention to the cause and made him a key figure together with the leader of the movement, Evgeniya Chirikova.[12] The Khimki movement, created in 2007, became extremely important during 2010 and 2011 as a catalyst for the growing frustration and protest among intellectuals in Moscow. It provided a venue for protest by organizing actions, demonstrations and concerts.

The response to both NOIZE MC and Shevchuk suggested that there was an important change in mood among the public, primarily the intelligentsia and the middle class. Opinion polls by the Levada Centre in early 2011 indicated falling support for Putin, Medvedev and the United Russia Party (*Vestnik*, 2011). In March 2011, a sociological study by the Centre for Strategic Analysis, based on extensive focus group interviews, showed a remarkably sharp fall in support for Putin first and foremost among the middle class. The authors of the report concluded that a 'political crisis was rapidly under way although it had not yet reached the surface of political life' (Belanovskii and Dmitriev, 2011).

Social concern and the theatre

The increasing social concern in the visual arts and contemporary music had its parallel in the theatre. The New Russian Drama that evolved at the end of the 1990s and in the early 2000s developed its own subculture. It traced its roots to the need felt for plays that described the radically different post-Soviet reality. The repertoire of Moscow's theatres in the 1990s had been dominated by classic plays or translations of foreign plays.

Back in 1991, the Lyubimovka Festival for young scriptwriters had been founded to encourage a new generation of writers to take on the task of portraying contemporary Russian life.[13] Aleksander Kazantsev and Mikhail Roshchin created the Centre for Playwrights and Directing (Tsentr dramaturgii i rezhissury) in December 1998. It opened its doors to young directors and playwrights and became the first theatre to stage New Russian Drama.[14] The centre participated in a joint Russian–British theatre project with London's Royal Court Theatre, which introduced new British playwrights such as Mark Ravenhill and Sarah Cane to Moscow. The new British drama, with its focus on social themes and the dark side of society, immediately received a strong response in Russian theatre circles and influenced the evolving New Russian Drama.

Although inspired by the Brits, the young Russian playwrights found their inspiration and form of expression in Russian life. In 2002, Mikhail Ugarov, one of the first young directors to stage a play of the new kind at the Centre for Playwrights and Directing, opened the small, independent Teatr.doc with Elena Gremina and a small number of young playwrights. The theatre concentrated on *verbatim*, or plays based on documentary material collected through personal interviews.[15] Ugarov was the driving force behind the New Drama Festival from its start in 2002. In 2005, Theatre Praktika was created by Eduard Boyakov, who

declared it 'a theatre of a new generation, a theatre of the texts and heroes of today'. According to the theatre's website, 'We talk honestly about the topics of the citizens of the megapolis: love, business, fashion, politics, narcotics, poetry, sex and the conscience'.[16]

New Drama was a way to analyse post-Soviet society, its living conditions and the existence of the individual. It represented, in the words of Birgit Beumers and Mark Lipovetsky, 'a return to social reality and to those social problems that the Eltsin era generated and that the cultural establishment of the Putin era refuses to notice' (Lipovertsky and Beumers, 2008: 294). A common trait of New Russian Drama was its analysis of the violence that penetrated society and constituted its social fabric. In their analysis, Beumers and Lipovetsky distinguish between different kinds of violence in the Soviet and post-Soviet context, paying special attention to what they call 'communal/communicative' or 'causeless' violence. It is this type of violence, they argue, that characterizes post-Soviet Russia. It is a 'non-ideological' violence in the sense that it has no rationale. Instead, it is everyone's war against everyone else and characterizes the daily relations of authority and submission. They explain that '. . . the arbitrariness in the definition of the Other – the target of violence – is not characterized by ideological, religious or any other discourse, but transforms violence into a form of social communication, which is destructive and self-destructive at the same time' (Beumers and Lipovetsky, 2009: 59). Such violence is reflected in the language, which is full of aggression and words with aggressive sexual connotations. New Drama is about the exposure of and vulnerability to violence, and it uses naturalistic, absurd or fantastic forms of expression.

The New Russian Drama formed a whole generation of playwrights, such as Vasilii Sigarev, the Presnyakov brothers, the Durenkov brothers, Ivan Vyrypaev and Yurii Klavdiev. Beumers and Lipovetsky's words about the Presnyakovs are valid for many of the New Drama writers: 'The Presnyakovs return social values to the theatre stage, inverting them in effect: they convince the audience/reader that the "community" to which they belong is cemented by pseudo-identities based on spectacles of violence; therefore their plays do not "assert afresh" but, on the contrary, undermine the performed identity, aggravating the existing crisis and taking it to its explosive limits' (Beumers and Lipovetsky, 2009: 291).

The Kazantsev and Roshchin Centre, Teatr.doc and Praktika constituted a subculture within the otherwise conservative life of Moscow theatre. They did not deal directly with political topics, but their plays expressed dissensus in relation to the dominant consensus discourse.[17] Teatr.doc was unique in basing its plays on documentary material, but the theatre stood out, first and foremost, because when staging plays on overtly political and highly sensitive topics Ugarov and Gremina always allowed different voices to be heard. When in 2005 they staged the play *September*, about reactions to the terror attack on the school in Beslan, their actors gave a voice to all sides of the event. The play *00.17*, staged in early 2010, was a documentary on the night when the jailed lawyer Sergei Magnitskii was left to die in his cell by the prison authorities. The name of the play indicates the exact time of his death. Only documentary material was used, but it was

nonetheless the first play to take a clear and directly stated civic position on such a hot political topic.[18] Gremina recalled: 'Before this play Teatr.doc had been a theatre outside politics and we had been proud of that. We staged "September. doc" about the events in Beslan and everyone was given a voice: Russian fascists, Wahhabists, philistines. This was a mutual recognition of the hatred, and we took no position. We considered that this is hell in the head of the contemporary human being, and we were happy that we were free to talk about it. But "00.17" was the play where we changed this "zero-position"'.[19]

Thereafter, Teatr.doc became the most politically outspoken theatre. Among its plays were *Offended Feelings* (Oskorblennye chuvstva) (2011) about the trial of the Forbidden Art exhibition, *BerlusPutin* (2012), after a play by Dario Fo about two political leaders who merge their brains, the title being a merger of Berlusconi and Putin, *Pussy Riot* (2012), about the trial of the group, and a play about the people arrested at the demonstration in Bolotnaya Square in May 2012. The choice of repertoire was a sensation in the Moscow theatre world. Teatr.doc avoided the attention of the patriotic-religious groups until August 2012, when Orthodox activists broke into the theatre at the end of a performance of the Pussy Riot play shouting: 'Repent!' and 'Why do you hate the Russian people?' The audience threw them out. The most surprising thing about this incident was that the activists came with a television camera crew from NTV.[20]

The radical theatre directors were not taken to court, as was usually the case with the visual arts. There are several possible reasons for this. A major factor was probably that a picture is more easily accessible because it can be spread over the Internet. A theatre like Teatr.doc is more of a closed world, with its limited number of seats. Another factor is that Teatr.doc usually avoided the burning issue of religion.

Organizations of protest

Political opposition was weak during Putin's first and second terms as president.[21] The Duma elections of 2007 extinguished the liberal opposition in parliament. The Communist Party became the only opposition party in the Duma, but it did not assume the function of a proper opposition. In this new situation, with the democratic opposition excluded from parliament, some liberal leaders became part of the non-systemic opposition. Liberal politicians, however, met with popular suspicion. They were discredited by their past records, and their internal quarrels and splits contributed to a general feeling that the liberals had no future. Were there any political organizations that could articulate the new critical mood among groups in society and transform it into political action?

In the summer of 2006 the movement Drugaya Rossiya (The Other Russia) was created. This was a coalition of non-governmental human rights organizations and political organizations from the non-systemic opposition, with leaders as diverse as the liberal chess grandmaster Garry Kasparov and the National Bolshevik Party leader Eduard Limonov. In December 2006 it launched a first public manifestation, the March of Dissenters. Demonstrations were held in Moscow,

St Petersburg, Nizhnii Novgorod and other cities, until Drugaya Rossiya in 2010 was taken over by the followers of Limonov.[22] In the meantime, the liberals split, reorganized and reappeared in new constellations.

The Strategy 31 movement was formed in the summer of 2009, with the intention to hold regular demonstrations. By 2010 it had held meetings in 40 locations around Russia. Nonetheless, the number of demonstrators was limited and in Moscow they usually attracted only a few hundred people. The situation seemed paradoxical. The dedication of the demonstrators strengthened even though they were divided between themselves and the number of demonstrators did not increase. Instead, the masses seemed not to understand why the demonstrations were taking place. In September 2010 the Russian political analyst Dimitrii Furman compared the situation with dissidents in Soviet times. Those dissidents had also been few. He emphasized that the logic of the situation remained the same. No normal person, he said, will voluntarily get involved in defence of a paragraph of a constitution that he has never read. If people are to stand up against the authorities in an atomized society such as Russia's, there has to be a strong trigger that forces people to wake up: 'There have to be other reasons, and they will come by themselves' (Tsvetkova and Samarina, 2010). His point was that the potential support for political protest was strong in principle but current political slogans would not help the movement to grow.

Thus, in 2010 the non-systemic political opposition remained highly marginalized but with a small core of dedicated activists. The liberals, the left and the nationalists would later assist during protests and demonstrations, but none would be able to initiate or take the lead. Nonetheless, that opinion critical of Putin was in the making was reflected in March 2010 when an Internet campaign started to collect signatures for the proposition 'Putin must go' (Putin dolzhen uiti). Among the first signatories were human rights activists and people from the liberal and leftist wings of the non-systemic opposition. A year later the list had 80 000 signatures and by March 2012 it had 130 000 names, which is a large number given that the list was public and thus so were the identities of the signatories.[23]

Socio-economic protest grew during Putin's second term. At the end of 2004 and in early 2005 a wave of protests against the monetization and reform of social benefits swept the country.[24] It engaged mostly elderly people, but also young people primarily of a leftist and anarchist orientation. The authorities reacted rapidly and made partial concessions, as the government feared the protests. In 2007 a wave of wildcat strikes followed (*Russkii reporter*, 2007: 18–28). In cities around the country, people engaged at grassroots level in defence of their own material interests. Small-scale protests and temporary movements appeared to oppose the demolition of old buildings, new construction works, cases of corruption or higher local taxes. Such protests took the form of spontaneous, often desperate reactions and ad hoc demonstrations. Three themes dominated: the monetization of social benefits, housing and issues related to labour and work (Kleman, Mirzsova and Demidov, 2010). Even if individual protests sometimes attracted a fairly large number of participants and coordinating structures were created, no permanent organizations were set up capable of continuing and developing the protest. These

movements could be regarded as embryonic 'new social movements' (Clement, 2008: 68–89), but they still had a long way to go.

Normally, these protests were not reported by the official national media. Nor did they capture the attention of the political opposition or intellectuals in the larger cities. The exceptions were those protests that created a strong resonance among the population and thus broke the information wall. One example was the Shcherbitskii case of February 2006 (Kleman, Mirzsova and Demidov, 2010: 107–108; Robertson, 2011: 186), named after a car driver. As Shcherbitskii was turning left on a highway in the Altai region, the governor's car suddenly appeared travelling at 200 km an hour. It clipped Shcherbitskii's car, flipped over and ended up in a field. The governor was killed, and Shcherbitskii was convicted by a local court. The decision led to popular uproar and people publicly expressed their support for Shcherbitskii in 20 locations across Russia. This was a spontaneous grassroots revolt against an arbitrary decision of the bureaucracy. Another incident took place in the summer of 2006 in the southern Butovo district of Moscow. The Mayor of Moscow, Yurii Luzhkov, wanted to tear down small, wooden, single-family dwellings to make room for the construction of new commercial buildings. The local authorities tried to force the families to leave their homes but, in spite of the presence of bulldozers and policemen outside their doors, they refused. Instead, they acted together to defend their rights. Although they did not manage to prevent the construction work, they did manage to negotiate somewhat better terms when offered new homes. The spirit of resistance in Butovo became widely known (Kleman, Mirzsova and Demidov, 2010: 186–187; Robertson, 2011).

A protest movement of car owners in the Russian Far East, which began at the end of 2008 in opposition to increased taxes on imported cars, soon spread across the country. Within a year, actions had taken place in several cities (Bashkirova, 2012: 300–313). The international financial crisis hit Russia in 2008–2009 and drastically increased the number of unofficial and unregistered strikes. An estimate in early 2010 claimed that there had been 100 times more strikes than official figures admitted (Kulikov and Sergeev, 2010).

While most of these protests related to people's material and social situation, they nonetheless had political overtones and sometimes rapidly transformed into political demands. The slogan 'Putin resign!' was first heard in a serious public context at the car owners' demonstration in Vladivostok in 2008. In Russia, 'economic demands often rapidly transform into political ones', according to journalists at the daily newspaper *Kommersant*.[25] When 10 000 people gathered in Kaliningrad in January 2010 to protest against increased taxes and fees, including on imported cars, the protest soon turned against the local political leadership as well as the federal government, with demands that the governor and Prime Minister Putin leave their posts (Ryabushev, 2010). The car owners' protest set an example for other groups. They were joined by people protesting against unemployment and the increasing cost of living. Socio-economic and political protests developed in parallel. They were cautiously monitored by the authorities, which regularly cracked down on them.

Because the socio-economic protests in the provinces did not draw the attention of the middle class and intelligentsia in the larger cities, the traditional gap between Russia's intellectuals and the rest of the population seemed as wide as it had ever been. Two issues would partly bridge this gap in Moscow. The first was the protest against the blue flashing light (migalka) used by VIP cars, which provided them with the right to make way in the crowded streets of Moscow but exacerbated the city's traffic jams. Traffic-related problems were a constant source of popular frustration to the population. In March 2010, a protest meeting against the migalki, organized by the Russian Federation of Automobile Owners, gathered more than 1000 people in central Moscow (Bashkirova, 2012: 297). The new 'Blue Bucket Movement' became a symbol of civic protest against the bureaucracy. In April 2010, Leonid Nikolaev of the Voina art group gave his public performance with a blue bucket on his head (see Chapter 5).

The second issue was the protests against the construction of a motorway through the Khimki forest on the outskirts of Moscow, as part of the new motorway to St Petersburg. The protests were started in 2007 by environmentalists and people living in the area, but became famous in the summer of 2010 when tensions between the environmentalists and the construction company took a violent turn after the authorities ignored requests from the demonstrators for a dialogue. The movement, under its leader Elena Chirikova, became widely known on the Internet.

The defence of the Khimki forest was an important experience in the mobilization of civil society. It played a big role in merging different kinds of protest and bringing together people of various political orientations. This movement received the support of people from the cultural sphere, such as musicians, artists, actors and writers (Kashin, 2009). The movement grew, and its demands developed from the ecological to the political.

The Khimki movement 'took on a truly epic resonance', according to *Kommersant* journalists, as it mobilized broad support from within Russian cultural and intellectual circles (Bashkirova, 2012: 321). In August 2011 the Anti-Seliger festival was organized in the Khimki forest as an alternative to the Putin-loyal Seliger youth camp. Two months later a follow-up festival was organized, The Last Autumn, this time to discuss political and cultural issues under a single heading in preparation for the anti-government campaign before the parliamentary elections. Among the speakers was Evgeniya Chirikova. The purpose of these arrangements was to get people, young people in particular, interested in supporting the opposition in the upcoming elections. By now, the Moscow faction of the Voina group was among the organizers.[26]

In sum, the mobilization of protest in Moscow, which took off in the autumn of 2011 in time for the parliamentary elections, was not initiated by any existing political organization, as such organizations were weak and not trusted. Instead, individuals who had gained fame and prominence thanks to the Internet took the lead. Among them was Aleksei Navalnyi, who had gained a reputation from his struggle against corruption. By now, various websites and blogs were filling the void left by the non-existent public political debate.

By 2010 Facebook had definitely entered the scene. In the Russian arts community 'Facebook has really turned the narrow art world into a proper village, where everyone knows what, where and when [something is going on]' (Fedotova, 2010: 70). The Internet made communication easier. Political mobilization was an illustration of the new phenomenon of so-called new media activism, already well known in other parts of the world (Lievrouw, 2011).

New media activism and political action

When in September 2011 Putin announced that he would run for president in 2012, that Medvedev would step back and that the two of them had agreed this some years previously, many voters felt humiliated. His words clearly demonstrated that they were completely without influence on such an important issue. The reaction to his announcement was strongly negative, as reflected in opinion polls, and the Internet erupted in various forms of protest. It gave a flying start to the opposition's campaign against the pro-Putin United Russia Party in the upcoming parliamentary election.

The protests that followed had many similarities with the techniques of the new media activism on the Internet that were used in several other countries (Lievrouw, 2011). A central role in this new activism is 'culture jamming', a phenomenon defined in 1990 in an article in *The New York Times* as 'artistic "terrorism" directed against the information society in which we live'.[27] The US media scholar Leah Lievrouw wrote in 2011 that '[c]ulture jamming captures and subverts the images and ideas of mainstream media culture to make a critical point . . .' The Internet, she said, seems 'ideally suited to the cut-and-paste, collage-style, hit-and-run tactics favored by media designers and artists making art with a point' (Lievrouw, 2011: 73, 78). The methods and techniques that were introduced by the evolving protest movement were clearly influenced by this new kind of activism.

One technique is the *meme* – an idea, expression, image, practice or other piece of cultural 'code' that is picked up and spread. It has been characterized as 'a sort of cultural counterpart to the gene, with analogous abilities to diffuse, replicate, mutate, and hybridize its way into the "organism of culture" '.[28] The blogger Aleksei Navalnyi coined a nickname for the United Russia Party, the 'Party of Scoundrels and Thieves ', in February 2011 with reference to words used by Putin. In 2010 Putin had quoted from a well-known 1979 film that 'a thief has to sit in jail',[29] and these words were merged with his words about Chechen terrorists from September 1999: '. . . we will find them in the toilet and whack them in the john/shithouse' (Chapter 2). Together, these phrases formed the slogan of the opposition: 'To whack scoundrels and thieves in the shithouse' (Lure, 2012: 56). The term 'Party of Scoundrels and Thieves ' spread rapidly and by the autumn of 2012 had become so popular that it was used not only by the opposition but also by people who did not side with the opposition.[30]

Another example of a meme was the slogan 'Freedom for the slave in the galley', which was used at demonstrations. It arose from Putin's words in February 2008, speaking of his tireless work from early in the morning to late at night

during his eight years as president. He compared himself to a slave in the galley, but in the interview he appeared to be comparing himself to a crab in the galley – instead of *kak rab na galerakh*, he seemed to have said *kak krab na galerakh*. The crab therefore became a symbol of Putin, and numerous pictures of and jokes about Putin-the-Crab circulated on the Internet.[31] The art group ZIP created its Crab-Propagandist in the shape of a battle tank with crab arms. It was exhibited at various exhibitions, including the Moscow Biennale in 2011.[32] The crab symbol could appear anywhere, as for example in a parody of Medvedev giving a speech while Putin crawled out of his pocket (Azbuka protesta, 2012: 66).

Putin's phrasing about a galley slave also resulted in the 'galley' meme. The word galley was linked with 'boat', and Putin's words in the Duma of November 2011, when he told the opposition 'not to rock the boat', stimulated new varia-tions of the meme. The galley became a metaphor for a Russia at risk due to the behaviour of the slave. A ship taken over by a slave is usually in danger of being wrecked. The word 'slave' also raised the question of who the master was. As the answer of the opposition could only be the people, it called on the people to liber-ate the slave by voting him out. The slave reference also had associations with Anton Chekhov, 'to squeeze the slave out of oneself, drop by drop', in the sense of teaching oneself inner dignity and freedom from conformism.[33] A new for-mulation of Chekhov's words was invented for a meeting in March 2012: 'Drop by drop we squeeze the slave out from the galley' (Lure, 2012: 34). In this way, memes were endlessly transformed and this creativity was visible on banners at demonstrations as well as on the Internet (Moroz, 2011: 85).

The current wave of protest folklore, wrote Andrei Moroz, 'is based to a very large extent on mechanisms of intertextuality and presents itself as an endless combination of different kinds of hints, references and projections, understand-able as a rule not to everybody but to significant groups of people who share social, generational and cultural characteristics' (Moroz, 2011: 85). This may be the case, but the humour, irony and laughter used as political weapons were understood by broad groups of people. Putin's words were publicly twisted and made fun of to an extent that had never happened before. He was used to having a monopoly on the public stage and to nobody talking back to him. Now he was faced with an audience that turned his words against him. In a live television inter-view on 15 December he said that in the future he would try to establish contacts with opposition parties. However, he said, 'This is often useless and impossible. What can one say in such a case? You know, maybe one could say after all "Come to me, Bandar-log"'.[34] Bandar-log are the rough apes in Kipling's *Jungle Book*, so in a sense Putin was comparing his opponents to rough and uneducated people. Endless variations of responses to his words followed. In December 2011, in one of his satirical poems, the 'Citizen Poet' (*Grazhdanin poet*), Dmitrii Bykov wrote about a Boa constrictor named Puu (Putin) that keeps all animals in fear apart from the Bandar-log, who turns into a human being because he does not fear Puu. At the 24 December demonstration, the theme of Bandar-log and Puu was very popular. Thus, the yellow python Kaa in Kipling's book became the symbol of the 'snake monster' Putin (Azbuka protesta, 2012: 130).

Putin also said that the white ribbons worn by demonstrators as a symbol of protest reminded him of condoms in a propaganda campaign against AIDS. This was like an open invitation to attack him.[35] Variations on this theme recurred at demonstrations. At the 24 December demonstration, the music journalist Artemii Troitskii opened the meeting dressed as a huge condom, and demonstrators carried posters with Putin dressed in a condom. Two demonstrators distributed condoms while their banner read: 'Didn't you like the condom? Choose another one. You have a free choice' (vybor, the same word as election) (Lure, 2012: 88).

The opposition produced propaganda videos less than five minutes long urging people either to 'vote for any party except the Party of Scoundrels and Thieves', or to cross out all parties.[36] These videos parodied and mocked the political leadership. Official news material was 'appropriated', 're-appropriated' or 'cross-appropriated'. For example, the heads of Putin and Medvedev were used in manipulated photographs, dancing like maniacs, or in Putin's case faking his victory in a running race with other politicians. In one brief film that circulated on the Internet, a television interview was cut to nothing except Putin's hums, mumbles, stumbles, sighs, nonsense words and empty gestures. The film gave the impression that Putin could not answer the questions posed by the journalist. The footage of the audience was also manipulated to look surprised at the otherwise articulate leader.[37]

Music videos by rap, rock and punk groups contained lyrics critical of Putin. The rock group Rabfak made a series of music videos against voting for the United Russia Party and Putin under the heading 'Nash Durdom (Our Madhouse) Votes for Putin' (Rabfak, 2011). The name of the group was a play on words as *rabfak* in Soviet times was a preparatory faculty to help workers and peasants attend university, but also a play on the word *fuck*. Another group, consisting of five middle-aged former paratroopers, 'Veterans of the Airborne Troops against Putin', had a big hit with a song urging Putin to resign.[38] As former paratroopers, the jewel in the Russian military crown, they had joined the opposition as 'the ordinary man'.

The political satires written by Dmitrii Bykov under the title 'Citizen Poet' and regularly read by the popular actor and comedian Mikhail Efremov became extremely popular.[39] They were intelligent, witty, well written and excellently performed. The humour made each satire as sharp as a knife. They were produced and read for more than a year, from February 2011 until the day after the presidential election on 4 March 2012. Like everything else in this new media activism, they spread over the Internet at the push of a button.

This lack of respect for Putin had been unthinkable only two years earlier. The flood of jokes about Putin helped to desacralize his power. The political leadership was mocked, directly and in public, to an extent never seen before. During the pre-presidential election period in 2012, anti-Putin activities on the Internet intensified but were complemented by serious political analyses.[40]

In several manifestations the white colour was used as a symbol of the opposition in the form of ribbons, flowers, clothes, toys, fantasy costumes or plain blank papers. The colour white was introduced as a symbol of the opposition during the autumn of 2011 and was represented by the white ribbons in the 10 December demonstration. Actions like 'White Streets' and 'White Ring' in Moscow in

January and February 2012 were a kind of flash mob that used anything white as their symbol.[41] This included 'auto runs', which consisted of cars driving around displaying something visible in white. In the 'White Square' action people with white ribbons suddenly appeared on Red Square,[42] while in White Ring in late February people wearing something white stood hand in hand in double rows along the Garden Ring Road around the centre of Moscow. To avoid being regarded as a meeting or demonstration, for which permission was needed from the local authorities, they refrained from banners and slogans and did not disturb the traffic (Azbuka protesta, 2012: 16). Blank paper had a meaning of its own, referring to a political anecdote from Soviet times when a man was arrested in Red Square for distributing leaflets. When asked why they were blank, he replied: 'Also that way everything is evident' (Moroz, 2011).

The large meetings of 10 and 24 December 2011 in protest against the falsifying of the election results became the first manifestation of an atmosphere of carnival, euphoria and liberated energy. The mass meeting in February continued this atmosphere of exuberance. It was like a carnival in the tradition of the European and Russian Middle Ages, when established concepts were turned upside down. Although the medieval carnivals were allowed for only a limited time before life went back to normal, the contemporary mass meetings gave hope and raised expectations of real change in society. Nobody could avoid the fear, however, that again these carnivals would be nothing but a temporary phenomenon (Trudolyubov, 2012).

Fear aside, they were organized as happy manifestations. Dressed as clowns, a voters' bulletin, a stuffed dragon or in a Guy Fawkes mask from the film, *V for Vendetta*, the creativity of the crowd and the character of the demonstration was evidence of a new atmosphere in society (Oleinik, 2012). Similar to the style of 'grotesque realism' described by Mikhail Bakhtin, the high and the low as well as the sacred and the profane changed places and a linguistic turn took place towards what he called the niz, 'the domain of the nether' (Sandomirskaja, 2012: Bakhtin, 2007). This was part of a larger political context in which words, humour and laughter were weapons. Therein lay the key that helped to unlock protest for young people in the creative intelligentsia and the middle class.

The slogans, costumes and various mobile installations used during the mass demonstrations were recycled as cultural artefacts and shown at exhibitions. A large exhibition at the Design Centre ArtPlay in February 2012 included artefacts from the demonstrations after the parliamentary election in December 2011 (*The New Times*, 2012). They were proof of the spontaneous creativity of the participants. The slogans ran like a play on words: 'Vy nas dazhe ne predstavlyaete', which can mean either 'You don't even represent us' or 'You don't even understand us'; and 'Vernite narodu golos!', which means both 'Give the people a voice' and 'Give people the right to vote', as well as more simple slogans such as 'There is no need for a strong leader in a strong society', 'No Putin, no cry', 'I didn't vote for these assholes, I voted for other assholes', and so on.

These large, peaceful and joyful demonstrations in the winter and spring of 2012 were watched over by huge numbers of police, with special police forces (OMON) on alert in the immediate vicinity.[43] The police were instructed to keep a low profile, as were the demonstrators. On 6 May, the day before Putin was

inaugurated president, the peaceful character of the demonstrations changed when the police aggressively tried to stop the demonstrations and provoked a response that threatened to set off a spiral of violence. Obviously, the police had new orders. Violence was averted thanks to people like the poet Lev Rubinshtein. Early the following morning he turned the course back to peaceful protest by spontaneously inviting people to walk along the Boulevard Ring Road in central Moscow, which developed into 'popular festivities'. People responded to calls on the Internet, joining the walks, which took place from 7 May to 17 May (*Lenta*, 2012). The walks became a way to peacefully reclaim the streets of the city centre – the streets that OMON forces had emptied on 6 May.

Inspired by the Occupy Wall Street movement, an informal camp, 'Occupy Abai', was set up at the statue of the Kazak poet Abai Kununbaev at Chistye prudy on the Boulevard Ring Road. Here, discussions, lectures, music and mobile art exhibitions took place until the camp was forced to close on 21 May. 'Occupy Abai' followed the international practice of the occupy movements of earlier years and became a symbol of popular participation, self-organization and decentraliza- tion. It was an experiment in direct democracy in which the participants' assembly (assambleya) jointly resolved problems. This had great symbolic significance in a Russia that had never lived through anti-hierarchical revolts such as those that had taken place in Paris and large parts of Europe and the USA in 1968.[44] An important role in the 'Occupy Abai' action was played by 'contemporary politi- cized artists and all those usually associated with the "creative class"– and its

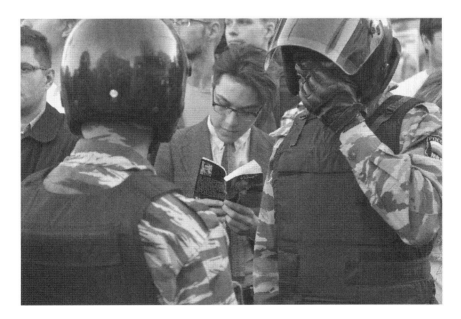

Figure 7.1 Reading Camus in front of OMON, 2012

(Photographer: A. Sorin)
Source: Courtesy of A. Sorin.

capacity for nonstandard solutions and improvizations', according to observers in *Artkhronika*, who enthusiastically concluded: 'What the artistic circle managed, and what the rest were unable to, was to organize a common space that included everyone in the collective experiment of creating new forms of life. For the first time art and politics joined in one place' (Pesnin and Chekhonadskikh, 2012).

The core group of protest: The creative class

Protests against the falsification of the elections and the authorities' use of so-called administrative resources began on the evening of election day.[45] It was the liberal Solidarnost, however, that was able to mobilize about 5000 people on the following evening, more than in any previous demonstration by the opposition. The demonstration had been permitted by the local authorities well in advance. Many participants came after reading the reports by observers monitoring the elections, which told of procedures that did not work and presented examples of fraud. Independent media publications such as *Novaya gazeta* and *Kommersant* published these reports on their websites (Volkov, 2012: 9–10).

News of the next planned demonstration, in Bolotnaya Square on 10 December, spread among broader circles on the Internet. It gathered 80 000 people, according to estimates by the organizers, although the police estimates were much lower. A Committee for Fair Elections (Za chestnye vybory) was set up to organize a new demonstration on 24 December. The organizing committee was not related to any political body – it scrupulously avoided all political connections and therefore had the support of most political organizations. Crucial issues were discussed and decided on the Internet, such as the ranking of candidates when selecting speakers for the 24 December meeting. The number of participants at the 24 December meeting on Sakharov Avenue was reported to be more than 100 000, although the police estimated the number at no more than 30 000. Four key demands were made at the meeting: free and fair elections, holding the falsifiers to account, an end to political repression, and guarantees of political rights and political reform. On 4 February, about 120 000 people participated in a march from Kaluzhskaya Square to Bolotnaya Square, although again police estimates were substantially lower.

A solid majority of the demonstrators were highly educated and many belonged to the middle class. A survey by the Levada Centre during the 24 December meeting showed that more than 70 per cent had higher education, 25 per cent held a leading position with up to ten employees or were private sector businesspeople and 12 per cent were currently students.[46] Later surveys by the Levada Centre confirmed the high percentage of well-educated people. At the demonstrations of 24 December and 4 February, graduates and undergraduates accounted for about 80 per cent of the demonstrators. It is worth noting that less than one-third of Russia's citizens have attended higher education colleges (Volkov, 2012: 50).

Looking more closely at the list of speakers and organizers of the mass meetings during the winter of 2011 and the spring of 2012, the crucial role of people from the cultural and intellectual spheres becomes obvious.[47] Among the ten

highest ranked people selected to become speakers at the 24 December meeting were three actors, two writers, one journalist and one musician. There were also a blogger, a jailed businessman and a veteran liberal opposition politician.[48] The committee organizing the 24 December demonstration included, among others, several writers. Many of the speakers and organizers of the December meeting reappeared as members of the 'League of Voters', created in January 2012 to organize civic monitoring of the upcoming presidential elections. Among them were the writers Boris Akunin, Dmitrii Bykov and Lyudmila Ulitskaya, the musician Yurii Shevchuk, the journalists Leonid Parfenov, Sergei Parkhomenko and Olga Romanova, and a representative of the 'Blue Baskets', Petr Shkumatov. Denis Volkov of the Levada Centre defined three categories of speakers at the mass meetings during the six months: people from the creative professions (poets, writers and musicians) and journalists, opposition politicians[49] and civic activists.[50]

The prominent role played by people from the creative intelligentsia and the small number of politicians among the organizers and speakers reflected the general mistrust of politicians (*Interfax*, 2011). This was also true of the liberal politicians, since people linked them to the failed reforms of the 1990s. Confidence was instead shown in people who had demonstrated civic courage in their relations with the authorities and were therefore expected not to compromise their beliefs. Another factor was the visibility of cultural personalities. These people were already known through the media. By the autumn of 2012, however, the situation had changed and 'the position of poets, writers, musicians and journalists had weakened', according to the Levada Centre. Now a new kind of politician came to the fore – those who were working on a daily basis with the issues of organizing and managing the protest movement (Volkov, 2012: 50).

Politically, the protest movement was a highly heterogeneous coalition. According to the Levada Centre, about 70 per cent of the participants on 24 December identified themselves as 'democrats' and 'liberals', 10 per cent as 'socialists/social democrats' and 13 per cent as nationalists. Yet, to many, the political label of a person was less important than whether he or she was known to be a person with civic courage.

Fear of an 'orange-style' revolution in Russia, similar to that which occurred in Ukraine, strengthened the conviction of Russia's political leadership that the intellectuals participating in the protests must be stopped. An official campaign was launched to discredit the protest movement and exploit the traditional gap between the intelligentsia and ordinary people, as well as that between the middle class and workers. One sign of this came in early February 2012, when the head of Putin's re-election team, the well-known film director Stanislav Govorukhin, repeated Lenin's words and called the intelligentsia the 'shit of the nation'. He said, 'I am waiting for a time when finally our Rus, Russia, wakes up and says "Listen Vladimir Vladimirovich, cut all these fat cats down to size. Why do they mire themselves in this quagmire (Boloto)? Eighty-four per cent of all money circulation takes place in Moscow, which in essence produces nothing! There this office plankton sit, there are the ladies in mink coats, and the evil spirit which once governed the country. They sit on our back and try to turn our heads. Stop

them!"' (Minin, 2012). A new page was being turned in Russia's thorny political development.

Conclusions

The parliamentary elections of December 2011 provided the fuel for the counter-culture to transform into political action. In 2011 there was a readiness for this to happen that had not existed during previous elections, even though electoral fraud had been widespread. Cultural personalities played a crucial role in the political mobilization during the autumn of 2011 and the spring of 2012. First, individuals from the cultural field and intellectuals served as role models by openly declaring their critical views. They broke the wall of silence and conformism in public life. It seemed as if the call by Aleksander Solshenitsyn (1974: A26) had become relevant once again: 'Don't participate in the official lie'.

Second, the trend towards expressing social concern in art had its equivalent in other cultural spheres, first and foremost in the theatre. Sometimes, classical plays were interpreted and staged with a critical view of contemporary life. Most important in this regard, however, was the new generation of playwrights. New Russian Drama reflected the turn towards socially oriented theatre. Three small Moscow theatres took the lead – Teatr.doc, the Centre for Playwrights and Directing and Praktika. During 2010 and 2011, Theatre.doc took a distinct civic position on politically delicate issues.

People from the cultural sphere contributed to the media activism that flooded the Internet during the months preceding the December 2011 elections. The choice of media techniques transgressed the borders of media, art and design. In mass demonstrations, poets, writers, journalists and musicians played together as initiators, organizers and speakers. The protest movement evolved spontaneously. None of the existing political organizations from among the opposition was able or trusted to take the lead. Instead – from various political wings of the opposition – they supported and assisted the new movement. This movement was decentralized and heterogeneous, like many similar movements around the world. It was also coloured by ideas of direct democracy, of which 'Occupy Abai' was an example.

The evolving protest movement was based on values and norms contrary to those in current use: free elections, democracy, political freedom, the rule of law and a state free from corruption. It included people of various political colours and convictions (liberals, leftists, communists, anarchists and nationalists) who came together around a few common slogans concerning the elections. The general feeling among the demonstrators was expressed as 'enough is enough!'

As a protest against the falsification of election results in an authoritarian country, it fell into the pattern of protests in Eastern Europe in the 1980s, the countries of the former Soviet Union in the 1990s and the Middle East in the 2000s (Bunce and Wolchik, 2011). The Russian regime was much better prepared, however, and had in the beginning of 2012 developed a counter-strategy – as illustrated by the

pro-Putin mass rallies in the run-up to the presidential elections, the result of an effective campaign of bussing people to Moscow from other cities.

The 6 May demonstration in Bolotnaya Square, the day before the 2012 presidential inauguration, resulted in 14 demonstrators being arrested by the police. This figure would soon increase. Putin's return to the presidency announced a new and harsher political climate. There were accusations against and interrogations of opposition leaders. It became obvious that the aim of government policy was to wipe out a potentially threatening protest movement. A new era began.

Notes

1 Among the other names were the chairman of the Union of Theatre Workers Aleksander Kalyagin, the singer Aleksander Rozenbaum, rector Irina Khaleeva and the athlete Alina Kabaeva. On the controversy surrounding this letter, see Shenderovich (2005).
2 'Zayavlenie v podderzhku Khodorkovskogo i Lebedeva (sbor podpisei)', 4 March 2009, www.platonlebedev.ru/documents/2009/04/03/12334.
3 Among them were the film director Eldar Ryazanov; the theatre director Kama Ginkas; the journalists Vladimir Pozner, Leonid Parfenov and Viktor Shenderovich; the writers Boris Akunin and Boris Strugatskii; and scholars such as Evgenii Gontmakher (Pismo 45, 2011: Infox 2011).
4 See www.youtube.com/watch?v=O9nvQhUBA0k&hl=ru. Listev was the first director general of the federal television channel, ORT.
5 See www.youtube.com/watch?v=PRwFD-QjZac.
6 See http://mc-noize.ru/tvorchestvo/texts/drugie-treki-nojjza/mercedes_s666/.
7 See www.youtube.com/watch?v=-Q3Q-NW94UQ.
8 NOIZE MC, '10 Sutok V Rayu (Stalingrad)', http://mcnoize.ru/load/tabs/noize_ mc_10_sutok_v_raju_stalingrad/3–1–0–125.
9 Ekho Moskvy is a liberal independent channel despite the fact that it is owned mainly by Gazprom's media holding company. It is important as the only politically outspoken radio station open to voices from different political wings.
10 Yurii Shevchuk 'Edet Putin po strane, a my po-prezhnemu v . . . govne', 31 August 2010, http://video.yandex.ru/users/iv-kuzneczoff2011/view/1/#.
11 'Yurii Shevchuk i Putin', www.youtube.com/watch?v=Oaxf7txb-l4.
12 Yurii Shevchuk zovet na kontsert v zazhitu Khimkinskogo lesa, www.youtube.com/ watch?v=0M0jiUu6BIc.
13 See www.lubimovka.ru/.
14 Among the young directors who had their breakthrough at the Centre were Kirill Serebrennikov, Vladimir Ageev and Olga Subbotina, as well as dramatists such as Vasilii Sigarev, Ksenia Dragunskaya and the brothers Presnyakov. Author's interviews with Marina Astafieva of the Kazantsev and Roshchin Centre, Moscow, March 2011, and theatre critic Kristina Matvienko, Moscow, April 2011.
15 See www.teatrdoc.ru/stat.php?page=about.
16 'O Praktike', www.praktikatheatre.ru/CommonPage/Index/about.
17 In the otherwise traditional Moscow theatres, only a few directors, most often of an older generation – the so-called shestidesyatniki such as Yurii Lyubimov at the Taganka Theatre – staged plays with a political subtext.
18 Author's interview with Kristina Matvienko, theatre critic, Moscow, April 2011.
19 Interview with Elena Gremina in *Bolshoi gorod* (2012).
20 Teatr.doc, 'Pravoslavnye edva ne sorvali spektakl o sude nad Pussy Riot, NTV vela semku', www.teatrdoc.ru/news.php?nid=355; 'Pravoslavnye i zhurnalisty NTV pytalis

sorvat spektakl o Pussy Riot', *Polit.ru*, 28 August 2012, http://polit.ru/news/2012/08/28/spektakl/.

21 On the Russian opposition before 2007, see Gelman (2007).

22 The National Bolshevik Party was banned by the authorities in 2007.

23 'Putin dolzhen uiti', http://ru.wikipedia.org/wiki.

24 Social and political street protest during Putin's first two terms as president (2000–2008) is covered in excellent detail by Robertson (2011) and Kleman, Mirzsova and Demidov (2010).

25 Vladislav Dorofeev in *Kommersant,* quoted in Bashkirova (2012: 8).

26 ' "Poslednyaya osen" v Podmoskove: poidet li molodezh v politiku?', www.voanews.com/russian/news/Russia-Last-Autumn-Forum-2011–10–02–130926778.html.

27 Mark Dery in *The New York Times*, quoted in Lievrouw (2011: 72).

28 Richard Dawkins in his 1976 book, *The Selfish Gene*, quoted in Lievrouw (2011: 79).

29 The film by Stanislav Govorukhin, *The Place of the Meeting Cannot Be Changed* (Mesto vstrechi izmenit nelzya), where the hero Gleb Zheglov was played by Vladimir Vysotskii.

30 It was even used ironically in a United Russia roller 'Golosui za partiyu zhulikov i vorov!', 1 December 2011, www.youtube.com/watch?v=FAv54E-zrC4.

31 See, for example, www.politota.org/popular/putin_krab; and www.youtube.com/watch?v=-aMGHO5uYKk.

32 'Krab-propagandist. Anapa. Gruppirovka ZIP', an action carried out in the summer of 2011, www.youtube.com/watch?v=7L4BoT9Q2Wg.

33 Letter by Anton Chekhov to A.S. Suvorov, 7 January 1889, http://ebooks.adelaide.edu.au/c/chekhov/anton/c51lt/chapter24.html.

 'What writers belonging to the upper class have received from nature for nothing, plebeians acquire at the cost of their youth. Write a story of how a young man, the son of a serf, who has served in a shop, sung in a choir, been to a high school and a university, who has been brought up to respect everyone of higher rank and position, to kiss priests' hands, to reverence other people's ideas, to be thankful for every morsel of bread, who has been many times whipped, who has trudged from one pupil to another without galoshes, who has been used to fighting, and tormenting animals, who has liked dining with his rich relations, and been hypocritical before God and men from the mere consciousness of his own insignificance – write how this young man squeezes the slave out of himself, drop by drop, and how waking one beautiful morning he feels that he has no longer a slave's blood in his veins but a real man's . . .' (Chekhov, 1889). Compare the reference to this quote in Chapter 6 (note 14).

34 See www.youtube.com/watch?v=-qVsVLqggsg.

35 See www.youtube.com/watch?v=htvgfA-HRO4.

36 Song against the party of 'Scoundrels and Thieves', www.echo.msk.ru/blog/merculove/829478-echo/.

37 See www.youtube.com/watch?v=nB3zj0L3oiA.

38 'Komitet veteranov raiona "Akademicheskii"', Moskva, www.youtube.com/watch?v=lSc9wiV7JBI, 28 January 2012. Moved to http://muzofon.com/search.

39 See http://ongar.ru/grazhdanin-poet/.

40 During the pre-presidential election period up to 4 March 2012, Internet propaganda against Putin intensified. Election campaign films such as *Nastoyashchii Putin* (Real Putin) skilfully presented a propagandistic, broad, critical social and political analysis of the state of the nation and the Putin regime. See *Nastoyashchii Putin*. 1 hour, 2012, produced by The Initiative Group of Citizens, www.echo.msk.ru/blog/merculove/829478-echo/.

41 Auto-runs took place in Moscow on 29 January and 19 February 2012. The 'White Ring' action was held on 26 February.

42 See, for example, ' "Belaya lenta" provodit fleshmob na Krasnoi ploshchade', BBCRussian.com, 8 April 2012, reported on www.inosmi.ru/russia/20120408/190164858.html;

'Protesty v Moskve: belye lentochki na Krasnoi ploshchade', 9 April 2012, www. newstube.ru/media/protesty-v-moskve-belye-lentochki-na-krasnoj-ploshhadi.
43 For a list of the demonstrations that took place on both sides, see 'Protestnoe povedenie', www.kommersant.ru/document/2021447.
44 On the 'Occupy Abai' experience see, for example, Grigoryeva (2012: 183–188) and Degot (2012).
45 The Left Front activists, the followers of Limonov, and the nationalists immediately mobilized. The Communist Party leader declared that this was the most unfair and dirty election since Soviet times.
46 'Opros na Prospekte Sakharova 26 dekabrya', 26 December 2011, www.levada.ru/ 26–12–2011/opros-na-prospekte-sakharova-24-dekabrya; See also Samarina (2011).
47 At the planning meeting of 22 December 2001 the following people participated: Boris Akunin, Dmitrii Bykov, Oleg Kashin, Tatyana Lazareva, Elena Lukyanova, Aleksei Navalnyi, Boris Nemtsov, Sergei Parkhomenko, Olga Romanova, Vladimir Ryzhkov and Anastasiya Udaltsova, www.echo.msk.ru/blog/echomsk/841907-echo/.
48 The television journalist Leonid Parfenov, who had criticized the media situation when he was awarded a journalism prize in 2010; the rock musician Yurii Shevchuk, active in the movement against the construction of the motorway at Khimki; the writer Boris Akunin, who had conducted interviews with the jailed businessman Mikhail Khodorkovskii; and Dmitrii Bykov, writer of novels, poems and chronicles, and the satirical Citizen Poet. Among the ten were also three actors respected for their civic stand: Liya Akhedzhakova, Mikhail Efremov (who read for the Citizen Poet) and Chulpan Khamatova. Other names high in the rankings were the jailed businessman Mikhail Khodorkovskii and two politicians – the upcoming leader, Aleksei Navalnyi, known through the Internet, and the old liberal Eltsin supporter, Boris Nemtsov.
49 Among them were two former members of the Eltsin government, Boris Nemtsov and Mikhail Kasyanov; the liberals Vladimir Ryzhkov, Garry Kasparov, Ilya Yashin and Grigorii Yavlinskii; the leader of the Left Front, Sergei Udaltsov; and the Duma delegates Ilya Ponomarov, from the Communist Party, and Gennadii and Dmitrii Gudkov, from the Fair Russia Party (Volkov, 2012: 13).
50 Among them were Aleksei Navalnyi, Evgeniya Chirikova and Denis Volkov (Volkov, 2012: 13).

References

Bakhtin, Michail (2007), *Rabelais och skrattets historia* (Riga: Anthropos).
Bashkirova, V.G. (2012), *Protiv: Protestnaya kniga No 1 v Rossii* (Kommersant materialy po delu) (Moscow: chitai! Rid Grupp), pp. 300–13.
Belanovskii, Sergei and Dmitriev, Mikhail (2011), *Politicheskii krizis v Rossii i vozmozhnye mekhanizmy ego razvitiya*, Center for Strategic Analysis, 28 March, www.intelros. ru/strategy/gos_rf/9246-politicheskij-krizis-v-rossii-i-vozmozhnye-mexanizmy-ego-razvitiya.html.
Beumers, Birgit and Lipovetsky, Mark (2009), *Performing Violence: Literary and Theatrical Experiments of New Russian Drama* (Bristol, UK: Intellect).
Bolshoi gorod, (2012), 'Komu mstit-to? Oni zhe pobedili', 11 July.
Bunce, Valerie J. and Wolchik, Sharon L. (2011), *Defeating Authoritarian Leaders in Postcommunist Countries* (Cambridge, UK: Cambridge University Press).
Clement, Karine (2008), 'New Social Movements in Russia: A Challenge to the Dominant Model of Power Relationships?' *Journal of Communist Studies and Transition Politics* 24(1): 68–89, http://dx.doi.org/10.1080/1353270701840472.

Degot, Ekaterina (2012), '"Okkupai Abai": forma demokratii, forma iskusstva?', *Open Space*, 16 May, www.openspace.ru/art/event/details/37087/. Reposted on os.colta.ru/art/events/details/37087

Fedotova, Elena (2010), 'Litsom k litsu', *Artkhronika* 12: 70.

Gelman, Vladimir (2007), 'Politicheskaya oppozitsiya v Rossii: zhizn posle smerti', *Otechestvennye zapiski* 6(40), http://strana-oz.ru/?numid=40&article=1575.

Grani (2005), 'Deyateli kultury i nauki prizyvayut Khodorkovskogo politzaklyuchennym', 22 February, www.grani.ru/Society/m.85041.html.

Grigoryeva, Anna (2012), 'Observing OKKUPAI: Practice, Participation, Politics in Moscow's Movable Protest Camp', *Laboratorium* 4(2): 183–88. www.soclabo.org/index.php/laboratorium/article/view/40.

HRO Human Rights Organization (2010), 'Lebedev i Khodorkovskii dolzhny, byt osvobozhdeny! Zayavlenie uchastnikov Obshchestvennykh slushanii vtoroi protsess Khodorkovsogo-Lebedeva: verdikt obshchestvennosti', 11 February, www.hro.org/node/9437.

Infox (2011), 'Ryazanov, Basilashvili, Strugatskii i eshche 43 cheloveka poprosili priznat Khodarkovskogo uznikom sovesti', 14 March, http://infox.ru/authority/mans/2011/03/14/RyazanovBasilashvi.phtml.

Interfax (2011), 'Orgkomitet otchitalsya po mitingu', 23 December, www.interfax.ru/society/txt.asp?id=223421.

Izvestiya (2005), 'Obrashchenie deyatelei kultury, nauki, predstavitelei obshchestvennosti v svyazi s prigovorom, vynesennym byvshimi rukovoditelyami neftyanoi kompanii "YUKOS"', 28 June. Reposted on www.grani.ru/Politics/Russia/yukos/m.91375.html.

Kashin, Oleg (2009), 'Predvyrubnaya kampaniya', *Kommersant Vlast*, 23 February, www.webcitation.org/69nZr6IHV.

Kleman, Karin, Mirzsova, Olga and Demidov, Andrei (2010), *Ot obyvatelei k aktivistam: Zarozhdayushchiesya sotsialnye dvizheniya v sovremennoi Rossii* (Moscow: Tri kvadrata).

Kotova, Yuliya (2010), 'Zhurnalist Parfenov zachital telenachalnikam rech o tsenzure na TV', 26 November, www.compromat.ru/page_30131.htm.

Kulikov, Sergei and Sergeev, Mikhail (2010), 'Rossiya grozit protestnoe obostrenie', *Nezavisimaya gazeta*, 19 February, www.ng.ru/economics/2010-02-19/4_protests.html.

Lenta (2012), 'Besstrashnye i zlye: Kto delaet novuyu ulichnuyu politiku v stolitse', 10 May, http://lenta.ru/articles/2012/05/10/street/.

Lievrouw, Leah A. (2011), *Alternative and Activist New Media* (Cambridge, UK and Malden, Mass.: Polity).

Lipovetsky, Mark and Beumers, Birgit (2008), 'Reality Performance: Documentary Trends in Post-Soviet Russian Theatre', *Contemporary Theatre Review*, 18(3): 293–306.

Lure, Vadim F. (ed.) (2012), *Azbuka protesta: Narodnyi plakat po materialam 15 mintingov i aktsii v Moskve i Sankt-Peterburge 10.12.2011–01.04.2012* (Moskva: OGI and Polit.ru).

Manotskov, Aleksander (2011), '31-oe: obyasnenie', *Grani*, 10 August, http://grani.ru/blogs/free/entries/190618.html.

Minin, Stanislav (2012), 'Rossiya svobody i Rossiya uklada: Vlast umyshlenno i posledovatelno stalkivaet dve Rossii', *Nezavisimaya gazeta*, 4 February, www.ng.ru/columnist/2012–02–04/100_freedom.html.

Moroz, Andrei (2011), 'Protestnyi folklore dekabrya 2011g: Staroe i novoe', *Antropol-igicheskii forum* 16: 85, http://anthropologie.kunstkamera.ru/files/pdf/016online/moroz.pdfIbid.

New Times (2012), 'Folklor mitinga', 27 February, www.newtimes.ru/articles/detail/50269.

Nezavisimaya gazeta (2010), 'Laureat i grazhdanin: Russkii pisatel Mikhail Khodor-kovskii', 20 January, www.ng.ru/editorial/2010–01–20/2_red.html.

Oleinik, Anton (2012), 'Karnaval kak predchuvstvie', *Vedomosti*, 15 February, www.vedomosti.ru/opinion/news/1503792/karnaval_kak_predchuvstvie.

Pesnin, Aleksei and Chekhonadskikh, Mariya (2012), 'Vremya-seichas: aktivisty i khu-dozhniki na #Okkupai Abai', *Artkhronika* 3: 42–43.

'Pismo 45-ti ili vnov o Khodorkovskom' (2011), *Proza.ru*, 14 March, www.proza.ru/2011/03/15/1079.

Rabfak (2011), 'Nash Durdom golosuet za Putina', 11 October, http://pravdaoputine.ru/video-audio/nash-durdom-golosuet-za-putina-video-tekst-pesni-rabfaq/.

Robertson, Graeme B. (2011), *The Politics of Protest in Hybrid Regimes: Managing Dis-sent in Post-Communist Russia* (Cambridge, UK, and New York: Cambridge University Press).

Rubinshtein, Lev (2011a), 'Marginalnaya ulichnost, *Grani*, 5 May, www.grani.ru/Culture/essay/rubinstein/m.188297.html.

Rubinshtein, Lev (2011b), 'Kogda nachinaetsya iskusstvo?', *Grani*, 9 September, www.grani.ru/Culture/essay/rubinstein/m.191289.html.

Russkii reporter (2007), 'Probuzhdeniya gegemona: Chem obernetsya dlya Rossii epidemiya zabastovok?' (22–29 November): 18–28.

Ryabushev, Aleksander (2010), 'Ot stavki do otstavki. Mitinguyushchie v Kaliningrade pereshli ot ekonomicheskikh lozungov k politicheskim, *Nezavisimaya gazeta*, 1 Febru-ary, www.ng.ru/politics/2010-02-01/1_otstavka.html.

Samarina, Aleksandra (2011), '70 % mitinguyushchikh: liberaly po ubezhdeniyam', *Nezavisimaya gazeta*, 27 December, www.ng.ru/politics/2011–12–27/1_70percents.html.

Sandomirskaja, Irina (2012), 'Khutin Pui, or what's up in Moscow: Election Campaign, a View from Below', *Baltic Worlds* 5(1), www.balticworlds.com.

Shakirov, Mumin (2011), 'Anastasiya Volochkova ukhodit k Mikhailu Khodorkovskomu', *Radio Svoboda*, 3 February, www.svoboda.org/content/article/2295402.html.

Shenderovich, Viktor (2005), 'Pismo pyatidesyati: Mikhail Khodorkovskii raskolol ros-siiskuyu intelligentsiyu', *Novaya gazeta*, 29 June, www.newizv.ru/news/27195.

Solzhenitsyn, Aleksander (1974), 'Live Not By Lies', *Washington Post*, 18 February, p. A26, www.columbia.edu/cu/augustine/arch/solzhenitsyn/livenotbylies.html.

Treshchanin, Dmitrii (2011), 'Pervymi iz "Narodnogo Fronta" dezertirovali arkhitektory', *Svobodnaya Pressa*, 27 June, http://svpressa.ru/society/article/44967/.

Trudolyubov, Maksim (2012), 'Bitva Posta i Maslenitsy', *Open Space*, 29 February, www.openspace.ru/media/projects/12969/details/34757/?expand=yes#expand. Reposted on os.colta.ru/media/projects/12969/details/34757.

Tsvetkova, Roza and Samarina, Aleksandra (2010), 'My zhivem, pod soboyu ne chuya strany. Politicheskii tupik, v kotoryi planomerno zagonyayut drug druga vlast i oppoz-itsiya, opasen dlya obeikh storon', *Nezavisimaya gazeta*, 7 September, www.ng.ru/ng_politics/2010–09–07/9_tupik.html.

Vestnik obshchestvennogo mneniya. Dannye. Analiz. Diskussii (2011), 'Monitoring peremen: osnovnye tendentsii' 3 (July–September): 3–7.

Vlasenko, Elena and Shakirov, Mumin (2011), 'Sud zashchitili ot Khodorkovskogo', *Radio Svoboda*, 3 April, www.svoboda.org/content/article/2327368.html.

Volkov, Denis (2012), *Protestnoe dvizhenie v Rossii v kontse 2011–2012gg: istoki, dinamika, rezultaty* (Moscow: Levada Centre), www.levada.ru/books/protestnoe-dvizhenie-v-rossii-v-kontse-2011–2012-gg.

8 Art and protest after Bolotnaya

The December 2011 parliamentary elections secured a solid majority for Putin's United Russia Party. It was not, however, the qualified majority required to make changes to constitutional law that it had won in the 2007 elections. Nonetheless, in March 2012 Putin was elected president after the first round of voting. At the demonstrations in Bolotnaya Square the day before his inauguration, the police changed their previously restrained, low-profile tactics, provoking the demonstrators and brutally responding to their reaction. A year later, a substantial number of people had been arrested in connection with the Bolotnaya Square demonstrations. Bolotnaya became a symbol of the turning point and the new harsh reality of protest. The new political situation not only put the protest movement under heavy pressure, but also created new conditions for cultural life and for the art world.

By the time of the events in Bolotnaya Square, Putin had been building his official consensus for more than a decade. The official discourse was now distinct and pronounced traditional Russian authoritarian conservatism, which involved ideas of state nationalism, Orthodoxy, the conception of a 'close symphony between church and state', Russian uniqueness and anti-Westism. The alliance between Putin and conservative patriotic and religious forces had strengthened as he searched for allies in the pre-election period. Now this alliance became physically visible. People who not long before had been considered politically marginal, such as the patriotic right, were integrated into governmental and presidential structures after the December and March elections.[1] This chapter examines how the events in Bolotnaya Square influenced conditions for the protest movement and the immediate consequences this had for the art world.

The post-Bolotnaya political situation

The protest movement was clearly affected by the harsh new policy of repression. Government tactics towards the opposition began to change after the parliamentary elections in December 2011. Vladislav Surkov was moved from his post as Deputy Head of the Presidential Administration, where he had been responsible for political–ideological strategy, including policy towards the opposition. Now, as Deputy Prime Minister, he no longer had direct responsibility for handling the growing protest movement. About a year later he was forced to resign all his

government positions.[2] Surkov's strategy had consisted of elaborate and sophisticated manipulations of the political scene, the creation of fake opposition parties, organizing pro-Putin youth organizations and the creation of democratic facades for institutions and politics. His successor, Vyacheslav Volodin, pursued a traditional and straightforward power policy of which direct intervention by the police, arrests, threats and trials of opposition members were key components. It was Volodin who before the elections had designed the counteroffensive against the opposition, staging mass pro-Putin rallies in Moscow in order to demonstrate popular support for the regime.

The political climate changed rapidly with the waves of arrests of demonstrators after 6 May, charges against them for causing 'mass riots', and accusations against leading names in the protest movement of economic embezzlement of various kinds. The ideological concept of a 'besieged Russia' was strengthened by media campaigns that claimed that the protest movement was nothing more than the creation of foreign secret services, paid for and initiated by the West in order to undermine Russia. On television, three programmes by Arkadii Mamontov, 'Provocateurs' and the film 'Anatomy of Protest' in two parts, presented the protest movement and Pussy Riot as enemies of Russia. Using lies and insinuations, the film provided material that would later be used by the State Committee of Investigation in its investigation of protest leaders accused of having received money from abroad to organize mass riots.[3]

The new political climate was also supported by draft laws hastily introduced in the Duma during the summer with a clear edge against the opposition.[4] It became illegal to organize, participate in or call for participation in demonstrations for which the authorities had not given permission. The penalties for such activities were substantially increased.[5] A new law on slander was introduced with a vague definition that would limit the opportunities for journalists and the opposition to criticize public leaders and civil servants.[6] Foreign financial support for non-commercial non-governmental organisations was stigmatized and effectively obstructed, since such NGOs had to register as 'foreign agents'.[7] The law on espionage covered any information handed to a foreigner or foreign organization that was later used in a way that was deemed 'against the interests of Russia' (*Lenta*, 2012b).[8] Finally, under the pretext of defending the interests of children, any material, either printed or on the Internet, that could be suspected of being harmful to the health or morals of children was considered illegal, with a special focus on 'propaganda for non-traditional sexual orientations'.[9]

Lists of forbidden websites and literature were drawn up.[10] Moreover, in September a draft law was introduced to protect the feelings of believers against offence and to defend religious sanctuaries against defilation. It proposed substantial penalties – up to three years in jail and fines of up to 500 000 roubles (*Rossiiskaya gazeta*, 2012; Samarina, 2012b).This was exactly the kind of law that church representatives had requested after the Pussy Riot action. Since existing laws already included the defence of believers, the draft was made an amendment to an existing law and was signed by the president in the summer of 2013. By then, however, the definition of the crime had been expanded to include 'acts of clear

lack of respect to society carried out with the purpose of offending the religious feelings of believers'.[11] In March 2013 a law was adopted introducing fines for any media that use a so-called non-censored lexicon, that is, swearwords (RIA Novosti, 2013). It was clear which way the wind was blowing. In late November 2012 four of the five videos of performances by Pussy Riot available on the Internet were declared 'extremist material' by a Moscow court. To distribute them would now be considered a criminal act.[12]

The conservative ideological direction was emphasized in June 2012 when the newly appointed leader of the United Russia Party, Prime Minister Medvedev, declared the ideological platform of the party.[13] In December 2009 the United Russia Party had made Russian Conservatism its official ideology. This took place briefly after Medvedev launched his modernization idea. Boris Gryzlov, the leader next to Putin in the party, said at the 2009 congress that 'conservatism', meaning stability, development, spirituality and patriotism, fully corresponded with the modernization previously called for by Medvedev (*Izvestiya*, 2009; Solomonov, 2011). By the summer of 2012, however, all talk of modernization campaigns was already gone and Medvedev announced: 'We absolutely have to create a situation where "United Russia" is not only a party of leaders . . . but . . . associated with a selection of values for which people will always vote . . . the traditional values of our state and society based on morals, based on church, but with consideration of the fact that there are four major confessions in our country' (Maltsev, 2012a). Putin now directly and strongly positioned his policy upon conservatism (*Nezavisimaya gazeta*, 2013e). Throughout 2013 he repeatedly returned in his speeches to the issue of the ideologically conservative platform, as he did when the All-Russian People's Front had its first congress, elected him chairman and adopted a conservative manifesto.[14]

Patriotic fostering became a key issue. In October 2012 a special section of the presidential administration was set up dedicated to issues of patriotic education and the strengthening of spiritual–normative foundations.[15] In February 2013 Putin ordered a commission to work out a concept for a series of history books for schools 'without internal contradictions and ambiguous interpretations'. The Orthodox Church was given a central role in formulating and spreading ethical, moral and religious values and guidelines. This closer alliance between state and church was reflected at an archbishops' conference in February 2013, when Putin declared it necessary to leave behind the primitive understanding of the 'secular state'. 'Today a deepening of our joint work is especially needed, a partnership between the state and all traditional religions' (Samarina, 2013). He raised as a warning example the developments leading up to the revolutions of the early twentieth century –'the erosion of spiritual foundations' which resulted in 'destruction and disruption of the country into revolution and breakdown'. Some commentators interpreted these words as a reference to events in Bolotnaya Square and to the protest movement.

Patriarch Kirill and the patriarchate also became more pronounced in their political and ideological statements, and the church stood out more as a political actor. In early April 2012, an address by the Highest Church Council, read

in Orthodox churches in Russia and abroad, accused 'aggressive liberalism', 'enemies of the faith' and 'anti-Russian forces' of standing behind what it called anti-church actions (Orlova, 2012). In February Kirill had stated that 'believers do not participate in demonstrations', but in April he called for a mass prayer session outside the Cathedral of Christ the Saviour against 'aggressive liberalism'. As many as 65 000 people turned up, according to police estimates (Maltsev, 2012a). The theme of liberals as the enemy of the country was further developed in 2012.[16]

In his television speech on the eve of the 4 November holiday that celebrates the anniversary of Russian troops ending the Time of Troubles, Kirill compared calls by liberals for a modernization of Russian society, politics and economics to the Polish military intervention of the early seventeenth century. He asked how Polish invaders at that time were able to reach all the way to the Kremlin. His answer was that people from within the Russian elite had betrayed the Russian nation by believing that Western experience, culture and beliefs could be a model for Russia. They almost destroyed the country, he said, but they did not succeed since at that time there were people, as there are today, prepared to fight for Russia's sovereignty (Kirill, 2012). Nowadays, he explained, there is again a threat although the threat is spiritual rather than physical: 'many fancy borrowing from other models of social and political development, rejecting their own originality and their own faith, which they consider as something stagnant and conservative that prevents people and society from developing.' He concluded that 'Today we need to be concerned with, first of all, preventing disorder (smuta) in our consciousness, in our minds' (Maltsev, 2012c).

A remarkable move in preparing the conservative platform of the All-Russian Folk Front was the attention paid in government circles to the Izborskii Club. The ambition of the Izborskii Club, an initiative by radical conservative intellectuals of different brands, was to become a conservative alternative to the Valdai Club of international experts,[17] and to 'create an intellectual environment' able to oppose the liberal project.[18] People from government met with radical conservatives at conferences organized by the Izborskii Club. Among the participants were the new Minister of Culture, Vladimir Medinskii, the new presidential adviser, Sergei Glaziev, leaders of conservative think tanks and well-known conservative intellectuals such as Aleksander Dugin, Aleksander Prokhanov, Vitalii Averyanov (deputy head of the journal *Zavtra* and author of the 'Russian Doctrine'), Mikhail Leontiev, Maksim Shevchenko and Father Tikhon, head of the Sretenskii monastery and writer of the film about the fall of Byzans (see Chapter 2).[19] Some of them, among them Dugin, had previously been regarded as political outcasts or far too extreme. Now they had definitely come in from the cold.

The conservative vector of Putin's policy triggered activities by extreme patriotic and religious forces. Therefore, when in August 2012 the media reported that a group called 'Holy Rus' had announced its intention to start patrolling Moscow streets as 'religious police squads' to guard churches and uphold morals and order, this came as no surprise (Maltsev, 2012b).[20] Later, the Cossacks, well organized and solidly conservative, would be allowed a minor guard role by the Moscow police authorities, and a new draft law extended this right to 'patriotic'

organizations (Rodin, 2013). In the meantime, religious–patriotic activists multi-plied as new organizations were formed to defend the feelings of believers. Young Orthodox conservative activists, such as the group 'God's Will', acted against the Darwin Museum as a representative of the theory of evolution, in support of creationism.[21] The group also attacked people in public places whom they accused of blasphemy or suspected of being supporters of Pussy Riot.[22] Although it could be argued that the actions of Pussy Riot triggered the conservative reaction, it is important to keep in mind that the conservative wave had been under way for some time. The performance in the Cathedral was exploited to whip up conserva-tive sentiments in society, which drastically worsened the political situation.[23]

Consequences for protest

Understandably, the sharp conflict between the protest movement and the authori-ties frightened many people away from participating in demonstrations. During the summer and autumn of 2012 the number of participants declined and this damper was already being felt at the 12 June demonstration. One participant later wrote, 'What immediately captured attention was the small number of people with funny, absurd posters. The slogans had become more serious, and sometimes just ruder' (Skovoroda, 2012). Fear spread that the political springtime of carnival had come to an end. The repressive state started arresting people and since most of the people were not well known to the protest movement, the arrests seemed random. When the arrests increased in number and preliminary investigations started, some people left the country.

The political climate made it difficult for the protest movement to develop an organizational capacity or work out a common programme, policy and strategy. The political reforms that Medvedev had promised at the end of his presidency, to give space for a legal opposition to develop, came to nothing. New legislation made it easier to register new political parties, but the authorities' control and manipulation excluded free and fair regional elections in the autumn of 2012, and the legal channels through which an opposition could work were minimal. In the election for a Moscow mayor a year later, the authorities made an exception and gave Aleksei Navalnyi the opportunity to stand as a candidate in order to pro-vide legitimacy to the election of the Putin-nominated Sergei Sobyanin. Navalnyi received more than a quarter of the votes.

The number of participants in the demonstrations reduced still further after the June 2012 demonstration. The wide political spectrum among the demonstrators, which from the start had resulted in separate sections according to ideological conviction and priority issues, indicated an internal heterogeneity which became more pronounced over time. The ideological gap widened between the nationalists, marching with military discipline with their yellow-black flags shouting 'Russia for the Russians', and the rest, with their mainly democratic liberal or leftist pref-erences.[24] In spite of these differences of opinion, a Coordinating Council for the protest movement was elected over the Internet in October 2012. With a quota of five elected representatives each for the nationalists, liberals and leftists, and

30 general representatives, the movement managed to hold together. They could not, however, unite around a constructive programme. By the autumn of 2012, the authorities were in control. The protest movement had not been able to become a factor for change as the regime aggressively fought to wipe out opposition.

Cultural policy: The conservative turn

A new minister of culture was appointed in May 2012. Vladimir Medinskii, the author of a series of books entitled *Myths about Russia*, had a distinctly conservative profile. His convictions were well known and were characterized by one critic as a Russian kind of 'Weimar *resentment*', that is, feelings of national indignation over the lost position of a once great power. It is worth quoting at length Aleksander Morozov's definition of the resentment concept in its Russian context:

> In a very crude form and at the lowest levels of social hierarchy, it consists of poorly articulated [statements, such as] 'enough spitting on our history', 'we are cool', 'thanks grandpa for the victory', 'too many blackasses', 'all deputies are faggots', and so on. At one step higher, resentment is already more respectable (like Nikita Mikhalkov's). And further up there is the technological use of resentment for commercial and political purposes. Ironic people and 'pragmatists' of different kinds mobilize it for 'the benefit of the Fatherland'.
>
> (Morozov A., 2012)

Moreover, he described the different components of resentment as: (a) latent and overt neo-Stalinism; (b) a conception of 'them', that is, Russia's neighbours, 'Europe', and the US State Department impinging on 'our Victory'; (c) a non-reflective anti-liberalism where 'liberal' means anyone with a positive view of Russia's 1990s; (d) an emphasis on sports and popular music; (e) 'positive Christianity', in the sense of a triumphant Orthodoxy; and (f) ideas of 'national character' and 'anti-intellectualism' against intellectuals who only 'discuss' but never 'get anything done' (Morozov A., 2012). Morozov argued that such resentment can be projected on everything. With regard to art, he said, such art is patriotic, monumental, energetic and made to be easily understood by the people.

From the very beginning there were expectations and fears about how the new minister of culture would handle the cultural scene. Referring to economic efficiency and strict management, Medinskii soon focused on merging institutions, reorganizing, closing, replacing leaderships and using the allocation of resources as a carrot and a stick. Critics saw more than purely economic motives behind his policy, and an effort to control cultural life. For example, his proposal for the future of state-financed film production was perceived as a model to control the content of films (Borisova, 2012).

Although the previous two ministers of culture had had conservative preferences and no interest in contemporary art, the policy profile of the ministry was not as clear-cut. As is highlighted in Chapter 3, on the one hand, the government

had financially supported the Moscow Biennale for Contemporary Art and provided the NCCA and its regional branches with basic, albeit meagre, financing. On the other hand, the state had neither built a system of education in contemporary art, nor created stipends for young artists. Nonetheless, a plan to build a federal museum of contemporary art was taking shape for reasons of international prestige. In the spring of 2012 the ministry had signed all the necessary documents for the NCCA to take responsibility for the museum. However, by the autumn the new leadership of the ministry had revised the plan. At one point it was again an open question whether there would be a state-financed museum at all. After a period of intrigue and infighting between different interests, the NCCA was given a new mandate for the museum, along with new directives and closer cooperation with the ministry. State and commercial interests were merging, as was evident from the discussions on the new state art museum, during which the directors of the Garazh and Strelka centres actively moved against the NCCA (*Artkhronika*, 2012). It seemed that the directors would be given a significant say in return for their support for the minister of culture, and thereby a share in his growing influence over the art scene and the NCCA. The NCCA, although a federal state institution, had always followed an independent course. It appeared in May 2012 that this was now under threat.

The new minister created an advisory Public Council at the ministry consisting of professionals from across the field of culture. Among the 66 members were several heads of key art institutions: Iosif Bakshtein from the Moscow Art Biennale; Anton Belov from the Garazh Art Centre; Aleksander Mamut from the Strelka Institute for Media, Architecture and Design; Olga Sviblova from the Moscow House of Photography and Anna Tereshkova from the Siberian Centre of Contemporary Art. Theatre was represented by Kirill Serebrennikov and Eduard Boyakov.[25] Only Irina Prokhorova, the head of a publishing house and with a solid reputation for being a liberal and an independent person, declined an invitation to participate (*Kommersant*, 2012).

The new ministry leadership seemed to favour an art that reduced its critical edge in favour of decorative and formalistic forms. The idea that contemporary art can assist regional economic development by being innovative and creative, an idea that Gelman had been among the first to expound, now became received wisdom at the ministry. Reorienting art in an innovative but politically toothless direction was among the new government initiatives. In March 2012 Vladislav Surkov, in his capacity as a deputy prime minister, had announced the creation of a network of regional cultural institutions – a project that had been worked up by Marat Gelman.[26] These Houses of New Culture were to include various cultural activities, including art exhibitions. According to a government decision of August 2012, the Houses were to be implemented before the end of 2015. Three locations were selected for the first phase: Pervouralskoe in the Sverdlovsk region, Kaluga to the south-west of Moscow and Vladivostok (Kolesnik, 2013). Representatives of existing local art centres were invited to participate. As Surkov explained in Kaluga: 'People here have to acquire knowledge, they have to learn to work with new materials and new technology in contemporary art.

Therefore this House of New Culture [has been created]. Also in Kaluga people must know what is going on in New York, without a delay of decades as is usually the case in Russia' (Stolyarchuk, 2013). This didactic and interventionist approach by the government to propagate a new culture was not appreciated by everyone at the local level.[27] When Surkov was removed from government in the spring of 2013, the future of the Houses of New Culture became unclear, but the ministry clearly wanted to build art institutions in the regions.

Medinskii, the new minister of culture, was highly sceptical about contemporary art. Referring to the exhibition on the main project of the 2013 Moscow Biennale, he said, 'I kept thinking: Why doesn't anyone shout "the king is naked!"?' At the first meeting of the organizational committee of the Year of Russian Culture, planned for 2014, he asked rhetorically: 'Why do we, under the label of contemporary art, have to see something abstract–cubic, clumsy, in the form of a pile of bricks? And, moreover, it is paid for by public money! Not to mention that this is incomprehensible to the absolute majority of the inhabitants of Russia' (Yablokov, 2013). Valentina Matvienko, the Chairman of the Federal Council and head of the organizing committee, opened the meeting by saying: 'Russia has for a long time been in need of new cultural standards, since for the past ten years we have witnessed an intervention by ideas alien to our culture'. The chief editor of *Kultura* continued the thought by calling for the creation of a new patriotic elite: 'When part of the cultural workers supported Pussy Riot, it came to my mind that it is necessary to change the cultural elite in the country. It is necessary to invite people from the regions and to correctly orient them, and then make stars out of them, new stars' (*Interfax*, 2013). As part of a new policy to curb critical intellectuals and replace them with a new loyal cultural elite, the plan seemed to be to create new centralized associations for various intellectual professions. At the same time, Putin continued his meetings with a select group of writers.

Thus, various political forces were at play simultaneously in Russian cultural policy. This was evident at the federal level, but more especially at the regional level. There was a difference between the conservative federal ministry, which was suspicious of contemporary art, and the culture department of the Moscow city government, which actively supported culture in general and contemporary art in particular. As a result of decisions taken by the head of the Moscow Cultural Department, Sergei Kapkov, large reorganizations took place and a new art exhibition complex consisting of several institutions was organized around the Manezh exhibition hall.[28] A network of municipal galleries in the suburbs of Moscow was also reorganized into venues for art exhibitions and local social activities.

There were also differences between regions. On the one hand, the governor of the Ulyanovsk region promoted a conservative vision. In 2011 he created an international art contest in the name of the Soviet Realist painter Arkadii Plastov, with the largest monetary prize in Europe. Andrei Erofeev saw this as a sign of a new version of an old Soviet cultural policy model (*Gazeta*, 2013). Such an initiative at this specific time added to the suspicion that the authorities wanted to hijack realism in art in order to divert interest from controversial contemporary art.[29] On the other hand, local authorities in other regions encouraged the free development

of art by supporting existing contemporary art centres, financially contributing to festivals and exhibitions, and even taking measures which seemed to be possible steps towards a state-financed education system for contemporary art.

The Moscow art scene expanded as new private galleries opened, existing art centres were enlarged, and new ones were established on the grounds of former factories. In October 2012 the Garazh Centre of Contemporary Culture moved to a new location at the Krymskii val in Gorky Park.[30] The Udarnik Art Centre under Shalva Breus opened in November 2012 as a new private museum of contemporary art in the classic Stalinist-era cinema, the House on the Embankment. In the autumn of 2012 the ZIL Cultural Centre opened as a centre for the visual arts, contemporary dance and music, also including a library and sports centre, in the building of the former cultural centre of the ZIL car factory.[31] The Flacon Design Centre, which had opened in 2009, now presented itself as the 'first creative cluster in Moscow dedicated to the development and support of a wide range of projects in the field of contemporary forms of creativity, street art and civic activity'.[32] In the field of design and architecture new private centres and institutes were created, sometimes with an art exhibition component.[33] Both the ArtPlay Design Centre and the Strelka Design Centre had been created in 2010 as creative clusters of architects, designers, studios and exhibition halls on converted industrial sites.[34]

Thus, cultural life was blooming and dynamic, in sharp contrast to the political situation. This was not stopped by the announcement in April 2012 that three key private galleries – the Aidan Gallery, the Gelman Gallery and the XL Gallery – would no longer work as commercial galleries. Yet, a conservative cultural policy was under preparation in the federal ministry.

Art after Bolotnaya

The conservative wind from official policy was strong enough to make extreme patriotic-religious organizations a significant factor in cultural life. Right-wing activists came to function as conservative 'Storm troopers', closely monitoring the art scene and intervening in order to cleanse culture of blasphemy and immoral or unpatriotic ideas and artworks.

Conflicts around art

In this situation of moral and cultural conservatism, the visualization of symbols of power, religion and morality in art became highly sensitive. Several scandals followed as a result. Incidents around exhibitions in the regions exposed the ongoing political battle. In November 2011 the exhibition 'Rodina' (Motherland) opened at the Perm Museum of Contemporary Art (PERMM) and then toured the country. The idea was to stimulate a discussion about the image of modern Russia.[35] The Motherland concept made the separate works part of a discussion of national identity with reference to Orthodoxy, the nation, ethnicity and state history. The exhibition was curated by Gelman but produced in cooperation with the Siberian Centre for Contemporary Art, among others. The exhibition could be seen as a

follow-up to Gelman's 2005 exhibition 'Rossiya 2', in that the new exhibition also intended to question both the official smooth and unproblematic image of Russia as well as stereotypes of the country, its people and its history (Orlova, 2011). The exhibition was opened with the support of the Governor of Perm and praised in the national media, such as *Rossiiskaya gazeta* (Orlova, 2011). It included works by about 30 well-known Russian contemporary artists, among them Aleksander Brodskii, Dmitrii Vrubel and Viktoriya Timofeeva, Dmitrii Gutov, Valerii Koshlyakov, Vitalii Komar and Aleksander Melamid, Vladimir Dubossarskii and Aleksander Vinogradov, Yurii Shabelnikov and the Sinie nosy.

Many agreed that the exhibition contributed to the discussion about contemporary Russia, but others were of a different opinion. In January 2012 the Narodnyi sobor group tried to take the exhibition, Gelman and the Perm Museum of Contemporary Art to court under article 282 of the Criminal Code.[36] This was the peak of the political campaign against the exhibition in Perm led by conservatives from the church, Cossack organizations, Narodnyi sobor and other right-wing organizations.[37]

Most of the works had already been shown separately without encountering any problems but, in the new political atmosphere and as a result of the conservative campaign, the exhibition was criticized. Three works in particular came under attack. The first work to be criticized was Tatyana Antoshina's installation 'Blue Cities', which consisted of glass bottles of different sizes with intense blue rubber bulb syringes on top that gave the illusion of church cupolas (see Figure 8.1).

Figure 8.1 Tatyana Antoshina, 'Blue Cities' (photo: Konstantin Rubakhin) 2011
Source: Courtesy of T. Antoshina

The installation mediated a spiritual beauty but was far from the conventional symbols of religious power and the authority of the church. As the artist said, she had had in mind the beauty of the church cupolas along the Volga river, which had remained visible above the surface of the water even after Stalin had ordered them to be blown up and large areas to be flooded for the construction of a reservoir and hydro-electric power stations.[38] Her installation caused strong reactions by critics who accused her of blasphemy.[39] The contrast between the prosaic function of a syringe and the illusion of churches seemed to be a major reason for the criticism. The installation was removed before the exhibition was allowed to open in Novosibirsk. The criticism of Antoshina's work is a good illustration of the absurdity of the arguments of the Orthodox fanatics.

The other two heavily criticized works which had to be removed in Novosibirsk were the installation 'The Hole' by Khaim Sokol (see Figure 3.20) and the photo-montage by the Sinie nosy group 'Inno, Nano, Tekhno' (see Chapter 5). Even so, the planned exhibition at the museum of local history in Novosibirsk (NGKM) was stopped by the local authorities at the last moment in response to an orches-trated campaign.[40] In a letter to the governor, representatives of Narodnyi sobor called for the exhibition to be banned. Gelman was called an active blasphemer and a Russophobe.

> Recently, our country has been disturbed by various acts aimed at violat-ing moral principles and removing the boundaries between good and evil, between elementary decency and open rudeness with the final goal of destabi-lizing and dividing society. Such concepts as family, faith and motherland are portrayed as caricatures and mocked. Part of this bacchanal is the exhibition by Marat Gelman with the highly spiritual title of 'Motherland'. This is an exhibition where the map of Russia is laid out in floor rags, where empty jars and blue-coloured syringes symbolize Russian churches, where three Rus-sian *bogatyrs* on Vasentsov's painting from the 19th century, symbolizing the strength of Russia, are replaced by three naked women on horses dressed only in kokoshniki [traditional knitted women's head garments], and our national leaders are presented in a caricatured form.
>
> (*Imperskii zhurnal*, 2012).[41]

A second venue in Novosibirsk was found – an airport hall – but was used for only a few days before the owner cut off the electricity (Popov, 2012). Finally, the 'Rodina' exhibition successfully opened at a third venue, the Novosibirsk Siberian Fair (*Epoch Times*, 2012). It is important to note that the atmosphere in the city was tense even before Gelman's exhibition due to an exhibition of Picasso's erotic gravures, which caused a reaction from the archbishop Tikhon of Novosibirsk and Berdsk, who called on the state museum to remove the 'pornography'.[42] It is likely that the problems in Novosibirsk were the main factor behind the change of the name of the exhibition from 'Motherland' to 'The Unknown Country of Artists' before it opened in Krasnoyarsk, another Siberian city, two months later (Semendyaeva, 2013).

At about the same time as the scandal reached its peak in Novosibirsk, Gelman opened another exhibition, 'Icons', at the Krasnodar regional museum of local history in southern Russia. The aim was to discuss the relationship between contemporary art and Orthodox icons. The introductory text of the exhibition referred to Europe, where over the centuries art had developed within the framework of religious art. In Russia the icon gave birth to art.[43] Church and art have the evangelical myths in common and this is especially the case in Russia due to the central role of the icon. Therefore, Gelman said, it is important to open a dialogue between church and art.[44]

This exhibition displayed works by famous artists, such as Mikhail Schwartzman and Irina Zatulovskaya. Vrubel and Timofeeva presented works from their Evangelical Project, Dmitrii Gutov his metal-multidimensional icons, Anatolii Osmolovskii his Bread project, Konstantin Khudyakov his Deisis series and Gor Chakhal his works 'The Names of God' and 'Sun of Truth, Good and Beauty' (see Chapter 3).[45] None of the works was an offence to religion or the church. Nonetheless, in the local context of Krasnodar the exhibition created strongly negative reactions.

Before the opening, representatives of the Ekaterinodarskii, Kubanskii, Stavropolskii and Nevinnomysskii dioceses demanded that the exhibition be banned (*Open Space*, 2012a). They argued that 'it is impossible to allow a permanent Gelman museum to open in our Cossack and Orthodox land, since violation and defamation of religion and culture would become the norm of life' (Morozov I., 2012). Their campaign was massive, even though the number of critics was limited. The exhibition was supposed to open on 15 May but after protests by hundreds of Orthodox activists and Cossacks, which included Gelman being spat at in the face by a priest and bomb threats against the exhibition hall, the opening was postponed until the following day (Sukhoveeva, 2012). At the opening, activists blocked the entrance to the museum, and leaflets and posters outside the museum read 'Warning! Gelman's exhibition brings death and corruption to the human spirit'.[46] Even members of Zhirinovsky's Liberal-Democratic Party and of the Communist Party participated in the demonstration.

'It was a protest against the unknown, but also personally against Gelman', according to one member of the local art scene. Gelman explained the reaction as a conscious and planned campaign by conservative forces.[47] First of all, he said, there were 'echoes of the rally in support of Putin at the Poklonnaya Gora on 4 February'. He thereby referred to the organizers of the pro-Putin mass rallies in Moscow.[48] Governor Aleksander Tkachev, who had lent his support to the exhibition, did not initially give in to the demands of its critics. The exhibition was planned as a first step towards creating a permanent museum of contemporary art in Krasnodar. Tkachev declared that Gelman would still open a museum in the autumn of 2012, but before long no more was heard of the plan.

The 'Icons' exhibition opened at the PERMM in September 2012 without any problems. By then it seemed likely that Gelman would leave Perm, since the

governor and the regional government had been replaced after Putin's return as president. Gelman stayed, however, and a year later the new governor extended his contract as head of the museum. Nonetheless, Gelman was fired by the regional minister of culture in June 2013 after another scandal involving an art exhibition (see below).

The scandals around the 'Icons' exhibition continued in St Petersburg, where it was planned to open at a private gallery, the Rizzordi Art Foundation, in November 2012. After a meeting with the governor, the gallery owner asked Gelman to postpone the exhibition for a year because of the 'unfriendly atmosphere' in the city (*Gazeta*, 2012). In October, Gelman decided to cancel the exhibition after several incidents linked to a heavy conservative offensive. A theatre play based on the novel *Lolita* by Vladimir Nabokov was removed from the repertoire after criticism from conservative moralists (*Grani*, 2012a). An exhibition at the Hermitage by the British Chapman brothers was taken to court by Narodnyi sobor for offending the feelings of believers, although the local court threw out the case. Narodnyi sobor then insisted, again without success, that the director of the Hermitage leave his post (*Nezavisimaya gazeta*, 2012). Only after a new venue was found in the Tkachi gallery complex could the 'Icons' exhibition open in late March 2013. Gelman regarded this as a victory, especially when his invitation to leaders of one Cossack organization was accepted and they visited the exhibition before it opened. The Cossack leaders declared that they found nothing 'subversive or against God' (*Metro*, 2013). The exhibition was a success and Gelman later told how 'people came up to me and thanked me'.[49] Other Cossack groups, however, painted threats against him on the gallery wall (*Nezavisimaya gazeta*, 2013b).

It could be argued that Gelman acted provocatively by organizing exhibitions on controversial topics. He, however, claimed that the 'Icons' exhibition was the most discreet exhibition of his entire professional life and completely without any provocative works.[50] The 'Rodina' exhibition was characterized by irony but 'It turned out that even irony was dangerous'.[51] It seemed as if the 'Rodina' and 'Icons' exhibitions had become litmus tests of the state of Russian politics and society.

The political atmosphere led many cultural institutions to avoid topics and situations that had the potential to insult or offend the political hierarchy (the power vertical), nationalism and radicalized religion (Semendyaeva, 2013). It was therefore unsurprising when in June 2012 a contract between the company responsible for letting gallery space at the Vinzavod to Gallery Gelman overtly stipulated that the leaseholder was prohibited from carrying on any activities beyond the original purpose stated in the contract – and especially no activities 'with a political or religious slant' (Semendyaeva, 2013).

Gelman's activities in the regions drew media attention but he was not the only notable actor in contemporary art. The lion's share of the art exhibitions, biennales, festivals, seminars and lecture tours outside Moscow and St Petersburg were organized by the branches of the NCCA. The centres in Nizhnii Novgorod,

Ekaterinburg, Kaliningrad and, since 2012, Vladikavkaz were now reaping the benefits of many years' work, in spite of their low level of financial resources. They often had to tread a narrow line between federal and local authorities, convincing them of the advantages of art from a regional development perspective. All had strong female directors who took on responsibility for the regeneration of former military arsenals and castles into exhibition halls, while at the same time organizing a regular programme of activities. Their work had not only regional but also national relevance, such as, for example, the Industrial Biennale of Contemporary Art in Ekaterinburg, which began in 2010 with international participation. The exhibitions of the NCCA were not usually targets for Orthodox patriots, but they contributed substantially to moving the frontier of contemporary art in the regions.

As is noted above, the 'Rodina' exhibition was produced with the support of the Siberian Centre for Contemporary Art in Novosibirsk. This independent institution reflected the development of art in the regions. Created in 2010 with Anna Tereshkova as its director, this small centre became known all over Russia when its exhibition, the 'United States of Siberia', toured the country. Ironic and provocative, the exhibition raised heated debate. Its logotype was a painting by Damir Muratov from Omsk of a hypothetical flag of Siberia, made after Jasper Johns' famous painting of the US flag but with green and white stripes and snowflakes instead of stars. About 100 works of art by Siberian artists claimed humour and irony as Siberian characteristics. The exhibition played with images of mass culture as well as national myths. The curator, Vyacheslav Minin of Sinie nosy, explained:

> The exhibition is about how we live in our world and handle all shortcomings with an ironic smile. You must not forget that dull dog-eat-dog seriousness and the joyful non-prejudiced gaze at the world are not compatible. To our joy, there is no national problem in Siberia. In Siberia and the Urals people do not differ much with regard to nationality. At least, they do not think it is important. It seems the cold winter makes it more important to stick together. Social conflicts also seem to be smoothed out since you cannot deport someone further than Siberia. Therefore we joyfully look at common issues as from the side, the more so since such issues are international rather than national – rather worldly than divine. Siberia is the infinity, cheerfulness and freedom. Siberian is not a nationality but a worldview and a kind of cheerful activity.[52]

The exhibition toured Novosibirsk, Tomsk, Perm, Moscow and St Petersburg and was a big success. It included a series of works by Vasilii Slonov on the upcoming Olympic winter games in Sochi, which mocked not only stereotypes of Russia but also the authoritarian traits of its system. However, when Gelman exhibited the Sochi series separately at the PERMM, both he and the series became the targets of heavy criticism. After accusations of extremism, the police

searched the museum and confiscated Slonov's works – and Gelman was fired (*Nezavisimaya gazeta*, 2013c and d).

Intellectual resistance and the search for a new engaged art

In a chronicle about cultural life in the past year, the daily newspaper *Vedomosti* wrote in early 2013 that culture and contemporary art had become politically charged: 'The social atmosphere had become so dense that nothing remained neutral. All the strength of the creative intelligentsia was given to the struggle . . . everything reasonable during the year was only that which was made for the sake of the struggle for civil rights or that at least had a socially relevant topic' (Zintsov, 2012). In a sense, the author said, all new art had 'become leftist regardless of the political orientation of the artist', and even liberal artists had involuntarily started to cultivate a leftist vocabulary. It was not only art that had become politicized, he noted, but so too had the audience: 'We have begun to comprehend the cultural product exclusively in a practical context: What is it for or against?'

It is possible to find proof of this claim, but it could also be refuted a few months later. In the new political situation after the Bolotnaya demonstrations, the experts at the Kandinsky Prize or the Innovatsiya Prize appeared to prefer to avoid artworks with political references.[53] Consequently, Pussy Riot's action in the Cathedral in February 2012, nominated for the Kandinsky Prize, was not included on the shortlist by the expert committee. Some commentators argued that this was for political reasons. Many in the arts community, however, were of the opinion that Pussy Riot's action could not be considered art of high enough quality to be included.

Nonetheless, the artworks nominated for the 2012 Kandinsky Prize reflected an ongoing politicization of art and a turn towards social issues. Major topics among the exhibited works were political protest, apocalypse, religion and migration. The 'White Canvases' installation by an art collective curated by Anton Nikolaev had a straightforward political message. The artists lined up on the embankment opposite the Kremlin wall in order to paint the Kremlin, but the action resulted in white canvases – either white painted on white or just empty canvas. As Nikolaev explained, 'the drawings of white on white are an excellent metaphor for the emptiness and insipidity of the government, which constantly avoids taking responsibility for events in the country and presents no plans for the future' (Nikolaev, 2012: 42–45). Anton Litvin's video work, 'The Procession', showed the marching feet of people from the three largest protest demonstrations in December 2011 and early 2012 under the heading, 'We will be back'.[54]

The exhibition of works nominated for the Innovatsiya Prize in April 2013 confirmed both the social trend and an intellectual resistance among artists. As in the case of the Kandinsky Prize, the jury's choices avoided outright political works. Even so, among the finalists were works of political reflection. The pessimistic message of the installation by Vladimir Seleznev shocked the spectator into reflection. In a room where the light was regularly switched on and off, a graffiti text 'It's All in Vain' appeared in phosphoric paint to be replaced in the

brightly lit room by slogans of political protest and revolutionary resistance in different languages (Seleznov, 2013: 52–53). A young street artist from Ekaterinburg presented his project 'Above Everything' (Prevyshe vsego) under the pseudonym Timofei Radya with photographs of graffiti painted on the roofs of buildings. The texts were not political. Instead, phrases such as 'Come back!' (Vosvrashchaisya!) were open to interpretation. Radya, who had also been a finalist in the Innovatsiya contest in the previous year, was known for a work with more overtly political content – the video 'Stability' from December 2011 (see Figure 8.2).[55] Against the background of a snowy landscape and pompous music, people dressed in police winter uniforms built a high pyramid of 40 riot shields. At the top they placed a throne and unrolled a red carpet. After a few seconds the construction collapsed like a house of cards.[56]

The political protests of 2011 and early 2012 also resulted in a search for art forms more directly related to overt political engagement. One articulate spokesperson for this orientation was the young artist Arsenii Zhilyaev. He wrote in December 2011 that the protest movement needed to unite people around a positive goal. They could not only be 'against', he said, but had to formulate a programme on what to demand and what to do. He argued that artists need to take a stand and ally themselves with political forces (Zhilyaev, 2011). The political awakening after the parliamentary elections had changed the circumstances for art, and artists must show their political priorities and act for 'a new past and a possible future'. He criticized Voina's action on the bridge for not making clear

Figure 8.2 Timofei Radya, 'Stability' (video) 2011
Source: Courtesy of T. Radya.

the values for which the group was fighting. The action had been successful and understood by all layers of society, he said, but had expressed nothing but protest for the sake of protest. Art performances directed against the KGB or criticism of Russia's 'abnormal capitalism' could only be satisfying for a brief time since, like all spontaneous political protests, they were only a first step in the development of political protest. '[Today] political forms [of protest] that evolve in the squares are more mighty and more important than any forms of contemporary art'. He concluded that in the near future 'the artists' support for protest meetings would be relevant in the form of civil and political acts rather than artistic ones' (Zhilyaev, 2011).

By April 2012 Zhilyaev had developed his arguments (Zhilyaev, 2012). What kind of art could there be, he asked, after the artist had encountered 'real politics', that is, experienced mass meetings and participated in monitoring the elections? His answer, in the form of a 'call to the young generation', was twofold. First, artists need to use the experience of the Russian avant-garde in preparing and participating in the transformation of social life. 'I am talking about a completely non-politically correct turn to utilitarian and enlightening art', he said. Second, the artist has to leave his cellar and 'return the hope of a future to the world'. He urged artists to: 'Create conditions under which real acts that restore the genuine ethical dimension become the guide to action for the young artist. The ethics of real action will become our future aesthetics'. The artist must contribute to the process 'of learning to speak again'. He was referring to the avant-garde of the 1920s, the Constructivists, who had lent their skill to the service of building a new society.

Zhilyaev's words were only one voice in the discussion of the relationship between the artist and political life. The predominant view among the art community did not support Zhilyaev's opinion about the Constructivists. Boris Groys, who wrote in the catalogue of the exhibitions on the Russian avant-garde at the Garazh Center in the autumn of 2010 (see Chapter 3), returned in the Russian media a year later to the issue of the political contribution of the avant-garde (Groys, 2010). He argued that if the avant-garde was to be regarded as part of the political revolution in the early twentieth century, we must ask ourselves whether an artistic practice beyond art can change the dominant conditions of political and economic life, or whether art instead would suffer from being in the service of political or social change.

He compared the political role of the Russian avant-garde with the contemporary political role of art in the West. He found the role of the latter to be twofold: a critic of the dominant political, economic and artistic systems, and a tool for mobilizing society to change these systems by opening up utopian perspectives, often with the help of 'quasi-carnival-like events' and by inviting the public to participate. The Russian avant-garde of the 1910s had not been at all interested in a mobilization of the masses, he said, but they paved the way for the revolution by constantly questioning fixed and established perceptions and concepts. Therefore, he said, the Bolsheviks, after taking power, considered these avant-gardists to be counterrevolutionary. In contrast, the late avant-garde, that is, the Constructivists of the 1920s, viewed art as a didactic and propagandistic tool for the sake of the

revolution. Groys concluded that only the pre-revolutionary avant-garde can be considered relevant to the contemporary Russian situation.[57]

A similar view was held by Sergei Kudryavtsev, whose small publishing house, Gileya, focused on literature about the avant-garde (Lazareva, 2012). The experience of the avant-garde can be of interest to political work in contemporary Russia – but only that of the early avant-garde of the 1910s. Referring to its Western followers, the European Situationists of the 1950s and 1960s, he emphasized their practice of 'breaking down steady meanings in the social–political reality' (Lazareva, 2012). He found this heritage alive in contemporary Russian art in 'street actions and other social actions, in the construction of social situations'.[58] He argued that the genuinely avant-garde is closer to anarchism than to the left or to Marxism. Avant-garde movements are principally anti-hierarchical or a-hierarchical with regard to ideas and practices, while the left still 'remains on the principles of hierarchy and cult'. He could not understand how the 'productionist, collectivist and documentalist experience of LEF' (the Constructivist Left Front of Art, created in 1923) could be useful today, since its ideas had been 'creations of utopia and compromise'.

Anatolii Osmolovskii, the former art Actionist, warned against allowing art to become directly engaged with a political organization. Such efforts always fail, he said, giving the example of not only the Soviet Constructivists of the 1920s, but also the Surrealists who tried to cooperate with the French Communist Party in the late 1920s and early 1930s. Experiments of this kind, according to Osmolovskii, always end in either 'a dramatic denial of art or a proud break with the engaging political force'. Art, he said, is itself 'an autonomous political project, and can therefore only become the engaging part itself, dissolve under a stronger "partner" or start competing with him' (Osmolovskii, 2012).

Osmolovskii's view was questioned by those who wanted artists to engage in social change. Already in 2005 Miziano had told him that 'The artists' civic position is not really decided through his party membership card. Instead it is primarily a question of your existential and ethical experience. There are moments when your civic position will manifest itself as political indifference, but there are also moments when indifference is simply the triumph of conformism, which is directly reflected in the feasibility of your creative product' (Riff, 2005).

The discussion continued among socially oriented artists. People who had participated in 'Occupy Abai' now asked themselves how to proceed. There was an increasing interest in protest art. Galleries wanted to exhibit it. Even banners and slogans were exhibited as artefacts. Galleries were interested in the new wave of protest in art. Zhilyaev, for instance, continued his search for new forms of political art intervention. Using museum space, he tried to create new narratives and write the protest movement of 2011–2012 into the history of the revolutionary movement and into the history of participatory art. At the Historical Memorial of Presnya, a museum dedicated to the revolutionary workers' uprising of 1905, he tried to link the events of 1905 with those of 2011–2012.[59] In an exhibition at the Tretyakov Gallery 'Museum of Proletarian Culture: Industrialization of Bohemia', he turned to the social projects of the period of the revolutionary avant-garde

'in a search for its lost utopias'. He combined a partly fictive and partly documentary history of workers' creativity in the form of hand-made objects and linked them to the social activism of the protest movement in 2012.[60] From a leftist position, he searched for art that would be socially relevant and have a didactic element. It seems to me, he said, 'that society has developed a demand for real pro-articulated alternatives in art as well as in politics' (Krizhevskii, 2013). Zhilyaev attracted young followers, especially in the provinces, who were looking for participatory art for the purpose of social change. Although many in the Moscow arts community found Zhilyaev's ideas too theoretical and too dedicated to an old revolutionary utopia, others emphasized that the experience of 'Occupy Abai' – popular participation, horizontal communication, collective decision-making, resistance and a new engagement – had changed the role of art and the artist. The concepts of 'occupy' and 'assembly' had become calls to artists to enter social political processes and make art a collective activity.

Various methods were tried in the search for ways to make socially concerned art under the new political conditions. In June 2012 an exhibition and extensive seminar programme at ArtPlay explicitly connected art and protest. Called 'Silence equals Death: Art, Protest, Rock 'n roll, 1980s–2010s', it combined political manifestos, artefacts and music.[61] The music was documented by records of the Soviet underground and post-Soviet music videos. The exhibition was a clear statement in support of Pussy Riot but also of the message that art is politics. The title was taken from an album by the punk group Tarakany,[62] but could also be seen as a paraphrase of Descartes' *Cogito ergo sum* (I think, therefore I am) into 'I am not silent, therefore I am' (Kurbyukova, 2012). The art critic Darya Kurbryukova concluded her review: '. . . the Silence equals Death [exhibition] and the discussion of hot topics in the "dead" summer season are signs that there are no plans to keep silent. This exhibition is an archive of protest, an archive with an open end' (Kurbyukova, 2012). Thus, engaged and participatory art in various forms was finding its way on to the Russian art scene.

Other artists among the young generation searching for alternative ways for art to contribute to social change, tried to deconstruct authoritarian and patriarchal ideational structures. Stas Shuripa's approach seemed representative to many as he emphasized the artist's critical distance and non-engagement, while at the same time striving to express social, political and philosophical senses in artistic metaphors. There seemed to be a new search for hidden structures and knowledge, for the gap between what is viewed and heard, experienced and known.[63]

The trend towards socially relevant art finally also resulted in art that directly dealt with the dark sides of Soviet history. The exhibition 'Commissioned by the State', shown in April 2013, played with the idea of proposals for public art monuments. Among them, Khaim Sokol's installation 'Poste Restante', on the memory of the past, stood out. It consisted of letter boxes with the names of people arrested during the Great Terror of the 1930s (Machulina, 2013). The boxes were intended to be put up on the houses where these people once lived. Sokol's work was the first contemporary art work that sought directly and seriously to deal with the

Figure 8.3 Irina Nakhova, 'Without title' (mixed media) 2013
Source: Courtesy of I. Nakhova.

theme of *Vergangenheitsbewältigung* – that is, to confront and make up with the past. It seemed a breakthrough when in December 2013 Irina Nakhova, an artist with a reputation as a Moscow Conceptualist, was awarded the Kandinsky Prize for an installation built on fragments of her family history over nearly 100 years (see Figure 8.3). In a three-channel video, photographs replaced each other in a composition reminiscent of a Stalin-gothic building, where the faces of people were rubbed out one by one by a ball-point pen. Nakhova explained: ' "Untitled" is my reckoning with history as understood through the history of my family – my grandma, executed grandpa, mum, dad and myself in the past. This is my attempt to understand the inexplicable state of affairs that has reigned in my country for the past century, and to understand through private imagery how millions of people were erased from history and happily forgotten; how people have been blinded and their soul destroyed so that they were able to live without memory and history' (Nakhova, 2013).[64]

Art exhibitions therefore continued to reflect a clash in society between different worldviews and values. While the authorities and their official conservative consensus tried to insert absolute values of good and bad based on false premises about the past and the present, art reflected the fluid situation of values regularly being turned around. The exhibition 'Weightlessness' of the Moscow Biennale programme in the exhibition hall of the newly renovated monument the 'Worker and the Kolkhoz Girl' illustrated this situation. In 1937 the monument had crowned the Soviet pavilion at the Paris World Exhibition and represented the absolute values of the Soviet system, but the new exhibition presented a different world. According to its curator, Elena Selina, 'Weightlessness and lack of balance are the biggest stresses for contemporary man who has lost his foothold in the world'. Among the participating artists expressing the idea of the fluid situation in which people live was Sergei Shekhovtsov, whose installation 'Road to Nowhere' was inspired by David Lynch's film of the same name (see Figure 8.4). His figure, carved in polystyrene, leaned exhaustedly towards a road heading uphill as the questions of existence made his world tremble: 'We have lost our foothold not only in Russia but in the whole world. You are in a state of hangup, and from time to time you find your foothold and then lose it again, and so on, endlessly. It is now impossible to keep the foothold for long. . . . The movement is a way to prevent you from falling. Moving through thousands of questions to which there are no answers'.[65]

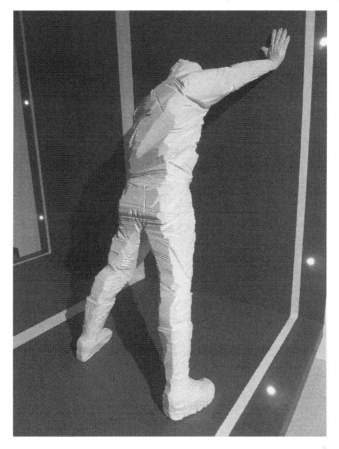

Figure 8.4 Sergei Shekhovtsov, 'Road to Nowhere' (installation) 2013
Source: Courtesy of S. Shekhovtsov.

In a situation in which the regime was trying to enforce a unitary political-religious-ideological filter on society in order to structure what could be heard, seen, conceived and expressed, while at the same time society was characterized by growing contradictions and diversities, contemporary art obviously had a crucial role to play. Through its ambiguity and elusiveness, art functioned as a corrective to the new illusions of absolute and eternal ideological values and conceptions.

Conclusions

Putin's return to the presidency in May 2012 brought with it completely new conditions for the protest movement. The police's reaction to the demonstration in Bolotnaya Square became an indication of the new repressive policy against the

opposition. Putin's previous strategy of relying on the middle class and centrist-conservative forces had been a failure, so he made a definite turn in 2011 towards conservative, Orthodox and patriotic forces. The new minister of culture, appointed in May 2012, was coloured by these ideas. A new conservative, patriotic, Orthodox moralism filled the vacuum left by Soviet Marxism. The aggressive conservatism and moralism of the Duma majority and the United Russia Party was lifted to new heights by the introduction of new legislation. As the promises of political reform by Dimitrii Medvedev came to nothing, opportunities for a viable opposition within the system were more or less eliminated. The media was circumscribed and the Duma discussed how to control the Internet. The number of participants in street demonstrations and the protest movement declined. The reasons for this were many and varied. The repression scared many away from participating, but a no less important factor was the feeling that the demonstrations were pointless. The protest movement could not agree on a joint political programme, and there were no leaders or organizations able to continue the struggle in a situation in which repression increased and the channels for political influence were closed.

The conservative wind manifested itself in scandals around art exhibitions in 2012 and 2013. To discuss issues of the motherland, religion, nation and the history of the state, ideas central to the identity discourses of the official Putin consensus had become highly controversial. Extreme patriotic-Orthodox groups of the radical conservative wing became the 'Storm troops' of the Putin consensus. The Cossacks again became a symbol of repression and intolerance.

The guilty verdicts handed down to the members of Pussy Riot and confirmed by a higher Moscow court, and the arrests and legal processes that followed against the demonstrators in Bolotnaya Square, seemed to be victories for the regime. The dominant concern of the protest movement became the increasing political repression and support for the people suffering from it. In late September 2012 an open letter requesting that those arrested after the Bolotnaya demonstration be released was signed by people from a wide spectrum of culture and the social sciences as well as human rights activists (*Colta,* 2012).

The letter showed that, in spite of the repression and the fact that many from the middle class had chosen to leave the country, intellectual resistance among those who had stayed had not subsided. The exhibitions of nominees for the Kandinsky Prize and the Innovatsiya Prize in 2012 and 2013 confirmed the trend towards art with social concerns and socially oriented topics. Young artists searched for an art that would integrate their striving for social change. In the strongly conservative climate, with patriotic and religious fanatics on the offensive, visual art became a battleground. In spite of the difficult political situation in the country, the arts community blossomed and continued to demonstrate intellectual resistance. Nonetheless, the political conditions were tightening.

Notes

1 Among these should be mentioned Dmitrii Rogozin, who together with Sergei Glaziev had created the Rodina Party in 2004 and the Congress of Russian Communities in 1993. Rogozin became a Deputy Prime Minister in December 2011 with responsibility for the military-industrial complex. Glaziev became an adviser to the President on

issues of Eurasian integration in July 2012. Vladimir Medinskii was appointed Minister of Culture in May 2012.

2 There was a scandal in the spring of 2013 involving the Skolkovo Innovation Centre launched by Dimitrii Medvedev. The accusations against Surkov seem to have been only a pretext for removing him from the political scene in the new political situation. However, he was soon back.

3 The films 'Provokatory' I, II and III by Arkadii Mamontov were broadcast on TV1 on 24 April, 11 September and 16 October 2012, www.youtube.com/watch?v=aeT0dZbGkzc; www.youtube.com/watch?v=z0oHHEtcMdM; www.youtube.com/watch?v=K4ryu-MHs6s; 'Anatomiya Protesta' I and II, www.ntv.ru/video/peredacha/296996/; www.ntv.ru/video/354142/ were made by NTV and broadcast on 15 March and 5 October 2012. See also Melnikov (2012).

4 One Duma delegate who was especially active in initiating new draft laws was Aleksander Sidyakin, the author of the drafts of three laws – on meetings, on non-commercial organizations as 'foreign agents' and on responsibility for offending the feelings of believers. Sidyakin has been referred to as a 'Zhirinovsky' of United Russia (*The New Times*, 2012).

5 Federalnyi zakon RF ot 8 iyunya 2012g, N 65-F3 g, Moskva. [Federal law]

6 Putin signed the law on 30 July 2012 (Interfax, 2012); Federalnyi zakon RF ot 20 iyulya 2012g, N 121-F3, www.rg.ru/2012/08/01kleveta-dok.html.

7 RF Federalnyi zakon. O vnesenii izmenenii v otdelnye zakonodatelnye akty RF v chasti regulirovaniya deyatelnosti nekommercheskikh organizatsii, vypol-nyayushchikh funktsii inostrannogo agenta, http://.consultant.ru/cons/cgi/online.cgi?reg=doc;base=LAW;n=132900.

8 Federalnyi zakon RF ot 12 noyabrya 2012g. N 190-F3, http://rg.ru/2012/11/14izmeneniа-dok.html.

9 'Vneseny izmeneniya v zakon o zashchite detei ot informatsii, prichinyayushchei vred ikh zdorovyu i razvitiyu', 30 June 2013, http://kremlin.ru/acts/18423.

10 On websites, see *Open Space* (2012b).

11 Federalnyi zakon ot 29 iyunya 2013g. N 136-F3. O vnesenii izmeninii v statyu 148 Ugolovnogo kodeksa RF i otdelnye zakonodatelnye akty RF v tselyakh protivodeist-viya oskorbleniyu religioznykh ubezhdenii i chuvstv grazhdan' (*Rossiiskaya gazeta*, 2013). For a discussion of the implications of the new law, see Melnikov and Orlova (2013).

12 Decision by the district court, 29 November 2012, Zamoskvoretskii raionnyi sud; http://zamoskvoretsky.msk.sudrf.ru/modules.php?name=sud_delo&srv_num=1&name_op=doc&number=32166799&delo_id=1540005&text_number=1.

13 Needless to say, the meaning of 'conservative' has little in common with how conserva-tive is understood in a contemporary European context.

14 'Manifest narodnogo fronta, Obshcherossiiskii narodnyi front', http://onf.ru/structure/documents/manifest. See also his speech to parliament in September 2013. See also *Nezavisimaya gazeta* (2013f).

15 'Sozdano "patrioticheskoe" upravlenie administratsii prezidenta', 20 October 2012, www.rtkorr.com/news/2012/10/20/325465.new; *Grani* (2012b)

16 In an interview Kirill said the devil was behind criticism of the church and accused liberal opinion of trying to break the 'moral accord' in society (Melnikov and Maltsev, 2012).

17 The Valdai club was created in 2004 at Russia's initiative and included famous Western and Russian experts on Russian affairs. It was financed by the Russian side and was considered a measure to improve the image of the country abroad (*News.ru.com*, 2004).

18 This was said by Mikhail Delyagin of the Institute of Problems of Globalization (Sama-rina, 2012a).

19 See *Zavtra* (2012); Samarina (2012a).

20 On Holy Rus and the danger of such organizations, see Maltsev (2013).

21 The action by God's Will (Bozhya volya) was led by a young man with the pseudonym Enteo.

22 See, for example, the intermezzo at a Moscow cafe initiated by Orthodox activists led by Enteo.
23 A series of incidents in the spring of 2012, when unknown people burned wooden crosses at different locations around the country, was portrayed by the mainstream media as acts by followers of Pussy Riot. Pussy Riot members immediately condemned these actions.
24 See the interview with Vladimir Ryzhkov (Solomonov, 2012).
25 Ministerstvo kultury Rossiiskoi Federatsii, http://mkrf.ru/otkrytoe-pravitelstvo/sostav-obshchestvennogo-soveta.
26 Author's interview, Marat Gelman, Moscow, April 2013.
27 See, for example, the blog article by Andrei Karpov from Kaluga 'Zachem priekhal Vladislav Surkov?', 6 April 2013, www.gorbatin.info/2013/04/blog-post_6.html.
28 This complex included six exhibition halls altogether, among them the Manezh, the New Manezh and the museum of the Worker and Kolkhoznitsa. It also housed the MediaArtLab and the Museum of Design, www.moscowmanege.ru. Sergei Kapkov became responsible for the Moscow Culture Department in September 2011 and from the summer of 2013 had the title of minister in the Moscow city government, www.mos.ru/authority/mosdepkultura.
29 One reaction was a call made by Aleksandra Novozhenova and Gleb Napreenko to 'remove the barrier which separates realism from the critical discourse' (Novozhenova and Napreenko, 2013).
30 See http://garazhccc.com/ru/page/buildings.
31 See http://zilcc.ru/index.php/creativity-centre.
32 See http://flacon.ru.
33 Among them was the Strelka Institute, dedicated to media, architecture and design on the grounds of the former chocolate factory 'Red October'. In late 2012 plans for a new private museum of contemporary art were announced within the framework of a redevelopment project of the huge Bolshevik confectionery complex.
34 See www.strelka.com/content/vision/?lang=ru.
35 Photographs of the artworks can be viewed on 'Vystavka 'Rodina: Neopublikovannoe', starcom68.livejournal.com. An exhibition of the same name, also reflecting on identity, took place in Moscow in 2002: 'Vystavka 'Rodina/Otechestvo'', 10 July 2002, www.gif.ru/projects/rodina/.
36 'Ne dopustit provedeniyu vystavki 'Rodina'!', Informatsionnaya sluzhba MAPO Narodnaya zashchita, 3 May 2012, http://maponz.info/index.php?option=com_content&Itemid=9&id=2333&task=view.
37 A defence of the exhibition was written by Sergei Samuileno, the coordinator of the Siberian Centre for Contemporary art, 'Bitva za 'Rodinoi' v krayu nepuganykh idiotiv', Sibirskii tsentr sovremennogo iskusstva, www.artcentresibir.ru/digest/155.
38 Author's interview with Tanya Antoshina, Moscow, 12 April 2013. On the history of the flooded areas in Stalin's time, see *Russkaya Atlantida: Putevoditel po zatoplennym verkhnei Volgi*, Rybinsk: Format-print, 2005.
39 'Svetlo-sinyaya magiya pravoslavnykh klizm', 24 November 2011, starcom68.livejournal.com.
40 'Pora rabotat', *Expert Online*, 15 May 2011, http://expert.ru/2012/05/15/pora-rabotat/.
41 'Ne dopustit provedeniya vystavki "Rodiny"', Informatsionnaya sluzhba MAPO Narodnaya zashchita, 3 May 2012, http://maponz.info/index.php?option=com_content&Itemid=9&id=2333&task=view.
42 'Novosibirskii metropolit osudil vystavku Pikasso', *Artkhronika*, 6 April 2012, http://artchronika.ru/news/picasso-etchings-condemned/; *Imperiskii zhurnal* (2012).
43 About the 'Icons' exhibition, see 'Vystavka Icons', http://vk.com/iconsgelman.
44 See the interview with Gelman at 'Marat Gelman: Pro Icons, ikony i iskru bozhyu', Yuga.Portal Yuzhnogo regiona, 2 May 2012, www.yuga.ru/articles/culture/6307.html.

45 Also included were the Recycle group (Andrei Blokhin and Georgii Kuznetsov), Ilya Gaponov and Kirill Koteshov, Vladimir Kuprianov, Nikolai Makarov, Arsen Savadov, Aleksander Sigutin, Elena Sukhoveeva and Viktor Khmel. All the artworks in the Icons exhibition can be viewed at Gelman's website, Dnevnik Marata Gelmana, 'Vystavka Icons. Vse khudozhniki', http://maratguelman.livejournal.com/3016862.html.

46 See http://os.colta.ru/photogallery/37551/354571/.

47 Interview with Marat Gelman (Lenta.ru, 2012a).

48 The so-called Anti-Orange meeting was organized by the movement Essence of the Time (Sut vremeni under Sergei Kurginyan, http://osutivremeni.ru/faq/4/) and the Congress of Russian Communities under Dmitrii Rogozin (www.rodina.ru) with the support of several patriotic–Orthodox organizations.

49 Author's interview, Marat Gelman, Moscow, April 2013.

50 Author's interview, Marat Gelman, Moscow, April 2013.

51 Interview with Marat Gelman, Lenta.ru, 2012a.

52 'Vystavka "Soedinennye Shtaty Sibiri"', 19 March–21 April 2013, www.museum.ru/N48782.

53 Two groups shared the prize: Grisha Bryuskin reflected on the myths of the 'enemy' in his juvenile Soviet life, and the AES+F group on the destiny of modern civilization in the apocalyptic final part of the group's trilogy 'Allegoria Sacra'.

54 Other works related to major themes were those of Aladin Garunov on the role of Islam in society – rich as a culture but causing tensions in society; Aslan Gasumov on the destruction of culture due to war; and Anastasiya Khoroshilova on the lives of immigrant workers. Dmitrii Gutov showed his three-dimensional 'Icons' made of thin metallic threads and Yurii Shabelnikov his 'Bible Mail', paintings with paper pigeons made of pages from the Bible (Nikolaev, 2012).

55 'Tima Radya khudozhnik', http://aktualno.ru/guest/89.

56 See http://t-radya.com/street/35/.

57 This view is in line with that in the book *Aesthetics of Anarchy* by Nina Gurianova, presented in Chapter 1, but differs substantially from what Groys claimed in his 1992 book (Groys, 1992).

58 He mentioned Aleksander Brenner and his literature from the 1990s and the Voina group, and among the latter's actions he mentioned the cockroaches in the Taganskii Court during the trial of 'Forbidden Art', and their 'Prick: a Prisoner of the FSB'. This last action he called 'unbelievably talented with regard to conception and performance'.

59 Exhibition project together with the historian Ilya Budraitskis et al., 'A Pedagogical Poem: Final Exposition of the Archive of a Future Museum of History'. This was the culmination of a series of seminars and discussions over several months. The exhibition was shown in November–December 2012. 'O upushchennykh vozmozhnostei k politizatsii muzeya', *AroundArt, Zhurnal o sovremennom iskusstve*, 8 November 2012, http://aroundart.ru/#OT-UPUSHENNYK-VOZMOZNOSTEI-K-POLITIZATSII-MUZEY.

60 'III Moskovskaya mezhdunarodnaya biennale molodogoi iskusstva youngart.ru', 2012, www.tretyakovgallery.ru/ru/calender/exhibitions/exhibitions3769/.

61 Exhibition at ArtPlay curated by Tatyana Volkova of Gallery Zhir, 19 June–1 July 2012. On the exhibition, see Machulina (2012). On the discussion arranged by Volkova at the Zhir Discussion Club in August 2012, see 'Ískusstvo. Muzyka. Protest´', http://zhiru-zhir.ru, filed under Diskussionyi klub Zhir.

62 'Tarakany: Tishina eto smert', www.youtube.com/watch?v=siz-HjMoKSM; and the lyrics at www.song-text.ru/index.php?type=text8id=2760.

63 See, for example, Napreenko, 2014.

64 The Kandinsky Prize 2013 exhibition took place at Udarnik on 13 September–10 November 2013.

65 Taken from Sergei Shekhovtsov's text accompanying his installation at the exhibition. A state of hangup is a condition that occurs when computer programs conflict or do not run properly.

References

Artkhronika (2012), 'Nyneshnyi budushchii Muzei sovremennogo iskusstva predlozhili obedinit', 5 October, artchronika.ru/news/ncca-museum-critique/.

Borisova, Darya (2012), 'My vam zakazhem: "Minkult nameren opredelyat tematiku finansiruemykh filmov"', *Nezavisimaya gazeta*, 18 September, www.ng.ru/cinematograph/2012–09–18/100_medinskiy.html.

Colta (2012), 'Net politicheskomu sudilishchu! Obrashchenie deyatelei kultury i nauki i pravozashchitnikov', 28 September, www.colta.ru/docs/6385.

Epoch Times (2012), 'Vystavka 'Rodina' otkrylas v Novosibirske', 1 June, www.epoch-times.ru/content/view/63090/67/.

Expert.ru (2012), '"Rodina" otkrylas', 31 May, http://expert.ru/2012/05/31/rodina-otkrylas.

Gazeta (2012), 'Gelman vynos svyatykh iz Peterburga', 16 October, www.gazeta.ru/culture/2012/10/16/a_4813457.shtml.

Gazeta (2013), 'Kultura federalnogo podchineniya. Vladimir Medinskii otchitalsya o rabote Minkultury v 2012', 26 February, www.gazeta.ru/culture/2013/02/26/a_4988625.shtml.

Grani (2012a), 'Spektakl "Lolita" v Peterburge otmenen po trebovaniyu kazakov', 20 October 2012, grani.ru/Culture/Theatre/m.207643.html.

Grani (2012b), 'V administratsii prezidenta sozdano "patrioticheskoe upravelenie"', 20 October 2012, http://grani.ru/Politics/Russia/President/m.207616.html.

Groys, Boris (1992), *The Total Art of Stalinism: Avant-Garde, Aesthetic Dictatorship and Beyond* (London: Verso Books).

Groys, Boris (2010), 'Repetitsiya revolyutsii: eshche raz o russkom avantgarde', *Open Space*, 11 November, www.openspace.ru/art/projects/111/details/18601/page2/. Reposted on os.colta.ru/art/projects/111/details/18601/.

Imperskii zhurnal (2012), 'Russofobskaya vystavka "Rodina" ne sostoitsya v Novosibirske?', 25 April, http://puco-sib.livejournal.com/148140.html.

Interfax (2012), 'Putin podpisal zakon "O klevete"', 30 July, www.interfax.ru/world/txt.asp?id=258078.

Interfax (2013), 'Yampolskaya predlagaet smenit kulturnuyu elitu posle podderzhki ee predstavitelyami "Pussy Riot"', 9 October, www.interfax-religion.ru/orthodoxy/?act=news&div=52933.

Izvestiya (2009), 'Sokhranit i priumnozhit: konzervatizm i modernizatsiya', 1 December, www.izvestia.ru/news/355987.

Kandinsky Prize. Exhibition of Nominees: Catalogue (2012, 2013), (Moscow: Artkhronika).

Kirill, Patriarch (2012), 'Slovo pastyrya', *Russkaya Pravoslavnaya Tserkov*, 3 November, www.patriarchia.ru/db/text/2565765.html.

Kolesnik, Anna (2013), 'V Sverdlovskoi oblasti sozdayut novyi Dom Novoi Kultury', *Rossiiskaya gazeta*, 23 March, www.rg.ru/2013/03/26/reg-urfo/surkov-anons.html.

Kommersant (2012), 'Irina Prokhurova otkazalas vozglavit obshchestvennyi sovet pri ministerstve kultury', 9 June, www.kommersant.ru/news/1956414.

Krizhevskii, Aleksei (2013), 'Rossiiskomu obshchestvu nado zanovo uchitsya govorit', *Gazeta*, 4 April, http:// m.gazeta.ru/culture/2013/04/04/a_5243941.shtml.

Kurbyukova, Darya (2012), 'Protestnyi zvuk', *Nezavisimaya gazeta*, 25 June, www.ng.ru/culture/2012–06–25/7_sound.html.

Lazareva, Ekaterina (2012), 'Sergei Kudryavtsev "Chestnye liberaly, novye kommunisty, oppozitsionnye syashchennii i anarkhisty budut sidet v kamerakh vmeste"', *Open Space*, 22 June, www.openspace.ru/art/events/details/37928.

Lenta.ru (2012a), 'Pokhod v Rossiyu: Marat Gelman o sorvannykh vystavkakh' (interview with Marat Gelman), 19 May, http://lenta.ru/articles/2012/05/19/guelman/.

Lenta.ru (2012b), 'Vstupil v silu zakon o gostaine', 14 November 2012, http://lenta.ru/news/2012/11/14/espionage.

Machulina, Diana (2012), 'Protestnaya tishina', *Artkhronika*, 26 June, http://artchronika.ru/vystavki/protest-silence/

Machulina, Diana (2013), 'Ot repressirovannykh do Kenni: nikto ne zabut', *Polit.ru*, 14 April, http://polit.ru/article/2013/04/14/goszakaz-winzavod/.

Maltsev, Vladislav (2012a), 'Vlast odolzhila tsennosti u Tserkvi. RPTse i 'Edinnaya Rossiya' nashli obshchuyu ideologiceskuyu platformu', *Nezavisimaya gazeta*, 20 June, http://religion.ng.ru/facts/2012–06–20/1_property.html?mpril, reposted www.interfax-religion.ru/cis.php/?act=print&div=14794.

Maltsev, Vladislav (2012b), 'Vera s kulakami', *Nezavisimaya gazeta*, 5 September, http://religion.ng.ru/facts/2012–09–05/1_druzhiny.html.

Maltsev, Vladislav (2012c), 'Tserkov otkrestilas ot modernizatsii: Ko Dnyu narodnogo edinstva RPTs vklyuchilas v borbu pravyashchikh elit', *Nezavisimaya gazeta*, 7 November, http://religion.ng.ru/facts/2012–11–07/1_modernizacia.html?insidedoc07/1_modernizacia.html?insidedoc.

Maltsev, Vladislav (2013), 'Pravoslavnye druzhinniki pomenyali vragov', *Nezavisimaya gazeta*, 3 April, www.ng.ru/facts/2013-04-03/1_drujinniki.html.

Melnikov, Andrei (2012), 'Nochnoi koshmar ot Arkadiya Mamontova', *Nezavisimaya gazeta*, 13 September, www.ng.ru/politics/2012–09–13/2_mamontov.html.

Melnikov, Andrei and Maltsev, Andrei (2012), 'Tserkov nadeetsya pobedit "dyavola liberalizma"', *Nezavisimaya gazeta*, 16 April, www.ng.ru/politics/2012–04–16/2_rpc.html.

Melnikov, Andrei and Orlova, Lidiya (2013), 'Pomni o "dvushchechke"', *Nezavisimaya gazeta*, 19 June, www.ng.ru/ng_religii/2013–06–19/1_feelings.html.

Metro (2013), 'Kazaki odobrili vystavku "Icons" Marata Gelmana', *Metro*, 21 April, www.metronews.ru/novosti/kazaki-odobrili-vystavku-icons-marata-gel-mana/Tpomdu – hb2MYVc07wwI/.

Morozov, Aleksander (2012), 'Medinskii v interere. Pozitivnost fashizma', *Open Space*, 23 May, www.openspace.ru/society/russia/details/37261/?expand=yes#expand, reposted http://os.colta.ru/society/russia/details/37261/.

Morozov, Ilya (2012), 'Pravoslavnye aktivisty v Krasnodare razgromili vystavku Marata Gelmana', *Kontrabanda.ru*, 17 May, http://kbanda.ru/index.php/society/2312-pravoslavnye-aktivisty-v-krasnodare-razgromili-vystavku-marata-gelmana.html.

Nakhova, Irina (2013), *Kandinsky Prize 2013: Exhibition of the Nominees. Catalogue* (Moscow: Artkhronika).

Napreenko, Gleb (2014), 'Kompromiss/beskompromissnost; consensus/raznoglasie', *Khudozhestvennyi zhurnal* 91: 35–45.

News.ru.com (2004), 'Kreml pytaetsya skupat zapadnykh zhurnalistov, kotorye uluchshat ego imidzh', 13 September, www.newsru.com/russia/13sep2004/conference.html.

New Times (2012), 'Kto ya takoi, chtoby Putina obsuzhdat?', 26 November, www.newtimes.ru/articles/detail/60282.

Nezavisimaya gazeta (2012), 'Ermitazh berut sobornostyu', 11 December, www.gazeta.ru/culture/2012/12/11/a_4887277.shtml.

Nezavisimaya gazeta (2013a), 'Putin prizval rossiyan uiti ot primitivnoi traktovki ponyatiya "svetskoe gosudarstvo"', 1 February, www.ng.ru/politics/news/2013/02/01/1359735002.html.

Nezavisimaya gazeta (2013b), 'Politsiya razyskivaet "kazakov" iz pisavshikh v Peterburge steny zdaniya, gde razmestilas skandalnaya vystavka Gelmana', 4 April, www.ng.ru/news/427170.html.

Nezavisimaya gazeta (2013c), 'Gelman: kartiny iz permskogo muzeya sovremennogo iskusstva budut proveryat na ekstremizm', 21 June, www.ng.ru/news/435277.html.

Nezavisimaya gazeta (2013d), 'V Permi nashli zamenu Gelmanu', 22 June, www.ng.ru/news/435335.html.

Nezavisimaya gazeta (2013e), 'Prezident vzyal kurs na konservatizm', 30 December, www.ng.ru/politics/2013–12–30/3_conservative.html.

Nikolaev, Anton (2012), *Kandinsky Prize: Exhibition of the Nominees, Catalogue* (Moscow: Artkhronika), pp. 42–45.

Novozhenova, Aleksandra and Napreenko, Gleb (2013), 'Trudyshchiesya myslom', *Colta*, 12 February, www.colta.ru/docs/13100.

Open Space (2012a), 'V Krasodare vsetaki otkrylas vystavka Gelmana', 16 May, http://os.colta.ru/news/details/37083/.

Open Space (2012b), 'Duma sozdast "chernyi spisok' saitov" ', 7 June, www.openspace.ru/news/details/37649/.

Orlova, Mariya (2011), 'V Muzei PERMM pokazali "Rodinu" na eksport', *Rossiiskaya gazeta*, 14 November, www.rg.ru/2011/11/14/reg-pfo/perm-rodina.html.

Orlova, Lidiya (2012), 'Moskovskii Patriarkhat oglasil vragov very', *Nezavisimaya gazeta*, 9 April, www.ng.ru/politics/2012–04–09/2_patriarhat.html.

Osmolovskii, Anatolii (2012), 'Angazhirovannoe iskusstvo', *Open Space*, 13 April, www.openspace.ru/art/events/details/35903/. Reposted on os.colta.ru/art/events/details/35903/.

Popov, Aleksandr (2012), 'Sorvali Icons', *Expert Online*, 16 May, http://expert.ru/2012/05/16/sorvali-icons/.

RIA Novosti (2013), 'Ministr kultury RF podderzhivaet zakon o zaprete netsenzurnoi leksiki', RIA novosti, 22 May, http://ria.ru/culture/20130522/93877123.html.

Riff, David (2005), 'Which ethical horizon are we in need of? Viktor Misiano–Anatoly Osmolovsky', *What Do We have in Common?*, Newspaper of the engaged creative platform 'What Is To Be Done?', 9.

Rodin, Ivan (2013), 'Gorizontal politseiskaya', *Nezavisimaya gazeta*, 15 March, www.ng.ru/politics/2013–03–15/1_gorisontal.html.

Rossiiskaya gazeta (2012), 'V nebe i na zemle: Deputaty reshili zashchishchat religioznye chuvstva veruyushchikh ne tolko slovom, no i delom', 27 September, www.rg.ru/2012/09/27/duma.html.

Samarina, Alexandra (2012a), 'Apostoly konservativnogo patriotizma. Izborskii klub brosaet vyzov rossiiskim liberalam', *Nezavisimaya gazeta*, 10 September, www.ng.ru/politics/2012-09-10/1_apostoly.html.

Samarina, Alexandra (2012b), 'Trete tysyaletie. Novoe 'Srednevekove', *Nezavisimaya gazeta*, 26 September, www.ng.ru/politics/2012–09–26/1_dark_ages.html.

Samarina, Alexandra (2013), 'Razmyvateli i ukrepiteli: Opponentov vlasti obvinyayut v beznravstvennosti i bezdukhovnosti', *Nezavisimaya gazeta*, 4 February, www.ng.ru/politics/2013–02–04/1_opponenty.html.

Seleznov, Vladimir (2013), 'Space of Struggle', in *Innovatsiya 2012, Eighth All-Russian Competition in Contemporary Visual Art* [exhibition catalogue] (Moscow: NCCA), pp. 52–53.

Semendyaeva, Mariya (2013), 'Poostorozhnee tam!', *Colta*, 7 March, www.colta.ru/docs/15655.

Skovoroda, Egor (2012), 'Sakharova-2: Steny i ruchyi', *Open Space*, 13 June, www. openspace.ru/society/russia/details/37717/, reposted http://os.colta.ru/society/russia/ details/37717/.

Solomonov, Yurii (2011), 'Samoprovozglashennaya orientatsiya na konservatizm: O tezi-sakh kotorye "Edinaya Rossiya" vdrug uvidela v state Medvedeva "Rossiya, vpered!" ', *Nezavisimaya gazeta*, 12 October, www.ng.ru/politics/2011–10–12/3_kartblansh.html.

Solomonov, Yurii (2012), 'God na ploshadi: uroki na zavtra, O tom chto budet s otnosh-eniyami vlasti i opposzitsii dalshe', *Nezavisimaya gazeta*, 25 December, www.ng.ru/ stsenarii/2012-12-25/15_lessons.html.

Stolyarchuk, Aleksander (2013), 'Surkov zamenit DK na DNK', *Colta*, 21 March, www. colta.ru/docs/17080.

Sukhoveeva, Elena (2012), 'Chto zhe proizoshlo mezhdu Gelmanom i Krasnodarom', *Colta,* 6 June, http://os.colta.ru/art/projects/160/details/37551/?attempt=1.

Yablokov, Aleksei (2013), 'V 2014 godu gosudarstvo vserez vozmetsya za kulturu', *Vedomosti*, 11 October, www.vedomosti.ru/lifestyle/news/17373481/v-2014-godu-gosudarstvo-vserez-vozmetsya-za-kulturu?full#cut.

Zavtra (2012), 'Izborskii klub: Vtoroe zasedanie', *Zavtra*, 3 October, http://zavtra.ru/ content/view/izborskij-klub-2/.

Zhilyaev, Arsenii (2011), 'Nauchitsya byt za', *Open Space*, 20 December, www.openspace. ru/art/events/details/32953/?expand=yes#expand. Reposted on os.colta.ru/art/events/ details/32953/.

Zhilyaev, Arsenii (2012), 'Etika budushchego: ili Fuck Art, Let's Dance', *Open Space*, 4 April, www.openspace.ru/art/events/details/35652. Reposted on os.colta.ru/art/events/ details/35652/.

Zintsov, Oleg (2012), 'Trend goda: za borbu', *Vedomosti*, 28 December, www.vedomosti. ru/lifestyle/news/7704231/za_borbu.

9 Conclusions

A major objective of this study was to learn what prompted the sudden outburst of popular discontent in Russia when about 100 000 people took to the streets of Moscow in December 2011. The simple answer is that the values of specific social groups had gradually shifted. A gulf had widened between Russian leaders and the population, and there was a new understanding of 'we' and 'them' that differed from the official one. Lev Rubinshtein wrote about this new awareness: 'They are those who all the time threaten society with their majestic finger. *They* are those who sentence and jail while sending out to society the, as they believe, convincing signal of "stand still and fear"' (Rubinshtein, 2013). Although there was no distinct definition of what constituted the 'we', there was an awareness that its members did not belong to 'those' in power, and this reflected a clear divide in society. While people did not necessarily take a radical stand against the system in general, they clearly opposed the way in which the system worked. A counterculture had arisen that was defined as a conflict over values. This volume has sought a comprehensive answer to the questions of how this change took place and how art played a role in communicating messages to wider sectors of the population.

The mind-liberating function

This book examines the art sphere as a significant component of the societal value changes in the era of the rule of Vladimir Putin, with a focus on the nine-year period 2005–2013. It uses art as a telescope to view social processes in Russia. There were several reasons why culture was selected for this task. Scholars highlight the cultural sector as a crucial 'social seismograph' of society and a good measure of change. Albert Melucci has written: 'In complex societies, conflict develops in those areas of the system which are crucial for the production of information and symbolic resources, and which are subject at the same time to the greatest pressure to conform' (Melucci, 1989). Information about the world, the underlying values necessary to recognize in order to understand it and the way this is expressed in symbols and signs are all fields of concern to the authorities. They are also of concern to cultural workers, whose function is to analyse, question, deconstruct and reformulate these symbols. As culture exists on the territory of the very production of symbols of values, clashes arise. People in the cultural and

intellectual sectors are directly affected by systemic influences on the formation of meaning and are thus among the first to mobilize. 'These groups become the indicators, the symptoms of the structural problems of the system. Through their visible action they publicize existing conflicts, even though their mobilization is limited to a specific time and place . . .' (Melucci, 1989).

The main task was to follow the process of value change in order to understand how dissensus in art related to dissensus in politics – how art contributed to the process of political subjectivation, to use Jacques Rancière's concept. It was assumed that by the time people raise their voices, aesthetic ruptures have already taken place in art. Dissensus in art and dissensus in politics are two sides of the same coin. The point here is not that they are mere parallel phenomena, but that what is happening in the art sphere precedes what is happening in politics. Art visualizes value shifts before they are articulated in politics.

The field of visual art developed dynamically in the period under study. The physical space for art developed rapidly in private galleries, museums, art centres, art fairs, exhibitions, festivals and biennales. From this followed a mental space for art, and a subculture was formed by the networks of artists, collectors, galleries, curators and visitors to exhibitions. The art space functioned as an arena for experiment and innovation beyond the otherwise watchful eye of the authorities. It attracted young professionals and the creative class. Visual art's absence of text increases its ambiguity, and the subtlety and playfulness of an art object allow various readings and interpretations. The visual image could therefore represent a sensitive subtext that has not yet been articulated and especially not formulated in political terms.

This study examined art artefacts, that is, various kinds of art objects shown at major exhibitions in Moscow or that otherwise attracted attention; performances in the form of words and deeds by the community of contemporary art that organized exhibitions and seminars and made public statements; and ideations – the values and beliefs expressed by members of the arts community and perceived by the audience. A major conclusion of this study is that art contributed to the process of political subjectivation during these years through its mind-liberating function in: (a) reconfiguring the sensory landscape; (b) making visible the shifts in the official discourse; and, in some cases, (c) functioning as a substitute for political action.

The ideas of Jacques Rancière inspired the understanding of what reconfiguring means. He defines 'the political' as the relationships that evolve when the 'proper' order (consensus) is questioned – that is, the established order of what is seen, heard and understood in the surrounding world. Dissensus art reconfigured the fabric of sensory experience. In examining dissensus in art, the focus was on aspects related to the identity discourses of the official consensus (the 'collective we'). The issue of identity is central to the Russian regime's efforts to construct a fabric for sensory experience in which leaders and the led compose a single unit of 'we'. The proper order is understood as the official discourse to create a new collective 'we' of national, religious and political dimensions. During these years the official consensus developed towards state nationalism, glorifying the past

and idealizing the present, Orthodoxy (meaning the Russian Orthodox religion) as defining the nation and prescribing the normative/ideological basis of the state and its citizens, a strong belief in a Russian uniqueness and suspicion of 'the Other' and loyalty to the political leader and the symbols of the state. Dissensus is identified as the questioning of this official consensus.

Dissensus art attracted increasing attention in the expanding art scene. It represented something innovative and creative, and it was in line with the new independent and individualistic lifestyle and tastes of people who were exposed to international ideas and trends through frequent use of the Internet and travel abroad. Dissensus art is not political in any conventional sense of the term. Nor is it intended to be so. Most of this art belongs here to a category called art of an *other gaze*: it is ambiguous and open to various interpretations. Examples include installations by Aleksander Brodskii of models of buildings made from unfired clay, demonstrating the fragility and volatility of cities, houses and milieux; and video works by the Sinii sup (Blue Soup) group in which a component of insecurity is inserted into the scenery to create the perception of a lurking unknown threat. This art carries no hidden political message, but it adds new dimensions and complicates official discourses. Artists of an other gaze avoid making political statements in the traditional sense and emphasize that their works have no political purpose. Avoiding politics is a kind of mantra among Russian artists that goes back to the time of the Soviet underground of the 1960s. Nonetheless, Stas Shuripa's words are representative of this group when he emphasizes that critical distance and non-engagement are important to him as an artist as they also allow him to express his socio-political feelings and ideas in artistic metaphors.[1] Moreover, even if not political in a traditional sense, the aesthetic rupture of these works makes them political in Rancière's sense of the term.

The second category, as defined here, is *dissent art*, with its jokes, irony and parody of political symbols and signs. Artists assume the role of provocateurs and tricksters, thereby contributing to desacralize power as they openly challenge what is 'proper' in the consensus order. The ambiguous irony, the irreverent laughter and the provocation make this art subversive in relation to the official consensus. The more visually outspoken among these artists follow the Russian carnival popular culture, with its roots in medieval times of mocking, parodying and laughing at the authorities, state and church. While sharing this tradition with the rest of Europe, the Russian version became more pronounced in reaction to the stronger repressive measures taken by the state and church authorities to stifle this form of popular culture. The carnival culture created an anti-world of topsy-turvy, where the world of the real, with its pretensions to be decent, organized and cultivated, was replaced by its mirror image of a chaotic and unstable world of the ugly, low and indecent. It was a parody of the real world where nothing seemed to be taken seriously (Yurkov, 2003: 36–51). Russian 'dissent' art adopted this tradition of innocuous laughter, carrying a double meaning with an edge of criticism of the authorities. These artists thereby helped to desacralize power and to directly question the official 'we' of the Putin consensus. Art activism of dissent art, in particular, attracted the attention of the public as exemplified by the Sinie nosy (Blue Noses), PG and Voina groups.

The third category, *art of engagement*, was completely different – an artistic act located at the very border of the field of politics. While remaining mainly within the field of art and recognized as art, it included open and direct political statements and demands. As a phenomenon it appeared in 2009–2010, the time of the trial of the 'Forbidden Art' exhibition. The Pussy Riot group became its main representative when it went active in the early autumn of 2011. Its members used forms of carnival culture but without the ambiguity of that culture. Instead, Pussy Riot played out direct and serious criticism of the Putin regime.

The questioning of the official consensus was the result of independent reflection and an evolving counterculture. Conflicts related to art during these years proved that the art sphere had become a significant critic of the evolving conservative regime-consensus as well as the main target of the regime's criticism. The Orthodox dimension of the official discourse was propagated aggressively. Conflicts over art also showed that there were individuals in the art sphere who were determined to stand up. Marat Gelman was the most visible among them. His successes can be explained by his skills as a gallery owner and political spin doctor and his talent for social networking. There were also other people who defended the independence of the art world from more remote corners, away from the media's attention. The conflicts over art exposed how the official Russian consensus was rapidly becoming more adjusted to Orthodox discourse.

The subculture of contemporary art developed a counterculture through discussions, seminars and letters disseminated on the Internet or published in journals. The trial of the 'Forbidden Art' exhibition in 2007–2010 crucially raised the art community's awareness of its common interest in defending the freedom of expression. While the trial of the 'Beware! Religion' exhibition 2003–2005 kept the art community at a distance from the organizer and curator, the trial of 'Forbidden Art' created support for the accused and contributed to the development of a counterculture in art and the mobilization of what Alberto Melucci calls 'submerged networks'. Such networks are not usually visible, at least not until collective actors confront them or they come into conflict with a public policy (Melucci, 1989: 70). Inertia and a habitual fear of standing up in public usually prevent people from engaging with controversial cases, but now the publication of open letters signed in support of artists under threat demonstrated that there were people with the courage of their convictions. These networks not only became visible but also expanded.

Against this background of an evolving counterculture, individual art actions acted as a substitute for political outlets. Voina's action with the phallus painted on the bridge is a vivid example. The irreverent laughter it elicited helped to consolidate the counterculture, since it articulated a sentiment of frustration in society. Pussy Riot's action in the Cathedral of Christ the Saviour was another in which art took on a political role. The group's prayer highlighted the authoritarian character of the system and the close links between church and state. Both these art interventions in the public sphere were successful in the sense that they had a strong resonance in society. By their actions these artists seized the right to speak up and gave a voice to all those who did not dare to or could not make their voices

heard. The Pussy Riot action, however, came at a moment ripe for a backlash of aggressive conservatism.

Dissent art inspired a further wave of art activism in Russia. Socially oriented art became the new trend, as reflected in the 2009, 2011 and 2013 Moscow art biennales. The subsequent nomination and award of the state Innovatsiya Prize for Contemporary Art to the Voina group in the spring of 2011 demonstrated the existence of a counterculture in art. Art actions expressed the frustration and discontent felt by large groups of society who lived far outside the art sector. Socially oriented art, and art activism in particular, may be marginal phenomena both within Russian contemporary art and in Russian society as a whole, but it was receptive to the sentiments in wider society and managed to attract people's attention by using shock effects.

As in other countries, Russian art and society do not exist in a national vacuum but are in continuous contact and exchange with the rest of the world. Artists are invited to international biennales, festivals and exhibitions, and foreign artists exhibit in Russia. Trends on the international art scene quite naturally influence Russian art, just as Russian art makes its mark abroad. Interest in socially oriented, engaged and participatory art is an international art trend (Bishop, 2012). Access to news about political life abroad as well as personal contacts and travel contribute to the spread of inspiration from other parts of the world to groups in Russian society. Nonetheless, the local context remains the dominant factor for both artistic and political ideas and acts.

Subjectivation

Dissensus in art and dissensus in politics are separate but mutually dependent processes. The development of one paves the way for or triggers development of the other. As this book shows, art was first to visualize protest in Russian society, long before any significant political actions took form. The politicization of art had its parallel in society, where a redefinition of 'we' took place that was later transformed into political action. The mass protests of December 2011 and the following months were the result of a process of *subjectivation* in Rancière's terms – people who in the existing political order did not count and had no voice stepped forward and made their demands. By their own political demonstrations, they exposed the unequal rules of the political system. Moreover, they did so by representing not only their own interests but also the interests of society as a whole. The Moscow demonstrations reminded of the East German crowds who stood outside party headquarters in the final days of East Germany, shouting 'We are the People'.[2] The Moscow crowd also saw themselves as representing a larger group of people and manifested a feeling of solidarity and a new definition of 'we the people'. However, this feeling did not transform into political change because of the regime's reaction and also the unpreparedness of the protest movement to develop into a political opposition.

Art that questioned the official consensus and the official 'we' was important for the process of subjectivation to evolve in the 2010s. Russian artists had no

agenda for creating a new 'we'. Instead, they followed the path of the early avant-gardists of the 1910s, questioning the established and proper order. By doing this, they contributed to a change of values in society.

Looking at art's role in the process of political subjectivation shows that art follows a logic of dis-identification. According to Rancière, 'The aesthetic effect is initially an effect of dis-identification. As such it is political because political subjectivation proceeds via a process of dis-identification' (Rancière, 2009: 74). This process also has a constructive side. To quote Rancière, 'What the artist does is to weave together a new sensory fabric by wresting percepts and affects from the perceptions and affections that make up the fabric of ordinary experience' (Rancière, 2009: 56). This kind of art, he writes, is not intended to produce any theoretical persuasion about what must be done or any framing of a collective body. 'It is a multiplication of connections and disconnections that reframe the relation between bodies, the world they live in and the way in which they are "equipped" to adapt to it' (Rancière, 2009: 72). In an authoritarian society, such symbolic negation of the existing world constitutes the core of the mind-liberating function of art. Moreover, this process results in a new identification with an enlarged 'we', unspecified in all but one regard – we are not those in power.

Yet, such an approach may not be enough for artists engaged in bringing about social change and who want to point to an alternative state of things or offer ameliorative solutions rather than the exposure of contradictory social truths. They would argue that the latter is amoral and inefficient as it only reveals, reduplicates or reflects on the world.[3] This discussion found its way also into the debate among young, independent Russian artists.

Dissensus art is based on the assumption that direct cause-effect schemas in art do not influence the audience, or provide any straightforward road from looking to understanding or from intellectual awareness to political action.[4] The effect follows instead from what is in the eye of the beholders, their experiences and the context in which they evaluate the work of art.

This book makes no claim to list all the various factors in Russian society at large that nourished a counterculture in 2010 and 2011. Nonetheless, it is relevant to highlight a few additional factors. The creative class and the middle class were the major participants in the demonstrations of 2011 and 2012. They felt the urgency to act, but what made them take to the streets were events and conditions that they shared with other groups in Russian society. The international financial crisis of 2008 played a role but not in the sense of a serious deterioration in the material conditions of the population. The Russian government largely managed to overcome the most acute economic consequences. Instead, the crisis was an eye opener, exposing the Putin system. Putin's promises of a steady increase in national wealth might not be fulfilled. The crisis exposed the inefficiencies and weaknesses of the system. The 'social contract' that many Russia observers spoke of was a tacit agreement between Putin and the population – 'I give you wealth and you accept the authoritarian political system'– but it had been broken. The way in which the law enforcement bodies and the courts worked demonstrated the enormous corruption and arbitrariness to which any citizen could at any time

become a victim. This feeling of total exposure and helplessness vis-à-vis the authorities frightened the growing middle class, which compared this political reality to the situation in other countries. Incidents of police brutality, murder and police corruption strengthened people's suspicion of the authorities. The lack of preparedness of the local authorities when huge forest wildfires broke out in Russia in August 2010, and their perplexity and inability to act when large areas were destroyed, contributed to the crisis of confidence in the authorities. As a reaction to the state's inadequate initiatives, deeds and resources, the population organized rescue groups and helped to support those who had lost their homes in the fires. Contacts were made and networks developed over the Internet. This self-organization demonstrated initiative at the grassroots level. It also took on an important symbolic meaning for the suburban Khimki protection movement in Moscow.[5]

It is possible to argue that Putin allowed President Medvedev to float for a while on the rhetoric of a possible modernization of Russian society, the economy, and the legal and political systems that stoked expectations in society. The modernization debate was received hopefully for a short time, until it became obvious that nothing of the kind could be implemented. Nonetheless, Medvedev's criticism of current conditions and government policies seemed to be the beginning of a new wave of perestroika. Was Putin's policy perhaps not the only option? The dynamism of the modernization debate obviously frightened the Putin establishment and led him to take measures to try to save the situation, but these only encouraged the evolving social discontent. Added to these measures, Putin's decision to stand for election in 2012, thereby ending Medvedev's career as president, was crucial. Thus, the foundations of discontent were already prepared when the accusations of electoral fraud in the December 2011 parliamentary elections spread on the Internet. Then people took to the streets.

The Internet played a huge role in the protest media activism during the build-up to the parliamentary and presidential elections. People from the creative professions, such as writers, journalists, actors and musicians, were prominent organizers of rallies and demonstrations. Looking back, this period illustrates how life invaded art, made art social and made it relate to and comment on developments in society. Art invaded life as activists entered the public sphere in the belief that their artistic actions could, directly or indirectly, make a difference as political acts. In the ongoing politicization of art and society, it was not surprising that art groups such as the West European Situationist movement of the 1950s and 1960s, with their notions of 'moment' and 'constructed situations', as well as the US art activists of the 2000s, with their notions of culture jamming and social activism, would be emulated by Russian protesters. 'Occupy Abai' at the Chistie prudy was a Russian follow-up to the 1968 revolt against hierarchical society that swept across Europe but never reached Russia, and to the various Occupy movements that spread around the world in the early 2000s. The 'Occupy Abai' experience of mass protest and direct democracy in the form of the assembly fuelled the discussion among young Russian artists about how art could engage in and become integrated into the struggle for social and political change.

The Russian protest movement of 2011–2012 fits a pattern of similar movements in the Middle East and North Africa as well as the USA and Europe. Despite their specific differences, they represented a new kind of demonstration, a new kind of protest, a new kind of social basis and a new kind of organization that lacked an organizational and a political programme. One Russian scholar described the characteristics of the Russian protest movement:

> Analysts of the most different colours discussing the probability of mass pro-tests in Russia usually look at the dynamic of the price of oil and the size of the stability fund and shrug their shoulders as if there are no preconditions for mass action. Therefore it was assumed that the only factor that can take people to the streets is material deprivation, and discontent with their well-being. Meanwhile, protest matured on a completely different basis – it turned out to be a protest against the very idea that loyalty can always be bought. This is a moral protest, a protest against corruption and greed, against the lack of a moral order. Personal interest told the majority of those who participated to remain at home; in the short-term perspective they risked problems at work and in the family, in the medium term they risked the stability which they had earned through hard work, and the long-term perspective does not exist in Russia. The uniting force was neither class nor national belonging . . .
>
> (Grigorii, 2012)[6]

The Russian protest movement reflected a reconfigured political landscape. Although the political acts were the demonstrations and media activism related to them, a euphoria developed rapidly. Hopes welled up that political change was possible and that collective action would make a difference. A new communality was created related to the conflict and to the demands raised by the protesters. It was a vague but emotionally positive feeling of belonging that transcended traditional criteria of religion, nationality/ethnicity, social class and gender. It tran-scended the political divisions that existed in the protest movement.

The backlash

It was a huge disappointment, therefore, when the authorities responded with repression in May 2012. The dynamics in society had worked not only to create a protest movement but also to strengthen the Putin regime's restorative ideas of traditional Russian state conservatism similar to the Official Nationality, the ideological dogma formulated under Tsar Nicholas I in the nineteenth century. Its pillars had been autocracy, Orthodoxy and nationalism, or 'for the Tsar, the Faith and the Fatherland'. The return of these dogmas under Putin was a gradual devel-opment over several years. If, however, during his first decade in power there had seemed to be alternative options for the way his ideological–political paradigm would develop, these options had narrowed and, finally, the infighting at the top before the 2011 parliamentary and 2012 presidential elections left the utmost con-servative Orthodox, patriotic and authoritarian option victorious.

The polarization of society during the years under study differs from that of the last years of the Soviet Union, when it more clearly took the form of 'we the people' against shrinking support for the communist nomenklatura. In contrast, Putin was able to build up strong support among large segments of the population at the same time as he alienated the creative class and the middle class. He managed to bring in new core groups to uphold the conservative anti-reform and anti-liberal paradigm after the middle class abandoned him. Opinion polls gave him a remarkably strong support even before his Crimea campaign was fulfilled in March 2014.

The protest movement was politically highly diverse and not able to formulate and unite around a common political programme. The traditional gap in Russian society between the intellectuals and the broad masses as well as between the middle class and the workers was preserved and no efforts were made to overcome it. This contributed to the defeat of the protest movement. The self-isolation of the intellectuals would later result in a discussion of reflection and criticism.[7]

Many from the creative class emigrated when they saw how repression hit the opposition and the prospects for reforms vanish. Others chose internal exile, turning inwards into private life. Through his repressive policy, Putin severed major branches of the country's intellectual and creative tree – and thereby the preconditions for innovation.

The more active role of the church in secular state affairs and in society threatened to split society. Konstantin Remchukov, chief editor of *Nezavisimaya gazeta*, warned of this development and reminded readers of the necessity of keeping state and church apart: 'It is dangerous to consign to oblivion the evangelical truth "Render unto Caesar the things that are Caesar's, and unto God the things that are God's (Kesaryu – kesarevo, Bogu – Bogova)"' (Remchukov, 2013). As a result of the aggressive conservatism that penetrated the official discourse, non-state actors were given a free hand to uphold the new moral and political order. This was demonstrated when Cossacks and Orthodox-patriotic activists were allowed to take the law into their own hands.

While the Putin consensus found its formula, the Moscow contemporary art scene blossomed. As evidenced by the art exhibitions of late 2012 and 2013, the intellectual resistance continued. The policy of the Moscow government's Culture Department became more supportive of contemporary art than the federal ministry was. To some extent, this depended on the specific individuals at the head of the department, but also on the dynamism of the art sector to which the department responded. At the same time as the federal ministry was becoming more conservative under its new minister, and scandals erupted in Moscow and the regions around art exhibitions, art centres consolidated and new art centres opened. The scandals surrounding Gelman might give the impression that he was the only representative of art working outside Moscow, but this was not the case. There were also independent art centres and producers of controversial exhibitions in the provinces. The new political situation fuelled a continuous debate over the relationship between art and power. Intellectual resistance in visual art was far from dead.

The political situation was tightening, however. In April 2014, about half a year after Medinskii's words about how incomprehensible and clumsy contemporary art was, an internal document of the ministry of culture on a new state cultural policy was published (*Izvestiya*, 2014). Although the proposal, prepared by the presidential administration and published a month later, somewhat modified the formulations of the earlier document, its main ideas remained the same (*Rossiiskaya gazeta*, 2014). The April document had stated that "Russia is not Europe" but a unique civilization with a specific "cultural-civilizational code" of values presented as conservative and rooted in Christianity. The major task of the state cultural policy, the document said, was to strengthen its specific civilizational code. Culture was given a crucial role in the document in educating and strengthening the Russian value system.

The ministry wanted to take on a more regulating and guiding role and with contemporary art in mind it declared: 'This will in a natural way lead to a reconsideration of the relationship between the regulator [the ministry] and the curators of "contemporary art" concerning manifestations without spiritual-moral content or with a negative impact on society. As a minimum, such "art" should not receive state support. As a maximum, the state ought to suppress the negative influence on the social consciousness' (*Izvestiya*, 2014). In response to an open letter of protest from the Academy of Sciences, formulations were modified (*Colta*, 2014). Nonetheless, the new document was in line with the policy flagged in Putin's speeches in the preceding months. A new, utterly conservative state cultural policy was coming.

The situation in the country was vividly illustrated by the scenes from Sochi in February 2014, when Cossacks whipped members of Pussy Riot in order to prevent them from performing (see Figure 9.1). Pussy Riot had travelled to Sochi after the Putin regime had released its two jailed members together with Mikhail Khodorkovskii in January, in time for the Winter Olympic Games. Dancing and singing in their balaclavas, bright neon dresses and stockings, some of their lyrics referred to the grandiose opening ceremony at Sochi, the security arrangements around the town, Putin's repressive policy and the hope for change: 'Firework for the bosses. Hail, Duce! Sochi is blocked, Olympus is under surveillance' and 'Putin will teach you to love the Motherland. In Russia, the spring can come suddenly'. The scenes of the Cossacks intervening in the performance, and whipping Pussy Riot members in order to silence them, provided flashbacks into Russian history. In 1649, jesters and tricksters ridiculing the authorities were banned from performing and all musical instruments associated with them were forbidden. These restrictions were then part of the new harsh legal code (Sobornoe ulozhenie) that was introduced against the background of urban riots. The code strengthened autocracy, serfdom and the position of the Orthodox Church. Any jesters violating the law were lashed.[8] Pussy Riot represented a link to the tradition of jesters, with their unorthodox dress, loud music and mocking lyrics. In their dark, old-fashioned uniforms, caps and whips, the Cossacks in Sochi performed as the guards of Putin's Ulozhenie.[9]

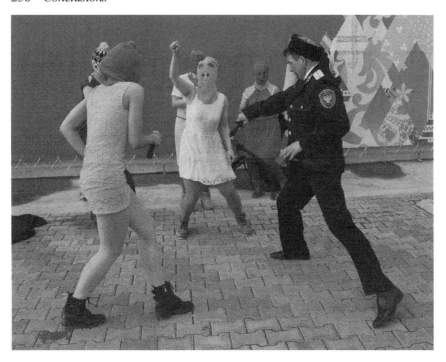

Figure 9.1 Pussy Riot meets the Cossacks in Sochi, February 2014
Photo: Associated Press

Box 9.1 Pussy Riot, 'Putin Will Teach You to Love the Motherland'

$50 billion and a rainbow ray
Rodnina and Kabaeva will pass you the torch
They'll teach you to submit and cry in the camps
Fireworks for the bosses. Hail, Duce!
Sochi is blocked, Olympus is under surveillance
Special forces, weapons, crowds of cops
FSB – argument, Interior Ministry – argument
On [state-owned] Channel 1 – applause
Putin will teach you to love the Motherland
In Russia, the spring can come suddenly
Greetings to the Messiah in the form of a volley
From
Aurora, the prosecutor is determined to be rude
He needs resistance, not pretty eyes
A bird cage for protest, vodka, nesting doll
Jail for the Bolotnaya [activists], drinks, caviar

The Constitution is in a noose, [environmental activist] Vitishko is in jail
Stability, food packets, fence, watch tower
Putin will teach you to love the Motherland
Motherland
Motherland
Motherland

Source: www.newrepublic.com/article/116668/
pussy-riot-releases-new-music-video-sochi

After their release from jail in February 2014, the Pussy Riot women played a role that was probably greater than its individual members realized. They not only acted as a litmus test for how far the conservative processes in society had gone, but were also 'verifiers', testing whether and how the system was working in various extraordinary and unexpected situations. In Sochi, Pussy Riot tested whether the Russian system could uphold a clear divide between what is forbidden by law and what is not. The failure of the system was exposed when the Cossacks, who are not part of the state structure, were allowed to use violence against peacefully performing citizens without any intervention of the police. Pussy Riot thus exposed how arbitrarily the law is upheld, and they acted as a substitute for opposition politics (Malenkov, 2014).

'The hidden transcript'

The value shifts that took place below the surface of society during the 2000s and burst out into open protest in the early 2010s may be understood using 'the hidden transcript of resistance' formulated by the US scholar Frank C. Scott. Scott makes a distinction between a 'public transcript', which he describes as the open interaction between subordinated people and those who decide and dominate what can be said in public, and the hidden transcript. The latter consists of discourses of resistance that develop 'offstage', that is, at social locations beyond the control of the elites. In the public transcript a circumspect, almost invisible struggle is waged daily by subordinate groups. This struggle is, according to Scott, 'like infrared rays, beyond the visible end of the spectrum' (Scott, 1990: 183). It takes place in public view and is therefore a partly sanitized, ambiguous, coded version of the hidden transcript. Often under the shield of disguise and anonymity, it is the result of tactical decisions born out of an awareness of the balance of power (Scott, 1990: 183). Scott uses the metaphor of guerrilla warfare, where there is an understanding on both sides of the relative strength and capacities of the antagonists and therefore about what the likely response may be (Scott, 1990: 192–193). This balance is tested continuously, he says, and he compares the hidden transcript to the water pressing against a dam beyond the limit of what is permitted on stage (Scott, 1990: 196).[10]

At a certain point there will be a rupture in the political cordon sanitaire between the hidden and the public transcript. The first act of insubordination towards the public transcript is an electrifying moment. Behind it lies a long prehistory comprising 'songs, popular poetry, jokes, street wisdom, political satire, not to mention a popular memory of the heroes, martyrs and villains of earlier street protests' (Scott, 1990: 212).

A hidden transcript may exist in elite circles as well as among their opponents.[11] This means that in the backstage discourses, 'there are variants, fissures and cracks, and this make[s] discourses change, and paves the way for different policy options emanating from the same discourse'. This explains how critiques of power can take place behind the back of domination, and how discourses of both consensus and dissensus change over time. In the Russian case this opens up the prospect for a hidden transcript within the elite to produce a future split among the ruling elite and result in a new period of reform in the future.

Scott emphasizes the need to pay closer attention to political acts that are disguised or take place offstage in order to chart the realm of possible dissent.[12] We cannot pay attention solely to declared resistance that is in the public view, he says. Instead, we need to pay more attention to the immense political terrain that lies between quiescence and revolt in order to 'understand the process by which new political forces and demands germinate before they burst on the scene' (Scott, 1990: 199).

The transformation of societal values is usually a slow process. To understand such change one must take into consideration discourses of both consensus and dissensus while being observant of fissures, cracks and variations on both sides. Neither consensus nor dissensus is a static entity. Discourses change over time and influence each other (Bleiker, 2000: 189). This may bring a hopeful future. A wave of protest may be stopped temporarily, but striving for an open discussion cannot be stopped.

By early 2014 the Putin consensus seemed to have reached its peak. Opinion polls showed strong support. At the same time a polarization had developed in Russian society, including a widening gap between leaders and led. With such a constellation, only Vaclav Havel's words can provide direction: 'Society is a very mysterious animal with many faces and hidden potentialities, and . . . it is extremely short-sighted to believe that the face society happens to be presenting to you at a given moment is its true face. None of us knows all the potentialities that slumber in the spirit of the population'.[13]

Notes

1 Author's interview with Stas Shuripa, Moscow, 24 February 2014.
2 They would later shout 'We are One People', demanding to be regarded as one people together with the West Germans.
3 On this discussion, compare Bishop (2012: 275–77).
4 Compare Rancière (2009: 74).

5 Author's interview with Lev Gudkov, Moscow, April 2012.
6 Yurii Grigorii is a sociologist at the Higher School of Economics.
7 See, for example, Ilya Budraitskis (2014) and Aleksander Bikbov (2014).
8 Compare Moss (2003: 212–13); Obshchaya kharakteristika Sobornogo ulozheniya 1649g, http://student-vuza.ru/istoriya-otechestvennogo-gosudarstva-i-prava/lektsii/obschaya-harakteristika-sobornogo-ulozheniya-1649-g.html.
9 I am grateful to Barbara Lönnqvist, who drew my attention to this parallel.
10 Latency and visibility are the two interrelated poles of collective action (Scott, 1990: 70–71).
11 Compare, for example, the discussions taking place within the academic elite in the 1970s on the need for social information and transparency in order for the state to better manage social processes (Gerner, 1979).
12 Compare the studies by Ted Hopf (2002, 2012) of the hidden discourses in Stalin's Russia.
13 Vaclav Havel, 31 May 1990, quoted in Scott (1990).

References

Bikbov, Aleksander (2014), 'Samoispytanie protestom', *Khudozhestvennyi zhurnal* 91: 58–59.

Bishop, Claire (2012), *Artificial Hells: Participatory Art and the Politics of Spectatorship* (London and New York: Verso).

Bleiker, Roland (2000), *Popular Dissent, Human Agency and Global Politics* (Cambridge, UK, and New York: Cambridge University Press).

Budraitskis, Ilya (2014), 'Intelligentsiya kak stil', *Khudozhestvennyi zhurnal* 91: 71–77.

Colta (2014), 'Akademiki RAN raskritikovali "Osnovy gosudarstvennoi kulturnoi politiki"', 16 April, www.colta.ru/news/2912.

Gerner, Kristian (1979), *Arvet från det förflutna: Sovjet på tröskeln till 80-talet* (Stockholm: Liber Förlag).

Grigorii, Y. (2012, 'Putin vnutri', *The New Times*, 13 January, www.newtimes.ru/articles/detail/48560.

Hopf, Ted (2002), *Social Construction of International Politics: Identities and Foreign Policies, 1955 and 1999* (Ithaca, NY: Cornell University Press).

Hopf, Ted (2012), *Reconstructing the Cold War: The Early Years, 1945–1958* (Oxford: Oxford University Press).

Izvestiya (2014), 'Osnovy gosudarstvennoi kulturnoi politiki' published in 'Minkultury izlozhilo "Osnovy gosudarstvennoi kulturnoi politiki"', 10 April, http://izvestia.ru/news/569016.

Malenkov, Aleksander (2014), 'Pochemu ya blagodaren Pussy Riot', *Rosbalt*, 20 February, www.rosbalt.ru/blogs/2014/02/20/1235878.html.

Melucci, Alberto (1989), *Nomads of the Present: Social Movements and Individual Needs in Contemporary Society* (Philadelphia, Penn.: Temple University Press).

Moss, Walter G. (2003), *A History of Russia, vol. I, to 1917* (Anthem Press), pp. 212–13.

Rancière, Jacques (2009), *The Emancipated Spectator* (London: Verso).

Remchukov, Konstantin (2013), 'Ob osnovnykh tendentsiyakh ukhodyashchego 2013 goda. Ot redaktora', *Nezavisimaya gazeta*, 30 December, www.ng.ru/itog/2013–12–30/1_red.html.

Rossiiskaya gazeta (2014), 'Proekt "Osnovy gosudarstvennoi kulturnoi politiki"', 16 May, www.rg.ru/2014/05/15/osnovi-dok.html.

Rubinshtein, Lev (2013), 'Sotsialnaya gruppa "oni"', *Grani*, 12 May, http://grani.ru/Culture/essay/rubinshtein/m.214587.html.

Scott, James C. (1990), *Domination and the Arts of Resistance: Hidden Transcripts* (New Haven and London: Yale university Press, 1990).

Yurkov, S.E. (2003), '"Smekhovaya" storona antimira: skomoroshestvo', in S.E. Yurkov (ed.), *Pod znakom groteska: antipovedenie v russkoi kulture (XI–nachalo XX vv.)* (St Petersburg), pp. 36–51, http://ec-dejavu.ru/s/Skomoroh.html.

Index

Abramovich, Roman 14
Actionism 27–8, 144, 146, 158, 175
AES+F group 79–80, 79*f*
aesthetic rupture 7, 9, 15, 247, 248
Agamben, Giorgio 81–2
Akhedzhakova, Lilya 194
Akunin, Boris 209
Albert, Yurii 145, 187
Alchuk, Anna 109, 110
Alekhina, Mariya 185, 186
Alekseev, Nikita 88
All-Russian Folk Front 220
anti-hierarchical networks 12, 134, 207, 234
anti-Westism 217
Antoshina, Tatyana 226, 226*f*
Ap-art movement 167
art and protest: expanding art scene
 12–15; introduction 1–2; overview 2–4,
 9–11, 172–86; political protest and
 11–12; protest and dissensus in 7–8;
 structure of study on 15; subcultures and
 countercultures 4–6; *see also* political
 protests
artefacts 7–8, 11, 206, 234–5, 247
Arte Povera (Poor Art) 64
Artkhronika (journal) 122, 187, 208
art activism 146, 159, 173–6, 248, 250
Art-m2 group 178, 178*f*
art of engagement: common interests
 166–9; conclusion 186–7, 249;
 documentary art 176–7; introduction
 9–10; overview 165–6; performances
 and actions 174–6; political posters and
 graffiti 177–9; politicization of art
 169–72; Pussy Riot group 179–86,
 180*b*, 180*f*, 181*b*, 182*b*–183*b*, 182*f*
art on trial: 'Beware! Religion' case
 109–10; conclusions 123–4; 'Forbidden
 Art' exhibition 110–23; mythology of

sacrifice 105–6; overview 105; post-
 Soviet conflicts 106–8
ArtPlay Design Centre 206, 225, 235
Ass, Evgenii 195
avant-garde art: experience of 233–4; by
 French curators 72; introduction 2–3,
 10; 1910s 22–6, 28, 251; ontological
 anarchism 130; pre-Soviet avant-garde
 169; to Stalinist architecture 51
Avdeev, Aleksander 123
Averyanov, Vitalii 220
Azarkhi, Sofiya 91–4, 93*f*

Bacon, Francis 109
Bakhterov, Igor 23
Bakhtin, Mikhail 131, 206
Bakshtein, Iosif 40, 95, 223
Banksy 132, 155
Bauman, Zygmunt 9, 54, 77
Bazhanov, Leonid 13
Belov, Anton 223
Belyaev-Gintovt, Aleksei 68–71, 69*f*, 71*f*,
 171–4
Belyutin, Eli 24
Berezovskii, Boris 29
Berlin Wall 2
Beumers, Birgit 198
'Beware! Religion' case 109–10, 249
Bishop, Claire 7
Bleiker, Roland 2
Bolsheviks 22, 23, 168, 173, 233
Bombili art group 130, 172
Bondarenko, Viktor 85
Borovskii, Aleksander 171
Boyakov, Eduard 197–8, 223
Boym, Svetlana 73
Brenner, Aleksander 27, 109
Brodskii, Aleksander 54–6 55*f*, 57*f*, 64
Bryullov, Karl 54